MICROSOFT®
WINDOWS®
MOVIE MAKER
HANDBOOK

**Bill Birney,
Matt Lichtenberg,
and Seth McEvoy**

PUBLISHED BY
Microsoft Press
A Division of Microsoft Corporation
One Microsoft Way
Redmond, Washington 98052-6399

Library of Congress Cataloging-in-Publication Data
McEvoy, Seth.
 Microsoft Windows Movie Maker Handbook / Seth McEvoy, Bill Birney, Matt Lichtenberg.
 p. cm.
 Includes index.
 ISBN 0-7356-1180-7
 1. Motion pictures--Editing--Data processing. 2. Microsoft Windows Movie Maker. I.
Birney, Bill, 1950- II. Lichtenberg, Matt, 1974- III.Title.

TR899 .M37 2000
778.5'235'0285369--dc21 00-060071

Printed and bound in the United States of America.

1 2 3 4 5 6 7 8 9 QWT 5 4 3 2 1 0

Distributed in Canada by Penguin Books Canada Limited.

A CIP catalogue record for this book is available from the British Library.

Microsoft Press books are available through booksellers and distributors worldwide. For further information about international editions, contact your local Microsoft Corporation office or contact Microsoft Press International directly at fax (425) 936-7329. Visit our Web site at mspress.microsoft.com. Send comments to *mspinput@microsoft.com*.

Acquisitions Editor: Casey Doyle
Project Editors: Denise Bankaitis and Victoria Thulman

Dedications

Bill Birney

To Pleck and Mr. Green.

Matt Lichtenberg

To my family, and my long-time girlfriend Kate, all who have given me so much love and support over the years and throughout my life.

Seth McEvoy

To my wife, Laure Smith, and the San Juan Islands, both of whom have given me so much.

In Memoriam

This book is dedicated to the memory of our friend and colleague Bob Acosta. His passing reminded us all of how precious and fragile life truly is. Bob will be remembered fondly and deeply missed by all of us, and will forever hold a special place in our hearts and thoughts.

Contents

Introduction

This book is about how you can make better amateur movies with the Windows Movie Maker feature of the Microsoft Windows Millennium Edition operating system. Movie Maker is a computer-based video editing tool that enables you to capture video, sound, and still images to create finished movies, complete with cross-fade transitions and narration. The finished movie can then be sent to family and friends or business associates through e-mail, or played back on Windows Media Player. All that you need to make movies is a camcorder, a computer with a video capture card, and Windows Millennium Edition.

Movie Maker is the perfect tool for anyone who wants to learn about video editing or simply doesn't feel like hassling with details. It's easy to use, and in hardly any time you will be up to speed and making movies.

Movie Maker makes extensive use of Windows Media Technologies. The movies you create can be played using Windows Media Player 7. You can also upload movies to a Web site, send them in e-mail messages, or copy them to a floppy disk. The movie files can be very small because Movie Maker uses Windows Media-based file formats. The special data compression methods implemented by the Windows Media Audio and Windows Media Video codecs enable you to compress movies at a number different bit rates and quality settings, making your files small and easy to share. You can also prepare your movies for broadcast over the Internet using Windows Media streaming technologies.

Who is this book for?

This book is for people who want to go further with their movies than they did before. Movie Maker is designed for amateur moviemakers, so they can learn editing fast, and quickly put together movies to send to relatives, friends, or employees. Going further with Movie Maker means journeying beyond the tool and into the world of movies. With Movie Maker, you can explore the art of storytelling and movie production rather than learning a new and complicated editing tool. On the surface, Movie Maker is simple. Its power and depth are not discovered until you add your creativity. There isn't any wizard that can automatically turn your videos into a movie. You learn and grow by experimenting and practicing, seeing what works and what doesn't. And Movie Maker is simple enough to use that you can start experimenting right away.

This book is for people who see the possibilities of moviemaking all around them. The art of moviemaking can be applied to creating a dramatic masterpiece or a video of a child's

birthday party. A home movie doesn't have to be boring. Movie Maker gives you the power to tell a story, demonstrate a product, or simply turn a humdrum vacation video into something exciting.

Aspiring moviemakers

This book is for people who enjoy movies and stories, and have always wanted to produce one of their own. You can write a script, shoot the video, and edit it into a finished movie. Then, you can put it up on a Web site and make it available to the world. We'll explain every step of making your movie, from the initial idea, to the script, through production, and finally editing and distributing your film.

Corporate presentations

This book is also for companies that are looking for creative ways to get a leg up on the competition. You can enhance a static slide presentation with edited video of your products, services, or production facilities. Then you can use Movie Maker to add a narration—a professional touch that should impress your clients. We'll show you how simple it is to put all these pieces together with Movie Maker and a camcorder, scanner, or digital camera.

Creating home movies

Finally, this book is for the parent who is always looking for interesting ways to capture family memories for generations. Home video tapes are often relegated to a dusty shelf, memories forever lost—or buried amidst hours of material. With Movie Maker, you can unearth those buried memories and create movies that family and friends will ask to see over and over. We'll walk you through each step of the process.

How this book is organized

This book will make you think and show you how it's done. The on-line help for Movie Maker that is included with Windows Millennium Edition gives you the basics for using the program. This book gives you the basics for making movies. To make it easy to find the information you need quickly, this book is organized in three parts:

- **Moviemaking Basics.** Contains basic information about writing, planning, shooting, editing, and distributing a movie.
- **Using Windows Movie Maker.** Shows you how to get the most out of Movie Maker—how to record, organize, edit, and share your video with others.
- **Advanced Uses for Windows Movie Maker.** Describes how to use other programs and processes along with Movie Maker to enhance what you can do in editing and post-production.

Part 1: Moviemaking Basics

Chapter 1 introduces you to the concept of making a movie versus shooting a video. It reveals the power of the editor and of the media. You'll see that with just a camera, you are limited to capturing disconnected slices of life; the scope of what you are able to do is confined to one tape. As soon as you add an editor like Movie Maker, you complete the picture. You can give life to those disconnected moments and turn them into finished movies that tell stories—and have the potential to inspire, engage, and change the world.

Regardless of whether you are making a wedding video or a feature film, you need a plan. Chapter 2 shows you how to do that. You learn about the different planning elements that professional moviemakers use. You'll learn how to create a goal for your movie that drives every decision you make. From that goal, you write a script or outline, make plans and schedules, and prepare everything for production.

Chapter 3 covers audio and video basics, and describes what you need to assemble your production toolkit. You'll learn about camcorders, lights, sound equipment, and other production accessories. You also learn about what all those buttons do on a camcorder so that you can make a wise purchase decision.

In Chapter 4, you'll use your production toolkit and put the plans you made into action. You'll learn how professionals make movies: how to approach a shot, compose a scene, and shoot a movie. After production, you'll have all the raw material you need to start editing.

Chapter 5 opens the door to the editing room. In this step of the production process you make the magic happen. All of the work you put into shooting your video pays off as you assemble the pieces into a finished movie. You'll learn how to organize the flow of the shots so they make sense and communicate the right message and emotion. You'll also get inside a cut and learn what makes good editing seem invisible.

Chapter 6 gives you ideas for distributing your finished movie to your intended audience using Windows Media Technologies. This chapter describes the difference between streaming and downloading, and shows you how movies can be distributed over the Internet or any computer network.

Part 2: Using Windows Movie Maker

Chapter 7 provides a quick overview of Movie Maker. You will get a birds-eye view of the interface and commands.

Chapter 8 gets you on your way to creating movies. The chapter begins by explaining how to connect and configure your different capture devices. After your devices are connected, you can transfer movies from tape in your video camera or VCR, or you can use Movie Maker to record live from a camcorder or Web camera. Finally, you'll learn how to import

existing files—such as videos, sounds, music, or still images—into Movie Maker to include in your movies.

Chapter 9 provides information about organizing your clips after you have imported or recorded source material into Movie Maker. In this chapter, several strategies for organizing your clips and collections are provided, so you can quickly find and add items to your movies. You'll learn about the collections area to see how you can move and copy clips between collections, delete unused clips and collections, or edit clip properties. Finally, you'll see how you can backup and restore your collections file.

Now, it's time to make your movie. Chapter 10 teaches you how to add clips to your current project and then edit it. The basic editing techniques you'll use to create your movie, such as rearranging, copying, trimming, splitting, and combining clips are explained and detailed in step-by-step scenarios. Furthermore, you'll learn how to add transitions and a narration track to enhance your finished movie.

After you create and edit your project, it's time to save the movie so you can share it with family, friends, and the world. Chapter 11 shows you how you how to save and share your movies. You'll learn how to determine which quality setting to use when saving your movies. Then you'll find out how you can send your movies in an e-mail message or post them to a Web site.

Part 3: Advanced Uses for Windows Movie Maker

Chapter 12 introduces some of the more advanced uses for Movie Maker. In this chapter, you'll learn how to create title slides in your favorite graphics program, and then use them to create a slide show in Movie Maker. This chapter includes different Web camera tricks you can use to create fun and dynamic movies, such as fast-motion and stop-motion videos. Finally, you'll see how you can animate your title slides so they move within your movie.

Chapter 13 discusses how you can add different sound effects to the movies you create in Movie Maker. You'll learn how to edit these sounds using various sound editing and recording tools.

Chapter 14 provides an overview of how to play your movies with Microsoft Windows Media Player 7. You will also get an overview on how to use markers to navigate through your movie easily, how to add your movies to a Web page, and how to create custom user interfaces known as skins to go along with your movies.

About the companion CD?

A companion CD-ROM is included with this book to give you tools and information that will help you create movies with Movie Maker. Here are the tools and materials you can use:

Microsoft software

- **Windows Media Player 7.** Play the movies you create with Movie Maker.
- **Windows Media Encoder 7.** Create Windows Media files and live streams.
- **Windows Media Advanced Script Indexer.** A tool for doing some simple editing tasks with Windows Media files.
- **Windows Media Player 7 SDK.** Create a custom Windows Media Player 7.

Content

- **Production music.** Music that you can add to your movies.
- **Clip art Title slides.** Insert titles and graphics to enhance your movies.
- **Sample video.** Source and final edited Windows Media files that correspond to the scenarios in the book that you can use to create movies with Movie Maker.
- **Storyboard template.** Print this template and draw storyboards for your movies.

Third-party tools

- Hyperlinks to third-party products that you can use to enhance your moviemaking experience, including tools from Sonic Foundry, Adobe, and Syntrillium.

Acknowledgements

Written by: Bill Birney, Matt Lichtenberg, and Seth McEvoy

Project managed by: Seth McEvoy

Edited by: Terrence Dorsey

Illustrations by: Ned Cannon

Content provided by: Bill Birney, Matt Lichtenberg, and Cornel Moiceanu

Production by: Greg Lovitt

Technical content reviewed by: Ray Dillman, Robert Ferguson, Dave Fester, Mick Garris, Kurt Hunter, May Lau, Jennifer Morris, James Peters, Scott Randall, and David De Wolf

Legal review by: Donna Corey and Sue Glueck

Additional editorial assistance provided by: Sharon Carrol, Steve Hug, Brad Joseph, Jay Loomis, Gail McClellan, Greg Pettibone, Kelly Pittman, John Shaw, Karen Strudwick, Jennifer Winters, Tom Woolums, and Jeff Zhu

Companion CD produced by: C. Keith Gabbert

Companion CD additional contributors: Henry Bale, John Green, Cornel Moiceanu , Robert "Bob" Porter and Tom Woolums,

Special thanks to Microsoft Press editors: Denise Bankaitis, Casey Doyle, and Victoria Thulman.

System requirements

Windows Movie Maker

Windows Movie Maker is a feature of the Windows Millennium Edition operating system. You must have Windows Millennium Edition installed on your computer to use Movie Maker.

Companion CD

To use the CD, you must have Microsoft Internet Explorer 5.0 running on any Microsoft Windows operating system.

Microsoft Press Support Information

Every effort has been made to ensure the accuracy of the book and the contents of this companion CD. Microsoft Press provides corrections for books through the World Wide Web at

http://mspress.microsoft.com/support/

If you have comments, questions, or ideas regarding the book or this companion CD, please send them to Microsoft Press via e-mail to:

MSPInput@Microsoft.com

or via postal mail to:

Microsoft Press

Attn: Microsoft Windows Media Player 7 Handbook Editor

One Microsoft Way

Redmond, WA 98052-6399

Please note that product support is not offered through the

above addresses.

Part 1
Moviemaking Basics

Making Movies

As the name suggests, Microsoft Windows Movie Maker enables you to make movies. Can you make a wide-screen movie with multiple-layer special effects? No. Movie Maker does not produce a picture that is suitable for display on a large movie screen or create multi-layer effects. It will also not cost you millions of dollars to use. However, Movie Maker does enable you to do what many professionals consider the most important part of making a movie: it enables you to edit video.

The Windows Movie Maker feature of the Microsoft Windows Millennium Edition operating system, is a simple tool for organizing and editing video footage. With a video capture card and Movie Maker, you can import video from a camcorder or VCR, edit it into a movie, and distribute the finished movie through e-mail or over the Internet. You can work with video the same way you work with text in a word processor—you can select sections, and then delete, move, copy, and paste them in any order. Though editing with Movie Maker is simple to understand, a full appreciation of the importance of editing and the power you have with an editing tool comes from a more complete understanding of how movies are made. This book will take you behind the scenes and give you a better understanding of the important role that editing plays in creating movies.

Why editing is important

When you first think about editing, you may think of it as a way to correct mistakes—for example, to cut out the part of a video where you thought you'd turned the camera off and instead shot ten minutes of the inside of a camera bag. You may also see editing as a way to shorten a video—for example, to cut a two-hour vacation video down to 30 minutes. However, as you actually edit a video, you'll start to see other possibilities. You will begin to view a two-hour video tape as being composed of individual shots, scenes, and sequences of scenes: kids in the pool, driving along the coast highway, shopping in Carmel, taking a tour of a winery. You will see that editing is a way to rearrange those moments. As you use Movie Maker, you will start to make creative editorial decisions. You may decide that moving the winery tour sequence closer to the beginning makes the video more interesting. Then you will move the part showing the outside of the winery building to before the part inside during the tour so your audience will have a better sense of where they are. You might also move the sunset scene to the end of the movie, because it's a nicer way to finish than showing cranky kids waiting in line at the airport.

As you experience the feel of an editing tool, you begin to understand the importance of editing. Editing allows you to cut out mistakes and shorten a video. But more importantly, editing enables you to create a story, to turn a bunch of disconnected shots into something that has meaning—to make a movie. As the saying goes, movies are made in the editing room. This saying can only truly be appreciated after you have experienced editing. When you sit at the computer with Movie Maker and begin to pull apart the pieces and move them around, the possibilities begin to flood in. You see that following a close-up shot of the kids smiling with a shot of the sunset over the ocean has a completely different feel than following it with a shot of the kids at the airport. In editorial terms, this is called *juxtaposition*: adding meaning to a shot by the shots you place next to it. You also see that it appears jarring to make a direct edit from Susie running to the same shot of Susie running a moment later. This is called a *jump cut*. Both of these terms will be discussed in detail in Chapter 5.

As you become an editor, you see that editing is learned by experience. The more cuts you make, the more experience you get, and the better and faster you become. If you care about what you are editing and how it will appear to others, you will become very picky. When you first start out, you won't really have a full appreciation for the art of editing. Editing can be a gut-wrenching, soul-searching experience. An editor is just as involved in his movie as a painter is in his masterpiece, or a writer in her novel. A professional editor can spend hours, days, or weeks trying to get a scene just right. Many editors become directors because they know exactly what types of things to shoot to make a scene work when it's edited.

Telling a story

Editing is about telling a story. Even if you're just using Movie Maker to cut time out of a vacation video or your kid's soccer game, you are still making editorial decisions and you are still creating a story. Reality is a soccer game. As soon as you start shooting a game with your video camera, you are making editorial decisions and reality goes right out the door. Even if you are completely unbiased, you are still deciding to shoot one group of kids instead of another. The location you choose to shoot from, whether to zoom in or zoom out, whether to move the camera with the ball or stay with a group of players—these are all decisions that go into the story you are trying to tell. You also consider your audience—who are you creating the story for? You may shoot the video differently if it is to be played at the end-of-season team party than if it is for the grandparents to see.

If you take the raw video you shot of the game and edit it further in Movie Maker, you can fine-tune the story: cut out the boring parts, the bad angles, the parts where the other team scores. With editing, you have complete control over what the audience sees and experiences. This gives you control over what the audience thinks and

feels. You can create stories that educate and inspire; that promote teamwork and build team spirit; that pull people together and change lives. If the purpose of the video is for team training, you can focus on good plays and mistakes, and remove shots of the audience, the post-game celebration, and so on. If you're making the video for the team party, you select only shots that accentuate the positive, such as those showing team members cheering, smiling, and scoring goals. You can add music that further enhances the feelings that you want to convey.

No matter how big and expensive a movie, there is something very priceless and simple at its core. A movie is nothing more than a story told with pictures. The story can be a script by a Hollywood writer or Grandma's 100th birthday party. The characters can be intergalactic aliens or members of a soccer team. All the visual effects, the wide-screen picture, and digital sound are merely window dressing for the story.

Home movies as art

If you already own a video camera and a computer running Windows Millennium Edition, it will be easy for you to experiment and explore the process of creating a movie. You can make movies on any scale you want. You can invest years collecting video shots and editing them into a movie, or you can plan, shoot, and edit an entertaining piece over a weekend. With Windows Millennium Edition and a video camera, making movies is no longer restricted to professional filmmakers. Not everyone will make great movies, but almost everyone now has the opportunity to give it a try.

This book is aimed at the amateur moviemaker. Most amateurs will probably use the Movie Maker feature of Windows Millennium Edition to edit home movies of weddings, vacations, and parties, so that they can e-mail the finished movies off to friends and relatives. Movie Maker is a great tool for this, and it has many more possibilities as well.

Editing doesn't just enhance the use of a camera, like adding lights and a tripod. Editing enables you to turn a simple video recording device into a moviemaking device. It can vastly change how you will think about using a video camera, and has the potential of changing how people express themselves and communicate. Instead of writing a letter or making a phone call, why not make a movie and share it with the world?

Digital video editing has already changed the way professional moviemakers work. Today, almost all feature films and television programs are edited on computer-based systems. Also, more and more feature films and TV shows are being shot and edited using digital video cameras and editing systems. *The Blair Witch Project* is just one example. With Movie Maker and other consumer video editing programs, we will see just as profound a change in the way amateur movies are made.

History of amateur moviemaking

Amateur moviemaking grew out of the professional film industry in the early 1900s. As soon as the first professional, hand-cranked camera and projector went on the market at the turn of the century, a few brave amateurs began experimenting with this new medium. But the temperamental and costly 35-millimeter film stock kept most people from becoming filmmakers.

It wasn't until 1923 that amateur moviemaking took off with the introduction of 16-millimeter film. The frame size for 16-millimeter film is about 1/4 that of 35-millimeter film, and associated costs are much lower. Simple, compact cameras from manufacturers such as Bolex and Bell & Howell soon became available, in which the hand crank was replaced by a spring-driven motor. All you had to do was wind up the spring and shoot. In the years to follow, cameras were further improved with the introduction of electric motors, zoom lenses, and automatic exposure devices. Shooting became even less expensive when 8-millimeter film was introduced in 1932. In 1965, Super 8 film, which had smaller sprocket holes and a larger frame size, came on the market.

To edit film, you use a pair of *rewinds*, a *scope*, and a *splicer*. This basic equipment is still in use today by film editors. With the rewinds, you hand-crank the film from a *supply* reel on the left side to a *take-up* reel on the right. As you crank, you view the frames by running the film through the scope. To edit, you use the splicer to cut the film between frames, and then join the pieces of film together with glue or tape.

Today, amateurs are split between film and video. The purists still prefer the look of film. However, others prefer the lower cost and simplicity of video. Prior to the 1970s, television production could only be done by professional companies with large budgets, and the equipment to shoot and edit video was very complex and expensive. In the past 30 years, video production tools have become more accessible to the average person. Anyone can purchase a camera for a few hundred dollars and shoot video of higher quality than professionals used to be able to produce in their million-dollar studios. However, even though cameras are within reach of the average person, video editing systems remained expensive and complex until recently.

Movie Maker and other consumer editing systems complete the picture. Now you can shoot video, edit it, and distribute it with tools you probably already have at home. With an inexpensive video camera, a video capture card, and a PC with Windows Millennium Edition, anyone can make finished movies easily.

Power to the amateur

With the growth of the Internet as a distribution system and the development of low-cost, high-quality moviemaking equipment, amateur film and video are certain to

increase in popularity and importance. It may soon be just as commonplace to watch low-budget amateur videos in our living rooms as it is to watch a Hollywood movie in a theater. Movies for mass distribution do not have to be created by only a handful of movie studios, and amateur videos do not have to be amateurish and dull. When moviemaking is accessible to everyone, we will see the line between amateur and professional begin to fade away. We can already see how amateur video has crossed over into the professional realm in so-called reality TV programs that feature real life events as they happen.

A professional moviemaker has all the tools and resources at his fingertips. He can shoot a really nice-looking scene and make an amazing, spectacular movie because he can pull together the equipment, know-how, and talent to make it happen. He knows what to do because he has done it before or knows where to find the resources to make it happen. Does this mean an amateur can't make an amazing, spectacular movie? Not at all. An amateur often just does not have the time, money, equipment, and experience.

The important thing to keep in mind is that an amateur can make movies. The movies may not have the polish and scope of a Hollywood spectacle, but they can be every bit as entertaining, useful, and inspiring. You can create amateur movies to entertain a mass audience on the Internet, to communicate the feeling of whitewater rafting to friends in e-mail, or to capture the warmth of a family reunion for future generations. With Movie Maker and an inexpensive video camera, you can capture and edit video to create whatever you desire.

By planning before you shoot and edit, and using the same approach professionals use, your movie can be all the things you want it to be. Instead of merely recording pictures of things, you can create a movie that touches people, even changes their lives in some way. Maybe all you want is a factual record of an event, but maybe you want to tell a story, convey a feeling, or persuade people of your point of view.

The one thing you have as an amateur that no professional has is complete creative control. As an amateur, you're not working for anyone but yourself. You can create your movie for any reason, for any audience, and go about it any way you want. Even though the professionals have all the tools and resources at hand, most have to work under various commercial constraints and pressures. As an amateur, you can do whatever you want. You can break the rules, discover some groundbreaking technique, or write a completely original story. Just because some editing rule says that jump cuts are bad doesn't mean you have to follow that rule. A camera and editor are the tools. With those tools and your imagination, you really do have a great deal of power. You can use that power to realize your dreams.

A new approach

First, it should be noted that we are not promoting an agenda or attempting to force some new style of moviemaking on you. You can make movies any way that you want. The point of this book is to offer ideas and possibly open some new doors. In part 1, we'll describe a general approach to moviemaking that can help the process become more enjoyable and productive. Movie Maker plays a central role in this approach because it enables you to create the movies from your raw video. You certainly don't have to use our ideas, and you are free to continue the way you have been working. However, if you enjoy shooting videos and you would like to expand your knowledge and explore new ideas, you can experiment with this approach to moviemaking.

Before delving into the details of moviemaking, let's consider how many amateurs approach the making of movies by looking at a hypothetical situation involving a fictional amateur filmmaker and his family.

Fred's first film

Fred's amateur filmmaking career starts with a specific need. He is going on a long-awaited, once-in-a-lifetime, very expensive vacation to Europe with the family and feels he must capture the event on video. So he goes to a video store, listens to the sales pitch, and walks away with a bag filled with video gear. When he gets home, he tosses the bag in the closet.

During the trip, he hauls the bag around as the family explores ruins and castles, and he gets shots of all the important places. He knows it's time to shoot when all the other tourists get their cameras out. He shoots video of the kids standing in front of a Stonehenge monolith, the kids standing in front of the Eiffel Tower, the kids looking at a piece of the Berlin wall, and gets action shots of the family walking into each hotel along the way. When the family gets home from the trip, Fred tosses the bag back in the closet.

Two months later, the family has a small dinner party. At one point, a guest makes the mistake of asking about the trip to Europe. Fred leaps up and pulls the tape out of the closet. Then he proceeds to play the two-hour long tape of the family standing in front of things in Europe. At the end of the show, the guests yawn and attempt to smile. They are polite for the most part, but privately, not one of them can imagine why Fred and his family went to all the trouble of going to Europe when they could've had more fun in a sensory deprivation tank.

The family vacation may actually have been fun and exciting, but Fred did not capture that in his video. It appears, in fact, that Fred waited until the fun had drained out of a scene before he rolled the camera. He purposely planted his characters in

situations where they would have no fun and then gave them no direction. The audience wanted to see his family having a good time in Europe, not the same tired angles of tourist stops. The video was boring because it didn't show the audience anything new. It was confusing because it jumped around with nothing to connect the pieces. It was frustrating for viewers because it didn't satisfy their needs. On top of all that, the sound track was noisy and didn't match what was being seen. Anything that boring, confusing, frustrating, and noisy is bound to put an audience to sleep.

You may notice that in our critique of Fred's video, the technical quality of the video is really not much of an issue. Even though the scenes were well lit and Fred's new camera allowed him to add special-effect transitions between shots, it wasn't nearly enough to resurrect a bad movie. A good picture and visual enhancements will certainly influence the enjoyment of a movie, but they are not as important as story and character. Hollywood has produced many high-budget flops that concentrated more on special visual effects than on developing an engaging story and characters.

Making a shooting plan

Fred's approach to making movies is very simple: shoot pictures of things. It appears he puts little thought into what he is doing. He has no plan, no idea of how to proceed. He pulls the camera out when he sees others doing the same. He shoots what he thinks he should be shooting, probably based on pictures in a travel brochure. A video camera is all about movement, but he shoots stationary objects and waits until any moving objects, like people, are standing still. He doesn't appear to enjoy shooting video, and doesn't seem to want to put any effort into it. He doesn't go outside the bounds of what he feels is sensible shooting practice. He doesn't take any risks and doesn't care about who will watch the video.

The first time he picked up the camera, he realized he didn't know what to do with it, but he somehow felt obliged to use it after having spent so much money. He didn't understand this contraption or anything about making a movie that people would want to watch—and then he began to fear the camera. It intimidated him. During the trip, the camera bag would glare at him from the corner of the hotel room. He would take the camera with him out of fear that it would tell. He trusted that the camera would somehow know what to shoot—and he became controlled by the camera. But in the end, he discovered the camera was no better than he was. It made nice, colorful pictures, but it couldn't make up for that fact Fred didn't know how to make movies.

Making a good amateur movie is really just a matter of planning ahead. During the plane trip to Europe, Fred had plenty of spare time. That would have been the perfect occasion to think about the camera and come up with a plan for shooting the

trip. A shooting plan can involve a script, but it doesn't have to. In the case of shooting a family event or vacation, all that is required is a little forethought. To come up with a simple shooting plan, ask yourself the following types of questions:

What prompted you to make this movie?

Most likely some event or specific need caused you to think about taking out the camera and shooting some video: a birthday, bar mitzvah, barbeque at the beach, or trip to Europe. These are all worthwhile subjects, but it doesn't have to be a special occasion. Rather than react to some event, you can create your own events just for shooting; in other words, you can create your own memories instead of waiting for them to come to you.

Who will watch the movie?

This is the first important question Fred failed to ask. No matter what you are creating, you should know who your audience is before you start shooting, otherwise your video will have no focus. This will affect what you choose to shoot and what you choose to ignore.

What do you want the movie to do?

After you decide who your audience is, decide what you want the audience to get out of your movie. Do you want them to learn something or share a feeling? Do you want them to fall asleep, or do you want the movie to excite and engage them? When you decide what you want your movie to do, spell it out in a one-line statement. That statement will become the goal of your movie and will drive all of your shooting decisions—for example, "I want the audience to share the excitement I feel about the trip."

What will you shoot?

Once you have a goal and an audience for your movie, you can make decisions about what to shoot and how to shoot it. Your goal statement will help you decide things such as when to roll the camera, what to point the camera at, what angles to use, what sound to record, and the type of lighting you will use.

Think of the camera as the eye of your audience; you are controlling what they see. For example, suppose that Fred had wanted his movie to show how different and amazing Europe is compared to his home town. He could use his wife and kids—the characters in his movie—as the benchmark for comparison. He could choose camera angles and moments that emphasize the difference. For example, when shooting the inside of a big cathedral, if he merely pointed the camera up and rolled the camera, the audience would see the dome. So what? However, if he shot one of his children

from a distance with the ornate dome looming overhead, the audience would see how awesome and amazing the place is in comparison.

You may have noticed that of all the important things to consider when making a movie, buying and operating a video camera were not mentioned. The reason is that the type of camera you use is simply not as important as having a well thought out goal. The fanciest camera in the world will not produce an enjoyable movie unless it is being used to shoot an enjoyable story. On the other hand, some people have created beautiful and compelling films with very inexpensive equipment. Many fine movies have purposely used low quality to help tell their stories. For example, a low-quality, grainy look to a film can help convey the gritty feel of a seedy urban street at midnight.

Learning how to operate a camera is important for shooting video, but most consumer cameras are easy to use. The vast majority of cameras available to consumers today produce high-quality pictures and sound, and you can figure out how to use most of them without even reading the manual—though we do not suggest doing so. If you can run a toaster, you can do at least basic shooting with any video camera.

You should place knowing how to operate a video camera down in the middle of the list of important moviemaking prerequisites. If need be, have your child or neighbor work the camera. Don't let that little contraption intimidate you. The really important and interesting stuff is non-technical.

Moviemaking art

The most common initial roadblock to success with a camera is a lack of appreciation for the art of moviemaking. The average person sees a well-executed movie and assumes it was easy to make, that the actors and cameras just appeared somewhere and it all magically came together. In fact, that's exactly what a good moviemaker wants the average person to think. The director's job is to tell a story and, if the director does his job, you see that story and nothing else. It takes hundreds of people to make a movie appear seamless, believable, and simple. If you see a disturbing shift in a shadow from one shot to the next, the lighting guy wasn't doing his job. If an actor's performance seems out of place, the director wasn't doing his job. If we should be focusing our attention on a young girl's face, but are distracted by an open window and annoying paintings on the wall, the director of photography wasn't doing his job.

A good movie remains focused on its goal. If we are allowed to see its seams—for example, a microphone hanging in the shot, drifting focus, an added scene that breaks the thread of the story, or acting that doesn't match the scene—the magical spell is broken. The movie falls apart in some way. We can forgive a few of these errors, but they add up. We start looking at our watches and noticing the popcorn

stuck to our feet. Perhaps we give up and walk out. If nothing else, a truly bad movie makes us appreciate the care that goes into the really good ones.

If you know a bit about how commercial movies are made, you can make your own movies more entertaining, more interesting, and more useful. Making movies shouldn't be a chore, and you should feel comfortable enough with your camera that you aren't intimidated by it. The best way to learn how to make good movies is by practicing. The more you shoot, the more you learn. After a while, you'll develop a style and things will become more natural. You'll know what works and what doesn't. You'll notice that framing the subject a certain way focuses the viewer's attention better, and that moving the camera slowly is less annoying.

As you become more comfortable shooting, you can start to explore the camera and experiment with the settings and buttons. You might turn off the auto-focus and auto-exposure features and discover that you can adjust these controls manually to create different effects. You can also get a different effect by positioning the camera back some distance from your characters and zooming in rather than always being right next to them.

As you explore moviemaking, there are points when you might become frustrated. You'll come across times when you wish you could do more, but find yourself running up against technical issues. Maybe the weather doesn't cooperate and the sunset is gray, a room is too small and you can't get the angle you need, or an actor is temperamental and refuses to come out of the hotel room.

But the biggest frustration for amateurs, after they become comfortable shooting and directing, is not having a way to edit. You can shoot individual scenes with a camera, but it is almost impossible to maintain control over a story if you don't have a way to put the pieces together. As you play a tape back, some shots are uncomfortably long, others are too short, mistakes abound, and the order of the shots is often not quite right.

Prior to Movie Maker, the amateur filmmaker had few choices for computer-based editing tools. Professional video editing systems are expensive and often very complicated. There are a few high-quality editing programs for amateurs, but they are generally expensive and aimed at users who already have some video editing experience and training. Movie Maker provides the beginner and part-time amateur with a way of entering the world of video editing. With Movie Maker, you can perform most video editing functions without needing a degree in film production. You can create finished movies that tell stories. You can also explore and experiment with new ideas.

Adding an editor

An editing tool opens up a whole new world of possibilities, and that is what Movie Maker is all about. With Windows Millennium Edition , you capture video from a tape to a file on your computer. Movie Maker then automatically divides the video into clips that you can arrange in any order. A clip, roughly speaking, is a section of the video that has similar visual content: a shot out the window driving through Big Sur, a shot of the kids playing on the beach, another shot farther back of the kids, and so forth. You can remove clips, copy them, and change where a clip starts and ends. By enabling you to select and order the clips, then adjust their timing, Movie Maker gives you the means to turn a series of disconnected shots into a story. It's very limiting to view Movie Maker as a tool for fixing video you have already shot. Although you can use it for that, Movie Maker enables you to completely rethink your approach to shooting video.

You can think of a piece of video in terms of its being edited or unedited. The tape that comes out of your camera is usually unedited, meaning the order and length of the shots follow no plan. The unedited tape is called the *raw footage* (filmmakers measure the length of film in feet) or *camera original*. An edited video is created by using an editing program, like Movie Maker, or by roughly selecting what you shoot with the camera. A final edited tape is called the *master*. Just because a video has been edited, though, doesn't mean it is a finished movie. You can, for example, edit some disconnected shots together to see what they look like, or you might decide to edit together a short sequence of shots to make sure you have shot enough coverage.

There is certainly value to being able to edit together a series of disconnected shots. For example, you can trim video of a swim meet down to an essential 20 minutes by cutting out everything but the events that include the swimmers you are interested in studying. An edited piece like this would be very useful for showing to the team. In a classroom situation, the video becomes support media for the speaker. The edited video doesn't have to be a complete story because the instructor is there to narrate and control playback. The instructor can start by running the edited video all the way through. Then he can replay selected pieces of the video, freezing and slowing down sections as needed, to answer questions or illustrate a particular point. In this case, the story is not in the video, but is created by the instructor in real time.

You can also edit different versions of the same video for different audiences. For example, the swim team's training video might contain more shots of the swimmers competing in individual events, while a video for the team's awards dinner might include shots of swimmers receiving their medals. All of the raw footage came from the same swim meet, but Movie Maker lets you put the pieces together in different ways for different reasons.

To go a step further and create a movie that has a story, you do not need extra tools or a bigger computer. All you need besides a camera and Movie Maker is an idea for a story, a plan for how to execute the idea, and the drive to follow it through. Movie Maker gives you the power of the storyteller. To take full advantage of this power, you need to rethink your approach to shooting video.

Exploring the possibilities

A camera and editor are the basic moviemaking tools. With these two tools, anyone can make movies. If you have been making videos up to this point with only a camera, you have learned one way to make videos, and you know your limitations. In this section, we will give you ideas for rethinking your approach to using your camera now that you have the Movie Maker feature of Windows Millennium Edition. Without an editor, a camera can do nothing more than record events in chronological order. With an editor, your camera becomes one half of a complete production system.

The following concepts explore some of the possibilities that open up to you with a camera and Movie Maker:

- **Coverage.** Because you can edit the video later, you are free to shoot as much as you want.

- **Being in the moment.** An editor frees the camera to become an actor.

- **Story development.** Movies are made in the editing room or on your desktop computer.

- **Planning.** Editing gives you complete control.

- **Control.** Create the movie that you want.

Just because your production system is small doesn't mean you have to think small. All that mysterious equipment you see in behind-the-scenes photos is merely there to enhance the capabilities of the camera or editor. For example, most of the equipment on a movie set is for adding and controlling light. In most cases, an amateur doesn't need special studio lighting. Most of the time, you can use *available* light—light that is already there. Filtered sunlight and lamps in a room, also known as *practicals*, are examples of available light. You have the tools to make movies. Now open your mind to the possibilities.

Coverage

If all you have in your moviemaking toolkit is a camera, the entire movie creation process begins and ends in the camera. As you shoot, you are constantly aware that everything you shoot will end up on the final video tape that everyone will see. This

gives you the added burden of trying to edit as you are shooting. As anyone who has ever shot a frame of film or video will tell you, that is an impossible task. No one, no matter how much film school or feature film credit they have, is able to edit successfully as they shoot. Not only is it difficult to tell a story, but having that extra concern distracts you from your primary job as director and photographer. While you are thinking about how your audience will react, you miss opportunities. It's kind of like trying to design and sew a dress at the same time. You are less likely to take chances and hold out for something better because you know that once you've made the commitment and sewn the seam or shot the footage, there is no backing out.

Movie Maker removes that burden. You can shoot as much as you want and only the parts you like will end up in the finished product. In the moviemaking world, this is called *coverage*. Instead of worrying about your audience seeing everything you shoot, you only have to worry about shooting enough to be able to edit a good story. When you have the option of editing, you are free to shoot plenty of coverage. Let's say you would like a spectacular shot of a flock of blue herons taking off from a pond and flying over the camera. Without an editing program, you would have to wait for just the right moment and then start the camera and hope the birds do what they're supposed to do. In reality, you would probably not even try to get the shot and you would miss a great opportunity to catch a dramatic moment for your movie. With an editor, you can put a fresh tape in the camera and start rolling. Even if you shoot an hour of tape for one 15-second shot, it might be worth the effort, and it costs practically nothing to try. If it works, the movie is better. If it doesn't, you can use the tape over again.

Coverage is the moviemaker's key to getting great shots and making engaging movies. Tape is cheap; it's better to let it roll—even if you might not use the video—than to cut it off or start late and lose a telling moment or a spectacular, once-in-a-lifetime event. A director's job is to shoot enough video for the editor to create a story. It doesn't matter what is on the tape before and after a good section, and it doesn't matter what order the shots are in. However, it does matter if you don't have the shot.

Being in the moment

There is a phrase that you may have heard used by actors and directors: *in the moment*. When an actor is in the moment, that means she is totally immersed in the character she is playing. Being in the moment is very important for an actor and the director. If the lighting, acting, and camerawork all come together right, they can create a moment on film that engages the audience, draws them into the film, and propels the story forward. When an actor's face is spread twenty feet across the big screen, every movement, every minor nuance of expression registers with the audi-

ence. Even a blink or a glance away at the wrong moment can telegraph the wrong feeling or take the audience out of the picture and send them back to the theater.

There is another phrase you may have heard: *suspension of disbelief.* A well-crafted movie allows the audience to suspend their disbelief—to forget that the movie is an illusion. For two hours, the audience is transported from their seats in the theater to another land and time. Each audience member becomes a silent actor in the movie experience. In reality, the person is sitting in an auditorium watching colored flashing lights reflected on a white surface. What turns the colored light into a movie is the person watching it. A movie is all in the moviegoer's mind.

Even though a hundred people may be watching the movie, each person is experiencing it in his own way. That's why everyone reacts to a movie differently. One person may walk out of a movie with a big smile and a warm feeling all over. Another person may walk out of the same movie feeling physically ill. When you have suspended disbelief and you are in the moment and following the story with the characters, the movie experience becomes a very personal thing—a very real thing. You are in the experience alone. You are there with the characters as they open a mysterious door that leads into a dark room, and as they leap out of their foxholes and charge the enemy.

The secret of creating the magic is to somehow get the audience to suspend their disbelief, forget they are watching a movie, and become part of the moment. To do that, you as director must be in the moment yourself. Don't think of your camera as some dispassionate recording device. Think of it as a player in the movie—it is in the moment, too. It isn't just there to record stuff for the viewer to watch; it is the viewer. It captures what viewers need to see to be part of the movie.

To get an audience to suspend disbelief, you have to make the right choices. As a director, you need to draw good performances out of your actors—even if they are your family members enjoying a vacation or birthday party. Movie Maker enables you to shoot enough coverage to capture those moments. For example, if you know that everything you shoot will be seen by an audience, you expect the person you are shooting to be in the moment as soon as you turn on the camera. You approach a child at the beach, point this scary contraption with a blinking red light at them, and expect them to be themselves right away and do something interesting. In many cases, the child stares at the camera with a stunned expression. If you can edit, on the other hand, you can keep shooting until your actor forgets about the camera, seems comfortable, and becomes himself. That's when you get the good performances—the memorable moments. You simply save those moments and throw out the parts where they seem stunned.

Story development

No matter how simple or complex you want your finished video to be, you can always make it more interesting and useful by telling a coherent story. This shouldn't be a difficult or foreign concept to grasp. You know about stories; you tell them every day. All that is required is a little thought before you shoot.

Every story has a beginning, middle, and end.

Beginning

This is where you introduce the main characters and engage the viewer in the story. You do that by involving the main characters in an activity that grabs the viewers' attention and then propels the story forward. For example, you could start a vacation video by showing the family packing their bags and leaving for the airport.

Middle

This is the main part of the story, roughly half or more of the length of your movie. During this part of your movie, you develop the characters and progress the plot. For example, during the middle part of the movie, the family would explore Europe, taking in the sights, sounds, smells, and tastes of foreign countries along the way. The complaints about sore feet and no clean towels melt away as they progress in their journey.

End

This is where you make the experience pay off for the viewer. Your story and characters have progressed to this point. Now you bring the story full-circle and tie it back to the beginning. In the beginning, they ran around frantically. Now as we see the family waiting at the airport to come home, they look a bit ragged, but they now have a new world of experiences to reflect on and share.

A movie is as good as its story and characters. That applies to a multimillion-dollar feature or a home movie of a vacation. It's all how you look at it. In either case, you are asking people to sit there, watch, and hopefully take something away from the movie. If the movie is a series of disconnected shots, viewers will feel as if their time was wasted. All it takes is a camera, some editing, and a good story to create a movie worth watching.

We will discuss more about developing a story in Chapter 2.

Multiple takes

Movie Maker enables you to turn disconnected shots into a story. It also enables you to change your approach to shooting. Because you can change the length and order of shots with the editing program, you have complete flexibility in what you shoot

and the order you shoot it in. You can shoot multiple takes, shoot out of order, shoot long, and experiment.

A camera original tape consists of a series of *shots*. A shot begins when the camera starts recording and ends when it stops. If you shoot continuously from the beginning (or *head*) of the tape to the end (or *tail*), the tape has one shot. Usually a tape has many shots. For example, if you want to capture the color of Las Vegas at night, you might grab 20 or more shots of hotel and casino signs and many random shots of people gambling and socializing.

A *take* is a version of a shot. Having multiple takes of a shot gives you choices in the editing room. When you grab random shots of gamblers, you may only get one take of each shot. However, if you have control over the subject or can predict the behavior of the subject, you can shoot multiple takes. Suppose you find an interesting casino sign. Because the sign is stationary, you can shoot a number of takes of the sign and choose the best piece when you edit. For example, you can shoot the whole sign straight-on, shoot it again with the camera tilted, shoot it as you zoom in to part of it, and shoot as you move the camera from left to right. You can shoot as much as you want. When you edit your movie, you can choose the best take and throw out the rest. The takes you don't use are called *outtakes*. Your audience never has to see the five minutes of outtakes, only the 10 seconds or so that you choose.

If it seems like a waste of tape and time to use only 10 seconds out of five minutes, consider that the few minutes you spend shooting the subject gives you more choices later. If you have the choices, you are more likely to make a better, more interesting movie. Tape is cheap, and a few extra minutes spent while you are in place and set up is worth it. You may never get another chance. After you finish the movie, you can recycle the original tape if you want.

As you get more practice shooting and editing, you will get a better feel for how much coverage is necessary. Professionals always err on the side of shooting too much. On an expensive movie shoot, it is always better to get a few more takes than to have to set everything up again and re-shoot a scene. You will most likely not know what is too much and what is not enough until you try to edit a sequence of shots and see how everything looks together. For example, when editing the Las Vegas movie, you might discover that out of the entire five minutes, the part that worked the best was when you bumped the tripod by mistake. If you hadn't taken the extra time to shoot more coverage, you would've had to settle for a mediocre shot. You also learned something. The next time you shoot, you will purposely do a take where you bump the tripod.

Shooting out of order

Since Movie Maker allows you to edit individual shots to create your movie, you can shoot *out of order*. In this case, out of order doesn't mean something is broken. It means you don't have to be concerned with what order the shots are in on the tape. You can shoot the shots in any order and shuffle them later when you edit.

For example, suppose you arrive in Las Vegas just before sunrise and you are booked to leave that night, but you want to make a movie that shows the Vegas nightlife from sunset to sunrise. If you had to shoot events in order, you couldn't do it. But because you can shoot out of order, you can grab the sunrise shots first before you even check into the hotel, then get the sunset and night shots later. When you edit the movie, you can pick shots from anywhere on the tapes and put them in whatever order you want. The shots on your edited master don't have to be in the order they were shot. Even though the first shot you made was in the morning, your first shot in the movie can be the Las Vegas sunset. The second shot can be people on the street at four in the morning. The third shot can be gamblers in a casino at ten that night. The fourth can be a sign that you shot at eight.

It doesn't matter what order you assemble the shots in; the viewer will always assume a movie is in chronological order unless you do something specific to break the feeling of continuity. As long as you are careful when you edit, the story will seem continuous. For example, in the Las Vegas movie, you probably wouldn't want a shot of the sunrise, then a shot of the signs lit up at night, and then a shot of people walking along the street during the day; that would ruin the effect of showing the progression of time from evening to morning. If you try to maintain a logical progression of events, your viewers will find it easier to suspend their disbelief and become immersed in your movie.

Shooting long

Because you can remove unwanted video with Movie Maker, you don't have to worry about shooting too much before and after the part you think you will want to keep. This is called *shooting long*. If you are shooting life as it happens, you often don't have the luxury of shooting long. However, if you do have the control, you should always start rolling the camera in anticipation of the event you want, and then let the camera continue a few seconds after.

If you are shooting a specific action, such as a swimmer making a dive, you should shoot long. When you edit, you can trim off the unwanted head and tail (beginning and end) of the shot. It's safer to shoot this way because you never know exactly when the dive is going to occur. Events can happen in a split second. The swimmer might dive before you get the camera started, for example. You can think of shoot-

ing long the same way you think about buying lumber: always buy pieces that are longer than anticipated just to be safe.

Continuing the Las Vegas example, suppose you find out that a big, colorful sign is being illuminated right at 6:00 and you decide to make this the opening shot of your movie. You can set up your camera at 5:30 across the street from the sign with the sun setting behind it. Start the camera a minute or two before 6:00 and then let it run for a longer period than you think you'll need. You only get one chance to shoot the sign coming on, so don't take the chance of waiting right up until a second before six just to save some tape. What if the sign comes on early? What if the camera doesn't start up right away?

With every camera, there is a pause between the time you press the start button and the camera actually starts recording video. Also, the action of pressing the start button can cause the camera to jump slightly no matter how carefully you are holding it. Consider these things and make sure you have plenty of video at the head and tail of a shot.

Experimenting

With an editing program, you don't have to be shy about what you shoot. Make mistakes and take chances. The only people who need to see the camera original are you and the editor. And if you are the editor, no one else will see the mistakes you made or the shots that didn't work out.

Often, the truly great, original shots are those that you weren't sure would work. Experimentation is how you learn. You may have spent thousands of dollars for a trip, an event, or a party. A few dollars spent for extra video tape is well worth the investment if it results in having the shots you need when it comes time to edit the final movie. If nothing comes of the experiment, you can record over the tape and try again.

As you shoot, use your imagination and think of all the possibilities. You should always have a variety of angles to choose from when you edit. Be bold; think big. In Las Vegas, you might hire a taxi and have the driver drive slowly down the strip as you shoot up at the signs out the passenger window. Then you could have him drive down the strip again as you shoot people walking.

Try to get different versions of particular shots and shoot alternate takes. Suppose you need one panning shot of the inside of a particular casino. Shoot that one, and while you're there, grab a few more. Try one *pan* (moving the camera from side to side) with the camera zoomed all the way in. Try another from a different position. Try holding the camera waist-high and walking steadily through the casino. Experimentation will often produce an inspired shot that you might not have thought of before.

Note If you do shoot in a casino or in any other public space, make sure you have permission first.

Adopting an open, creative attitude toward shooting can mean the difference between an interesting, memorable movie, and one that is predictable and dull.

Planning

A party or vacation would probably be only partially successful if you just let stuff happen without any planning. You don't want to over plan, but you do want to plan enough so that everything proceeds well and your event is everything that you want it to be. A video should be no different. If you do nothing to plan a video, you will get random shots of things that will make no sense to an audience. If you do some planning up front, you can create a movie that has meaning. The audience will understand what they are seeing and can become engaged in the story.

Without a way to edit your video, you are forced to take the approach that everything you shoot will be seen by your audience. If you're shooting an event that you have no control over, you have to somehow predict what things will happen when. You either end up shooting too much or too little. You miss some important events and you don't have the luxury of being able to take risks. When the job of predicting unpredictable events becomes too much, you opt for the easy way out and shoot only those things that don't move, like buildings and trees. You end up shooting inanimate objects instead of people and events.

Editing with Movie Maker works best when you plan your movies in advance. Instead of allowing luck to control what your audience experiences, Movie Maker gives you the ability to control what the audience sees. You might think that having an editing program means you don't need to plan your shoot—that you can shoot whatever you want and make it all work later when you edit the raw footage. This is certainly one approach, but not one that we suggest. Your completed movie will only be as good as the original footage you had to work with in Movie Maker.

You plan the shooting phase of your movie so that your edit goes smoothly. The amount of planning you do depends on the movie you are making. You start a production plan by deciding on a goal and audience for your movie. You then let that basic description drive all other decisions. One goal might call for extensive planning: a shooting script, diagrams, actors, sets, props, and a crew. Another goal might call for minimal planning: a few minutes thinking about it on the drive to the shooting location and a couple of notes jotted down on paper. Either way can work fine, but for your movie to be everything you want it to be, you should make appropriate plans.

Think about the story you want to tell, plan how you want to shoot the story, follow your shooting plan, and then edit the best shots into the final movie. Keep your goal

in mind as you create the movie and remember to put yourself in the place of your audience. Are you throwing something together, or investing some thought and planning into what you are doing?

Control

When you think about it, one of the main differences between shooting a video and painting a picture is control. The more control you have as an artist, the better you can express your vision. When you paint, you have complete control over where every color goes on the canvas. You can change the weather, add and remove objects, and filter the world through your imagination. In fact, you don't even have to paint the real world. With a video camera, you generally have to capture the world the way it is. You can control many aspects of the picture, such as the subject, lighting, and camera movement, but you are at the mercy of the real world. If you want a picture of your child playing in the sun at the park, but you're at home and it's raining, you have to physically set up the situation: put the child and camera equipment in the car and drive to a sunny park. If you can't find a sunny park, you have to create the situation with lighting.

With video, you also have to consider how everything in the picture changes over time. That's why professional films cost so much to make: more money and resources buy the director and other creative people control over the real world. Rather than waiting for a sunny day, a professional crew can create their own sun. Rather than dealing with a real group of teenagers, they hire actors.

In a way, editing is more like painting than shooting video. With an editing tool, moviemakers have complete control over the elements they are working with. That is why they will often choose to "fix it in post," because shooting can place you in frustrating situations and it can be expensive. When a main actor is late to the set, the last camera battery is low, the sun starts to disappear, and you have to get a shot that day or else, any frustrated director will begin to entertain ideas of how they can resurrect the movie by cutting around the shot or working with what they have. Editing gives you options.

With Movie Maker, you gain a great deal of control over your movie. When you edit you can take as long as necessary and cut as many versions of a movie as you want, and with Movie Maker, it doesn't cost you anything other than your time. You can adjust the length of shots and put them in any order. Using advanced techniques, you can move the sound in relation to the picture, add music and narration, and create special effects, such as freeze frames.

The more coverage you shoot, the more choices you have. If you have enough, you can work around many problems. Suppose you're shooting a wedding and the power goes out briefly causing you to lose a minute of the ceremony. Simply cutting from just before the power outage to just after will result in a jump cut. The picture will

change abruptly and cause a distraction for the viewer. However, if you have shot the right coverage, you can patch the hole and no one will notice the gap. You could cut to a reaction shot of the bride's mother smiling with tears in her eyes, for example, that you took at a different time. In reality, the mother doesn't even have to be weeping about the bride. You could've grabbed the shot before the ceremony when she was thinking about her dog. But when you insert the shot next to a shot of the happy couple at the ceremony, the juxtaposition of the shots will sell the idea that she is weeping about the bride. You used a creative solution to further the story you are telling. Editing enables you to tell a story by giving you complete control over the length and order of shots, just as a painter has over color and placement.

Editing is all about creating your own reality by giving you the power to make choices. Reality is shooting a 30-minute wedding scene and playing back the entire 30 minutes from beginning to end. When you create your own reality, you can insert your vision. You do that by showing the viewer what you want, when you want. Suppose that during the power outage, the camera gets the real audience reacting to the flashing lights by spinning around in shock and murmuring loudly. As the editor, you have a choice. If your vision for the piece is to show how perfect the wedding was, you're not going to want the viewer to see this part. If, on the other hand, you're putting together a blooper reel of the wedding, this might be the first thing you show.

As editor, you can choose your own take on an event, and then spin it any way you want. You can smooth out a rough wedding or give a face-lift to a bad vacation. You can determine or change how the viewer feels about a subject. You can make viewers feel good or bad about something, or about themselves. You can influence public opinion or promote a cause, or simply make people smile.

Movie Maker gives you complete creative control. You can change the length and order of shots to create your own reality, based on your own vision of the finished movie. The new reality you create can inspire, engage, support, teach, and do just about anything you want. You can view Movie Maker as a tool for fixing mistakes, or you can take advantage of its power to change lives. Editing gives you choices and opens up a world of possibilities.

Getting started

The remaining chapters in part 1 of this book take you through the process of creating a movie. In doing so, you will be introduced to many of the same concepts and terms used in making professional movies. As you have hopefully seen from this chapter, the same processes and concepts apply to making big-budget feature movies and movies of a birthday party. You may have been using these concepts all this time, but never really thought about them in a structured way.

- The first phase of moviemaking is called pre-production. This is the period preceding the production phase. The pre-production phase starts when you begin planning your movie, and ends when you start actually shooting. We will also include conceptualizing and scriptwriting in this phase, though technically they precede pre-production.

- The second phase, production, begins when you set up your first shot and start shooting.

- The third phase, post-production, starts when you begin editing what you have shot. Often, the phases overlap. For example, you may find it necessary to start shooting before you have finished the script, or you may start editing before you are finished shooting.

- The fourth phase is called distribution. In the movie industry, this is when the finished film enters the distribution channel on its way to theaters. In the context of Movie Maker, we will talk about distribution as the time when your finished movie is delivered to your intended audience. We will discuss two options for distribution: streaming and downloading.

In the next chapter, you will learn how to plan the movie you want to make.

Planning Your Movie

You can't create anything without at least some planning. The amount of planning, or pre-production, you need depends on what you want to accomplish. If you want to create a full-blown movie, you will need everything from a script to call sheets for the actors and crew. The pre-production for a birthday party shoot, on the other hand, will require only a few minutes of forethought and possibly a few notes.

From idea to concept

The extent of your pre-production planning depends on the complexity of your movie. Before you start planning, you should decide what you want the movie to be. In other words, take the rough idea in your head and formulate a concept; articulate a goal for your movie. Ask yourself the following questions:

- Why make a movie?

- Who is your audience?

- What do you want to tell them?

- How do you want to tell them?

Why make a movie?

What is your motivation? What was it that prompted you to think about making a movie? For example, say a company picnic is coming up and you want to get it on video, or you had an experience that really touched you and you want to make a movie about if for your close friends. The movie could be motivated by a business need: you want potential customers to see how you make your product. It could simply be motivated by a need to express your point of view; perhaps you want others to understand the importance of spaying their pets. If your answer is that you want to take pictures of stuff, try digging a little deeper. Why do you want to take pictures of stuff? What kinds of stuff do you want to take pictures of? Come up with a simple, one-sentence goal statement and use that to drive your shooting decisions.

You might think that this is all esoteric stuff that only applies to professional filmmakers. How does this apply to a simple birthday party? The fact is, it does matter. It applies to any movie, whether it's a multi-million-dollar feature film or a birthday

party video. It applies because it has nothing to do with the content—what is being shown. It has to do with how people see and react to moving images and synchronized sound coming from a television or computer screen.

Imagine hanging a painting next to a television. How do you treat these two media? If the painting interests you, you might study it—follow the lines and forms, look at the different parts, and note how they all fit together. With television, on the other hand, you don't study the images—you watch them and observe the events unfolding. In other words, a painting requires you to take the first step, to be a participant in what it is trying to communicate. The painting is passive, so you must be active.

A television program, on the other hand, is active and requires little work on your part—you view it passively. Think of what would happen if, while you were studying the painting, a face popped on the television screen and the person said, "Look at me." Most people find it easier to be passive than active. If you are like most people, you choose the easiest route and turn immediately to the television. After you turn, you switch to input mode and wait for the voice on the television to say or do something. Television talks to people, while a painting hangs there silently. People are more likely to turn their attention to the active sound and motion in the television program. Television has that kind of power over people, and, as a moviemaker, you can make use of that power to influence your audience.

Most often, an amateur home video is shot to record a one-time event so that it can be viewed later—a birthday party, a wedding, a graduation, or a vacation. You could use that as your goal statement: record your spouse's birthday party. Many amateurs do this, and there's nothing wrong with it. However, as you start shooting, you may see that the goal is too vague. It describes what you want to do, but doesn't describe what the movie is about and what you want to get out of the movie. It suggests what you want to shoot, but it doesn't provide a story. If you want to shoot a surprise party, your goal could be to show the elaborate preparations, the guests arriving, and your spouse's reaction to the surprise.

As you think about a goal, keep in mind that the motivation for making a movie doesn't have to center around some special event. You can make a movie just to do it. Many amateurs think of bringing the camera along as an afterthought. However, as you discover the joy of making movies with your camera and Movie Maker, you might want to become more proactive. Take the camera along with you on ordinary occasions, like a trip to the park, a Sunday drive, or even a day at work. Create an event just to have something to make a movie about. Write a script or a one-page story and shoot it over the weekend, using family or friends as actors. Kids enjoy creating impromptu plays for the neighborhood. Why not make a movie instead and share it over the Internet?

A movie doesn't have to be confined to a single event, either. With the ability to edit scenes with Movie Maker, you can create a movie over time, like a documentary.

With a camera alone, you create individual tapes. You might have a tape of your child's birth, another tape of her first birthday, and another of her first piano recital. With an editing tool like Movie Maker, you can create a single movie that shows your child growing up: from birth to high school graduation. You can add to the movie as you go. Re-edit the pieces from time to time, making different versions of the movie. A long-term project like this drives what you shoot and the style you use through the years. It also pushes you to keep the story active. Instead of dragging the camera bag out to shoot a birthday for no good reason, now you have a goal. You might have a hundred hours of disconnected video on tape, but after 18 years you have one memorable movie—a totally unique story that could be meaningful to you, your family, and generations to come.

When you think of a goal for your movie, think big. Sit back for a moment and think of all the possibilities. Think of how useful and meaningful the movie will be. What is your motivation? Why do you want to record the birthday or make an assemblage of vintage trains? What is the movie's purpose? A movie can take on a life of its own if you have a reason for giving it life. Your goal for the movie should describe in a nutshell what the movie is all about, and why someone would want to watch it.

Who is your audience?

It might seem odd to start the planning of a movie by considering who will watch it, but this chain of reasoning does make sense. A movie is made to be watched. You create a movie based on what you want the movie to do for an audience. You follow the same logic when you build a table, for example. When you conceive the table in your head, you might picture people sitting around it eating breakfast. If you have children, you picture milk being spilled and sticky fingers being wiped on the legs. You use this picture when you plan the table, and plan ahead appropriately.

When you are planning a movie, think about who will watch the movie and how you want them to react. In other words, the picture you have of the audience watching your movie will drive your conception of the movie. After you decide the composition of your audience, think about how you want them to react, what you want them to get out of the movie. Finally, think about how to get to that point.

For example, as you plan the childhood portion of the movie about your daughter, imagine her watching it in 18 years. Imagine her showing it to her children. What does the audience look like? How are they reacting? If you see them smiling and laughing, you might want to add a few embarrassing bathtub shots. When planning the surprise birthday party movie, imagine friends and relatives seeing it. If you

don't consider your audience, your movie will have no focus or meaning, because the whole point of a movie is to communicate an idea, or a feeling. If it doesn't communicate, then it has no point.

The audience for a movie can be any size or makeup. If your movie is for general release to the public, like one made by a major studio, you might have many more concerns than if it is to be seen by your immediate family. You can make a movie that will be seen by any group of people, even just yourself. Whoever ultimately makes up your audience, factor them into every decision you make as you produce your movie.

What do you want to tell them?

When a video starts playing, people in the audience expect it to do something to them or for them. With a movie, you have a golden opportunity to have an impact on the lives of others. If you put no thought into what you want to tell an audience, they will feel cheated. If you have a solid goal in mind and stick to it while you shoot and edit, the audience will know you care about them and their viewing experience.

How do you determine what you want to tell an audience? Imagine walking into a room filled with people and standing on a platform facing them. As soon as they notice you, they assume that you must be there to tell them something because you are on the platform. They turn to you and look. If you tell them something they can use, or do something that interests them, they continue to watch. If you don't, they turn away. People do the same thing when they start playing a movie. They give it a chance—maybe more than a chance if they've paid a high admission price. If it doesn't say or do anything for them, they get on with their lives.

You have a brief window of opportunity at the beginning of your movie to grab an audience. As you watch any commercial movie made in the last 30 years, notice what happens in the first ten minutes; you can almost time it with a stopwatch. Like a big buttery bag of popcorn, the first 10 minutes is packed with excitement and interesting twists that instantly engage you and tell you what the movie is about. After only 10 minutes, you know where the movie is going and all the main characters. The hope is that after the first 10 minutes, like when you eat all the buttery part at the top of the popcorn, you will be hooked by story and want to continue. Without that 10-minute setup, the typical moviegoer would probably not give the movie a chance.

If the goal for your movie is to show how much fun you had on a cruise, do you start by showing the boat docked at the pier in the rain with long lines of bored passengers, or do you immediately hit the audience with hot, rhythmic Latin music and shots of smiling faces, balloons, and streamers? The first choice might be interesting

for another movie, but not yours. Know what you want to tell your audience and tell them right away. If your message is interesting and clear, they will be hooked. After that, make sure that everything you do in the movie reinforces the message and has a payoff for the viewer in the end. In other words, create a story. In the cruise movie, you've hooked them with the fun message. Use the rest of the movie to lead them along and show them how the fun never stops. Continue to add new twists and sub-plots: the wild night you had in Puerto Vallarta, the chance meeting with friends, the romantic dinners. End the movie with the final party on board, where you tie the whole story together and the audience leaves feeling good and satisfied with the ex-perience. You told them up front what you were going to tell them in the movie, and then you did it.

How do you want to tell them?

Just as you picture your audience watching the movie, you should have a picture in your mind of what you want your movie to look like. As the story of your movie evolves out of what you want to tell your audience, your pre-production plan will be determined largely by the style of movie that you envision making. There are many ways to write, shoot, and edit a movie, but the overall framework is usually built around one of these fundamental styles:

- **Documentary.** Real life events are shot first, and then edited into a story. The director does not usually have control over the events.

- **Television.** More than one camera is used to shoot an event from different angles. The video is then edited into a final movie. The director knows at least roughly what will occur as the event takes place and might have some control over it.

- **Feature.** Staged events are shot and then edited. The director has complete con-trol over every aspect.

- **Experimental.** Real and staged events are shot, and then edited into a story. The director might have control over what is shot, but often doesn't have a clear idea of a story until it is edited.

When you have a good idea of why you want to make a movie, who will watch your movie, what you want to tell them, and the style you want to use, you can then start planning the production. How you answer these questions, of course, depends on the movie you want to make.

If you are making a movie about a cruise trip, you can answer the questions in your head as you pack the day before leaving. On the other hand, if you want to make a documentary that requires months of investigation and collaboration with other film-makers and financiers, you might not have clear answers to some of these questions until later in the project. Even if you don't know exactly what you want to tell an

audience, you should at least have an idea. You might not know exactly what the results of your investigation will be, for example, but you will have an idea or a burning question that will drive you to make a movie.

Whatever your answers are, or however long it takes to come up with them, you are unlikely to make a satisfying movie without them. If you put off answering the questions until you start editing, you will most likely be frustrated by what you have shot. If you put off answering the questions until you are showing the movie to an audience, you will have to do a lot of explaining and risk a barrage of rotten eggs.

Production styles

The production style you use depends on how you want to tell your story. If your story is pure fiction, you can use the feature style. If you want to show and comment on real events or situations, you can use the documentary style. The style you choose determines every other aspect of your production, from how shooting progresses to the look of the final product. Therefore, you will use the pre-production elements differently depending on the style you choose.

Documentary style

With a documentary-style movie, real-life events are shot first, then edited into a story. Narration is often added to help tie the elements together. This style gives the appearance that the events being seen are real and that the camera is an unbiased observer. You use this style if you have no control, or don't want to have control, over what you are shooting, such as wild animals or a child's birthday party.

Examples of topics that can make good use of the documentary style include the following:

- Investigative report
- Nature survey
- Birthday party or family event
- Travel

The documentary style is typically used in news and journalism. In that context, the goal is to present or comment on a real event, situation, or person. Documentaries leave the audience with the impression that the things they are seeing are real and that events are unfolding as they happen. The truth is, a producer and editor have a great deal of control over the presentation of a documentary. Even though it looks like you are watching real people and events, the final product can be highly biased because the producer has complete control over how it is edited. It can even be entirely fictional: the "real people" can be actors, and the "real events" can be staged.

Just because the documentary style is used doesn't mean that the audience is watching life the way it really is.

This does not mean all movies made using the documentary style have sinister motives. The point is, you should think of a style as just a way of making a movie. It does not define the content.

The documentary style is probably the easiest for a beginning filmmaker. You may use the documentary style to create a movie about a child's first birthday or about the life of your great grandmother. This style is good for non-fictional subjects because you can allow real events, people, and situations to drive the story of the movie if you want. To create a movie using this style, you just grab shots of life as it happens. You can also set up a situation and allow it to play out naturally, such as an interview. Later, you create the story and tie the elements together when you edit the raw footage. It is not unusual for the editing phase of a documentary to last far longer than the shooting phase.

Documentary production steps

The flow of a documentary-style production goes something like this:

Concept

You define a subject and goal for the movie. You use the concept to determine the outline and look of the movie.

Outline

You know roughly the kinds of shots and content you will need, but nothing specific. You may know of a few people you would like to interview. If you have control over a birthday party, you can include some specific shots.

You create an outline or treatment to put the movie you envision down on paper. Even though you don't know how your movie about tagging whales will end up, for example, you can picture what it might look like and what interviewees might say: shots showing whales breeching next to the boat; shots showing tags being inserted; a person tagging whales talks about past experiences. You also have an idea of where the story might go: tagging is successful and gives scientists important information about how to bring whale populations back. Write these ideas down and put them in the form of a story.

Plan

Break down the outline into individual shots or types of shots, and then create a shooting schedule (and budget, if necessary). You can also make lists of equipment and resources, make travel plans, and, depending on the scope of your project, put a crew together.

Shoot

Follow your schedule. Shoot your interviews, events, and extra footage, also known as *b-roll*. Because you will create your story as you edit, make sure you have more than enough coverage. In other words, shoot more footage than you think you will need.

Edit and script

View the material you shot multiple times. As you are viewing the raw footage, look for a story—think of ways to put the pieces together. You will use Movie Maker to edit the pieces into a coherent story.

With Movie Maker, editing time is very inexpensive. Start by roughly assembling pieces. Ask yourself if the pieces can tell the story by themselves or if they will need narration to glue them together. Record the narration using a microphone and Movie Maker. We'll discuss this process in Chapter 13.

A documentary-style movie is more interesting if the pieces can tell the story with minimal narration. Some of the best documentaries have little or no narration. On the other end of the scale is a documentary that uses the "show me" style. In a show me movie, the narrator talks throughout the video and the viewer sees images that describe what he is talking about. It's really more like a video slide show. If your movie must include many still photographs and diagrams, for example, this may be the best solution. However, the audience will appreciate it if you use live action as much as you can.

Television style

With a television-style movie, an event is shot from several angles at the same time using multiple cameras. The tapes are then edited into a final program, cutting between the different angles to use whichever camera has the best shot. The director knows at least roughly what will occur as the event proceeds. This style is most often used to capture an event that cannot be repeated and over which you have little or no control. The video is usually edited so that it appears to play back in real time.

Examples of topics that can make good use of the television style include:

- Situation comedies with a live audience

- Sporting events

- Weddings or school plays

- Solar eclipse or other natural phenomena

This style is called the television style because it is used in television productions that are broadcast either live or *live to tape*. Live to tape means the production is run

as if it's being broadcast live, but is actually being recorded to video tape. In most television productions, the *cuts* from one camera to another are done in real time using a video *switcher*. A switcher contains rows of buttons that a director presses to switch from one camera's picture to another camera's picture. The finished video-tape does not necessarily need any further editing because the edits or cuts were made by the switcher as the event was recorded.

Often during a live-to-tape production, one or more *iso* cameras will be used. An iso, or isolated camera, is recorded on video tape separate from the switched master. Its video is used as extra coverage in case the switched tape needs to be edited. Because the event is being recorded to tape, the producers are not always concerned with exact timing. So even though the live-to-tape show can be ready to go on the air immediately, these shows are usually edited to adjust for time and to fix mistakes.

The television style you can use at home does not require an expensive switcher. To create your television-style movie, you can shoot with multiple iso cameras. For example, suppose you want to shoot a wedding using the television style. You can employ the services of three friends with video cameras. Place one camera in a position that will be able to get close shots of the bride and groom; place another in the back of room facing toward the front; and place the third facing the audience. Ask the friend running camera one to hold on the shot of the group at the front (a medium shot). Camera two could follow the couple up the aisle and stay on a shot that shows the whole room (a wide shot). Camera three could get various shots of individuals in the audience (close shots) and miscellaneous shots of things like the flower arrangements. After the ceremony, you will have a tape from each camera, which should be plenty of coverage. As you edit, simply use whichever angle works best.

Unlike the documentary style, where the movie is created in the editing room, with the television style most of the work is done in the planning and production phases. The story you tell is typically based around an event, so the flow of the movie is decided before you start editing. You could use the video from the three tapes and create a different story. For example, you could use the wedding video and add other footage to create a movie about the life of the bride. In this case, however, you would simply be using the television style as a production technique; you would be using the documentary style as the overall style for your finished movie.

Television production steps

The flow of a television-style production goes something like this:

Concept

The idea for the movie is typically triggered by some event. You should decide who the audience is and what you want to tell them.

Planning

Think about how the event will run. Ask questions and discuss the event with others associated with it, such as the wedding planner. The goal of your planning is to determine as much as possible about what will happen, when it will happen, and how you will set up your cameras to get the best coverage. If you are shooting a wedding, for example, find out when the event is to start, when and where people will come down the aisle, where the ceremony takes place, and how long the ceremony will last. Pass this information along to your camera-operating friends. They will need to know how long it is to make sure they have enough tape and batteries. Also, create an equipment list ahead of time so you are prepared.

Scouting the location

Scouting means that you check out where you are going to shoot in advance to determine how you will set up the production and to look for potential problems. Scouting will help you resolve concerns involving video, audio, and electrical power. If you are planning a complex setup, make a map showing elements like camera positions, any extra lights and audio equipment, and audio and power cable runs. Then give copies of the map to your camera people and your facilities contact at the event—you don't want someone tripping over or unplugging your power cable during the event.

Setup

If you have made adequate plans, setup should go smoothly. Allow extra time, though, to handle emergencies such as dead batteries, changes in event plans, and forgotten equipment. If a wedding starts at 11:00 am, for example, start setting up at 9:00 or 10:00 am. Meet with your crew before the shoot to handle any last-minute questions and go over plans again. You will want all cameras to be recording all the time, even if the camera does not have a good shot. Make sure everyone knows this.

Shooting

Start all cameras recording at the same time, so that "zero" time is the same for all. This will help when you are editing. Record the event according to your plan. Collect the tapes when the event is over.

Editing

Build the movie, starting from the beginning and moving toward the end, selecting whichever camera has the best shot. Use other angles occasionally to break things up; you don't want to hold on one shot for a long time. For example, you can stay with camera one for most of the ceremony, but cut away occasionally to the other cameras.

Even though you record an entire event, you don't have to show it all in your movie if you don't want to. Because you have multiple angles, you can *cut around* mistakes

and slow parts. The movie may also have to meet a time limit. If you want to re-move five minutes of the wedding ceremony, for example, you can cut to another camera at the start of the piece you want to take out. The camera you cut to can start at the end of the piece. If you are careful, the sound track will seem continuous and the cut in the video will be different enough to cover discontinuity in the picture.

Feature style

With a feature-style movie, all the events that are shot are staged, and then edited later. Therefore, the director has complete control over every aspect of the events: what people say and do, how they move, where they go, when an event starts and stops, and literally everything else that an audience sees and hears. The equivalent term for an event in a feature-style movie is a *scene*. A group of scenes that goes together is called a *sequence*. Typically, a director bases what is shot on a script, which is the blueprint for a feature-style movie.

Examples of topics that can make good use of the feature style include:

- Most commercial movies

- Independent short films

- Education and training videos

The feature style is in many ways the opposite of the documentary style. You would make a feature-style movie if you had a complete idea and wanted a movie that just showed that idea. If you enjoy writing, for example, you can write a script, then shoot the script and edit it into a finished movie that is entirely your idea. With the documentary style, you take a snapshot of real life and present it with your point of view. With the feature style, you create your own reality entirely.

It may seem that creating your own reality is more difficult and time-intensive than taking a snapshot of real life. In general, this is true. A documentary can also be far less expensive and require smaller crews, which is probably why many filmmakers, amateur and professional, start out making them.

If you decide to create a feature-style movie, you have total creative freedom. You can invent the characters, the locations, and the stories. The big advantage of using the feature style is control and freedom.

Feature film production steps

The flow of a feature-style production goes something like this:

Concept
You have a story to tell. It can be fiction or non-fiction. Write your concept down in the form of a goal statement or treatment.

Script

Write a script that contains all the dialog or narration for the characters, and describes what the audience will see and hear.

Plan

Assuming you have whatever financing might be needed to create your movie, you begin planning. Break the script down, locate a crew, actors, and co-producers, and then create production plans and schedules. Also, scout out your intended shooting locations. Revise the script if necessary to create a shooting script.

Shoot

Go through the shooting schedule and shoot all the scenes in the script. Adjust the script as needed. Shoot extra footage and any new or alternate scenes. The job of the director is to provide enough coverage so that the movie can be created in the editing room.

Edit

Create the movie out of the material that was shot. In theory, you should be able to assemble what was shot like a jigsaw puzzle. In reality, you will probably have to make many decisions and deal with many challenges. You may end up with a substantially different movie than the one that was shot. New directors often compensate for a lack of moviemaking experience by overcompensating with coverage.

Again, keep in mind that just because a movie was created using the feature style does not mean it was produced in Hollywood and cost millions of dollars. The feature style defines a method of approaching how a movie is made, not the content or cost. A feature-style movie can be anything you want it to be because you are not limited to real people and situations.

Experimental style

With an experimental-style movie, real and staged events are shot and then edited into a story. The director may have control over what is shot, but often doesn't have a clear idea of a story until it is being edited.

It is difficult to hang a definition on the experimental style because, by definition, it cannot be defined. That is why we are not including movie examples or suggestions of a production flow. The reason for including this style here is to make a point. By using Windows Movie Maker, you are breaking new ground; you are making a movie that will be used to communicate through the Internet, a corporate network, or some other digital medium. You are helping to define the future of Internet video. Your movie probably won't be shown in a theater or on television, at least not in the traditional sense. But you can make a movie now, put it on an Internet server, and

make it available to everyone in the world, or design and create a movie meant for only one person to see. You can use the standard forms and styles, or you can create entirely new ones. It's up to you.

Pre-production elements

During the initial phase of a planning movie, you can create standard pre-production elements that define the movie and how it will be made. The detail of your production determines how much planning is needed. You don't need much planning to create a birthday party movie—most of the planning can be done in your head as you prepare for the party. However, as the complexity of a production increases, so should the detail of your plan.

Pre-production elements are most important if you collaborate with other people. Many creative pursuits, like writing and painting, are best handled by one person. However, moviemaking is particularly suited for working in groups. For example, you may decide to work with several friends or hire a crew to split up production tasks and give you creative support. Pre-production elements are important for communicating important information about the project to the people you're working with. Generally, you will want to make sure they know the concept of the movie (treatment), the content of the movie (script), and technical aspects of the production, like the schedule and equipment list.

There are good reasons for planning a movie, as for planning anything. The two main reasons are to reduce hassles after the movie goes into production and to lessen the likelihood of budget problems. Planning is important even at the birthday movie level. For example, checking the contents of the camera bag against a list before you leave for the location of the party can reduce the hassle caused by not bringing any video tape or batteries.

During production, a director is often faced with many obstacles, and handling those obstacles takes time and resources. The point of pre-production planning is to anticipate and reduce the number of production obstacles. All high-budget professional productions benefit greatly from a massive pre-production effort. That is the main reason for the large crews and huge trucks of gear. Even if the lighting crew uses only half of the lights in the truck, it is far less time-consuming and expensive to pack them than it is to shut down production while someone runs back to the studio. With a complete set of pre-production elements, everyone on a crew has all the details they need to do their jobs. The person who packs the lighting truck knows what to pack because he has a list from his boss, who created the list based on notes from the director of photography, who got his information from the director and the script, and so on. A great deal of paperwork is generated during pre-production of a

big movie because paper is far less expensive and time-consuming than dealing with obstacles later.

Pre-production elements include the following:

- **Treatment and script.** Describe and define the movie you want to create.

- **Plans.** Decide on the production details.

- **Location scouting.** Determine where you are going to shoot.

- **Equipment lists.** Specify the production items you will need to complete shooting. This can include props, set pieces, camera accessories, and lunch.

- **Budget.** Estimate the cost of obtaining the needed equipment and anything else used during production.

- **Agreements.** Define the working relationships that will make your movie possible.

Treatment and script

A *treatment* is a short document that describes the story and characters. If a writer wants to sell a script idea to a producer, she usually writes a short treatment first. Treatments are usually four to 20 pages long. They are short because Hollywood producers don't have time to read complete scripts and novels. If a story sounds good, they may give the writer seed money to create a full script.

Even if you don't plan to sell your script or movie, it might be a good idea to spend a couple of hours to get your story ideas down on paper. If you want to collaborate on the development of a movie, a treatment is a helpful item to show potential partners. You could try talking them through the story, but a treatment on paper ensures that your story is consistent for everybody. A treatment or a more complete outline is also very helpful to keep you focused as you begin writing the script.

A *script* or *screenplay* defines a movie by describing what the audience sees and hears. A script takes on a different form depending on the style you choose. If you are doing a feature-style movie, you will usually start with a complete script. If you are using the documentary style, you will usually start with a very loose script or outline—possibly only a few pages. In general, you should view a script as a helpful tool. As you attempt to wrangle with all the elements of a movie—the shots, the people, the equipment, the goal—it helps to have a script to keep everything on track.

A script describes what happens in your movie, but it should also be the following things:

A tool for developing ideas

Think of the script as a way to organize your thoughts about the content of your movie. Your choice of whether to keep the script on paper or in your head depends on the size of your movie and your memory.

The thing to keep in mind is that a script does not have to be long and complicated, and it doesn't even have to be well-written. It can be 120 pages of detailed action and dialog, or it can be an outline scribbled on a couple of pages of a legal pad. However, the more detail you can get down, the better you can articulate what you want to accomplish, and the better you will be able to plan.

A blueprint for production

A script is the blueprint for a movie. The more detailed the script, the more solid the plan, allowing fewer ambiguities and misunderstandings to come up. Actors use the script as the basis of their interpretation of the characters. The editor uses the script to determine the tone of the movie, as well as how many assistants to hire. The script will also help you determine what kinds of equipment and outside assistance you will need to complete the movie.

Open to change

Think of a script as a work in progress. It's not really finished until the movie is delivered to an audience. During pre-production, a shooting script is created. This script is close enough to get started, but it is almost never exactly what ends up on the screen. As you shoot and edit, you will invariably discover better ways to do things.

A script is especially fluid if you are collaborating with other people. An actor may have a better way to phrase a line, or someone may see a better way to organize the scenes.

If you are creating a documentary, the script is usually created in the editing room once the raw footage is organized into a story. It's natural for a moviemaker to get tied to a vision, but it is better if your vision takes change into account.

All other pre-production elements are derived from the script. The more complete your script is, the better you can plan, and the less hassle and additional cost you will encounter when you enter the production phase. Even if your movie is simple or you've done the same thing so many times that you can keep it all in your head, you still need a clear vision of what the final product is going to look like before you can start planning. Later in this chapter, you will see how to create a script using one of two formats.

Plans

Plan elements communicate details about the production of a movie. Plans can be as simple as a reminder to yourself, or they can include reams of paperwork describing

everything about how the movie is to be made. The script is the blueprint. Production plans describe how to execute the script. If others are helping you make your movie, plans help communicate what everybody's role will be.

You will create one set of plans. From your set, others, like the cameraperson, director of photography, and editor, can create subsets for their use and to direct people who might be working for them. All principle participants in a production get a copy of the script, which they can use and mark up as they see fit. A set designer, for example, will use the script to determine what a room should look like.

There are as many different types of plans as there are movies and producers. However, there are a few basic plan elements that you can use:

- **Storyboard.** The script in visual form.

- **Script breakdown.** The script put into a form that makes it easier to shoot from.

- **Production plans.** Details that you derive from the script.

- **Production schedules.** Attaches dates to the script breakdown and production plans.

- **Budget.** Attaches dollar amounts to the production schedule and plans.

- **Call sheets.** Daily shooting plans.

Storyboards

A storyboard is a visual representation of the script (or parts of the script), much like a comic strip. After the writer hands off a script to the team that will produce it, a director will sometimes find it helpful to make sketches of key frames and display them as a storyboard in a series that represents the visual flow of a scene or sequence of scenes. A storyboard may not be necessary for a simple two-person dialog scene. Where a storyboard is of most use is in planning long, complicated sequences involving many characters and moving objects: a battle sequence, for example, or a car chase. It helps those people setting up and lighting shots to keep on track. A good storyboard can also be used by the editor.

Storyboards can be helpful, but they are not an absolute necessity. Many directors are visually oriented, having come from a background in photography or lighting, and it helps them to see the script as a series of pictures. Usually a director sketches one frame for each shot he plans to get. If a shot has a lot of movement in it, he may create several sketches. The sketches can be simple stick figures and blocks, or drawn by a professional artist. It is not important that a storyboard shows things like color, an actor's expression and wardrobe, or any detail. However, it is important that a director be cognizant of how objects are laid out in a frame and in which di-

rection the objects are moving, and a good storyboard can help him keep those details straight.

Exactly what is included in a storyboard frame depends on what the director feels is important in the shot. For example, a sketch for a car chase sequence may indicate that the car passes from left to right, and the camera is shooting up from an angle just above street level. The detail of the sign on a building across the street is not important, nor is the condition of the car.

Storyboards are a waste of effort in some cases, and a necessity in others. If you are shooting in a documentary style, such as creating a movie about a trip to Europe, storyboards are pointless. But just because you do not need to create storyboards does not mean that the information contained in them is not important. Regardless of what style you are shooting in, you should always be aware of composition and movement.

Figure 2.1 shows a blank storyboard template that is included on the companion CD. Open the file **Movie Maker Storyboard.doc** in Microsoft Word, print as many pages as you think you'll need, and then sketch in the frames.

Figure 2.1 – *The storyboard template included on the companion CD.*

Script breakdown

A script breakdown in effect reverse engineers the script into a form that makes more sense for production. As director, this is the first thing you do when you prepare a script or outline for shooting. You can think of the production process as a conversion from script form to movie form, like disassembling an unfinished table and building a new finished table from the pieces. When you break down a script,

you have to envision how all the different pieces of your story are to be produced so they can be assembled into a finished movie.

As you break the script down, you create a list of all the shots you will need to get during the production of your movie. If you want, you can enter the shot list into a spreadsheet, using a program like Microsoft Excel. With your shots in spreadsheet form, you can sort and filter the list to provide different views. For example, you can sort the shots by location, so you can more easily lay out a shooting schedule.

The essential pieces of information in a script breakdown would indicate the following information:

- Scenes and each shot that you need to cover the scenes.

- Locations and sets, props, and equipment.

- Characters, which would indicate the actors needed for a scene or shot.

- Special considerations, like rental of a special light or some legal clearance.

If your script is very detailed, all you have to do is pull the scene descriptions out and paste them in order in another document. If your script is more like an outline with little detail, your breakdown will also be vague. Instead of describing every scene shot by shot, you will describe the scene in general and roughly, the sorts of shots you will need. If you are using the documentary style and have only a treatment or rough outline, you will not do a breakdown per se.

The purpose of a breakdown is so you and your collaborators can see what needs to be shot.

Production plans

The purpose of production plans is to communicate and make things happen. If the details of a production are self-evident from the script or outline—or just because the project is very simple—you don't need to generate any additional plans. However, you should take a moment to visualize your production in progress. As you visualize the scenes being shot, look around; visualize where the camera is, what it is shooting, and where your crew is. Think about how everything got there. Think about all the details leading up to the shoot, and what you need to eliminate communication gaps. Think about all that could go wrong. If you are using a crew, they will expect you to deal with things like admission tickets, permissions, backstage passes, parking arrangements, and meals. If you're just shooting a family vacation,

this will be pretty easy. But planning in advance can save you headaches regardless of your project's scope.

If you are visualizing yourself shooting a statue in Rome, for example, check out the equipment: camera, tripod, and camera bag with extra batteries and video tape. Have you accounted for this equipment in your plans? Are you going to be able to carry all of it yourself? Maybe you should bring someone to help, or purchase some sort of backpack. If you are visualizing yourself getting a shot of a castle from across a wide valley, have you considered how you will get to that spot? Do you need help carrying your gear? Do you need permission from the local authorities?

You may have to put off many decisions until you get to the location where you plan to shoot. This is especially true for documentary-style movies. However, if you are venturing into the unknown, you should be prepared for obstacles and surprises. Allow extra time and be prepared for unexpected expenses. As a rule, it is far more of a hassle dealing with problems while shooting than it is handling them in pre-production.

Production schedules

After the script has been broken down into a shot list and all the pieces are exposed, you can estimate how long it will take to get the individual shots that make up the movie. After you do that, you can create a shooting schedule that indicates when each scene will be shot.

If you are using a crew and actors, everyone can use the shooting schedule to see when they will be needed, and they can refer to the script to get more details about what is being shot. If you are making a documentary, your shooting schedule may be the closest thing you have to a script. Your schedule can show when interviews will be shot and when you will be able to get extra shots to use as b-roll. (b-roll is a term used in documentary-style movies to classify the shots used to augment the primary footage, which usually consists of interviews.)

Creating shooting schedules

You should organize your shooting schedule to make the most efficient use of your resources (people and equipment). If you have many shots, a spreadsheet program such as Microsoft Excel can help you sort them. Keep these things in mind:

Location
Organize the schedule so that you get all the shots from a particular location at the same time. For example, suppose your script calls for scenes 3, 17, and 23 to be shot at the entrance to an old mine. It is far more efficient to shoot all three scenes while you are set up at the old mine than to make three trips. If you have the shots in a spreadsheet, you can sort the list by location to help organize the shots.

People

Decide who is needed for each shot and organize the schedule so you make the most efficient use of your crew and actors. For example, suppose you need five crew people for scenes 3 and 23, and only two for scene 17. Organize the schedule so you shoot 3 and 23 first. Then send three people to lunch while you get scene 17 with your cameraperson. This is particularly helpful if you have hired a crew, since you don't want to pay people to just stand around.

Equipment

If you need to rent or borrow special equipment or *props*, organize the schedule so you get all the shots using that equipment at the same time. Suppose you need to rent a camera *dolly* for several shots. Make sure you get those shots on days one and two, instead of days one and six to save on rental charges. (A prop is anything that is used by a character, such as a cigarette, boat oar, or lawn mower. A dolly is a heavy, wheeled platform used to move the camera smoothly while shooting.)

After you have a shooting schedule, you can create a *production* or *master schedule*. This is the main schedule for your production. It is based on the shooting schedule and incorporates all other activities that lead up to the release of your movie, such as editing and additional sound work.

Obviously, a very complex shot takes longer to get than a simple one: setup will take longer and more takes may be needed to get it right. A thirty-second shot does not take thirty seconds to shoot. You also need to factor in time to get from one shooting location to another and to set up all the equipment. Designing an accurate and useful schedule is an art that is learned with practice. Even professionals who design shooting schedules for a living rarely get it exactly right.

Estimating shooting time

When you estimate how long it will take to get a shot, keep these things in mind:

Divide and conquer

Break scenes down into individual shots and estimate the time for each shot. If one shot is very complex, it may be easier to break it into several simpler shots and then edit the pieces together.

Estimate setup and teardown

You not only need to estimate how long it will take to carry all the equipment to the shooting location and set it all up, you need to include how long it will take to carry it all back to the truck and pack it.

Think "more time"

As a very rough guideline, figure one hour per shot. If you are already in place and do not need to change the lighting, maybe half an hour. Add to the hour

time to move equipment and people. Do not plan too much for one day. When you are in production, everything takes longer than you anticipated. It is better to overestimate and finish an eight-hour day in six, than it is to plan a very tight ten-hour day and end up losing your sunlight and everyone's patience, and finishing in fourteen hours.

Rehearse first

If you can, make sure you rehearse your actors and discuss the characters and the production with them before shooting day. Also, insist that they know their lines. Having prepared actors will make the day go much smoother. If you are shooting an on-camera narrator who is not able or willing to memorize the lines, you can write the lines on cue cards and hold them next to the camera.

On the *set*, shoot everything, even the rehearsals. An actor or narrator will often give his best performance on the very first try. Even if he doesn't, tape is cheap. (The *set* in moviemaking is the scene you are shooting minus the characters and props. For example, it can be a room constructed specifically for the production or a real room.)

Allow for travel time

Regardless of the size of your crew—even if it's only you—always plan adequate time to get from one shooting location to another.

Plan breaks and meals

Regardless of the makeup of your crew, always figure adequate time for breaks and meals. You personally might be so focused on what you are doing that you can forget a meal here and there. However, you can't always expect the same level of commitment (or manic energy) from the friend you asked to hold the microphone boom. Try to see the production from their points of view before the tempers start to flare and you start losing crew members and friends.

There are many more factors involved in creating a good schedule. As you continue your production, you should plan to revise the schedule occasionally as you get a better feel for allocating time accurately.

Call sheets

After you lay out your shooting schedule, you can use call sheets to communicate detailed daily shoot information to your actors and crew. If you have a very small crew, call sheets can be combined into one document. A call sheet includes items like:

Scenes being shot

Number and name the scenes. If you are not organizing your production by scenes, indicate what is being shot, such as "Interview with Dr. Smith."

Crew and actors needed

Indicate names and which scenes the people will be needed for.

Times

Show any appropriate times, such as *call* times, shoot times, and move times. A call time is the time when you need a particular person or group of people on the set (the place where you are going to shoot). For example, if you plan to start shooting at 9:00 AM, you may have a call time of 8:00 AM for your crew to begin setting up. A move time shows when you plan to finish at one location and move to the next one.

Location information and maps

Any specifics about the location where you plan to shoot and how to get there. If necessary, include maps.

Equipment, props, and sets needed

List everything that will be needed for the day of shooting. If certain equipment is standard, such as the camera, you don't necessarily need to include it.

Special information

Include any additional information about the location or the scenes being shot that day. For example, if you plan to shoot in a restricted, top secret area, you should remind the crew to bring special identification.

Location scouting

Scouting a location means selecting the place or places where you want to shoot and then checking them out thoroughly. Often you will not have a choice of location, such as when you are shooting a wedding or a trip to the zoo. But if you do have a choice, you can take advantage of that fact and take as much time as you can to scout locations thoroughly. A good location:

- **Works with the story.** It looks good and photographs well, and it works well with the story. Bring the script or outline with you and step through the shots in your mind. Visualize where the characters will be and their movements. Visualize where the camera will be and how it will move.

- **Works technically.** Costs to use the location are within the budget, special permits are easy to get, and restrooms, water, and electricity are close by. In addition to visualizing how the location will look on camera, visualize all the activity behind the scenes. For example, you may find a location deep in a forest that works well with the story, but that will be impossible to get to with a camera and crew.

Typically, the initial scouting is done by the director (you) and one or two others, such as co-producers. There may be many hours of driving, hiking, or flying in-

volved. After the locations have been chosen, you should return to the locations with others on your crew, even the actors, and examine them closer. You may have final say on the locations, but we recommend that you ask others for their opinions as well—you may be too focused on getting the shot and miss important details. Someone else may notice that there are no working restrooms and the closest source of power is 200 feet away, for example. Your photographer might have a better way to stage the shot to take advantage of the light, and your friend who will be holding the microphone might notice that the room is too small for the crew, lights, and camera, and that a noisy exhaust fan could cause problems.

Think of everything, take copious notes, use a tape measure, and make diagrams and maps. Most importantly, bring a camera. Use a Polaroid or digital camera to take stills of the potential set and the area behind the camera. You will use this information in all your plans, from laying out the lights and dressing the set to figuring out how many power cables to bring and where to plug in the coffee machine for the crew.

If you cannot scout a location in advance, such as when shooting an interview, ask questions over the phone, and have someone fax you floor plans and drawings if necessary, then be prepared with extra cables and lights.

A list of all the possible things to look for when scouting a location would fill a book because every shot and shooting situation is different. That is why it is so important to use your time scouting a location wisely. Take pictures and notes, bring other people along for their suggestions, and try to visualize everything in your mind.

Equipment lists

As you plan your shoot, you find yourself making lists. In addition to the shot list, you should make lists of all the other elements that go into the making of your movie. As you add to one list, you think about another list you should make. When you finally sit back and try to absorb all the lists, you realize why moviemaking is a collaborative process. If you find yourself overwhelmed by the number of things to be done at this point, start looking for a friend to help or co-produce. It is better to share the credit than to over-extend yourself and end up not enjoying what should be a fun and rewarding experience.

You should already have a vision of your movie as a whole, and of your audience viewing it. As you plan your production, you need to have another vision of your movie—a long, multi-layered to-do list. Your list of lists can include:

Equipment

This is the one list needed by all moviemakers. It includes the camera, accessories, and associated equipment, such as a dolly or tripod; lights and

associated equipment, such as light stands and clamps; sound equipment, such as microphones and a mixer; and cables, such as electrical extension cords (known as *stingers*), power strips for dividing the power among several devices, and cables for sound and video.

Sets and props

This list includes all the items you need to bring along to construct and *dress* the set, and items that will be used by the characters. You can also include costume and makeup items in this category. Even if all you are doing is shooting an interview with no props or set pieces, think about whether you need to get b-roll shots of any support items, such as books, photographs, diagrams, and models.

People

This list includes all people working on the set (crew and actors), in the editing room, and at any production facilities that you plan to use. The complete list should also include contacts for acquiring location shooting permissions, people fronting the money for your project, attorneys, subject matter experts, security, and anyone else connected with making your movie. You can use a spreadsheet or some productivity program to hold people's names along their phone numbers, e-mail addresses, and mailing addresses.

Rentals

This list includes equipment that you need to rent.

Expendables and stock

This list includes all expendable items, such as duct tape and lamps, and video tape cassettes (the *stock*). Add to each item in the list an amount, or example: 3 rolls of duct tape, 10 video tape cassettes, 4 lamps.

The list of lists can go on and on, and can go into very fine detail. For example, if you plan to bring food and snacks for your crew, you will need to know at some point how many want chicken and how many pastrami. If you're shooting in a remote desert location, you will need to bring sunscreen and a snake bite kit. Production details can get very complex, and can often take you away from the actual job of creating a movie. Nevertheless, at some point, you will come to terms with the fact that all of it, from getting the best performance from an actor to putting gas in the truck, is part of making a movie. And the better you plan during pre-production, the more you will be able to focus on the fun, creative part when you shoot.

Budget

After you have broken down your script, drawn up your plans, made your schedules, and sorted your lists, you can attach dollar amounts to all the items. Coming up with a solid budget is especially important if you plan to look for financial help. Most people who you might approach for financial backing will not only be inter-

ested in the subject matter of your movie, but in the quality of your planning effort. They will look at your script or outline, your plans and schedule, and then finally the budget.

Even if you plan a very small production, such as a party or wedding, you should still consider making a budget. If you have made equipment and expendables lists, it won't take long to go through them and come up with an estimate. When you are in production, expenses seem to come out of nowhere. If you could study the budget for a multi-million dollar feature film, you would see that, after eliminating the inflated salaries of certain personnel, millions are spent on things like getting the film developed (lab work), expendables like tape and gasoline, car and equipment rentals, construction, travel, lodging, and shooting permits.

We won't go into all the details of creating a budget because the needs of productions vary greatly. Get figures from rental companies and travel agencies, add the costs for your crew and actors, add up your lists, and estimate the costs you don't know—then add 10 percent on top of that.

Agreements

Any time you do anything with a team or group of people, you need rules. If the rules are not automatically apparent, such as in the case of making a movie, you need agreements. And like all other plans you make during pre-production, the more you can articulate agreement among all parties, the smoother production will be.

If you are unsure whether you should obtain releases or other agreements from people associated with your production, seek advice from a competent legal source.

Planning a camping movie

To help you understand the concepts presented in this book, we will take you through the process of creating a movie using concrete examples. In part 1, we will walk through the process of making a movie of a camping trip.

The setup

Dave is going on a camping trip with his son and two of his son's friends. The purpose of the trip is to get away and have some fun—maybe do a little fishing and some hiking. Dave bought a new camera and some gear, which he'd like to bring along. He also has Windows Millennium Edition installed on his computer, so he can use Movie Maker to edit the movie later. He doesn't have any specific ideas for the content of a movie, but he does know he wants to have some fun with the camera and not make a boring video.

The concept

Dave decides to take a moment and come up with a concept for his movie. This is the way his thought process goes:

Why make a movie?

"To capture the camping trip. Why do I want to do that? Umm, because it would be a fun thing to do. How will I have fun capturing the camping trip? By creating a story showing the kids and me having fun. That's it. I want to make a movie that shows us having fun camping."

Who is your audience?

"The kids, their friends, the rest of the family, and me. We might want to e-mail it to friends and extended family, too. If it turns out well, we might want to show it to others at that barbeque we have planned next month."

What do you want to tell them?

"I want the movie to tell the audience how much fun we had camping. Do I also want to show the campground, the mountains, and the lake? Maybe some, but only if it helps to develop the story and shows how much fun we were having."

How do you want to tell them?

"Well, I won't have much control over what I shoot, so I'll have to create the story when I edit. That means I'll use the documentary style."

The outline

Dave doesn't want to think too much about the movie. He would like it to be spontaneous. Therefore, rather than create a detailed outline or treatment, he decides to let things happen naturally. He jots down a few ideas just in case having fun doesn't happen on its own:

- **Shoot video of the kids setting up tent.** This could offer some amusing moments.

- **Let kids lead a hike.** And don't help them.

- **Shoot video of the kids making dinner.** Make sure they talk about what they're doing.

- **Let the kids shoot video of something on their own.**

The problem with the spontaneous approach is that you cannot predict the outcome of your movie. It could turn out to be brilliant, or it could be a complete disaster. However, the value of spontaneity is that what you do see on the screen is fresh and real. Those two qualities are hard to capture on film. When the camera starts rolling,

many people feel they are not allowed to be real; they become very self-conscious and feel they have to choose their words carefully and look and act a certain way.

Big-budget Hollywood directors go to much effort to make their movies appear fresh and real, because those qualities make it easier for an audience to suspend disbelief, which is what audiences like to do. Spontaneity is a good thing. However, to avoid a disaster when making a movie, you need to plan for it. That might seem like a contradiction, but it's one of the reasons why some actors and directors are paid so much. They've found the secret to making something very planned and contrived look spontaneous and real.

The plan

Aside from the brief outline, the only planning Dave does is making an equipment list:

- Camera
- Two batteries
- Cigarette lighter charger
- Camera light
- Four blank tapes
- Tripod
- Clip-on microphone and cable
- Camera case

In Chapters 4 and 5, you will see how the shoot and editing progress.

The story

The story is the essence of your movie. Regardless of what shooting style you choose or how complex you make it, your movie is not complete unless it is constructed to tell a story. If your movie is not built around a story, the audience will see only a collection of disconnected shots that have no meaning as a whole.

To help you create a story for your movie you can take notes or write details down in the form of a script, outline, or treatment. However, if your movie is simple and straightforward, you can build the story in your head as you shoot and edit using the goal of your movie to guide your decisions. It doesn't require a lot of effort and anxiety to create a movie with a good story; a good story grows from a good idea.

In other words, spending a lot of time and money on equipment, writing scripts, planning, and production does not guarantee a movie with a good story. Think of a good idea and let the rest flow naturally.

There are some basic elements of a story. First, every story starts with one or more characters. A movie without characters is a video of disconnected things. In fact, there can be no story without characters because it is from the characters that the story emerges. Decide who will be in your movie first, and then allow the story to come from them. If you do, you will find that the story almost writes itself.

For example, suppose you are making a movie of a wedding and reception. Rather than shoot random things, you could follow the bride and groom that day, and build a story around their experience. It would be much more interesting for an audience to be with the two and see them changing from apprehensive before the wedding to happy and relieved at the end of the day. The audience wants and needs characters. If you plan to add narration to your movie, the audience will think of the person narrating as a character.

Second, every story has a structure: a beginning, middle, and end:

Beginning

This is where you introduce the main characters and engage the viewer in the story, often called the *setup* or *tease*. It is roughly the first quarter of your movie. At the end of the beginning section, your audience should have a clear idea of where the story is going.

Middle

This is the main part of the story, roughly half or more the length of your movie. During the middle, the story and plot progress: the viewer learns and changes along with the characters. The section is often called the *confrontation* because it is during the middle that we follow the main characters as they deal with one decision after another.

End

This is where you make the experience pay off for the viewer, often called the *resolution*. Your story and characters have progressed to this point, now you bring the story full circle and have it tie back to the beginning. This is roughly the last ¼ of a story.

Essential story ingredients

We all know someone who really knows how to tell a joke, and someone else who doesn't. The good joke teller has us hanging on every word, laughing even before the punch line. When we are cornered by the other guy, we can't wait until it's all over. We can learn a lot about storytelling and moviemaking by studying these people. What makes one joke teller good and the other so dreadful? The next time

one of them walks up to you with a joke, think about why one method works and the other doesn't.

Here is a partial list of points to think about:

Timing

The good storyteller watches how his audience is reacting and times his delivery accordingly. He knows where to put pauses, where to add a gesture, what words to emphasize, and by how much.

The bad storyteller rambles on. He recites the story as if reading it out of a telephone book. He doesn't realize that timing is like a fishhook. To keep a fish's attention, you don't just let the hook dangle dead in the water. To catch a fish, you have to know when to reel in some and then let it out.

Rhythm

Like timing, the rhythm of the delivery can either engage and mesmerize an audience or cause them to fall asleep. Again, the good storyteller watches the audience and adjusts the tempo of his story to the situation, and then maintains a steady clip throughout. The other guy seems to be oblivious to his audience and just rambles on. Even though the audience members are looking at their watches, yawning, and shifting uncomfortably, he continues on his slow and dull course.

Clarity and consistency

For an audience to follow a story and stay tuned in, it must be clear what is happening in the story. The good storyteller crafts his story so one point leads to the next logically. If there are many characters, he makes sure the audience understands who is who.

The other storyteller confuses elements of the story and important plot points. In the end, he has to explain the punch line. If the audience receives too many conflicting and confusing messages, they eventually give up trying to understand the story. If you tell a clear and consistent story, your audience finds it easier to suspend disbelief and become engaged in the story.

Invites participation

A good storyteller allows you to participate in the experience. You feel that he is telling the story for you; he is giving it to you, not keeping it for himself. You get the feeling he truly wants you to enjoy it. He isn't telling the story so you will think he's funny or clever.

This is a difficult concept to describe, but think of it this way. Imagine someone walking up to you holding a cute, fuzzy animal and telling you how much fun it is to hold. The good storyteller shares the experience and allows you to hold it too. The bad storyteller doesn't share, and wonders why you don't agree with him.

Risks

A good storyteller doesn't do the predictable. We will hang on every word from a talented storyteller if we think he is going to take us to interesting places.

Interesting

A good storyteller uses all the tools at his disposal to make a story interesting. He adds drama and unexpected twists, and tries not to reveal too much early on to keep us in suspense.

After you have an idea for a story, you can add it to the goal for your movie so that you have a concept. When you start production, all your decisions will flow from this concept. If your wedding movie is to focus primarily on the bride's experience rather than the ceremony itself, you might decide it is more useful to shoot her getting ready than to plan an elaborate production in the chapel. Let the story dictate how you make the movie.

With a solid concept in mind and a production plan for your movie, you can go into production. But if your story is complex, you should consider writing a script first.

Writing a script

A script defines a movie—it describes what you want the audience to see and hear. A writer can include any description or note necessary to convey his vision of the story, as long as it is something that can be seen or heard.

The following elements are standard in most scripts:

Characters and dialog

This includes people in the story and what they say. The script can also include brief stage directions for the actor, such as:

```
        LAURA
    (Through clenched teeth)
I want only to love you.
```

Action

This tells the actors what the characters do:

```
Laura spins on her heel and storms out, SLAMMING the door behind her.
```

Camera movement

The script can suggest camera movement if it is necessary to the story.

```
We PAN SLOWLY from the open window to Laura.
```

Scene description

This sets up the scene, describing what the camera sees, and then any changes that occur as the scene progresses. The scene heading indicates whether the location is indoors (interior or INT) or outdoors (exterior or EXT), the name of the location (LAURA'S BEDROOM), and whether the scene is NIGHT or DAY:

```
INT. LAURA'S BEDROOM - NIGHT
Laura is asleep, lying on top of the bedcovers. Moonlight illuminates
her face through an open window. The hot, summer night is alive with
the sound of CRICKETS.
```

Transitional descriptions

If telling your story requires that you describe a transition between scenes or shots, you can add these directions. However, you should use them sparingly. Too many can make the script difficult to read:

```
CUT TO:
LONG DISSOLVE TO:
ANGLE ON BARBARA
```

Aside from the form, a script differs from a novel in the type of information it can contain. A novelist has the luxury of being able to describe a character's thoughts and feelings. An author can go on for twenty pages giving his opinion or insight about some subject. A novel is also not bound by what is visible or audible. A script can only describe what is seen or heard. If you write a drama, for example, you must convey a character's emotions by what she says or by what the audience can see her doing. You can also convey a character's thoughts and feelings by what other characters say or do.

For example, there would be no way for a director to convey the following description in a movie:

```
John stood. He thought about all the times he had been forgotten,
left in the ditch next to the road of life. If only he had been more
forthright. If only he had spoken his mind, instead of always playing
the good little boy. Well, things would be different now - very, very
different - or so he thought.
```

To convey all this in a movie, the actor can walk a certain way and wear a peeved expression. John's plight can be shown by having another character do something to him, like kick sand in his face. The emotion can also be conveyed through the location, colors, and lighting you use.

Thoughts and emotions can be communicated more specifically through what a character says and what others say about him. However, you should beware of writing unnatural dialog that explains too much, for example:

```
            JOHN
        (Sadly, to himself)
I feel like I've been forgotten and
left in a ditch next to the road of life.
If only I had been more forthright…
```

Instead, create believable situations with other characters, and allow the story to unfold naturally, for example:

```
            BULLY
        (Snarling)
You again!?

            JOHN
You got a problem with that?
```

If you are making a documentary-style movie, the same rules apply: you use pictures and sounds to tell your story. The locations and the people you film tell your story. Most documentaries also include narration to help close any gaps in the story. You can think of the person doing the narration as another character in the movie. The story is driven not only by what the narrator says, but the way it is said—the narrator's tone and delivery.

A script is simply another tool to help you create your movie. You can adhere to every guideline of script construction or come up with your own style. Your script can include whatever information you need to communicate your vision to the actors and crew.

If you plan to write a script to be read by commercial film producers, however, you do need to follow the standards set by the film industry. Professional script readers and producers look at hundreds of scripts. If yours isn't formatted correctly, a reader may not even bother to go past the first page. Even if you will be writing only for yourself, it is a good idea to start with a standard format because a well-formatted script is easier to read and will help you communicate your vision to the actors and anyone else you might work with.

Over the years, a few script formats have become standard. The two formats that we will discuss are:

- **Television script format.** Useful for documentary and television-style movies and feature-style movies that make use of narration.

- **Feature script format.** Useful for feature-style movies, especially those with multiple characters and dialog.

Television script format

Use the television script format if you want to specifically show how the audio synchronizes with the video. This format is used in live television programs that are scripted. The television director calls the shots according to the script and everything follows in line. It's the perfect format to use for news and "show me" type corporate videos, because it is easy to read and anyone can instantly visualize which video clip goes with which narration.

The basic format consists of a table with two columns. The left column describes the video and the right column describes the audio. The horizontal rows of the table indicate how the two sync up. For example:

News broadcast –Tuesday 6/23

	Audio
Studio, Anchor on camera	ANCHOR: Research scientists have discovered what they believe to be a hole in the universe. With more on that story, we go to Don in Washington.
Tape, Don on camera	DON: Scientists here at the research lab have been doing a lot of digging.
Tape, Animation of universe hole	DON (VO): In fact, they dug so hard that many fear they may have gone right through the universe.
Tape, Scientist on camera	SCIENTIST: We didn't mean to do it. It just happened. Even scientists can make mistakes.

The advantage of using the television format is that there is no ambiguity: everything is laid out in a logical way. Everyone can follow along with the script and know exactly where the show is going. The writer controls every aspect of the production. The director makes very few creative decisions during production: he simply follows the script and puts the pieces together.

For live television, this format and way of organizing a production is essential. For simple slideshow-style videos, this format often makes the most sense, too. A writer can turn over a script to a production crew and know that it will be produced exactly as envisioned. The script calls for a clip of video or still image to go with a given section of narration and the editor does just that. A television-formatted script is an exact blueprint for a movie or television show.

In making a documentary-style movie, you can use the television format to write a script after you shoot all the pieces. If you use a word processor program, you can write and rewrite as you edit the movie. For example, as you edit with Movie Maker, you can write your script with Microsoft Word.

When creating a complex movie from hours of interviews and b-roll, it is often easier to move elements around and edit them in written form. The alternative is to keep track of where all the elements are in your head or by using the shot thumbnails in Movie Maker. You could also keep simple notes on paper, but it's better to use a script format.

Writing a television-formatted script is especially useful if you plan to add narration as you edit. Again, think of a script as a tool to help you make your movie. A documentary script in progress could look like this:

Grandma's life documentary

Video	Audio
Still #34 - as child, holding doll	NARRATOR: When she was only 4 years old, she showed more interested in dolls than most kids.
Still #42 - Close up on first doll	She actually sewed her first doll when she was only 5 [? NEED CORRECT AGE] on an old sewing machine that had been stored in her parents' attic in [GET NAME OF TOWN].
SLOW ZOOM OUT to show all the dolls	At the age of 7, she had created more than 200 dolls... [ADD STUFF HERE ABOUT SELLING DOLLS TO THE DEPARTMENT STORE...]

A television script contains the information for assembling a movie or show. It assumes that the characters and scenes already exist, and all the setup work has been done. For example, the script will just call out *Live in studio*, and assumes that the

reader knows what the studio scene looks like and what the anchor is wearing. It does not usually contain details.

The television format is useful when a writer has complete control over the production and much of the setup work has been done. The director, editor, and others can add their talent and ideas, but movies and shows that use television-formatted scripts usually follow those scripts to the letter. On the other hand, if your movie relies on creative input and collaboration from a number of people during production, and the script must contain details that drive production from the start, you can use the feature format.

Feature script format

Use the feature script format if you want to describe and define a movie. This format is used for feature films and most scripted television programs other than those that are live or live to tape. A feature script is written in the very beginning to define the entire movie. A television script, on the other hand, can be at the end of the pre-production process to direct the assembly of a show. Use the feature format if your movie has multiple characters and dialog, and if the script needs to communicate many details.

A feature script contains two types of information: *action* and *dialog*. To differentiate between the two, action formatting extends to the left and right margins, and dialog formatting is indented on both sides. The action describes what the audience sees: a description of the scene and any movement in the scene. The dialog is what the characters say.

The official film industry standard includes exact margin measurements and other details about the form. Anyone can pick up a properly formatted script and immediately skim through it for elements such as transitions, scene headings, and character names.

This is the basic form of a feature script:

```
FADE IN:
INT. OFFICE - DAY
The afternoon sun shines brightly through the wide windows. JOHN is
seated at his desk flipping paperclips into an ashtray, holding the
phone to his ear.
          JOHN
     (on phone)
Yeah, well, you can tell him
I refuse to budge on that issue.
```

And if he has a problem with it,
he can talk to me.

This example contains the basic elements of a feature script. They are:

- **Transition.**

 FADE IN:

- **Scene heading.**

 INT. OFFICE - DAY

- **Scene description.**

 The afternoon sun shines brightly through the wide windows…

- **Action.**

 …flipping paperclips into an ashtray, while holding a phone to his
 ear.

- **Character name.**

 JOHN

- **Stage direction.**

 (on phone)

- **Dialog.**

 Yeah, well, you can tell him I refuse to budge…

Feature script structure

A story that is scripted using the feature format is made up of acts, sequences, scenes, and shots. When you write a feature-format script for the first time, you can start by creating an outline of your story based on these four elements.

Acts

Every story has a beginning, middle, and end. In movies, these three phases are called acts: *setup*, *confrontation*, and *resolution*. The audience learns about the main characters and what they are doing during the setup (act I). The setup

leads to the confrontation (act II), when the characters move toward some goal. Finally, the main character or characters resolve the confrontation or reach a goal or ending point during the resolution (act III).

In a movie about a happy wedding, it may seem odd to refer to act II as the confrontation. But think of it this way: as a character progresses through the story, she faces obstacles and makes decisions. Confrontation doesn't necessarily refer to her relationship with the groom; a character's confrontation is with external and internal obstacles, one of which can be her fear of tripping while walking down the aisle. If a character has no confrontations, the movie has no story.

Sequences

Within each act are sequences, which are the basic building blocks of a story. A sequence is like a mini-story, with its own beginning, middle, and end. An audience's experience watching a movie should never be smooth and linear from beginning to end. A good story has many ups and downs, many small conflicts and resolutions. A sequence is an individual slice of time that you tie with other slices of time to create the big story.

For example, suppose your story is about a cop searching for a suspect. A sequence from the story could be when he tracks down a particular suspect. The sequence could begin when he breaks into the suspect's apartment, continues as he chases the person across rooftops, and ends when the suspect is trapped.

Scenes

Each sequence is composed of scenes, which are the core ingredients of a script. As you follow a movie or read a script, a new scene starts whenever there is a change in time or location. For example, when a character walks from the living room into the kitchen, it's a new scene. When a character falls asleep and the movie transitions to the character in the same place two hours later, it's a new scene. An exception to this rule is the *intercut*. For example, if you want to move between two characters talking on the phone, you can describe both scenes and then indicate that they are to be intercut.

Shots

Each scene is composed of one or more shots. A shot is one camera angle. It is what the camera sees. Where a scene is defined in the script, a shot is defined by the director. For example, the office scene example could be shot from several angles. There could be one shot from far across the room, a very close shot of the John's face, and a shot of the paperclips going in the ashtray.

If you use the feature format and need a rough timing of your script, you can figure one minute per page. A standard theatrical movie script is 120 pages, or two hours. Roughly speaking, act I runs to page 30, act II runs from page 31 to page 90, and act III starts at page 91.

Script terms

Certain terms are used in feature scripts and during production to help describe the composition of a shot. When you use them in a script, make them all caps so they stand out from the rest of the description. The basic terms are:

- **ANGLE ON [Character name].** Point the camera at [character name]

- **FAVORING [Character name].** If a shot has more than one character in it, angle the camera so [Character name] is prominent.

- **WIDE ANGLE.** Zoom or move the camera back from the subject so more of the scene is in the shot.

- **TIGHT ANGLE.** Zoom or move the camera toward the subject so less of the scene is in the shot.

- **POV [Character name].** Angle and move the camera so it appears to be from [Character name's] point of view.

- **REVERSE ANGLE.** Turn the camera around so it is looking back at where it was. For example, if two characters were talking, you can get one shot favoring character 1, then move the camera around and shoot a REVERSE ANGLE favoring character 2.

- **OVER THE SHOULDER [Character name].** With [Character name's] back to the camera, this is an angle shooting over the character's shoulder. This type of shot is used to show the audience what the character is looking at without it being a POV shot.

- **MOVING SHOT.** A shot where the camera moves.

- **TWO SHOT.** An angle showing two characters.

- **CLOSE SHOT [Subject].** The shot is close to the subject: a character or thing.

When you are satisfied that you have a solid concept for your movie and that you have completed all the necessary pre-production elements, you can go into production and shoot your movie. It is impossible to describe all that can happen during pre-production in one chapter. That is why we are taking the approach that it is better to understand the theory of planning and storytelling than to memorize a list of details. If you understand the basics, hopefully the details will come naturally with practice and experimentation. The goal of this book is not to train you in the old Hollywood style of moviemaking, but to give you the basics so you can make movies in any style you choose.

In the next chapter, you'll put together your production toolkit.

Production Tools

The director's primary moviemaking tool is the camera. Before shooting a scene, you need to have an understanding of video cameras and the other basic equipment used to shoot video.

A video camera converts light into an electronic television signal that is sent to a television set or video monitor, which then turns the signal back into light. Likewise, a microphone converts sound into an electronic audio signal that is fed into a speaker, which then turns the signal back into sound. In professional television production, the signals are typically recorded on video tape so that the video and audio can be played back and edited later.

The video camera and microphone are at the core of video production. Every other piece of hardware exists to improve or augment what they do. Lighting equipment shapes the light that reflects off the objects you are shooting. Camera accessories such as dollies and tripods give the director and cameraperson better control of camera movement. Sound accessories help the audio person record sound clearly.

In this section, you will learn about the different consumer cameras and accessories available to amateur moviemakers. We will also cover some technical aspects of video.

Camcorders

Most television cameras not used in a television studio environment are called camcorders because they have built-in video tape recorders, although we will just refer to them as cameras. Camcorders are basically self-contained production units that also have their own microphones and battery power. The tape is even neatly contained in a cassette. To further simplify using them, camcorders can set most of the audio, video, and optical functions automatically. All you have to do is point and shoot, and you get acceptable audio and video most of the time.

Camcorders were originally made for television and cable news production. With a self-contained camcorder, the news cameraperson becomes a self-contained production crew. He can move into a situation quickly and start shooting right away with the camera resting on his shoulder. Everything but the focus is automatic, so the cameraperson can concentrate on lining up the shot and following the action in a

fast-paced environment. He can keep one eye on what he is shooting, while scanning the area with his other eye for the next shot.

The quality of camcorders has improved greatly while they have become smaller and lighter over the years. The biggest improvement has come with the replacement of camera tubes with Charge-Coupled Device (CCD) chips. The light reflected off a scene enters the camera through the lens and focuses onto the surface of the camera tubes or CCDs. Their light-sensitive surfaces then convert the light into an electronic video signal. CCD chips are much smaller, lighter, less expensive, and more rugged than tubes, and the image quality is far better.

Camcorders are also the perfect solution for the amateur moviemaker. They have all the qualities that make them easy for non-professionals to use. By removing some professional features and further miniaturizing components, camcorders can be made to literally fit into the palm of your hand.

Choosing a camcorder

If you buy a new camcorder today, chances are you will get one that is reliable and of good quality. Even low-priced, basic cameras have higher picture quality and more features than professional cameras did 20 years ago. Higher-end cameras give you even better quality and more features.

Consider the following factors, in this order, when buying a camcorder:

Format

"Format" refers to the standardized method that a camcorder uses for recording a video signal on video tape. A given camcorder or other video recording device can only support one format. If you record a shot on a camcorder that uses the Hi-8 format, for example, you can only play the tape back on another device that supports Hi-8. Not only is the tape different, but the video signal is created and recorded differently as well.

There are five main camcorder formats in the consumer range today:

MiniDV

This format is capable of producing professional-quality video recordings because it stores the signal digitally on the tape. MiniDV provides the highest quality currently available to consumers when played back; it is generally free of video noise and problems typical of other consumer formats. Digital tapes can also be duplicated with very little loss of quality. The miniDV format uses 6-millimeter (mm) tape in a small cassette.

Most miniDV camcorders support IEEE 1394 connections, also known as FireWire, with which you can transfer video and audio digitally to and from your computer. IEEE 1394 is a very fast connection, which means you can copy a great deal of data—such as full-frame, full-motion video and audio—with little loss of quality. With Movie Maker, you can capture video and audio through an IEEE 1394 connection and control the camcorder *transport* (stop, play, rewind, and so on) from your computer.

Standard 8 and Hi-8

These formats are capable of producing good consumer-quality video recordings. Hi-8 camcorders have a better recording system and use a high-quality metal tape, which together produce a cleaner, sharper picture than camcorders using the old Standard 8 format. Hi-8 camcorders can also record high-fidelity stereo sound.

Because the video cassettes for this format are compact, camcorders can be small and light. The drawback of this format is that the 8mm-wide tape is more fragile than VHS tape, making it more prone to tape distortion and *drop-outs*. Drop-outs are caused by imperfections in tape stock, like magnetic holes in the tape. Drop-outs appear in the picture as specks and flashes. A Standard 8 camcorder can use only standard 8mm tape; a Hi-8 camcorder can use either standard or Hi-8 tape.

For the best quality when using Hi-8 video for editing in Windows Movie Maker, you should capture from the camera original tapes and not from copies of the originals.

VHS and S-VHS

These formats are also capable of producing good consumer-quality video recordings. Like Hi-8, the S-VHS format has an improved recording system that, together with high-quality metal tape, is capable of producing broadcast-quality video. The VHS cassette is larger than that of the 8mm formats (you're probably familiar with VHS cassettes from renting home videos), so the camcorders must be larger and requires a bigger battery. However, some people prefer the larger size because the tape is less fragile and is therefore more likely to reproduce a cleaner picture.

New VHS camcorders on the market use VHS-C or S-VHS-C cassettes, which contain the same tape in a compact cassette. Recording time is shorter, but the camcorders are more compact. Also, note that a VHS camcorder can use only VHS tape, but an S-VHS camcorder can use either VHS or S-VHS tape.

Camcorders that support the better recording formats are generally (though not always) higher-quality products. If a particular model of camcorder has the miniDV format, for example, the specification for that format requires the manufacturer to build a product that produces higher-quality video than a format such as VHS.

Resolution and color

Resolution is the amount of detail that can be captured in a picture—it is not related to focus. A camcorder can have a high-quality lens capable of focusing a very sharp image on the face of the CCD chip. However, if the resolution of the camcorder is low, the recorded image you see can lack detail no matter how well you focus the lens. Anything in a camcorder that creates, processes, carries, or stores a video signal affects its resolution: the CCD chip, the electronics, and the video tape format. You can, for example, get a lower-resolution picture by using a low-grade video tape.

Resolution is measured in the number of vertical lines that can be reproduced. A higher-resolution camera produces over 400 lines of resolution. Consumer camcorder specifications often do not give the resolution, so you might have to trust your eye when purchasing one. You can do a rough comparison in a store by focusing a camcorder on something with vertical stripes. The camcorder that produces the sharpest stripes has the best resolution. The chart in Figure 3.1 is often used in the television industry to determine the resolution of a camera, video tape recorder, or video system.

Figure 3.1 – *A standard television resolution chart.*

Along with resolution, a camcorder should reproduce colors accurately. You check for color accuracy using your eye. In the store, shoot a *subject* that has complex colors and see if the color shown on the screen is close to the actual colors; does a green shirt have the same green on the monitor. (*Subject*, in photography, is the primary object or objects in a shot.) Also, note subtleties in the color. If the subject has varying shades or a subtle mixture of hues, for example, see if the camera captures those subtleties.

The best way to check resolution and color is to take one or more cameras out of a store and check playback on a television or monitor you are familiar with. In most

cases you will have to check and compare in the store. Try to make sure you are checking on a well-adjusted monitor, and when you compare camcorders, do so on the same monitor if possible.

Light intensity

Light intensity is measured in foot-candles and lux. An object located one foot away from a candle receives one foot-candle of light, or about 10 lux. The specifications of a camcorder typically give a minimum lux rating for a camera, or the minimum amount of light needed to produce a useful picture. If a camcorder has a lux rating of 10, for example, it can produce a reasonable picture of an object lit by a candle one foot away from it. This figure can be helpful, but is subjective and often inflated by the manufacturer. Typically, the better the camcorder, the less light it requires and the lower the lux rating. Most camcorders today have lux ratings from 5 down to less than 1.

CCD chips

The more CCDs a camcorder has, the better the resolution and color of the picture it will record. Professional and higher-end consumer color cameras have three separate chips to pick up the red, green, and blue components of light reflected off a scene; most consumer camcorders have only one CCD. With three CCDs, a camera can render more accurate color; it is not only able to produce the same yellowish-green as the original, for example, it can produce all the subtle shades and hues in between. Three CCDs also produce a much higher-resolution picture. For most amateur video, however, camcorders with one CCD produce an acceptable image.

Inputs and outputs

One thing to consider is the types of inputs and outputs a camcorder offers. In addition to recording the video signal to video tape, most camcorders have video and audio outputs that enable you to route a video signal from the camera or tape playback device to a monitor, VCR, or capture card on a computer. If you plan to capture from your camera, make sure it has the appropriate output for your capture card. Some camcorders also provide inputs with which you can record material from a VCR or television to the camcorder's recorder.

To make a connection, you need a special cable that has the appropriate connectors on either end. A particular connector, such as an RCA plug, can be used for more than one type of input or output, so be sure you don't connect a video output to an audio input, for example. In most cases, though, the connectors are color-coded to help you make the correct connections. Figure 3.2 shows examples of the connectors typically found on consumer camcorders.

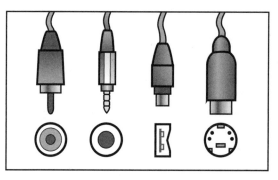

Figure 3.2 – *Typical connectors used on camcorders: RCA, mini-plug, digital, S-video.*

Here are the types of inputs and outputs typically found on consumer camcorders:

Audio

> Connects from the camera microphone or from the tape if the camcorder is in playback mode. The connectors are either RCA jacks or mini-jacks. A stereo camcorder that uses RCA jacks has two of them, usually red for the right channel and white for the left. If a stereo camcorder uses a mini-jack for audio, both channels are fed into one stereo connector. On some camcorders, the audio output connectors can switch to input connectors depending on the operation mode.

Video

> From the camera or from the tape if the camcorder is in playback mode. The connector is usually a yellow RCA jack. Some camcorders combine the audio and video into one mini-jack. The video signal from this connector is called *composite* video. A composite signal contains all the necessary components of a standard video signal and can be plugged into any monitor or VCR. As with audio, some camcorders offer a video input.

> Keep in mind that video standards vary throughout the world. If you connect composite video from a camcorder purchased in the United States, for example, to a monitor in Germany, the picture will appear scrambled. This is because both countries have different video standards. For more information on standards, see Video Basics later in this chapter.

S-video

> Video from the camera or from the tape if the camcorder is in playback mode. The connector is always the same. Video from an S-video connector can only be plugged into a capture card or VCR that has an S-video connection.

S-video transfers the video signal before it has been processed into a composite signal. Without the processing phase, the video has less video *noise*, higher resolution, and better color. (Video noise appears as graininess or "snow" in the picture.) You should use S-video instead of composite video if your camcorder and input device support it.

Digital (IEEE 1394 PC interface)

Digital video and audio, and recorder control to and from the camera or tape. This type of connection is only available on digital camcorders, such as those that use the miniDV format. It provides you with a way to transfer video and audio digitally before it has been converted and processed. Without going through all those processing steps, the picture and sound are as clean as they can be.

To capture digitally on your computer, you need to use a special capture card. The technical name for this digital interface is IEEE 1394, also known as FireWire.

Because the signals are captured digitally, there is little processing required, so a great deal more data can be captured per second. This means that you can easily capture full-screen pictures at the standard video frame rate of 30 frames per second (fps). You cannot do this with most analog capture cards unless you have a computer with a powerful CPU. You can also control playback from your computer using the digital connection.

Microphone

Used to plug in an external microphone, typically using a mini-jack connector. The camera microphone built into the front of the camcorder can be used for general sound pickup. But if you find that too much extraneous sound is being picked up, you can plug in an external microphone and position it closer to the sound source. A good example of this is the problem that you run into when attempting to record someone talking in a noisy location. In a situation like this, you can use a small clip-on *lavalier* microphone.

Headphones

Used to plug in headphones, typically using a stereo mini-plug connector. If you are concerned with the quality of audio in a particular shot, such as when shooting a person speaking, you should use headphones to monitor the audio signal that is being recorded. Headphones will tell you if too much extraneous noise is being picked up, in which case you should use an external microphone such as a lavalier.

External power

Used to connect an external power supply for charging camcorder batteries or running the camcorder without batteries. You should only use the power supply

that is made for your camcorder. Even though the connectors may be the same, the power requirements and configuration are often different for each camcorder. If you plug the power supply for one brand into another brand of camcorder, there is a very good chance that the camcorder won't work and will be damaged.

Sync

A sync connection is provided by some camcorders, and you can use this connection to control the camcorder externally. The functionality of a sync connection varies with each type of camcorder. Typically, you use it to connect the camcorder with an external VCR that has the same type of connection. You can then use the sync connection to edit video and audio.

Automatic and manual control

Consumer camcorders are made for people with little or no experience and knowledge of video. They are made to simply point and shoot. To the consumer with a high-quality camcorder, the process is easy and seamless. He doesn't know or care what goes on inside the camera when he shoots, and most consumers like it that way. However, there are good reasons to have control over certain settings that the camcorder handles automatically.

If you feel you may want to have that control, you should purchase a camcorder that gives you the option of switching between automatic and manual modes. Every camcorder offers different manual override options. Typically, the more expensive, higher-quality camcorders offer more override options because the manufacturers assume that they will be purchased by users with more experience. The following automatic settings are often available with manual override:

Focus

A sensor in the lens detects whether a scene being shot is in focus, and then corrects the focus if necessary by controlling a small motor that moves elements in the lens. Many times the sensor gets it right and the scene is in focus. However, there are times when it focuses on the wrong things. For example, if you are shooting a building and someone passes quickly in front of the camera, the sensor may attempt to focus on the passerby when you want it to stay on the building. To correct for this problem, simply switch to manual focus. Manual turns off the sensor and gives control to you. Most camcorders offer both manual and automatic focus.

Exposure

Another sensor detects how much light is entering the lens and adjusts an iris, similar to the iris in your eye. If too little light enters the lens, the scene will be dark and detail is lost. If too much light enters, bright areas of the scene will turn white, or *clip*, creating an overexposed picture. The sensor keeps the

picture as bright as possible without clipping, and this automatic feature gets it right most of the time.

However, there are times when you need to overexpose parts of a scene so the subject is exposed correctly. A good example of this is shooting a person in dim foreground light against a sunlit background. If you allow the automatic exposure to work, the subject will be in complete shadow. There are also situations when the automatic system becomes confused, such as when shooting fireworks or flashing lights. To compensate, you can switch to manual override and adjust the exposure yourself. Most high-end camcorders offer a manual exposure option.

White balance

A white object reflects a different color depending on the type of source light that is hitting it. Obviously, a red light will make a white object reflect red. But there are more subtle color variations in our environment that we don't notice because our eyes automatically adjust for the *color temperature* of the source light. Our eyes assume the prominent light source puts out white light and automatically adjusts our perception so white objects appear white to us, whether the source is a light bulb or the sun. A film camera is not able to make this perceptual adjustment; you have to make sure you use the right type of film for the prevailing color temperature: indoor or outdoor.

Consumer video cameras attempt to compensate automatically, but sometimes they do so incorrectly. For example, if your subject is lit by an incandescent light bulb and the background is lit by the sun, the camera either compensates by making the background appear bluish or your subject appear reddish. The camera may also adjust somewhere in the middle and get both colors wrong. Many high-end camcorders offer manual white balance, so you can adjust white for either color temperature.

Shutter

Rapid movement can appear blurry. Many camcorders offer a shutter feature with which you can reduce the blur and make objects appear distinct. To understand the mechanics of this feature, you need to understand a little about video frames.

The perception of motion in video is produced by rapidly displaying a series of individual still frames. You can see one still frame when you pause your VCR. In the United States, the television standard calls for 30 fps. To produce a frame, the image that is focused on the face of the CCD is scanned from left to right in thin horizontal lines, starting at the top-left corner of the image. In the United States, a frame consists of 525 lines. Odd numbered lines are scanned first, then even lines. Each time the image is scanned a *field* is produced that contains half the information in the image. When these two fields are displayed together, we see one complete frame of video.

A camcorder grabs a very small slice of time each frame: 1/30 of a second. If an object does not change position during that slice of time, its image is distinct. however, if an object moves even slightly in that 1/30 of a second, it appears blurred. With the shutter feature, you can set the amount of time that is captured on a frame. There are still 30 frames per second, but each frame contains a smaller or larger slice of time. If you set the camcorder to 1/1000 of a second, the image of a runner or diver, for example, is very distinct and clear. With some camcorders, you can set the shutter to less than 1/30. At 1/4 second, moving images leave long trails behind them.

Gain

The video and audio signals are controlled automatically so that what is recorded on the tape or digitized is not distorted. Most consumer camcorders do not provide a means of adjusting these elements manually, and that's probably for the best. However, on some high-end camcorders you can add gain to the video level manually to compensate for very dark scenes. Adding gain also adds video noise, so in most cases you should only add it when you have to. However, this feature can be very useful.

Other features

All camcorders except the most basic ones offer a variety of enhancements. In most cases, they do not improve the quality of the video, but add to what you can do with the basic camcorder. When purchasing a camcorder, see if any of them interest you. It's not likely any particular feature will make a purchase decision for you, but added to other attributes, they may make a particular camcorder more attractive. Typical features include:

Effects and titling

You can add an effect to the video and alter the way it looks. Effects like sepia and black & white alter the color. The negative effect switches colors to their opposites, making light areas dark and dark areas light. Effects like solarize and mosaic add digital distortion. Titling enables you to add text over the top of the picture.

Animation and time-lapse

When you press the record button, the camcorder shoots only one or a few frames and then stops. This allows you to do animation. Some camcorders provide a way to automatically shoot time-lapse sequences.

Transitions

You can press a button and the camcorder automatically fades a scene to black, or fades from black to the scene you are shooting. With some camcorders, you can create a transition with patterns from a still frame of the previous shot on

the tape to a new shot. These transitions can be interesting, but keep in mind you cannot change them later when you edit.

Night shot

The camcorder emits invisible infrared light that you can use to shoot in situations where there is no or very little ambient light. The picture is black and white, and people and animals have glowing eyes, but this can be a useful feature. Figure 3.3 gives you an idea of what a night shot looks like.

Figure 3.3 – *Night shot used in near total darkness.*

Stills

Most miniDV camcorders also offer the ability to take digital still pictures. You can then use a FireWire connection to transfer the stills to your computer and save them as *JPEG* files.

Many electronic stores allow you to hold the cameras, check them out, and see the pictures they produce in a monitor. After you have decided how much you can afford for a camcorder, make your decision based on which looks and feels the best, and has the features you want.

Exploring your camera

Most consumer camcorders are built so that all you have to do is point and shoot. Even so, we recommend that you read the manual before using your camcorder for the first time. It's possible—though not likely—that you could innocently do something to it that would cause permanent damage. More likely, you will simply not know where to plug something in or how to turn it on. Most manuals have a Getting Started section that gets you up and running quickly and alerts you to any possible pitfalls.

Regardless of which camcorder you own or purchase, the same basic process applies any time you prepare to shoot:

1. Put a battery in the camera. All camcorders come with one rechargeable battery. Insert the battery in the camcorder and check to make sure it is fully charged. If it's not, you will have to plug in the power supply. When the

camcorder is off, the power supply recharges the battery. If the camcorder is turned on, the power supply takes the place of the battery and runs the camcorder, but does not charge the battery.

2. Insert a tape. Press the eject button to open the video tape compartment. The compartment door is usually connected to a motor, so you shouldn't try to pull it open or close it manually. Let the motor do the work. Orient the video cassette the correct way and drop it into the compartment, then carefully push the compartment closed. Don't try to push the cassette in if it won't go in easily. If the cassette is backwards or upside-down, it won't fit in the slot.

3. Turn the power on and enter standby mode. Camcorders have two modes: camera and VTR. To get it ready to shoot, switch it to camera mode. The camera turns on and feeds a video signal to the viewfinder, the video output connector, and the built-in video tape recorder. Camera mode also puts the recorder in standby mode so it will start recording as soon as the record button is pressed.

When you switch the camcorder to VTR mode, the camera turns off and the videotape recorder goes into playback mode. The camcorder has basic transport controls with which you can control the recorder: play, stop, pause, rewind, and fast forward.

4. Remove the lens cap. You should see a picture in the viewfinder. If you don't, try zooming the lens out all the way and aiming the camcorder at a well-lit area. Check the camera over and make sure everything is on automatic: focus, exposure, and gain. If there are no lights on and information displaying in the viewfinder, check the battery to make sure it is inserted correctly and fully charged. If you still don't have a picture, read the manual. There could be a switch somewhere that places the camera in a mode that prevents the camera from producing a picture, such as a safety lock.

5. Press the red record button. The red record light comes on and the camcorder starts recording to video tape.

Before you start shooting the scenes for your movie, explore your camera and find out what all the buttons and displays do. In this section, you can follow along as we go through the main components of a camcorder. Position yourself with your camcorder in an area that is well-lit, with some objects close to you and others more than 50 feet away, such as outdoors or by a window. You can aim the camcorder at these objects to see how different settings change the image in the camcorder.

Video basics

That camcorder you're holding is an amazing little machine. In the 1960s you would have needed a 200-pound camera, a room full of electronic equipment, and a video tape recorder the size of a car to do the all the things your camcorder does, and you

still wouldn't have approached the quality of even the most basic camcorder. However, even though there have been many improvements, the process of turning light into a television signal is still about the same.

Figure 3.4 illustrates how a camcorder functions.

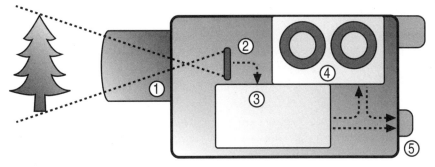

Figure 3.4 – *How your camcorder works.*

As shown in Figure 3.4, the following actions occur each time you record and play back a scene with your camcorder:

1. Light focuses on the CCDs. The image of a scene is focused via the lens onto the light-sensitive face of the CCD chip. If a camcorder has three chips, the light is first split into its red, green, and blue components using colored filters, and then each chip receives the image of one of those components. The intensity of light hitting the chips (the exposure) is controlled by an iris in the lens, which is usually adjusted automatically.

2. Chips convert light to a video signal. Synchronization signals generated in the camera control the scanning of the image displayed on the CCD chips. As the image is scanned, a video signal is generated.

3. Electronics enhance the signal. The weak signal from the CCDs is amplified and processed, then sent to the built-in video tape recorder. If the signal is too low, you can add gain electronically at this stage. This is also the point where digital effects and transitions are added to the signal. If you have a digital video camcorder (DVcam), the amplified signal is converted to a data stream.

 Note Even though a non-digital camera can add digital effects, the resulting video signal is still analog.

4. Video signal is recorded to tape. The video and audio signals or data streams are recorded to video tape. To record a good, high-resolution picture the system needs to be capable of recording a very high-quality signal. To achieve that quality, each frame of video is recorded onto the tape at a slant. The slanted

frames are stacked closely together on the tape by magnetic recording heads that are rotating rapidly on a drum. This process is called *helical scan*.

The slight buzzing sound you hear with the camcorder in standby is the rotating heads spinning over the tape. Most camcorders drop out of standby mode after a period of time if you have not recorded anything. This minimizes wear on the rotating heads and prevents the heads from wearing out that one section of tape.

5. Tape is played back to outputs. You can remove the tape and play the video back on a compatible playback device (such as a VCR) or use the playback features in the camcorder. When you switch the camcorder to VTR (video tape recorder) or tape mode, playback is fed to the viewfinder and output connectors. The signal from the tape is first amplified, and then processed into a standard composite video signal. The different types of output connections pull the signal from different points in the video processing chain.

The fewer stages the signal must go through, the cleaner your video signal. The composite video signal is the result of all the video processing stages. If you use the S-video output, you take the signal before it has been processed completely, so the signal is a great deal cleaner. If you use a digital camcorder and transfer the digital signal using an IEEE 1394 interface, you bypass the digital to analog converter and all the processing after that. The digital stream you transfer to your computer is identical to the digital signal recorded to the tape originally. By using the digital connection, you can copy multiple generations without any loss in quality. On the other hand, if you copy from the composite output, the noise and distortion added by the tape and processing stages add up each time you copy. Also, resolution and color purity worsen with each copy.

To enable tapes and video to be viewed on more than one system, international standards have been established. For example, a standard VHS tape can record and play on any VHS machine in the world. However, in addition to tape formats, there are standard formats for composite video signals, and these standards vary from country to country. In the United States, the NTSC standard is used. In most of Europe, the PAL standard is used. SECAM is a third standard that is used in France. The number of scan lines and the frame rate also vary from country to country. Knowing what standard a country uses is only important if you plan to play the tape you create with your camcorder on a system that conforms to a different standard, such as the television in your hotel room in Spain. Even though two machines use standard VHS tape, for example, they can each be set to use different video standards. In general, if you live in the United States and plan to shoot a vacation in another country, you will have no problems.

Your camera's features

After you have shot some video with the automatic settings on, explore some of the other parts of your camcorder.

Zoom

Using the zoom feature of your lens, you can get closer to your subject without physically moving any closer. Elements in the lens move as you press the zoom switch. If you press the switch on one side, you zoom in to a tighter shot and your subject appears to move closer to the camera. If you press the other side of the zoom switch, you zoom out to a wider shot and your subject appears to be farther away. The switch may also allow you to zoom at different speeds.

When you zoom, you change the *focal length* of the lens. Back in the old days before zoom lenses, cinematographers used lenses of a fixed focal length. If they wanted to move in to a tight shot while the camera was rolling, they had to physically move the camera on a dolly, adjusting the focus as they went.

Focal length is the distance in millimeters between the optical center of the lens and the face of the CCD. The longer the distance, the tighter the shot; the shorter the distance, the wider the shot. A zoom lens that has a focal length from 4.3mm to 43mm is a 10-to-1 zoom lens, or 10X. A typical consumer zoom lens has a range of 16X. Many camcorders are advertised as having ranges of 48X or 72X. To get these ranges, a camcorder digitally zooms in to the video image after the optical lens has reached its upper limit. Digital zooming is similar to enlarging an image on your computer. If taken too far, image quality suffers greatly. The range of the typical zoom lens should be sufficient for most of your needs without having to resort to this digital range.

Look through your viewfinder and zoom in on different objects. If your camcorder has a digital zoom, try to find the point where the optical zoom reaches its limit and the digital zoom takes over.

Focus

As you zoomed in on different objects, your camcorder adjusted the focus automatically. In many situations, auto-focus works fine. However, there are times when the sensor focuses on the wrong things. That's when it is nice to be able to go to manual focus. Try this:

1. With the camcorder in auto-focus, zoom in half way to an object 20 feet away. The camcorder focuses on the object.

2. Put your hand out about one or two feet in front of the lens. Notice that focus shifts to your hand and the other object goes out of focus.

If this is what you want, then auto-focus works fine, but imagine your subject is a speaker and your hand is someone walking in front of the camera. In this case, you want to stay focused on your subject and not draw the viewer's attention to the person walking in front of you. Therefore, you can do this:

1. With the camcorder in auto-focus mode, zoom in on the object 20 feet away. The camcorder focuses.

2. Switch to manual focus mode.

3. Wave your hand in front of the lens. The focus stays on the object.

In manual focus mode, you must make an adjustment whenever the distance between you and the object changes.

1. With the camcorder still in manual focus mode, walk closer to the object. The object goes out of focus.

2. Stop and turn the focus knob or lens ring until the picture is in focus again. To make sure you are focused as accurately as possible, turn the focus just past the sharpest point and then back the other way. Move the focus adjustment back and forth until you find the perfect focus point, right in the middle.

While you are trying these exercises, try a *rack focus*. A rack focus is when a cameraperson changes focus from one object to another during a shot. Try rack focusing from one object to another.

Focusing on stationary objects from a stationary camera position is easy. However, auto-focus is very useful when you or the subjects you are shooting are constantly moving. It frees you from having to worry about focusing, so you can concentrate on following the action and keeping the shot composed. In addition, the viewfinders in many consumer camcorders have low resolution. A shot that looks focused in the viewfinder might not be on a full-size monitor.

Depth of field

Having the ability to continuously adjust the focal length with a zoom lens enables you to do more than merely move in close to an object without moving yourself. You can use focal length to create shots that are out of the ordinary and that help focus the viewer's attention on your subject. An interesting phenomenon occurs as you zoom in. Your *depth of field* decreases and distance *compresses*.

Depth of field is the range that is in focus with a given focal length, exposure setting, and video camera. Try this:

1. Switch the focus on your camcorder to manual.

2. Zoom out all the way to a wide shot and focus.

As you see, almost everything is in focus. With that lens at that focal length and exposure, you have a wide depth of field. You can use this wide angle and depth of field when you want everything to be in focus for a particular shot—for example, if a person in the foreground is talking about a mountain behind him.

3. Zoom in almost all the way and focus on a tight shot of an object 15 feet from you.

You will see that objects in the distance and any objects closer than 15 feet are out of focus. At that focal length, you have a narrow depth of field.

You can use this tighter angle and narrow depth of field when you want to focus the viewer's attention on certain objects. For example, if you want to focus attention on one person in a crowd, you can position the camcorder 20 feet away and zoom in. With the narrow depth of field, people behind and in front of the subject are out of focus, so they do not compete for the viewer's attention. Figure 3.5 shows an example of using depth of field to isolate a subject.

If you are shooting on a sunny day, you might not see a substantial narrowing of the depth of field because the exposure is low—the lens iris is small.

Figure 3.5 – *Using depth of field to focus the viewer's attention.*

Distance compression occurs as you increase the focal length or zoom in. Objects not only appear to be closer to the camera, they appear to be closer to each other in relationship to the camera. Try this:

1. Zoom all the way out to a wide shot, then tap the zoom switch so you zoom in slightly. This focal length is approximately the same as your eye. An object 60 feet away appears to be about half the size of the same object 30 feet away.

2. Zoom in to objects several hundred feet away. You will see that the distance between objects appears to become compressed. Where a 30-foot difference in distance results in an apparent doubling of size when seen with a normal focal length, a 30-foot difference at 200 feet is barely noticeable with a large focal

length. The sizes of objects do not change and get smaller, as we would expect, so their distance from the camera appears compressed.

The image in Figure 3.6 is the same scene as the one in Figure 3.7 shot from about 100 feet back using a much longer lens. Notice how the long lens compresses objects in the distance.

Figure 3.6 – *A wide shot shows subjects as they appear naturally.*

Figure 3.7 – *Zooming in on the same scene causes distance compression.*

You can use this effect to make objects separated by a great distance appear closer together. News camerapersons sometimes use this effect to make a reporter appear closer to the action. A very long *telephoto* lens can appear to put a reporter right next to a space shuttle a mile away. A telephoto lens is one with a very long fixed focal length.

Exposure

Like auto-focus, auto-exposure works well most of the time. The exposure sensor in the camcorder looks at the whole scene and adjusts the iris in the lens so that the brightest part of the scene is as bright as possible without clipping. This would take care of all exposure problems if it weren't for *contrast ratio*.

Contrast ratio is the difference between the darkest and lightest parts of a scene. Our eyes have a very wide contrast ratio; we are able to make out detail of someone's face standing close to us in the shade and see detail in the bright sunlit background without our irises having to adjust. A video camera, on the other hand, has a very

limited contrast ratio. If you shoot the same scene with your camcorder, you will see that with the background exposed correctly, there is little or no detail in the shaded person's face. To compensate, you have two choices: you can add light to the person's face by having her stand in the sun, or you can change the exposure by opening or closing the iris.

You can increase the exposure to bring out detail in the face and allow the background to become clipped slightly. Clipping is usually not considered the ideal solution, but it is acceptable if done tastefully. You be the judge. Many camcorders have backlight buttons or special programs that attempt to handle contrast ratio problems automatically by increasing exposure a set amount. But it is often easier to override auto-exposure and make the adjustment manually if your camcorder has this feature. Figures 3.8 and 3.9 show two exposure settings when shooting dark foreground objects.

Figure 3.8 – *The background is exposed correctly, but foreground detail is obscured.*

Figure 3.9 – *Increasing exposure brings out detail in dark foreground objects.*

Manual exposure can also be useful in situations where the light intensity is constantly changing—for example, when shooting fireworks or flashing lights at night. In these situations, the auto-exposure attempts to adjust the exposure with every light intensity change. If the exposure changes are noticeable, they can become annoying. If you see this happening, switch to manual exposure and adjust for the fire-

works or night scene. Let the periods between fireworks go dark and the flashing lights clip.

You can view the exposure control as having a very practical purpose: it keeps the light even and video level as bright as possible. However, exposure should also be viewed as a creative tool when you compose a scene. If you want to set a somber mood, for example, you can lower the exposure and darken the shot. Photography is painting with light. The auto-exposure sensor assumes the correct exposure for a shot, but this might not fit with your vision. Don't allow the automatic functions to dictate what a shot should look like. The warning beeps and flashing lights can be intimidating. However, the warning lights aren't necessarily telling you something is wrong, just that you are doing something out of the ordinary that might not work. You should use the exposure control and all the other controls on the camcorder to help you paint with light and create the look you want.

Another way you can use exposure is to modify your depth of field. The more open your iris, the more light it lets in and the narrower your depth of field. If you shoot on a very bright day with your camcorder lens zoomed out wide and auto-exposure on, you see that almost everything is in focus. This is because the iris is closed down to restrict the amount of light coming in, so depth of field is wide. If you shoot the same scene at dusk, the iris is opened to let more light in, so there are more areas that are out of focus. You can use this to control the depth of field and keep certain areas of a shot in focus and other areas out of focus to help concentrate the viewer's attention.

Some camcorders indicate exposure settings using the photography system of *f-stops*. The smaller the f-stop number, the wider the iris, and the more light enters the lens.

Shutter

The shutter control enables you to increase or decrease the slice of time that is taken for each frame. If you use a fast shutter of 1/1000 of a second, for example, the shapes of fast moving objects appear more distinct and less blurred. Some camcorders have shutter speeds as slow as ¼ of a second. When this speed is chosen, any object that moves appears indistinct. Try this:

1. Find a place where you can shoot something moving, such as cars passing by or branches blowing.

2. Turn on your camcorder and press the shutter button or enter the shutter mode.

3. Change the shutter speed to 1/1000 and focus the camcorder on the moving objects.

Notice how the video appears to almost flicker, as if you can sense the individual frames. Also notice how distinct the objects are, even more so than with your naked eye. In Figures 3.10 and 3.11, droplets of water are very distinct at a high shutter rate, but turn into trails of light when the rate is lowered to ¼ of a second.

Figure 3.10 – *Raindrops appear frozen at a fast shutter speed.*

Figure 3.11 – *The same raindrops appear as streaks at a slow shutter speed.*

You can use the shutter feature to bring out the detail of moving objects, such as in a sporting event. And as with all the camcorder controls, you can use it just because you like the look it creates. You can use shutter controls along with focus and exposure to limit the depth of field. A high shutter speed requires more light, which requires a more open iris, which results in a narrower depth of field. If you want a limited depth of field on a sunny day, you can use a fast shutter speed.

White balance

There are times when you must shoot, or you choose to shoot, with source lights of different color temperatures. The most common situation is when you shoot a subject indoors lit by an incandescent light bulb and daylight filtering in from an outside window. The reflected light from the light bulb is reddish and the light from outdoors is bluish. The mix of color temperatures can give an interesting look to a shot if that is what you want.

If you don't want the mix, you can make the color temperatures the same by making the incandescent light bluer or the outdoor light redder. Professional moviemakers

do this by using colored *gels*. Gels are colored or frosted sheets of plastic that are able to withstand heat generated by high-wattage studio lights. If they want an incandescent lighting instrument to match daylight, they place a light blue gel over it.

If you don't want to deal with gels and don't mind the mix of lighting colors, you can use white balance to modify the mix. Your camcorder will most likely deal with the mix by adjusting the balance somewhere in the middle. Daylight will look a bit bluish and indoor light a bit reddish. By changing the white balance, you can make indoor light look white and daylight look very blue, or you can go the other way and make daylight look white and indoor light very red. Let's assume you want to try the first option:

1. Find a location indoors that has a mix of daylight and incandescent light and turn on your camcorder.

2. Turn on manual white balance.

3. Your camcorder may give you three choices: daylight, indoor light, or manual setting. If the camcorder does not allow you to set it yourself, switch to indoor light and the camcorder is set. Keep in mind that this setting is based on what the manufacturer of your camcorder considers the proper incandescent color temperature. Your light actually might be redder or bluer. If you can set white balance yourself, you can get a more accurate balance.

4. With the manual setting mode selected, place a piece of white paper or cardboard so that most of the light hitting it is from the incandescent source.

5. Point the camcorder so that the white paper fills the frame. Focus doesn't matter.

6. Press the button that sets the white balance. The white paper that had appeared slightly reddish now becomes white. When you zoom out you see that indoor light is now white and daylight is blue.

You can also use white balance to create interesting and even unreal color balances. For example, suppose you want the light on a very blue overcast day to appear warm and sunny. You can set the white balance outdoors using a slightly bluish piece of paper or cardboard. Or you can set white balance by shooting two pieces of paper at the same time: one white and one blue. The camcorder makes the blue paper its white reference point and the scene appears reddish. You can also try experimenting with setting white balance on red or green paper for an extreme effect.

Effects and titling

Every camcorder offers a different package of effects, transitions, and titling features. Now that you understand the basics of working your camcorder, you can experiment with these features and see if any of them interest you. Because there is

such a variety and they are not essential to taking good pictures, we won't go into much detail. See the documentation provided with your camcorder for details. You probably won't use them much anyway as you shoot your movies. However, it is good to know they are there just in case.

Keep in mind, though, that an effect tends to draw attention to itself. Your viewers might end up paying more attention to your eye-popping transitions than to what is going on in a scene. Also, if you shoot with an effect, you can't undo it later. For example, if you shoot a day at the beach with the solarize effect on the entire time, you won't be able to get rid of it later if you change your mind and get tired of it. It might be better to use the solarize effect on only a few shots, and shoot the rest without that effect.

Steady shot

Many camcorders today have a system for steadying the image as you shoot. In most cases, you should use this feature. Sensors in the camcorder send motion feedback information to a system, either optical or electronic, that shifts the image slightly to reduce small, jerky movements. It doesn't compensate for bad camerawork, but it can help if you've had one too many cups of coffee.

Use the camcorder's menu to turn the feature off and on. Zoom in to a tight shot of a distant object, and notice how steady shot affects the image. You might notice only a small effect, but every little bit helps.

Lighting

The introduction of the CCD caused a tidal wave of innovation in camcorders. They have become smaller, lighter, more rugged, easier to operate, more versatile, and video quality has improved dramatically. In the old days of the tube camera, you had to worry about so many things, including lighting, that shooting video was a chore. Today, you can pick up a camera and shoot what you see.

There is no point in going into all the details of lighting for tube cameras. Suffice it to say, the goal of lighting in the old days was simply to get a usable picture and had less to do with the art of photography and painting with light. That is why people who enjoy the art of moviemaking have for many years preferred film to video. However, that is slowly changing as CCDs and their associated electronics improve and become more film-like in the quality of the pictures they produce and the ways you can work with them. In many ways, shooting video with CCD-based camcorder is far easier and more rewarding than dealing with film. Film is more expensive to work with and you have to wait for it to be processed. Video provides instant gratification. You get exactly what you see as you are shooting.

Your approach to lighting for video is very close to how you would approach lighting for film. You use light as a paintbrush, to reflect the feeling you want to communicate and to help tell your story. With today's camcorders, you don't need trucks filled with expensive lighting equipment. Assuming you are not trying to do something complicated like turning night into day, you can usually shoot with available light—light that is already there. If an area is too dark, you can punch it up by turning on an overhead light, moving lights around, closing the blinds on a window, or aiming a desk lamp differently. The point is, you don't need to make lighting more complicated than it has to be; add a light here, move a light there, shape the light to create the effect you are after.

To this end, the basic lighting equipment you need is fairly minimal and inexpensive. Start with these items:

Small camera light

Bring along one of these just in case. You might find yourself in a situation where you need to bring the light level up just a bit on an actor's face. These lights typically attach to a connector called a *shoe* located on the front of the camcorder and provide a direct front light. If you are forced to use one, you can soften or diffuse the light by taping a piece of frosted gel over the light, or by pointing the light at the ceiling.

Foamcore

Soft, diffused light is always more natural and pleasing to the eye than light that comes straight from a source, such as direct sunlight or light from a bare bulb. You can create a soft light by bouncing direct light off something white. A good way to do that is by bouncing it off a large sheet of white cardboard or by using Foamcore. Foamcore is a ¼ inch sheet of Styrofoam sandwiched between two sheets of white cardboard, and can be purchased at any art supply store. Clamp, tape, or hold the Foamcore sheet a few feet from your subject and aim the direct light onto the Foamcore instead of your subject. This technique of indirect lighting is called *bouncing*.

You can also use the Foamcore to *flag* light off the subject. You can, for example, use the Foamcore to shadow your subject from direct sunlight. Then rely on light bouncing off another piece of Foamcore as the primary light.

Photoflood

This simple aluminum shell reflects light out in a diffuse flood of light. Photofloods are inexpensive, so you can keep one or two of them in your lighting kit just in case. In most cases, you don't aim the light directly at the subject; you point it at a white surface, such as a wall or ceiling, and let the reflected light add to the ambient light in a scene. You won't use the photoflood outdoors because it doesn't put out enough light, and you will only use it

sparingly indoors. If used improperly, a photoflood can make the light in a scene look unnatural.

Gels

Gels come in many different colors and densities. Most are transparent, but there is a translucent variety called a *frosted* gel. Frost is very useful for turning harsh, direct light into diffused, natural-looking light. All that you have to do is cut out a two-foot square piece and tape it over the front of a light, leaving a pocket for heat to escape. You can buy gels at a store that sells lighting equipment for stage and motion pictures. While you are there, take a tour through the store to get ideas for future lighting projects.

Clamps, duct tape, and tools

Duct tape, known in the industry as *gaffer's* tape, can be used to affix Foamcore and gels, to hold up parts of the set, or to keep an actor's hairpiece from flying off. You will find many uses for duct tape.

You might also want to put together a small collection of clamps. Wood clothespins, known in the industry as *C-47s*, can be used to clamp a gel to a light. Because they are wood, they don't conduct heat easily. You should also make up a collection of tools, like a hammer, saw, battery-powered drill, and an assortment of hand tools. These can be used to hang lights, repair sets and props, and fix various things.

Sound

When you are shooting with a camcorder, you are often a one-person production team. Most of your energy is spent composing the picture and getting the best performances from your actors. Sound is too often ignored until the tape is played back. Of course, by then it is too late to fix.

The microphones and sound systems on even the most basic camcorders have improved greatly, but like all the other automatic systems on your camcorder, they don't always get it right. The microphone is designed to pick up natural sound around the front of the camera. If you place your actor more than a few feet away in a noisy location, the microphone does a good job of picking up the natural sound, but does a very poor job of focusing on the sound coming from your actor. To get the sound you want, you need to have the right tools. Here are some of the tools you can use:

Microphone

Most of the sound you will be recording is natural sound (environmental noises from the area in which you are shooting), or dialog (people speaking). To get the natural sound, you can use the camera microphone or purchase a higher-

quality microphone and plug it into the jack on the camcorder. Many camcorders have a list of optional accessories that include microphones. Some microphones are made to attach to the light shoe on the camcorder; others come with a cable so you can place the microphone closer to the subject or have an assistant hold it. A *shotgun* microphone has a directional pick-up pattern that rejects some environmental sounds and enables you to capture the voice a person talking at a distance in a noisy environment.

Fishpole or boom

To get better dialog sound, you can have your assistant hold a microphone on a cable closer to the people talking. If you want to get more elaborate, you can add extension cables to the microphone and rig it on the end of a pole or broomstick, then have your friend hold it over the actors. This type of arrangement is used extensively in film sound recording. The pole is called a *fishpole* or *boom*. Professional fishpoles can be purchased from motion picture sound equipment companies.

Lavalier

The easiest way to get good dialog sound is with a clip-on lavalier microphone. These lightweight microphones can be clipped to a tie or hidden under light clothing. The thin wire can then be plugged into the camcorder. Inexpensive lavaliers can be purchased from many consumer electronic or computer stores.

Headphones

To make sure you record high-quality sound, use headphones. Most camcorders come with a headphone jack that allows you to plug in and listen to the sound that is going to tape. You should preferably use closed-type headphones that cover your ears and partially block outside noise. Some people are annoyed by having to wear headphones. Nevertheless, you should wear them any time the sound is important.

Mixer

If you can attract a friend to do sound recording, you might be able to talk him into holding the microphone and using a *mixer*. An audio mixer is an electronic unit that has a series of volume controls with which you adjust and mix the sound coming from one or more sources. There are a number of small, inexpensive, battery-powered mixers available on the market. Some of them can be worn around the shoulder or neck. Your sound person can wear the mixer while holding the microphone and checking the sound with headphones. Here is how all the pieces connect:

1. The microphone is plugged into the first channel of the mixer.

2. The headphones are plugged into the headphone jack on the mixer.

3. The output of the mixer is plugged into the microphone input on the camcorder. Make sure the mixer has a microphone-level output.

4. The sound person adjusts the microphone sound level using the volume control and meter on the mixer.

Accessories

Every cameraperson has a personalized collection of shooting accessories. No two are exactly alike. The more you shoot, the more personalized your collection will become. To get you started, there are a few essentials:

Extra batteries and chargers

When you purchase your camcorder, get at least one extra battery pack. Don't just use it as a spare; rotate its usage with the battery pack supplied with the camcorder, and make sure you start out a shoot with both fully charged. The basic battery that comes with the camcorder is probably only good for a minimal one or two hour recording time. Consider getting a second battery pack that lasts four hours. If you're planning camping trips, consider a 12-hour battery.

You can charge the battery packs with your camcorder, but you should also consider buying a stand-alone charger. You can buy chargers that plug into the wall or cigarette lighters.

Tripod or monopod

Camcorders are made to be held, but there will be times when you will want to shoot from a tripod. Tripods help you keep shots very steady. They also give your arms a break by holding the camcorder for you. If you are doing a lot of serious shooting, a good tripod is a necessity. Buy one that is light and folds into a small, portable unit. Snap-to-tighten leg locks are far easier to work than the old twist type. Finally, make sure the tripod has a fluid or fluid-effect head. This enables you to pan the camera smoothly.

A monopod is an alternative to a tripod. As the name suggests, a monopod has one leg. A monopod is very lightweight, as well as easy and fast to setup. It doesn't hold the camcorder for you, but it does provide a stable platform on which you can hold the camera. There are many situations where a tripod is difficult or impossible to use, such as when shooting in a crowded outdoor market. A monopod is a good compromise between hand-holding the camcorder and attaching it to a tripod. Your choice will depend on your shooting style and what you plan to shoot.

Case or bag

As you amass a collection of accessories, you will need a way to transport them all. A hard carrying case or shoulder bag helps you keep everything together and—most importantly—keeps them safe from damage. Use a case or bag with plenty of padding for the camcorder. You can make your own carrying case with a hard suitcase and thick chunks of foam rubber that have cutout sections for all the pieces.

In building your collection of lighting, sound, and camera equipment and accessories, you have two ways to go. In some cases, you will need to buy things from a catalog or store, such as battery packs and tripods. The other approach is to build your own and find creative solutions. The first approach can be expensive, and many amateurs don't have the luxury of unlimited budgets. Let the need determine the solution. If you need to place a light, for example, look for creative solutions. Rather than pay $50 for a special movie light clamp, use a similar clamp that you bought at a garage sale for ten cents and add some custom rigging to it. Simple clothespins are used all the time in professional movie shoots. If you decide you need to move the camera, find a creative way to do it: hold the camera and walk with it, attach wheels to the tripod, or pull the tripod with a wagon. You don't need to worry about impressing people with all your expensive movie equipment. All you have to be concerned with is what ends up on the screen, not what you did to get the shot.

Here's one tip to start you out: you can build your own camera dolly from parts you may already have around the house. A *doorway dolly* consists of a heavy piece of plywood with wheels and a rope to pull it. If you're handy with tools, you can add a steering device and brakes. If you're shooting people sitting around a table, you can sit with your camcorder in a chair with wheels and push yourself around with your feet. Shopping carts can be used to move a camera too.

Instead of giving up because you don't have the use of a Chapman crane to get a high-angle shot, think of creative solutions. Climb up a tree, stand on a car, or haul the camcorder up with a rope. All that matters is that you get the shot that helps you tell your story. That's what moviemaking is all about.

After you have assembled your production toolkit, you can put your production plans into action. In the next chapter, we'll explain how to set up, compose your shot, and start shooting your movie.

Production: Shooting Your Movie

You have a goal for a movie and you may have gone so far as to expand the goal into an outline or script. You have also done any necessary pre-production work, such as creating a script breakdown, shot list, shooting schedule, and equipment list. If your production is more extensive, you have done things like arranging for a crew and actors, building sets, renting equipment, and scouting locations. In Chapter 3, you learned about the camcorder and you have put together your production toolkit. In this chapter, you will begin production.

Starting production

The production phase is when you start to turn the ideas and plans you make during pre-production into a tangible product that you can see and hear. People often think that it is during production when the magic happens, but they are only partly right. Movie magic happens when you take the raw footage that you shoot during production and edit it into a finished movie during post-production. To be a successful director, you should think of shooting and editing as having a symbiotic relationship. Neither can exist on its own; you can't have one without the other. The editor's job is to finish what the director started; the director's job is to produce enough coverage so the editor can create a movie.

The successful movie director must think like a photographer, a stage director, and an editor. During a take, a director carefully watches the composition and the performance, and thinks about how the current shot will work with other related shots and the story as a whole when they are edited.

The unedited film or videotape containing the images and sound is called the raw footage, camera original, or shoot reels. The director is responsible for creating the raw footage so that it can be edited into a finished movie.

Though the roles of a director and editor during the making of a movie are very different, many directors are also editors, and many editors direct. The two are distinctly different jobs. However, the people who are successful doing those jobs get that way because they are able to cross over. Good directors and editors think alike, and are able to see a movie from either perspective. When making a movie, the director and the editor must be in sync; both must be able to see the whole picture and share the same vision.

The director

Though there is some overlap, the director is primarily responsible for adding these elements to a movie: picture, performance, and sound.

Picture

The director works with the director of photography (DP) to align the camera angle and compose the shot, which is then put on film or tape. As director, you must think like a photographer and arrange the objects that will be photographed (the actors, props, set pieces, and background) so that they look right for the story you are telling. You are concerned with how the objects are composed and lit, as well as their movement and how they are composed in the frame as they move. Objects can move on their own or appear to move as the camera moves.

The camera is the eye of the person who is watching your movie. Through the camera an audience member can participate in the movie as a silent character. You can think of the camera as being, in effect, a character in the movie. A director does more than create pretty pictures on the screen; a good director uses the camera to invite his audience to participate in the movie.

Performance

The director works with the actors to put the characters on film or tape. It is important to understand that this is not the same as shooting pictures of the actors in their costumes. Performance is that magical, invisible thing that happens when an actor, or any person being photographed, conveys their character to an audience. It is not reading a line or making a certain facial expression; performance is about communicating a persona. A talented actor uses her voice and body to create a believable character that is true to the story, and gives a performance that is engaging to an audience; as an audience member, we believe the character is real and fits with the story, and we enjoy the character and the performance.

Sometimes a director understands how to make pretty pictures on film, but hasn't a clue how to draw a good performance from actors. To direct a performance, you shouldn't tell an actor what to do, such as how to read a line. You should instead lead an actor to the character by giving her feedback and ideas, and then trust the actor to create the performance on her own. It is important to realize that performance applies to real people playing themselves, too. As director, you need to make sure even real people look and act like themselves on film or tape.

Sound

The director works with the sound mixer and designer to make sure the audio is well-recorded and free from extraneous noise. Most of the sound recorded during a shoot is straightforward. Special sound effects and music are added in post-production. But even though most directors leave the job of recording sound up to specialists, it is still the director's ultimate responsibility if there is a problem.

As director, make sure your sound people are capable and let you know on the set if a take is unacceptable, so you can decide whether to do another one.

The editor

The editor's role is to work with the raw footage and create a finished movie. The editor is guided by the script, comments from the director, notes from the shoot, and by his taste and judgment. By editing the length and order of shots, he is responsible for adding these elements to a movie:

Story

Using the script as the primary guide, an editor arranges the individual shots into scenes, the scenes into sequences, and the sequences into the final story.

Emotion

Certainly, the actor's performance greatly affects how we feel about a character, a situation, or even the whole movie. However, the editor draws the emotion out of a scene by controlling what we experience and at what moment.

Rhythm

The editor can set the speed of a sequence by the number and length of cuts that are made. He can also cut so that the dialog and movement seem to have a consistent rhythm.

Space and time

By ordering the shots properly, an editor is able to convey a consistent sense of space and time to an audience. Though not as critical as a good story or emotion, the construction of a movie should make it clear to the audience where they are, where actors and other objects are in a scene, and what time it is.

Sound

The editor and others involved in the design of sound and music add to and edit the sound recorded during production to create a final soundtrack. In general, it is far easier to do detailed sound work during post-production.

Even though as director you will not be setting the rhythm of a scene, for example, you must think like an editor and imagine how the shots will be cut together. A

movie works best if the editor is not fighting what is on film or tape. If individual shots have uneven rhythm, an editor may not be able to make them consistent.

Production begins with deciding on a visual approach that you will use as a guide throughout the shooting of your movie. After that, you can set up your first shot and start production. Before you start shooting, however, you should know a few basics about aligning and moving the camera.

Basic camera work

The first job of a director on a shoot is to decide how the shots look: how the objects in the shot are arranged and how they or the camera will move. Every shot must tell a small story, and make sense in the overall context of the big story, the movie.

To understand basic camera work, find a location with objects to shoot, such as your backyard, and set up the camcorder on a tripod. Turn it on and focus on an object—a rosebush, for example. Here are the basic types of camera movements you can use:

Static shot

Start with a basic, *static* shot. In a static shot, the camera doesn't move, only the objects within the shot. You typically use a static shot on a wide angle that shows your primary subject or subjects, and other objects in the background and foreground. Remember, the camera is the eye of the viewer. Everything that happens in the frame must tell a story. A shot must draw the viewer into a scene without calling attention to itself. You want the viewer to be aware of the story and the scene, and any kind of camera movement will draw attention to the camera. Therefore, the static shot is the fundamental shot. You should start with no camera movement and work outward from there, if you need to.

When you do move your camera, there should be a reason: the movement should be *motivated*. The motivation for movement comes from what the viewer is watching: the characters and the story. If the camera moves to follow something in the scene or to help center the viewer's attention, it is motivated, and the movement will not call attention to itself. The camera should not have a mind of its own. Study the scene you are about to shoot and let it decide if you should move the camera and how. When you move the camera, is it because you want to or because the scene requires it?

As with any so-called rule of filmmaking, however, we encourage you to take risks and break them if you want to, but you should be aware of what you are doing.

Pan

When you *pan* a camera, you pivot it in a horizontal plane on the tripod or while holding it. Try panning your camcorder from left to right and back. Pans look the best and make the most sense to a viewer when they are used to follow movement, such as a person running across the frame. On the other hand, pans across static objects, such as buildings on the other side of a river, can look very disturbing to a viewer unless they are very slow. This is because panning is an unnatural camera movement.

The camera is the eye of your viewer, and people don't naturally pan their eyes. As you study a line of buildings across a river, for example, your eyes jump from one point to another, like a series of static shots. You learn about what you are seeing by fixating briefly on a point, perceiving it, then jumping to the next point. The jumps are not smooth moves. They are quick movements that take place in the blink of an eye. It's almost as if our eyes are cutting quickly from one shot to the next, rather than moving smoothly across a line of static objects. Your eyes do, however, move smoothly when tracking a moving object.

Try panning your eyes across a static line in your backyard, and then try following a moving object like a bee. When you pan your camcorder across a static line, keep in mind that the viewer's eyes are cutting from one shot to another, centering on individual objects.

The fact that our eyes jump, or *cut*, from one fixed point to another is essential in our understanding of why cuts work in a movie. If you think logically about it, cuts should not work at all. It seems like it should be very jarring to change from one angle to another abruptly. As it turns out, though, cuts are the most natural transition because they mimic the way people perceive the world around them—by quickly jumping from one fixed point to the next. Some cuts, however, do seem jarring, while others flow by undetected. In the next chapter, you learn more about cuts, which ones work, and which don't.

Tilt

A *tilt* is like a pan, but moves the camera in a vertical angle. Try tilting down from the sky to the grass. Again, the same rules apply for tilting as for panning. People don't naturally tilt their eyes up and down, so it's most effective to pan or tilt slowly.

Zoom

A *zoom* is when you use the zoom control to move in or out from an object during a shot. Unlike a pan or tilt, it is natural for people to move toward or away from an

object. A viewer would naturally move closer if she wanted to exclude everything else in a scene and get a more detailed view of something; she would move away if she needed to see the area around the object. Zooming, though, is not the most natural way to move in or out from an object, because the distance compresses unnaturally as you zoom in. If you can, the best way to move toward, away from, or with an object is to physically move the camera.

Dolly

Dolly is both the name of the camera movement and the device that moves the camera. The professional studio dolly is a strong, heavy, wheeled platform for moving a camera. It's heavy so that it can move smoothly across a surface, and strong so it can hold the camera and one or two people. To move the dolly, a person known as a *dolly grip* pushes it with a handle.

A dolly move is usually motivated by the movement of a character in a shot, such as a butler carrying a tray holding a cigar to a man sitting by a fireplace. If there is no physical reason for moving the camera, you can move very slowly or *creep* the dolly. For example, you could "dolly in" to a character to emphasize his internal emotional tension.

In television, dolly means to move the camera forward or back. A move to the left or right in television is called a *truck*.

Pedestal

The act of raising or lowering the camera is usually named after the device that does the movement. In a television studio, cameras are mounted on wheeled pedestals, so the move is called a *pedestal*; the cameraperson pedestals up or down. If the camera is to be raised or lowered on a crane, the movement is called a *crane up* or *crane down*.

When in doubt, you can always use the generic term for any type of camera movement: *move*. For example, you could specify "move the camera down and then move in for a close shot." You would move up or down to get a *high* or *low* angle. Like a dolly, vertical moves can be motivated by movement in the scene, for example, a character standing. They can be used as a device at the beginning or end of a scene to, in essence, fly the audience in or out.

For example, in the opening shot of a movie, you can start with a high, wide angle shot and move down (assuming you can afford a crane for the shot) and in to a character, who then starts the movie. Because this radical, unmotivated type of move tends to drag the viewer in and out of a movie, it should be used sparingly.

Your visual approach

At some point before the first day of shooting, sit down in a comfortable chair and close your eyes. Play the movie in your mind. Even though you haven't actually shot anything yet, imagine how the shots will look. Is the movie fast and unpredictable with a lot of handheld camera work and erratic, movement? Does the movie have a peaceful tone with steady, slow camera movement and breathtaking photography? After you have a clear idea of what your movie will look like, you can blend all those ideas into one cohesive visual approach.

Every time you set up a shot, go back to the visual approach you envisioned and see if your shot fits. A consistent approach is essential for engaging an audience. An audience is comfortable being involved in only one story at a time. If you suddenly change from a slow and pensive look to a wacky, fun look, you will probably break the magic spell. Think of the visual approach as a way to hook the audience into your movie. The viewer trusts that you will guide her through your story. If you radically change your visual approach in the middle, it would be like taking the viewer on a tour and leaving her in a dark room to fend for herself.

As the director, your visual approach should be consistent throughout a movie. It should also engage the audience and draw them into the story. Decide on a visual approach and set that as the goal for everything you shoot from your first shot to the last.

Setting up a shot

When you start, you should have a plan that can include a script or outline, a shot breakdown or list of shots you want to get, and a shooting schedule. In this section, we focus on what it takes to get a shot. You start by setting up the shot.

Setup is an important part of production. It typically takes longer to set up a shot than the shot itself. When making feature films, it is not unusual for a professional crew to take hours setting up one 30-second shot. Setups can take a long time because a number of factors must be considered and coordinated.

Setup time is directly related to how much work is required to get everything ready to shoot. This may seem obvious, but production schedulers often do not take into account all the physical work that must go into preparing a shot. You have to consider the amount of equipment and props that need to be carried in, set up, and aligned. You also need to include time for readjusting, making changes, and creating solutions on the fly. Then you have to consider the time it takes to coordinate the movement of the elements in the shot and the camera.

A major Hollywood production can use hundreds of pieces of equipment, which must all be set up precisely. In a typical amateur shoot, you may only need a few lights, but it still takes time to carry those lights in and place them, then coordinate the camera and actors. Even if you are shooting real life with just a camcorder and no additional equipment, you still need to allow time to set up and compose the shots.

Arranging a shot

Composition is simply the way objects are arranged in a shot. You affect the composition of a shot by either moving the objects or by moving the camera to get the best angle. Composing a shot for movies is far more challenging than for still photography because movies include the element of time; as a shot progresses, the composition may change. For example, one person might move from the fence to the bench, another person moves from the door to the wall, and a seagull flies across the background.

To make sure all the necessary action is within the frame of the camera and the objects are composed properly, you *choreograph* their movement as much as possible. This choreography is called *blocking*. To block a shot, you tell the actors when and where to move, and plan the movement of the camera, if necessary, to keep the shot composed.

In many cases, amateur directors have some control over camera movement, and little or no control over the objects they are shooting, such as wild animals or children at a birthday party. To compose a shot under these circumstances, you have to anticipate what the objects will do and make sure you have additional coverage in case you don't get the shot. For example, even though you don't know exactly how the blowing out of the candles shot will proceed, you can anticipate what will happen and plan the best camera angle.

When you shoot, follow a cycle similar to this:

1. **Block.** Decide the movement of all the objects in the shot, if you have control of them, and the camera, so that the shot is well-composed.

2. **Set up.** Bring in the camera, light the set, and get your sound gear ready.

3. **Shoot.** Put the shot on tape. Do multiple takes until it is correct.

4. **Move on.** Go to the next shot, and back to step 1.

Blocking

If you have at least some control over the subject, you can do some blocking. When shooting a wedding reception, for example, you will want the movie to appear natu-

ral, but you can occasionally ask guests to stand in the light or angle themselves differently without being too intrusive. All that matters to a director is that you get the shot.

Here is how to block a shot:

1. **Determine what the shot covers.** Every shot is a mini story with a beginning, middle, and end. The shot also has to match any other shots that are adjacent to it in the overall story.

 Suppose you have a shot where Johnny enters a room and hands a message to Frank who is standing next to a table. Frank says something to Johnny, and then Johnny turns and leaves. End of shot. In the story, Frank then turns and walks to Sam, who is off-screen in the current shot.

2. **Break the shot into moves and positions.** A move occurs during a shot when subjects or the camera changes position. A position is the location of a subject or camera between moves.

 Johnny's first position is outside the door, and Frank's is by the table. Johnny's first move is through the door to Frank. Johnny's second position is facing Frank by the table. Figure 4.1 shows how these movements are blocked out.

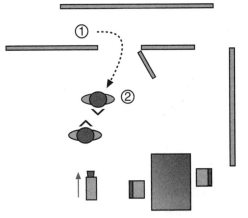

Figure 4.1 – *Floor plan showing blocking of the Frank and Johnny scene.*

3. **Have the actors walk through the shot.** During a walkthrough, the actors move from one position to the next while you and the DP watch and decide where the camera should go, and if there needs to be any additional lighting. As you walk through the shot, re-block any movement or position that doesn't work for the camera or lighting. For example, as the director watches the shot of Johnny and Frank, she may notice that the walk takes too long, so she repositions the table closer to the door.

4. Have the actors do a full rehearsal. Run the scene in real-time with the blocking and make sure everything looks natural and goes smoothly. After you are satisfied with how the shot looks, you can start lighting if necessary and setting up the shot.

To make it easy on yourself, keep the number of moves per shot to a minimum. Rather than shoot a complicated scene in one long shot, break it up into manageable pieces: separate shots that you can cut together in editing. A long shot may not seem very complicated when you are thinking about it in pre-production, but when you start shooting you may find yourself in a situation where you are spending unnecessary energy and time coordinating all the moves. You end up doing take after take because there are so many things that can go wrong: an actor forgets a line, the camera dolly runs over a rock, the sound person gets in the shot. Breaking up a complicated shot not only makes shooting easier, it gives you more flexibility in the edit room as well.

If you have control of your subject, you can block subject and camera movement to coincide so both seem natural and the shot stays composed. If you do not have control over the subject, such as when you are shooting family events or wild animals, you have to anticipate subject movement and block shots on the fly.

You may decide to let the camera roll while you shoot many different things. As you do, think about how you will edit the long section of video. Think about pieces that can be pulled out and turned into individual shots that tell mini stories. Sometimes you get a good shot; sometimes you don't. For every five minutes you shoot, you may only get 30 seconds of good material. Nevertheless, it is 30 seconds you would not have otherwise.

Composition

To compose a shot, study what you are going to shoot before setting up the camera. If you are using actors, place them on the set or use other people to stand in for the actors (these people are called, not surprisingly, *stand-ins*). If you have no control of the scene or set, study what you have. Move around and notice how the objects in the shot change in relation to each other—how they move closer or farther away, or get larger and smaller. Ask yourself how you can best relate the story visually.

Here are a few pointers for composing a shot:

Select a subject

Is it one person, two people, or a group of people? Is it an inanimate object, like a building, flower, or clouds? A shot should have only one subject. If a shot has more than one subject, you can break it up into two or more shots. For example, if a scene has two people conversing, you can shoot the entire scene from three different angles: one shot of both people, a second shot with the first person as

the primary subject, and a third with the second person as the primary subject. When you edit the scene, you can choose which subject you want as the primary subject by cutting to whichever shot has the best angle.

Find a frame for the subject

If you have control of your subjects, place them at their first positions. Then walk around, bend down, climb on top of rocks if necessary, and look for an angle where the subjects and all the other objects in the shot can be contained comfortably in the frame and each is angled the way you want. You may want the person talking to face the camera and the others listening to face away. If you are using a wide-angle shot, look for objects that you can place in the foreground between the camera and subject to add a natural frame, such as a tree branch or even a doorway.

Find a balanced composition

Notice how all the objects in your shot are balanced. Look at the shapes, colors, and areas of light and dark, and imagine them as simple shapes and lines. Do the shapes create a balanced, well-composed picture that draws attention to the subject, as shown in Figure 4.2, or does it seem lop-sided or draws the eye away from the subject? Keep moving until you find a balanced shot. As you do, imagine how the shot will be framed.

Figure 4.2 – *Shapes, lines, and light intensity draw your eye into the image.*

Bring the camera in and check the shot

Using the zoom and focus features on the camcorder, find the best framing for your subject.

Simplify

Knowing what your primary subject is, you can simplify the composition. Attempt to strengthen the focus on the subject by selecting uncomplicated backgrounds. Get closer to the subject, if necessary, to cut out distractions. Movement also draws attention. For example, if your subject is a child reciting a poem and another child is in the background running back and forth, the

viewer's attention will go to the child in the background. In theater, this is called *upstaging*.

Change the depth of field

Move the camera away from the subject and zoom in to reduce the depth of field. When you do that, you can center attention more on your subject by throwing distracting background and foreground objects out of focus.

Use the rule of thirds

The rule of thirds is a guideline used by photographers to determine positioning for a subject. To find those positions, imagine the frame divided into thirds, with equally spaced horizontal and vertical lines dividing the frame, as shown in Figure 4.3. The four points where the lines intersect are where you can center your subject to conform with the rule of thirds and create a good composition. Putting the subject dead center in the frame is generally considered by photographers to be bad composition.

Figure 4.3 – *A frame divided by using the rule of thirds.*

Lead the eyes and movement of your subjects

For example, if a person is walking across the frame from left to right, it feels more comfortable to a viewer if the person is framed on the left so there is space in front of him. If a person is standing looking off the left side of the frame (frame left), it feels more comfortable to place him on the right side of the frame. This is also called giving the subject more *eye room*. Figures 4.4a and 4.4b show some examples of eye room.

Figure 4.4a – *A subject on the left side of the frame has eye room to the right.*

Figure 4.4b – *Subject placement and eye room from right to left.*

Use your lens and camera angle to emphasize a feeling

Use a *long lens*, or zoom in and move the camera back, to create -a softer, intimate feel to a shot, as shown in Figure 4.5. Shoot your subject from a low angle—below the level of their eyes—to give the subject a feeling of power. Shooting down on a subject tends to diminish it. Ask yourself what will be the most eloquent way to angle the camera for the emotion you're trying to convey.

Figure 4.5 – *Using a long lens to create a more intimate feel.*

Adjust focus and exposure

If after lining up a shot, you notice that some areas are too dark or too bright, or the light just seems unnatural or uneven, add or subtract light. We'll provide lighting pointers later in this chapter.

Move to next position

If there will be movement in a shot, have the actors go to their next positions. In this new position, does the shot composition still work? If not, think about how you can move the camera or reposition the actors to recompose the shot. You may even need to re-block the shot to make all the elements work. The ideal situation is to have everything in the shot and the camera move fluidly and seamlessly from one position to the next and have everything neatly move from one well-composed shot to the next.

If you are shooting real life and have no control over the subject, you need to do all of this on the fly. You need to size up a shot, set the camera, and start rolling, often

before you have a completely balanced shot. When you watch television, you can usually tell the difference between shots that were planned or grabbed on the fly. That's the difference between having control of your subject and shooting real life. Unless you have complete control of the subject, your composition will often be compromised in some way; you may not be able to get the subject's facial expression or lighting exactly the way you want it. If you have no control of your subject and need perfectly composed shots, plan on spending more time for the shoot and bring along plenty of video tape.

Rather than try to fight a situation that is out of your control, you can try using the unplanned look as a style. Very often, a director will purposely plan a shot to look unplanned and spontaneous by unbalancing the frame or adding distractions, such as foreground objects that move in front of a subject or shaky camera work. While these techniques may not be appropriate in every case, they can add that necessary touch of reality that keeps an audience interested and engaged.

There is no law that says a shot has to be perfectly composed to work. You decide what look is right for your movie. It is important that a shot look balanced and composed, but in movies it often works to your advantage to balance a shot by unbalancing it and to purposely break the rules to give your movie the feeling you want to express. Composition is one part of the process. The overall goal of a shot is to help tell your story, and the story is of ultimate importance.

These rules, like all rules in moviemaking, were created to help new photographers shoot foolproof pictures. We urge you to learn the rules and tips, watch movies and television, find out what other people are doing and why, and then experiment with your camera. Try things. Note how audiences react. Then, push the envelope and break the rules. Don't worry if you try something and it doesn't work. When something fails, try to learn why it failed. When something succeeds, try to figure out why it worked. We've given you some guidelines, but you should just use these as a starting point to develop your own skills as a moviemaker.

Lighting

Photography is painting with light. You start with a raw subject, and then add or subtract light until it has the look you want. The goal of lighting is not to fill in all the shadows so that everything is lit evenly. This may have been the goal in the early days of color television when they needed to drown a set with light just to get a useable picture. Current camcorders can operate in a wide range of lighting conditions, which enables you to approach lighting the same way an artist approaches a painting. The lights are your instruments for creating an effect or mood.

We won't go into all the fine points of lighting here. But you should at least be aware that your camcorder, assuming it is a fairly recent model, enables you to cre-

ate an infinite variety of lighting effects. If you choose to do nothing and use just the available light, you can usually get at least useable pictures. However, if you take the time to control the light in a scene, you can produce great pictures that work well with your story.

In professional moviemaking, producers cannot be concerned with the time of day or the weather. They defy nature by bringing in trucks of lighting gear to create their own time and weather. If it's a little overcast, they can create the sun if they need it. If they need rain on a sunny day, they bring in rain machines and cut off the sun. The amateur does not have that kind of flexibility and budget. In most cases, you will not be creating a set and lighting from scratch, but using real locations and adjusting the available light.

For example, if you want to shoot the Johnny and Frank scene from the previous section, you can shoot in a real, wood-paneled executive office and make use of the lighting that is already there rather than building a set and bringing in all the lights. This makes the most sense for the low-budget, amateur movie.

Lighting a scene

Let's walk through an example in which we are shooting an office scene in a real executive office. The lighting is already there. However, the light is not quite right for the story we want to tell. Let's use that shot as an example and explore ways that you can improve the lighting in a real location.

After blocking, we decide to do the Johnny and Frank scene in two shots and then cut between them, or crosscut, in editing. We will shoot the main coverage, also known as the master shot, facing Johnny as he comes in and hands off the message. This shot favors Johnny because Frank's back is to the camera. The master shot will show all the action: Johnny entering, walking to Frank, handing him the message, and then walking out.

The second shot will favor Frank, and Johnny's back will be to the camera. This shot is called a *reverse angle* shot because the camera is turned around almost 180 degrees from the master shot with which it will be crosscut. In both shots, there will be no camera movement other than panning and tilting. The first shot will be the master.

Here is how we might approach lighting this shot:

Look at the shot

With the camera set up and actors or stand-ins in position, we'll study the current lighting, noticing how it works with the actors and the background. Does it accentuate the primary subjects? In the composition of the shot, is anything highlighted so that it competes with the subject for the viewer's

attention? Does the lighting make sense with the story? Will the lighting in this shot match the lighting in other shots when they are edited together?

We notice that there is only one light on in the office—on a desk behind the camera. The other light is strong, direct sunlight filtering through blinds on the other side of the room. The direct sunlight hits Frank from the neck down. As Johnny enters the room, he is in shadow until he reaches his second position facing Frank, where he is hit by the filtered sunlight from the chest down.

Make decisions

Is the existing light working? In our example, the first thing that has to go is the sunlight. It is so strong that the room light is too low for the given contrast ratio of the camera. In other words, everything that is not lit by sunlight is almost black. We could turn up the exposure and clip the sunlit areas, but then the clipped areas will look washed out. The sunlight also competes with the story. We want the scene to appear dark and foreboding, not sunny.

There are two other reasons why the sunlight is bad. First, it is not motivated. If we make a point of showing the viewer heavily filtered sunlight, the viewer is going to want to know why. She is going to want to see the window and how it connects with the room. She will automatically assume that the heavy sunlight is there because it somehow relates to the story. If it doesn't relate to the story, then we have added an element of confusion. We have no reason to establish the window in this short scene, so it is better to leave it out and not complicate things.

Also, the sun will move. The strong sun that is lighting the actors below their faces in the master will be lower in the sky and lighting their faces when we get around to shooting the reverse angle in a couple of hours. When we crosscut the two shots, they won't match—another reason to eliminate the sunlight.

With the sun gone, the room will be fairly dark. There is a floor lamp and an overhead light we can use. If those are not enough, we can use some of the lights we brought with us.

Set up lighting

The first bit of lighting we change is to reduce the sunlight by closing the blinds. Then, we add light by turning on the overhead room light. The room light adds a low, warm, diffused light from above that covers the whole scene. We can then turn the exposure up on the camera to compensate. We will use a relatively wide angle so we don't have to worry about focus even though the depth of field is reduced by turning up the exposure.

Even though the actors' faces are lit, they seem dull and undefined, and blend too much with the wood walls in the background. Definition is created by adding and controlling shadows. A completely shadowless surface has no texture, so it tells the viewer nothing. We can add lighting to the actors' faces at

the position where they are facing each other by bouncing a photoflood off a white wall that is *out of frame* (not seen by the camera) to the right of the camera. This will add a soft, diffused light to the sides of their faces and add some definition. It will also seem natural to the audience, which will expect there to be light like that in the room.

To add some color and warmth to the shot, we move the floor lamp into the background and turn it on. This light also adds a little definition to the back of Johnny's head and cheek. The final lighting plan for the scene is shown in Figure 4.6.

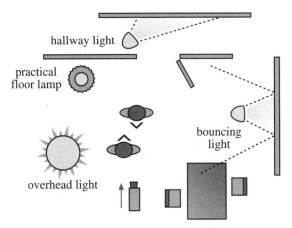

Figure 4.6 – *The lighting for the Frank and Johnny scene.*

Last check

We ask Johnny to walk through the shot one last time. As he walks, we watch every move carefully and look for areas where the lighting can be improved further. He walks through a shadow as he enters the room, so we add a light in the hallway outside. He is also a bit out of focus, so we will have to *ride* the focus as he approaches Frank and the camera. Riding the focus means keeping your left hand on the focus knob or ring and continuously adjusting it to keep a moving subject in focus. We cannot use automatic focus because the lens would focus on the back of Frank's head.

Everything looks good

The adjusted lighting now adds just the right amount of contrast and definition to objects in the shot—it complements the composition. It also matches the other shots in the scene. Most importantly, it helps set the mood for the scene. And by doing this, it fits with the story we are telling.

If you have little or no control over your subjects, you must block and set up shots as you go. When you study a location, such as a dance club, think about how you are going to get the shots. If you can, adjust the lighting before you start. If the

dance floor is very dark with bright, colored stage lights and you are not able to add any lighting, you will have to make do with the existing available light. You can also use a very diffused camera light or increase the gain on the camcorder. When you are shooting in situations where you have little or no control over lighting and the subject, you have to be extra creative. The pictures may not be pretty, but if they fit with the story you are telling, the shots will work.

Sound

As the director and DP block and light the shot, the person doing sound must determine how to capture the dialog. She does that by planning how to *mike* the shot. The two most common ways to mike dialog is with a *cardioid* microphone suspended from a *fishpole* or with *lavalier* microphones. Lavaliers are very small and come with clips used to attach the mike to a person's clothing. If more than one person needs a lavalier, you must mix the sound before sending it to the camcorder. Lavaliers are often the easiest way to mike one or two actors because they give you good, clean, consistent pickup of the dialog without adding a lot of extraneous noise.

In this shot, however, the sound person decides to use the fishpole method because the sound is of higher quality—the sound produced by the cardioid microphone is more realistic. She will hold the microphone out over the two actors. Cardioid refers to a microphone's pickup pattern; the clearest sound is picked up in a heart-shaped area in front of the microphone. Sound behind the microphone is muffled or rejected. She will hold the fishpole so that the microphone is slightly in front of the actors, aimed down at their mouths.

She watches the walkthrough and notes that all dialog takes place in one position, so she finds a clear space near the camera to stand and hold the fishpole. If there had also been dialog near the door, she would have had to figure out a way to cover both positions. She plugs the microphone and headphones into the mixer, and then runs a cable to the camcorder. She listens through the headphones for any extraneous noise. Other than the director calling to the actors, she notes that the sound is clean except for a small motor running someplace. A sound person aims to get clean recordings with as little extraneous noise as possible.

Problems with sound

Extraneous noise causes three main problems:

Continuity

A seemingly continuous innocuous noise, like a leaf blower outside, can suddenly jump right out when you attempt to edit a scene. In the scene with Johnny and Frank, suppose the first shot had the sound of a leaf blower in it and

the second didn't. Every time you made a cut, you would notice the blower going off and on. If the shots don't match, the scene cannot be cut. The only way to fix it in post-production, would be to add leaf blower sound to the second shot. The best solution is to eliminate the blower: ask the gardener to hold off until you are done shooting.

Competition

Even if you weren't cutting, the leaf blower sound would compete with the primary sound, the same way a person making faces behind the primary subject competes in the frame.

Motivation

The leaf blower sound could almost be ignored if it weren't for the fact that it is also unmotivated. When the viewer hears the leaf blower, she is going to wonder where it is and what it has to do with the story. Even if she is not conscious of the inappropriate sound, it will nevertheless add an incongruous element to the scene that colors how she feels about the characters and story. If the scene is a tense World War II drama, a leaf blower will pretty much blow the scene. You may have a beautifully lit scene and a brilliant story, but extraneous sound can ruin the whole effect.

The sound person takes off the headphones and listens to the room. She locates the source of the noise. Thankfully, it's not a leaf blower, just a small refrigerator, which she unplugs. She makes a mental note to plug it back in after they get the shot.

Shooting a scene

This is the point during production when it all comes together. You've spent time and energy planning, blocking, and composing the shot, setting the lights, and preparing the sound. Now it's finally time to start shooting. As the director, it is time for you to take charge. Before you press the red button on the camcorder, you need to prepare your crew, actors, and other people on the set and let them know, if it is not already apparent, who is in control.

If you are shooting dialog and have control of the location, you should first make sure that everything is as quiet as possible: all talking and noises stop. To do this, you might need to speak up so that you are louder than the prevailing noise level. Then, inform everyone that you are about to roll and that all people involved in the shot should go to their places or first positions; you can say "stand by" or "first positions." When everyone is quiet and waiting, start the camcorder and inform the group that the camera is "rolling," or "rolling and recording." When you are ready, cue the actors to begin the shot by announcing "action."

The type of shot, of course, will dictate how much direction you need to give before you start rolling. If you are shooting real life and want the shot to seem unplanned, you may not want to give any warning at all. For example, when shooting wildlife, shouting "action" might scare away the animals you are trying to film. Do whatever it takes to get the shot. It may require setting up 50 feet away from the subject and giving no direction; it may require setting up one foot away and jabbing the subject with a stick; it may require that you make a funny face to get the subject to smile. A director's job is to get the shot, and you go about that anyway you see fit.

Less is more

There will be times when you do nothing and the shot falls in your lap, and there will be times when you try everything and nothing seems to work. In moviemaking, less is often more. This philosophy has been guiding directors, actors, DPs, writers, and others in the making of movies for many years. "Less is more" can have many meanings, but in the context of directing amateur movies it means that you need to find creative ways to do as little as possible to achieve your goal of getting the shot. Often you get a better performance from a subject by letting the performance come out naturally instead of trying to completely control it.

For example, instead of telling a person exactly what to say and how to say it, the performance will always be better if you allow the person to say what you want him to say on his own and in his own words. This is not always easy to do, especially with non-professional actors, such as people you are interviewing or your child. It might require a creative approach and some gentle psychological manipulation, but the indirect, less-is-more style of directing usually produces better results than the direct approach.

As the camera rolls, keep your eyes and ears open. Watch for the framing of the shot, facial expressions, mistakes, and serendipitous moments—when a twinkle of light happens at just the right time and adds magic to the shot. Put yourself in the place of the viewer; is the shot doing what it's supposed to do? Does it propel the story forward or slow the movie down? Imagine how the shot is going to work when edited together with scenes you've already shot or are about to shoot; will the edit be seamless or will there be discontinuities? Look all around the frame and look inside the frame. Study the composition of the shot as well as the meaning of the shot. Does it look right? Is the meaning right?

Shooting strategies

Because travel time and location expenses are one of the biggest parts of a production budget, production schedules are typically arranged to get shots by location. For example, if you were using a mansion and a football field as shooting locations, you would shoot all the scenes in the old mansion before moving on to the football field,

even if you have to shoot them out of order. If you are shooting a documentary and your outline calls for shots of a beach, it's easier on your budget to get all shots on the same day even if they will be spread throughout your movie. Scenes, too, are typically shot together. At the mansion location, for example, you would shoot all of the shots in scene 1, then all the shots in scene 5, and so forth. Be on the lookout for ways to economize. For example, if a difficult setup is used for two scenes, you should plan to do both shots together.

The basic strategy for getting a shot is to shoot the scene all the way through and keep doing takes until you are satisfied with everything. Even if it seems repetitive and painfully boring to shoot the entire scene from every setup multiple times, you will be rewarded in the editing room with adequate coverage. If everything works right on the first shot, you can move on to the next one—or maybe get another take just for safety.

To make sure a take is good, especially if it was a complicated setup, you should play it back in the camera. As you play it back, carefully examine the performance, framing, lighting, and sound. If you are shooting general *wild* shots of people at a dance, for example, you may only be shooting from a basic outline and not have any specific shots in mind. Nevertheless, when you think you have enough material, go to a quiet place and play parts of it back. If your outline calls for about five good shots, make sure you have the coverage. It's possible a moment you thought was brilliant was actually out of focus, or the tape jammed and nothing was recorded. If you check your work often, you might be able to catch the mistake and re-shoot the material immediately.

During production of a big-budget movie, producers, the director, and the DP view *dailies* to make sure the shoot is on track. Dailies are a compilation of the good takes from the previous day's shoot. If you have time in the evening after your shoot, play back the material you took during the day. If you have a break between shooting days, do a rough edit of the pieces you shot. It is far easier to do a *pick-up* while you are set up for production than to have to set everything up again. A pick-up is a shot or part of a shot that you get later to repair or improve a previous bad shot.

Continuity

One important area that you need to look out for while shooting is *continuity*. We've all noticed errors in movies, such as when the actor is holding a cigarette in his left hand and it suddenly jumps to his right hand after a cut. These are errors in continuity. If a scene or sequence has good continuity, it seems to flow naturally and you can see no visual or audible differences between the shots.

In commercial movies, a Continuity person carefully studies each shot before the camera rolls to make sure there are no visual discontinuities. To help her do this, she makes meticulous notes in the script and takes photographs, using a Polaroid camera. She notes the body positions of all the actors, and their appearance—their costumes and makeup.

The cigarette jumping from the left hand to the right is apparent when you notice it, but that type of visual discontinuity is a fairly minor annoyance to an audience and can often be fixed or hidden in post-production with some deft editing. The discontinuities that are the most destructive are the ones that affect the story. For example, a plot discontinuity can destroy a mystery. This can happen when the storyline is adjusted in the editing room after a film has been shot. You can also get emotional discontinuities, such as with an uneven performance from an actor. As an audience experiences uneven performances and erroneous plot points, they find it more and more difficult to suspend their disbelief. After awhile, they lose interest in the movie and start looking at their watches.

Continuity is important regardless of whether your movie is scripted or real life. With any movie you make, you are creating a new reality in the editing room. You may not have to concern yourself with cigarettes changing hands, but you do have to be concerned with the bigger picture: the story. The ultimate continuity of your movie is driven by your vision, the goal you create for your movie. If you are doing a documentary style movie about a topic you feel passionately about, don't allow the passion to become diluted by time and your vision steered off track by situations. With every shot, ask yourself if the content of the shot is advancing the story or introducing a new topic that breaks the continuity you are building.

Continuity is maintained by adhering to your goal. Your goal defines the story and emotional content of your movie. Those elements define the scenes and shots you will get. Every bit of action and dialog, everything that the audience sees and hears must tie together logically in order for you to create a reality that is believable, and that will allow the audience to suspend disbelief. Specifically that means making sure a character is the same person from scene to scene and the point you want to make is clear. It also means making sure cigarettes don't change hands from one shot to the next.

Shooting styles

The basics of shooting apply to any production style: documentary, television, feature, and experimental. Specifics are related more to the content of a movie than to a basic approach to shooting. For example, a feature director does not have to learn any new basic shooting skills if she decides to do a documentary-style movie. However, she will have to approach the content differently; she is no longer dealing with fictional characters, but real people and situations. Differences in the shooting ap-

proach have more to do with the scale of the production. For example, the feature director who is used to working on big-budget productions has to be content with a crew of two or three and no catering truck. He may even have to carry his own chair. The one exception is the television style, which we will discuss later.

Regardless of the production style, your approach to composition, lighting, sound, the performance of an actor or interviewee, and the story are the same. The story drives every decision. Composition, lighting, sound, and the scale of the movie are dictated by the requirements of the story. For example, an interview with a nurse in a convalescent home will be composed and lit differently than a dialog scene from a galactic battle feature because the requirements of the story are different, not because of the production styles. Your approach to getting a performance from the nurse may be different from getting one from a space alien, but you will still use many of the same tricks and skills; the "less is more" rule applies in either case. The bottom line for any director is the same regardless of the production style, approach, or story: get the shot.

Shooting in the television style

In the television style, more than one camera is used to shoot an event from different angles. This style more or less requires a multi-camera shoot. The video is then edited into a final movie. The director knows at least roughly what will occur as the event takes place and might have some control over it. Because there are specific technical issues involved in shooting with this style, we will offer some suggestions.

The television style in the context of a low-budget amateur movie is far less technically challenging than in a professional setting. Professional television production facilities use studio cameras, video switchers, and racks of electronic equipment. All of this is used to record programs like game shows, sitcoms, and talk shows live to tape. The director does most of the editing in real time with a video switcher as the taping progresses. The final switched master video tape contains all the cuts between cameras, and can be broadcast directly without any editing.

The amateur television-style production is different in two respects: it is far less complicated and expensive, and all cuts between cameras have to be added in the editing room. You record an event with two or more camcorders. Then, in post-production, you edit the final movie together using footage from whichever camcorder had the best shot. A thorough location scouting is often important to determine the best setup for each camcorder. See Chapter 2 for more information about pre-production considerations.

Shooting procedures

On the day of the production:

1. Arrive early and set up the camcorders if you can. If you can't set up right away, at least meet with your crew and discuss the camera angles and the types of shots you would like from them. Show the camera operators where they will be, explain what will happen, and tell them what they should be shooting.

 For example, suppose you are shooting a rodeo. Camera 1 will cover action on one side of the arena, with camera 2 on the other side. Camera 3 will be positioned by the chutes to get close-up shots of the riders preparing. Cameras 1 and 2 will get close-up shots of the riders when the action is on their side of the arena, and wider shots that include the riders and animals when the action is on the opposite side.

2. Synchronize watches or devise some system of cuing the camera operators so all three start recording at the same time. Make that starting time "zero."

3. Set up the audio. In our example case of a rodeo, the sound picked up by the camera microphones on each camcorder will be sufficient. In some situations, such as when shooting a wedding, you may want the sound to be identical on all camcorders, so that when you cut between shots, the sound quality doesn't change.

 This will require some creative thinking because there are currently no simple systems available for consumer camcorders that enable you to divide the sound this way. Perhaps the simplest solution is to plant the camcorders near speakers in the location. The best solution is to use a mixer with a microphone level output. Run the sound from the PA system or another good source into a channel of the mixer, then split the output and run cables to the microphone inputs on each camcorder.

4. All camcorders start recording on your cue. Each camcorder should record the entire event without stopping, even if it does not have a useful shot. This will help you locate shots when editing. For example, if you want to cut from camera 1 to camera 3 at 22:03, you can roughly locate the shot on the camera 3 tape by fast-forwarding it to that point. If the camera 3 operator stopped and re-started the tape, the time would have no relevance and you'd have to check the entire tape to find the correct section. Your camera operators must make sure their batteries and tapes are sufficient for covering the entire event. You should coordinate any battery and tape changes so all camcorders change at the same time.

Other than adding a few camcorders, your approach to shooting a television-style production is the same as any other style. Your goal is still to get the shot and tell the story.

To help you visualize how a production progresses, let's go back to the scenario from Chapter 2 involving Dave and his camping movie. In the next section, you can follow the process used by Dave when he shot his movie. Keep in mind as you follow the process and view the results on the CD included with this book, that this movie is not meant to be the perfect model for making amateur movies. It is merely a vehicle for learning how to approach and shoot an amateur movie.

Shooting the camping movie

Before Dave goes on the camping trip with his son and his son's two friends, he decides on a concept for the movie, puts together a rough outline that includes four scene ideas, and makes some plans, which include a list of equipment. The general concept is to make only minor preparations and allow the shoot to proceed spontaneously. The group is to do all the shooting on Thursday and part of Friday, and then spend the rest of the weekend fishing.

Note that a setup means roughly the same thing as a shot. During a shoot, production people will often say they are "moving on to the next setup," or ask how many setups there are on a particular day. Shot and setup aren't exactly equal in meaning; it is possible to get more than one shot from a given setup by zooming to a different focal length, for example.

Dave's shooting plans

In this section, we will take a look at excerpts from Dave's shooting plan. Along the way, we will comment on what Dave planned to do and what he actually accomplished.

Shoot Day 1

Here is Dave's shooting plan for the first day of the camping trip:

```
Shoot Day 1
Location: Beaver Lake campsite
Day: Thursday
Scenes to shoot: Set up tent, kids make dinner, kids shoot something on
their own.
Setup 1: Setting up the tent.
Setup 2: Welcoming the audience.
Setup 3: Dinner scene, Master.
```

Setup 4: Dinner scene, OTS.
Setups 5 and 6: Dinner scene, bean and asparagus Cutaways.
Setup 7: Dinner scene, Master end.
Setup 8: Dinner scene, Wide shot end.
Setup 9: Dinner scene, dishing out food Insert.
Setup 10: Card game scene, Master shot.
Setup 11: Card game scene, cards Insert.
Setup 12: Card game scene, MS Kid #1, MS Kid #2, MS Kid #3.
Setups 13 to 15: Card game scene, OTS Kid #1 cards, OTS Kid #2 cards, OTS Kid #3 cards.
Setups 16 and 17: Night kids scene, Master and 2-shot.
Setup 18: Bean Witch scene, Monster POV.

Setup 1: Setting up the tent

The first shot of the day is setting up the tent, as shown in Figure 4.7. To make it more interesting, Dave has the kids set it up with no prior instructions. He hopes this will add some confrontation that can be used to develop a story. In addition, to help set the tone of the story, he decides to use a feature on his new camcorder that shoots single frames. This will enable him to shoot the tent setup as a *time-lapse* shot. He wants the tent scene to last about 30 seconds, so he makes some calculations and decides to shoot one frame every five seconds. When the time-lapse scene is played back, the three-minute tent setup will be compressed to about the right time.

Figure 4.7 – *Setup 1.*

He sets the camcorder up on top of his car to get a higher angle, and then has the kids prepare the area for the tent. When they are ready, he announces that he is rolling and starts shooting single frames. When he announces "action," the kids start.

After the tent is up, he stops the camcorder and plays back the shot. It looks good, so he makes a mental note that the scene is finished and moves to the next setup.

Setup 2: Welcoming the audience

He decides the movie needs a little introduction, so he adds a shot of one of the kids welcoming the viewer to the campsite. Figure 4.8 shows part of this shot. He opens the shot by walking with the camcorder out from behind some branches to make it seem like the audience is entering the campsite and coming in to the movie. This is a low-budget alternative to a crane shot, and it helps establish the campsite and characters.

Figure 4.8 – *Setup 2.*

Every new scene needs an *establishing* shot near the beginning, which gives the viewer a glimpse of the whole location. Viewers feel uncomfortable if they don't have a consistent sense of the geography of the scene.

Because this shot will precede the tent setup shot in the final movie, the kids reluctantly dismantle the tent for continuity purposes. It wouldn't make sense to viewers to see the tent already set up, then immediately go to a shot where it is being set up.

Setup 3: Dinner scene, Master

After a break, they set up for the scene in which the kids make dinner. Dave angles the stove, cooler, and actors so he can get all the shots he needs for the scene without moving anything other than the camera between setups. This will help maintain continuity. He also removes a part from the stove lid so the camera can see across the top of it—which you can see from Figure 4.9—and uses duct tape to keep the stove from sliding off the plastic crate. He directs the kids to take things out of the cooler and make hot dogs and beans. The only other direction he gives them is to talk about what they are doing as if they are chefs on a cooking show. Dave is hoping "less is more" will come through for him.

Figure 4.9 – *Setup 3.*

This first setup is a *master* shot of the scene. A master shot usually covers an entire scene. In this case, the master covers only from taking cans out of the cooler to starting to heat the food. He uses a wide angle for the master so he can see as much of the action as possible. The angle focuses on the kids. He will also get a shot focusing on the stove. He will use the master shot for timing the scene.

As he shoots the master shot, he keeps track of all the action in his head so the kids can repeat it accurately when he shoots from other angles. Because he has brought only enough food for two takes, he marks the first take of the master as the good one.

Setup 4: Dinner scene, OTS

Dave moves the camcorder around behind the kids and sets up an over-the-shoulder (OTS) shot on the stove, as shown in Figure 4.10. As he sets up, the kids clear the set back to the first position. They will run through the scene just as they did in the master. In editing, Dave will cut between the master and this OTS angle. With these two angles, most of the action in the scene is covered and the audience will be able to see everything that is happening.

Figure 4.10 – *Setup 4.*

When Dave starts shooting, things don't go as smoothly as planned. Instead of getting one clean take all the way through the scene, he has to re-align the camcorder and pick up pieces of action a second time. For example, the kids do some things out of order and Dave doesn't get a good shot of them lighting the stove the first

time. He also decides to stay with this angle to shoot the food after they have finished cooking.

Because he is using the master as his basic shot, the dinner shot does not have to be continuous—although that would make editing easier. Had the campout movie been scripted, it would have been better to shoot each setup in its entirety, thereby shooting all the way through the scene.

Setups 5 and 6: Dinner scene, bean and asparagus Cutaways

Before shooting the ending of the dinner scene, Dave moves the camera around and grabs two extra shots that can be used as *cutaways* in editing. A shot becomes a cutaway if it is used to, as the name suggests, cut away from the main action to show the viewer some related activity. Setup 5, shown in Figure 4.11a, is a shot following one of the kids as he opens a can of beans. Setup 6, shown in Figure 4.11b, is a shot of another kid opening a can of asparagus and taking a bite. This extra coverage can be used for a number of editorial purposes, which we will explore as we edit this scene in Chapter 5.

Figure 4.11a – *Setup 5.*

Figure 4.11b – *Setup 6.*

Setup 7: Dinner scene, Master end

As you can see in Figure 4.12, this is a shot similar to the master, but a little farther back. It shows the kids checking the food and putting it on the plates.

Figure 4.12 – *Setup 7.*

Setup 8: Dinner scene, Wide shot end

This shot covers the same action as setup 7, but shot from an angle much farther back. Figure 4.13 shows the wide angle of the shot. It will be used to end the scene. To get this shot, the kids have to dump the food they had just dished out back into the pans and serve the food again.

Figure 4.13 – *Setup 8.*

Setup 9: Dinner scene, dishing out food Insert

This is an optional shot. Dave handholds the camcorder and shoots close moving shots of the plates as the food is dished up. Figure 4.14 shows this shot.

Figure 4.14 – *Setup 9.*

After finishing this setup, Dave spot-checks the tape to make sure everything re-corded correctly. He also thinks about what has been shot and edits the scene in his head to help determine whether he has enough coverage.

After a break to eat and clean up the dinner scene, the group meets to talk about what the kids will shoot on their own. They decide to do a parody of the movie "The Blair Witch Project" that ties into the dinner scene. They will call the movie the "Bean Witch Project." After more discussion, they find a way to tie their scene into the camping movie. They will create a card game in which one of them leaves. In the scene that follows, the two remaining kids get worried because the first kid hasn't returned. In the final scene of the movie, the two go off into the woods in search of the first kid and are attacked by something with infrared vision.

Setup 10: Card game scene, Master shot

This shot covers the scene: cards are dealt; kids look at cards; each notices he has a full house. The first kid puts his cards down, and the third kid leaves and goes into the woods. It is a wide-angle shot that shows the three kids and all the action, as you can see in Figure 4.15. Dave gets the shot on the third take.

Figure 4.15 – *Setup 10.*

Setup 11: Card game scene, cards Insert

This is a high angle shot, as shown in Figure 4.15, looking down on the table as the cards are dealt.

Figure 4.16 – *Setup 11.*

Setup 12: Card game scene, Medium Shot Kid #1, MS Kid #2, MS Kid #3

In this setup, Dave gets three shots: one of each kid as he holds up his hand and re-acts to the full house. Figure 4.17 shows one of the shots. The angle is called a Me-dium Shot (MS)—not too close, and not too wide.

Figure 4.17 – *Setup 12.*

Setups 13, 14, and 15: Card game scene, OTS Kid #1 cards, OTS Kid #2 cards, OTS Kid #3 cards

These are three over-the-shoulder (OTS) shots as each kid picks up his hand and re-veals it to the viewer. Figure 4.18 shows one of these shots. Dave applies some very inexpensive movie magic with this angle. Each kid actually picks up the same hand of cards in this angle. When the scene is edited, Dave will cut from the master to each kid, in turn, as he picks up his hand. It will appear that the same hand is some-how magically dealt to each kid.

Figure 4.18 – *One of the OTS shots used for setups 13, 14, and 15.*

Setups 16 and 17: Night kids scene, Master and 2-shot

This is the scene where the two remaining kids voice their concern about the missing kid and go off into the dark woods in search of him. Dave sets up to shoot at *magic hour*. This is a special time just after sunset when the light is very indirect. This lighting helps produce some very interesting pictures. Dave adds the light of a candle and lantern to make it seem like night. The reddish glow mixes nicely, bring-

ing out the blue of the late sky. He also lowers the exposure. He plans to boost the video gain when he captures the scene to the computer. This will add a mysterious grainy effect to the picture.

The first setup is a wide-angle master covering the entire scene, as shown in Figure 4.19a. The second setup, shown in Figure 4.19b, is a tighter shot of the two kids (a 2-shot), also covering the entire scene. Because he is using the camera mike, the sound is better on this angle. He does several takes of the tighter angle. Because the dialog is unscripted, the kids tend to ramble, so he plans to cut back to the wide angle before the end of their tight-angle dialog. He will walk them out with the wide shot.

Figure 4.19a – *Setup 16, a wide-angle shot.*

Figure 4.19b – *Setup 17, a tighter shot of the same subject.*

Setup 18: Bean Witch scene, Monster POV

This is the last setup of the day, shot at night in the woods. Dave's camcorder has a feature that allows him to shoot in complete darkness using a built-in infrared light. With this feature on, the camcorder shoots in black and white and gives the picture a very spooky look. Figure 4.20 gives you an idea of the picture quality.

Figure 4.20 – *Setup 18, using the camcorder's night vision feature.*

The camera will be operated by the kid playing the missing kid and will appear to be from his point of view as the Bean Witch monster. He rehearses the shot and the group decides it will look more interesting if he crashes through leaves and makes grunting and snarling sounds. Fortunately, the camcorder is fairly rugged. They get the shot in three takes. As they play them back, Dave decides to use bits of two of the takes and to purposely jump-cut between them. Ordinarily jump-cuts are not used in movies because they appear jarring and unrealistic. However, for the Bean Witch sequence, this sort of effect is just right.

Shoot Day 2

This is Dave's shooting plan for the second day of the camping trip:

```
Location:  Beaver  Lake  trail
Day:  Friday
Scenes  to  shoot:  Hike  to  Beaver  Lake.
Setups  1  to  4:  Hike  sequence,  Wide  pass-bys.
Setups  5  to  7:  Hike  sequence,  Walk  to  lake  angles.
Setup  8:  Hike  sequence,  lake  POV  shots.
Setup  9:  Hike  sequence,  Walk-and-talk  master.
Setup  10:  Hike  sequence,  3-shot  on  bench  master.
```

Dave didn't have a clear idea of what he wanted to shoot before the hike because he had never been to the area. Before he could plan what to shoot, he not only had to know what it looked like, but how he felt about the area. If the lake were filled with noisy jet skis and bordered by a hot, gravel parking lot filled with RVs, he would shoot it one way.

As it turns out the lake is protected from the hordes by a five-mile trail through a lush evergreen forest. The wild beauty inspires Dave and he decides to shoot the scene in a way that shows the kids somehow relating to nature. An alternative would be to shoot trees and bushes by themselves, but that would not be very interesting. The viewer would be more likely to participate in the scene if there were people in it.

Setups 1 to 4: Hike sequence, Wide pass-bys

Dave does four setups, panning with the kids as they walk past the camera and talk. To give viewer a better sense of how massive the forest is in relationship to the people, he sets the camera back off the trail and shoots wide, as shown in Figure 4.21. He shoots through branches in the foreground and frames the kids so they seem almost insignificant compared to the big trees. He wants the viewer to have the same feeling he has about the location. He attempts to do this through the characters. He could point the camera at some trees and say, "Boy do I feel lost and awe-inspired," but it is far more effective to relate a feeling with pictures and indirectly through characters, for example, using a quick shot of one of the kids looking up in awe.

Figure 4.21 – *One of the wide panning shots used for setups 1 through 4.*

Setups 5 to 7: Hike sequence, Walk to lake angles

Instead of planning one long shot with complicated movement, Dave breaks the shot into three setups that follow the group as they walk down to the lakeshore. The first setup, shown in Figure 4.22a, is a pass-by on the main trail. The second shows them coming down from the trail and pans with them as they stop by the edge of the lake, as shown in Figure 4.22b. The third setup is a reverse angle of the second setup, and shows them coming to the lake edge and talking about what they see, as shown in Figure 4.22c.

Figure 4.22a – *Setup 5, walking down to the lake.*

Figure 4.22b – *Setup 6, a panning shot.*

Figure 4.22c – *Setup 7, a reverse angle shot showing the lake view.*

Setup 8: Hike sequence, lake POV shots

Dave lets the camcorder roll as he attempts to get several useful shots of birds and dragonflies, which he will use as *POV* shots. A POV shot represents a character's point of view. A POV shot could be used, for example, when a character points to the water and says, "What's that?" At that point, the viewer will naturally want to see what the character sees, so Dave can cut to a POV shot like the one in Figure 4.23. Keep in mind that a POV shot is not necessarily free of foreground obstructions and perfectly composed. This is because the viewer is seeing something from a character's perspective, which may not be the perfect view or angle of an object.

Figure 4.23 – *A point of view shot.*

Setup 9: Hike sequence, Walk-and-talk master

Dave does one walk-and-talk shot with the kids walking slowly along the trail. To get the shot, he has the kids come toward him as he holds the camcorder and walks backwards. Needless to say, this is a tough shot to get. He does three takes. On the first one, the kids walk too fast and the camera work is bumpy. On the second, Dave runs into a tree. It would've been easier to walk forward and shoot the kids from behind, but it is far more interesting if the viewer can see faces and expressions, as you can see in Figure 4.24.

Figure 4.24 – *Setup 9.*

Walk-and-talk shots are used frequently in movies and documentaries. It is often more interesting to walk with characters as they converse than to sit and watch them. Not only does it add movement and interest to a shot, it allows the actor to use more of his body. An actor's or interviewee's performance is often better if he is allowed to move while talking. He is more animated and the words come easier.

Setup 10: Hike sequence, 3-shot on bench master

Dave does one last setup with the kids sitting and talking, shown in Figure 4.25. He does one take and decides the shot is dull and the characters seem planted, so he abandons the idea. A person gives a better performance when he feels comfortable. As soon as the kids sat down, their energy went away. They were more interesting when they were allowed to stand and fidget occasionally, tap a stick against a tree, and be themselves. Dave got his best shots when he used the less-is-more philosophy and let the performances develop naturally from the characters.

Figure 4.25 – *Setup 10.*

At the end of the hiking scene, Dave sits on a log and spot-checks the tape to make sure everything recorded correctly. He edits the scene in his head again to make sure he has enough coverage before heading back to the campsite.

In the next chapter, you'll learn how to think like an editor: how to approach the raw footage, sift through it; organize it, and finally start assembling it into a coherent and engaging story.

Editing Your Movie

You have followed the plans and the outline or script you created in pre-production, and have gone through the production phase of your movie. Now you have one or more video tapes filled with disconnected shots. If you used the feature production style, each shot is part of a scene in a script, and for each shot you may have multiple takes. If you used the television production style, you have video tapes from each camcorder in your multi-camera shoot, which contain real-time coverage of an event from different angles. If you used the documentary production style, you may have many video tapes containing coverage from which you will create a story in the editing room. If you used the experimental style, your tapes may contain scripted scenes, unplanned events, random experimental footage, or any number of video elements.

Your goal in post-production is to create a movie from the material on those tapes. Like baking a cake, you first gather the raw materials, and then measure the ingredients and mix them together in the right order. If you planned appropriately and executed according to your plan, you should end up with all the pieces you need to create a movie.

The post-production process can involve more than just editing the pieces together. Depending on how elaborate you want to get, post-production can include:

Picture editing

The picture editor is the primary editor on a film or video production. The editor's job is to put the movie together. Because this job can be so overwhelming on large projects, the editor often delegates certain aspects to others. The job of sound design is usually handed over to sound and music editors and mixers. On productions with lower budgets and more time, the editor often works on both picture and sound. However, even if the editor is doing everything, she will most likely be concerned with making the picture and story work before dealing with sound design.

Sound design

Sound design can be done by one person or divided among several editors, technicians, artists, and mixers. On a low-budget amateur or home movie, the editor will most likely do everything. Sound design work can start as early as

the pre-production phase, when individual elements can be created. Sound design includes adding sound effects and music, and repairing or smoothing the sound recorded during production. Sound designers are the busiest when the movie is very close to being finished. That is when they can smooth the sound and add elements to create a final soundtrack. It's best to focus on sound design when the picture is mostly finished, or *locked,* to keep from having to redo the sound whenever the picture is changed. It would be like trying to paint a car before the bodywork is finished.

Visual effects

Visual effects are most often done by digital graphical artists and animators. The effects are added to images that were shot during production. The sort of visual effects that you will most likely do on an amateur's budget include adding titles, animations, and stills. If you want to add an effect to a movie in Windows Movie Maker, you can use a graphics program to create the stills or animation with selected shots, and then import the stills or video into Movie Maker.

It may be necessary to go back into production and shoot additional material. Because you are creating your story when you are editing, it may only become obvious in the editing room that you are missing shots or that a shot doesn't work. Your editor may also discover a better way to tell the story and send your movie off in an entirely different direction than originally intended. You may need to shoot new material, even find new actors and rewrite the script. If you are using the documentary style, you may play back your finished movie and realize your story is lacking some essential elements. Maybe the point you originally wanted to make is flawed, but it isn't apparent until you play the whole thing back. This realization can prompt you to shoot new material, such as more interviews, to fill in the gaps.

Moviemaking is like any other creative process; you can throw something together quickly, or you can invest a great deal of time and effort in a project. If you care about what you are creating, the process you use to create it can be as unique and rewarding as the product itself. That is why it is impossible to give you a clear idea of how to edit a movie. We will give you some general editing concepts and a starting point. What happens after that is up to you.

The product created by an editor is a finished movie that tells a story. Exactly how you get to that point depends on the requirements of the movie and your personal creative style. Are you the type of cook who works quickly, follows a recipe book, and measures all the ingredients precisely? Or are you the type who works slowly, carefully, and intuitively? However you decide to work, you will seldom be judged by how you approach a creative project—only by the product itself.

In this chapter, we will give you some insight into being an editor. If you are interested in exploring sound design and effects, see the advanced chapters in part 3 of this book. Editing is not something that can be taught easily. The craft of editing can

only be learned by doing. By showing you how an editor thinks and suggesting how to begin your editing project, we should be able to give you an understanding and appreciation of the editor's job. We want you to learn how to edit, but more importantly, we want you to enjoy it. Again, it doesn't matter if your movie is a multi-million dollar feature or a child's birthday party. The power of motion pictures transcends budget. With a camera and editor, you have the power to inspire, to entertain, and even to change lives.

Thinking like an editor

If you have stayed with the book up to this point, you should understand that editing means more than eliminating mistakes and cutting out time. A movie editor is not the same as a book editor. A movie editor does cut up film or video and assemble the pieces, but that would be like describing an artist as someone who applies paint to canvas. The true work of editing or painting or composing or any creative task goes on in the artist's mind. To edit video, you can read the Movie Maker online Help documents. To be an editor, you need to think like an editor. To be able to think like an editor, you not only have to edit, you have to know the effect of your editing. You can blithely cut out material and move it around, or you can consider how the viewer will react to what you are doing.

An error often made by would-be moviemakers is adhering to the notion that the running time of a movie should be as short as possible; otherwise the audience will get bored. The truth is, it's not running time that bores viewers; it's the content of a movie. A poorly executed video will bore viewers no matter how long it is. By keeping it short, you are only limiting the amount of time a viewer will be bored.

You should be more concerned with telling an effective story than trimming running time down to ten minutes. If the movie is structured properly, it will draw the audience into it and engage them in the story. A good movie generates a life of its own. A good story becomes reality—at least temporarily—for the audience. It reaches out and touches the viewer. It exudes feeling and engages the emotions. A good movie allows the viewer to suspend disbelief and become a participant, a silent character. A good movie changes the viewer in some way.

In many ways, an editor is like a magician. We know that a magician is not really sawing his assistant in half, the same way we know that the characters and situations in movies are not real. A magician is successful only because people want to believe that what he is doing is real. Reality is an illusion; people believe what they want. The magician uses sleight of hand and showmanship to create his tricks. When these tricks are performed well, even the most skeptical members of the audience can be caught up in the illusion.

Editors, as well as magicians, know this and use it to their advantage. Editors learn the tricks of making cuts work and adjusting scenes so they have the right rhythm by making the cuts and seeing how they work on themselves. In a sense, an editor is her own guinea pig. As she grows with experience, she develops a keen sensitivity to the magic. It's this sensitivity and an understanding of how people perceive the world around them that marks the difference between an editor and non-editor. The successful editor can put herself in the place of the viewer and be able to sense whether a cut is seamless and the right emotion is being transmitted even though she is behind the curtain, so to speak, and the one creating the reality. As you begin to explore the art of editing with MovieMaker, you too will learn how to switch between being the magician and being the viewer.

Learning to edit

Welcome to the world of film editing. The first step in becoming an editor is to start developing the ability to switch between cutting and viewing. A good editor can do both at the same time. It's really a matter of learning to play two roles at the same time: the cutter and the viewer.

When an editor works, she first decides where to make the cuts and operates the editing equipment to make those edits. Then she watches the playback of the cut and decides whether it works. That's how it works for every cut and every sequence in a movie: make the cut, play it back, make the cut, play it back, and so on.

As a viewer, it all seems continuous, one cut adding to the next. As an editor, you see individual cuts, each one a different shot that may have been shot out of order on a different day with different lighting. You see a close shot of a woman talking. As a viewer following the story, you think she's talking to a character off screen. As an editor, you know she might actually be talking to a stand-in or a member of the crew, because you can't see the other character. The director may have sent the actor home. Who knows? As a viewer, you enjoy the story and the magic. As a cutter, you are able to look behind the curtain. You realize that it's all a trick. The editor's job is to make the magic happen by editing disconnected shots into a story.

Becoming a cutter

As a cutter, you have to allow yourself to step back from the movie and analyze how it should be constructed. You have to take all of the footage created during production and figure out how it can be arranged into an engaging story.

To help you learn how to analyze a movie, try this exercise. Set up a VCR and television to play a movie, and then sit down with the remote, something to write with, and a notepad. Fast-forward past the credits and find the beginning of a scene.

Note Remember, a scene is a series of shots that takes place at a given time and location. A new scene starts as soon as there is a change to a new location or time.

Once you have located a scene in the movie, do the following:

1. Play the scene and write down one sentence describing it.

2. Play the scene again and pause the tape whenever you see a cut.

 Note A cut is a quick transition from one image to another.

3. Write down a description of the shot and what happens during the shot to advance the story.

After you finish the scene, study your notes. How long is the scene? How many cuts does it contain? What types of shots are used; were there close shots or wide shots? How does the editing make you feel about the scene: anxious, relaxed, or excited? Does the scene engage you, making you want to watch more?

The point of this exercise is to help you see movies as a cutter. As you do, you learn to analyze and question why certain cuts were made, why some cuts work, and why others don't. As you study your notes, notice the patterns and common structures used in movies. You can then take concepts such as *crosscutting*, *cutting to a POV shot*, and *cutting on action*, and apply them to your own movies. We will explain what these terms mean as the chapter proceeds.

Scene breakdown scenario

Here is an example of the scene breakdown for part of the first scene in the movie "Cruel Intentions." Note that you don't need to be a moviemaking expert to break down a scene. The only requirement is having seen and understood at least one movie.

Scene description

Sebastian turns the tables on his therapist and ends up psyching her out.

Cuts

1. Establishing shot: Sebastian, and his therapist in an office. The camera moves with Sebastian as he walks to the glass door and looks out. Sebastian tells the therapist that he's a fool.

2. Medium shot (MS): Therapist seated with notepad. She tries to comfort Sebastian with her condescending tone.

3. MS: Sebastian bangs his head with frustration against the glass door as he listens to the therapist speak.

4. Several *crosscuts* between the two as the therapist talks and Sebastian reacts.

 Note An editor crosscuts between shots to show two or more lines of action happening simultaneously, such as two people talking.

5. MS: The therapist hands Sebastian a copy of her book.

6. Insert of book, his point of view (POV): Sebastian reacts to the book.

 Note An *insert* or *cutaway* is a shot that cuts away briefly from the main action. This insert is also a POV shot showing the book from Sebastian's point of view; in other words, the audience sees the book as if looking through Sebastian's eyes.

7. MS therapist: She expresses pleasure with Sebastian's reaction.

8. Insert therapist's notepad: She writes, "bill for book."

9. MS therapist: Therapist tells Sebastian to stop being so hard on himself.

10. Close shot of Sebastian: Sebastian makes suggestive remarks to his therapist.

11. Crosscut Sebastian and therapist: Sebastian's dialog continues, and therapist reacts. The camera gets closer to the actors with each cut, underscoring the tension between the characters.

In this portion of the scene, which lasts one minute, 12 seconds, there were over 12 cuts, or one cut every 6 seconds. The scene started with medium shots, showing the actors from their legs up. As the tension builds within the scene, the camera moved in closer so that we could study the characters' faces. Sebastian maintained a composed, disinterested demeanor throughout, as the therapist changed from confident to highly agitated. The entire scene lasts no more than five minutes, but after it was over the audience knew almost everything they needed to know about the main character and had a clear idea of the direction of the movie.

What hooks the viewer is the interesting twist, how we see the roles of the characters reverse. This makes us want to see more. The editing helps maintain the tension that develops by cutting quickly, showing reactions, using medium and close shots, and avoiding wide shots. Also, as the scene progresses, the rhythm of the cutting and movement increases. As we leave the scene, we have very definite feelings for the characters and the situation. The cutting kept us engaged and carried the story forward in clear, simple steps.

Editing philosophy

Cuts focus the viewer's attention the same way our eyes work naturally. In Chapter 4, we talked about how our eyes naturally jump from one point to another rather than panning smoothly across a scene. Likewise, when our attention goes from a person talking to a dog barking, the shift takes place very quickly, in the blink of an eye. Cuts work in movies because they are similar to the way people naturally perceive their world, moving quickly from one point of focus to another. While watching a stage play, the audience can see the whole scene all the time, but that doesn't mean their attention is focused everywhere at once. Audience members do their own cuts: focusing on a face, a whole scene, or an object.

When you edit shots into a scene, you are just mimicking the way you would view the scene in real life. Say you hear someone call your name. Naturally, you shift your eyes to see who is talking to you—that's a cut. Your attention is focused in the general direction of the sound—that's a wide establishing shot. You recognize that it's your friend's voice, and your attention focuses on the friend's face as he talks— that's a cut to a close shot. As you reply to your friend's greeting, you look for a reaction. The friend makes an expression, then turns and points at something. Your attention shifts to the object your friend is pointing at—that might be a cut to a wide shot or to a close-up of the object your friend is showing you. Just as we perceive the world by shifting our attention from one source to another, we follow the story in a movie by cutting from shot to shot. Cuts are the building blocks of a movie. Each cut tells the viewer something new.

An editor chooses what the viewer sees. For a cut to work it must seem natural—it must be what the viewer would naturally want to see. The viewer sees a person who says, "Harry, what's that on your face?" What do you think the viewer will want to see next? Typically, you cut to Harry's face. But what if the viewer is concerned with a knife-wielding maniac sneaking up behind the person? What if the viewer already knows what's on Harry's face and is more interested in the person's reaction?

The editor shows viewers what they need and want to see. The action in a scene should appear to drive the cutting, not the other way around. If an editor makes a cut because he wants to, and not because the scene calls for it, the edit looks unnatural. The same holds true for camera movement and the things that an actor does or says. Everything the viewer experiences in a movie must be motivated by the story. There has to be a reason for it. Otherwise, the magic spell is broken and the viewer becomes aware of the directing, the camera, or the cutting instead of the story. This is probably the most difficult part of editing to get right.

For example, there may be times when you want to cut to a close shot from a wide establishing shot, but nothing in the action or dialog gives you a reason to move in

closer. A good director will see the problem in advance and build in a place to cut. She can do this by having an actor make some movement that invites the audience to come closer, such as stepping closer to another character or putting a hand on another character's shoulder.

Anticipating events

The story must drive and motivate the editing. It's also important that the edits react to events in the story rather than anticipating events. Think about this for a moment. If the editor's job is to show the viewer what he wants to or needs to see, then how can the editor show something that the viewer doesn't know exists? The answer is that he can't—or at least he shouldn't. Something in the story must motivate the edit, such as dialog, narration, the response of a person being interviewed, an actor's expression, or some knowledge the viewer has about the story.

For example, suppose a character named Sue is talking to someone over the phone. The conversation is interrupted by a knock at the door. Cutting to the door just before the knock, *telegraphs* an event in the story and seems unnatural and unmotivated. The best place to cut is just after the character stops and turns. Telegraphing means giving the viewer information prematurely, and is one of the major symptoms of an edit that is out of touch with the story and viewer.

This is not to say an editor can only react to what the main character does or says. This would mean that the audience could only have the point of view of the main character or subject. As a silent character in the story, the viewer also has a point of view; he knows certain details about the story that may be different from what the main character knows.

To illustrate this concept, think about the previous telegraphing example. Suppose the viewer knew that a stalker was after Sue, but that she was completely unaware of it. Now suppose, the editor cuts to the door a second before the knock. If the timing of the cut is right, the cut would not be telegraphing information because the viewer would know who was at the door.

Viewer point of view is also important in documentaries. The viewer knows what the narrator or producer of the piece knows, and does not share the point of view of individuals being interviewed.

Showing the geography of a scene

The editor must always show viewers, if only briefly, when a principle character moves or does something, otherwise the audience will be confused. People need to have a sense of where things are in a scene, a sense of the geography. Our eyes do this naturally. For example, if our attention is focused on one person talking to another and the second person lights a cigarette, our attention would be diverted to that

person briefly. We are naturally aware of everything that goes on in our area of attention because our eyes are shifting to check everything out. Likewise, we need to know if the person we can't see lights a cigarette, turns around, or moves someplace else. If the editor doesn't show us this movement, the cut will appear very unnatural. First we see Sue with no cigarette, then we cut to Greg. If we cut back to Sue and she is holding a lit cigarette, we will be wondering about where the cigarette came from instead of listening to the dialog. There will appear to be a lack of visual continuity.

The editor only needs to establish the movement. This can be done with a quick cut showing the actor pulling out a cigarette. The viewer can fill in the rest. Also, note that when crosscutting in a scene with dialog, if one character's eyes look toward screen right, the other character's eyes will look in the opposite direction, screen left. Look for other uses of crosscutting as you study movies. Identify inserts, cutaways, POV shots, and establishing shots.

Moving instead of cutting

Sometimes camera movement takes the place of cutting. Instead of shifting our eyes, we go for a ride. Camera movement is usually motivated by some other movement in the frame. In the scene from the movie "Cruel Intentions" we described earlier, Sebastian stands and walks to a glass door. As he does, the camera moves with him. This establishes character movement, and shows us a bit of the office so that it acts as an establishing shot for the scene.

Normally, an editor does not cut while a character or camera is moving, but makes the cut before or after the move. However, this is not a hard-and-fast rule. In fact, there are no unbreakable rules when it comes to editing. An editor finds the exact frame on which to make a cut based more on experience and intuition than rules. Having the ability to quickly find the right moment to make a cut is what differentiates an experienced editor from a novice.

Noticing the structure

When you view a movie as a cutter and you are studying how the editor constructed a scene, also make note of the scene itself. Everything in a well-made movie is there for a purpose: every edit, every actor, every bit of scenery, and every prop. Everything you see is there because the director wanted it there—the graffiti on a subway car, people milling around in a mall, and the trees in a forest background. This isn't to say the director personally planted all the trees. In many cases, the scenery is already there and the director just borrows it. The point is, a director owns the reality she is creating on film or tape. If it all seems natural and real, the moviemakers can take the credit. All those people walking with the actor on the sidewalk are actors, too. It all may seem as if it just happened naturally, as if the director had not even

thought about it. However, none of it would have ended up on the screen unless the director wanted it there. When you go to the movies, watch everything in a shot: the extras, the lighting, the color of the grass, the dirt and dents on a car, the dialog, and the background sound. All of it is there for a reason.

As you study movies, notice the structure of scenes. Notice how the editor and director built a scene or sequence to draw viewers in and engage them, often starting with an establishing shot to show them where they are, and then moving in to closer and closer shots. Notice how the rhythm of the cutting affects tension and excitement. Think about how cutting is analogous to the way we shift our focus from one thing to another. As you study a movie, try shifting from viewing it as a member of the audience to viewing it as an editor. An experienced editor can shift naturally without even thinking about it.

Rent a movie and view it all the way through just for enjoyment. After it's finished, note how it made you feel: sad, happy, confused. How did you feel about each character? If you disliked a character, was that because he was evil, or because the acting was unnatural? Likewise, if you disliked the movie, was it because you felt tense and upset, or because it was a poorly made movie?

Next, play the movie again and study it from an editor's perspective. Notice the sets and costumes, the acting and directing, the lighting and makeup. Notice how the editor uses cuts to affect the order and length of shots. Notice how the editor handles movement, the composition of a shot, and the direction eyes are looking to focus our attention in the right place and keep the viewer from getting confused.

The learning process

Often, students of film editing begin the learning process by having their heads filled with editing theory and lists of things to do or not to do. But none of this really makes sense until they try to make a cut work for the first time. After a novice editor toils for hours over a single cut, it begins to make sense.

Many student editors talk about how different movies look after they learn to think like a cutter. In fact, some students complain that they can't enjoy movies anymore because they notice the cuts and continuity errors rather than the movie as a whole. It's as if they can't stop viewing a movie as a cutter.

At some point, however, it all comes together. You start to know which cuts work and which don't. You can look at raw footage and edit it in your head. By watching movies and practicing, you learn to be an editor. Over time, you learn to look beyond the cuts. Instead of fussing over details of continuity, you begin to realize that the best way to make a cut work is to allow the story to make the cuts for you.

Part 2 of this book will show you how to use the editing features of Movie Maker and the actual process of editing a movie. However, to learn how to be an editor,

you not only need to know how to work the software, you also need to learn the mental processes behind deciding where and how to make the edits.

These four points summarize the process of learning to edit that we've discussed here:

1. **Learn the theory of editing.** The first time you read about the theory and philosophy of editing, most of it won't stick in your mind, and much of it won't make sense. It may all seem very complex and impossible to grasp.

2. **Try editing.** Put what you've learned about the theory by doing some editing. Attempt to make a few cuts work. When they don't, you try to invoke some of the theory to figure out why it did or didn't work.

3. **Watch and analyze movies.** When you watch a movie, notice how the shots were edited together. The cuts often seem so perfect and seamless. After having tried editing on your own, you understand why it can take an editor a week to cut a complex scene. Try to figure out how the editor put the scenes together as you are watching.

4. **Go back to the theory.** When you review the editing theory, it should begin to make more sense. You should be able to make connections between the theory and movies you watch or edit.

The more you edit, watch movies, and think about how scenes are edited together, the easier it gets. After a while, editing will begin to seem more natural.

A good editor cuts a scene in her head before she makes the cuts physically with the editing program. To do that, you have to be able to visualize the shots and know where they go. If you are also the director of the movie, most of the visual information will already be stored in your head. As you edit, you will learn how to organize the information so it is easy to visualize.

An editor must also learn how to visualize the raw video footage as individual shots and cuts. For example, if you are editing a documentary, you must develop the ability to view ten minutes of playground footage and recognize good shots that you can pull out. To the untrained viewer, the footage may look like ten continuous minutes of children playing. To an editor, the footage is a series of individual moments that can be extracted and edited to create a story. A viewer sees a child swinging, jumping off the swing, and running to a sandbox. A cutter breaks the video into individual actions and analyzes them as potential shots. You might like the child's expression just before he jumps; it fits well with the story. You make a note to use the section starting with his final swing toward the camera and ending when he lands on his feet.

Editing is like painting a picture. You start with a blank canvas and then add to it to create a finished piece that tells a story. You have started the learning process with

some theory and by seeing how the theory is applied in the editing of movies. In the next section, you learn about the process of editing and your editing tools. After that, you will be ready to make your first cut.

Editing styles

Every project has an editing style. A viewer can almost tell what style a program or movie uses by seeing how it was edited. Editing is not just the cuts, but also the shots that are used, the order in which they are presented, and their length. If you have cable TV, flip through the channels with the sound muted and notice the editing. Without even knowing what channel or program you are watching, you can often tell a lot by watching the visual content and how it is put together. You can tell a music video, for example, by its use of quick cuts that have little visual continuity from shot to shot, but do have a very definite rhythmic and emotional feel. You can tell an old Cinemascope movie by its use of wide angles and slow cutting.

Just as you began production by deciding on a visual approach, you start the edit process by deciding on an editing style. How are you going to put the pieces together to tell your story? What kind of impact do you want to make on your audience? If your movie is a child's birthday and it will be seen by the families of the other children who came to the party, it may be fun to try an experimental, music video style of editing. If your movie is a documentary, it may be good to use very slow cuts that have little continuity from shot to shot. If your movie is a scripted fictional story, the cuts should have visual continuity to create a sense of reality.

When you flipped through the TV channels, you could recognize types of programs because many of the editorial styles have become standardized. Only the most daring of filmmakers will take a chance and cross one style with another. As a viewer, you are probably accustomed to seeing a particular editorial style with a particular type of production and content. You feel comfortable with the arrangement of shots and scenes. You expect to see slow, rhythmic cuts in a love scene, and fast cuts in a car chase.

Take risks, but remember that you are guiding the viewer through the story. If you decide to go outside the range of viewers' expectations, you risk alienating them, and that may not be what you want to accomplish.

Each style of production suggests a certain approach to editing. You can begin thinking about the editing style you want to use based on your production style.

Documentary-style editing

The documentary style came about in the 1940s when compact, portable movie cameras became widely available. This innovation had an impact on movies the same way the camcorder affected television production. Heavy, expensive cameras and

equipment were confined to the studio where they were relegated to recording whatever events happened in that unreal environment. The compact camera, on the other hand, was free to roam the real world. In the studio, filmmakers had complete control. In the real world, they had much less control over the events they were shooting.

If you choose the documentary style, you are free to shoot anything in the world. However, because of the lack of control over the subject during production, you are limited to what you can do in editing. You can do things in production that can help when you edit, such as shooting extra coverage. Coverage gives you choices, and the more choices you have, the more likely you are to create a successful movie. However, no matter how much coverage you shoot, you can never have as much control as you get by shooting in a studio with a script and actors. If you choose to shoot real life and create a story later, then you must use an editorial style that embraces this lack of control, yet still allows you to tell a story.

When editing a documentary-style movie, you can employ an editing style that was originally called *cinéma vérité*. Cinéma vérité was differentiated from the prevailing moviemaking style of the 40's primarily by its lack of continuity—you could edit together a series of shots that were not necessarily visually continuous. For example, when editing in the cinéma vérité style, you might show cuts of a group of soldiers running, then a bomb going off, then soldiers shooting, then a soldier falling, then the face of a child.

Because today's audiences have experience watching documentaries, we can often build our own stories from the discontinuous pieces, as if we're surveying an unfamiliar scene with our eyes. However, in the 1940s this new film style was somewhat disturbing because it was unfamiliar and the typical audience did not know how to connect the pieces. To help the audience, narration was added. The narrator connects the disconnected shots together and fills in the story with his description of the filmed events.

When you edit your documentary-style movie, you do not have to worry about the continuity of shots. Your most difficult job is going to be building a story based on a collection of uneven, disconnected shots. You can tie together the pieces using interview segments, real people talking, and narration.

Television-style editing

The television style of production and editing grew out of the early days of live television. In the late 1940s, TV programs were performed and captured live using two or more television cameras. A director sat in a control room and cut to whichever camera had the best angle using a video switcher, and that picture went out live to the broadcast audience. When video tape recorders became available in the early 60's, the same production style was used to record live to tape.

The television production style gives you at least one major advantage over the documentary style. As with the documentary style, you shoot events as they happen. But unlike a documentary, your editing can have continuity. Instead of relying on a series of disconnected shots to build a story, with the television production style you have the same event shot from different angles—you can create your story from different shots of the same people or events. For example, when you edit the rodeo movie that we used as an example in Chapter 4, you can cut from a close shot of a rider to a wider angle with perfect continuity because the two shots are different angles of exactly the same thing.

Because you can create a continuous story, you do not have to rely on narration. The viewer can watch the event as it happened from a variety of angles and understand what is happening without the need of additional descriptions added in post-production. As a storyteller, this makes your job much easier. The story is already there; all you have to do is pick the best angles.

Of course, you can choose to break up the footage and change the order and length of shots. In other words, you can use the television-style footage to create a documentary-style movie. Because you have the coverage, you can also attempt to edit the story and maintain continuity. Whatever you decide to do, the television style of production gives you a range of choices.

Feature-style editing

The feature production style also gives you ample choices because you have complete control of the shoot. The production is scripted, so the director can plan every bit of movement and detail of emotion. You can have all the coverage you need to create your own reality, and enough choices to create continuity out of a series of shots that are actually not continuous. If you are also the producer, you have complete control of production, so you can create any sort of reality you want. You can for example create an old Hollywood style reality that is obviously not real, where the lighting and acting is contrived, the look is impressionistic, and people break into song while walking on sidewalks in the rain. You can also create a reality that seems very real, where lighting and acting seem uncontrolled, the look is intentionally gritty, and no one ever breaks into song.

Each style of reality can use a different style of editing, but in most cases you build a story and focus the viewer's attention on the action by maintaining continuity from shot to shot. By doing this, time progresses naturally, action seems continuous, and the story is driven directly by events on the screen. This has the effect of drawing the audience into the story and inviting them to participate as silent characters. In a documentary-style production, the lack of continuity tends to distance viewers from the action, making them observers along with the narrator.

Anyway you look at it, though, a feature-style production is completely controlled. As you edit a feature production, you have complete control of the editorial style. Aside from being faithful to the story and maintaining continuity, you can create the movie you want. You can even create a disconnected, documentary feel by purposely making cuts that seem jarring and uncomfortable. You can increase the tension of a scene by using quick cuts. You can use long-duration shots and slow cutting to create a peaceful, controlled mood. Assuming the director has given you good material to work with, you have complete control of the reality you create.

Experimental-style editing

Assuming your experimental-style movie is a mixture of planned and spontaneous footage, the editing style you use can be as planned or spontaneous as the story you want to tell. Many experimental movies purposely call attention to elements of the movie that are normally hidden to viewers. Some use jarring, annoying cuts that purposely break continuity. Some have acting, stories, and production elements that are overtly phony or low-quality. Some are interesting, others are funny, others are just difficult to understand. An experimental movie in many cases exists simply to try something new.

An experimental movie doesn't have to follow the rules and attempt to entertain an audience or make some worthwhile statement. The moviemaker is successful if he understands the power of movies and challenges the status quo, even if the movies he makes don't attract big crowds and money. Some of the best experimental movies upset and angered audiences when they first came out because they were so different. Of course, many of the experimental techniques used in these movies are now common practice.

The intention of this book is not to promote weird, upsetting movies, but to encourage risk taking. If filmmakers had not taken risks, we would still be watching movies without any camera movement, sound, and cuts. Don't worry about breaking with tradition and trying something new. With Movie Maker and a camcorder, you have the power to create movies any way you like.

The editing process

Up to this point, we've been discussing editing in the abstract. Now that you've finished production and have a collection of raw footage, it's time to start the post-production process. Post-production typically follows these steps:

1. **View, log, and organize.** View all the raw footage, create a log, and organize the reels.

2. **Edit a rough cut.** Edit the shots together into a first draft of the movie.

3. **Create effects.** Create and add any post-production effect shots.

4. **Edit a final cut.** Create a final cut that will not be changed.

5. **Add sound and music.** Create and add additional music and sounds, including narration if needed.

We'll discuss each step of this process in the following sections.

View, log, and organize

The first thing to do when you have all of the finished footage is create a log of shots. The log serves as a table of contents for the tapes and contains any comments you may have after viewing the material for the first time. The log can be written on a legal pad or entered into a spreadsheet program such as Microsoft Excel.

A log generally contains the following information, though you can add or remove entries to meet the needs of your particular project:

Reel number
Every reel of tape should have a number and possibly a descriptive name, such as "beach shots." If they don't, the editor or someone should take the time to add a number and description before it is logged. This helps you find footage later.

Timing
Every time there is a new item or point of interest on the tape, note the running time.

If the tape is in the miniDV format or a professional format such as BetaCam, a timecode is added to the tape as it's being recorded. A timecode is a digital stamp that is applied to each frame and tells you the time location of the frame on the tape. For example, the timecode 01:23:09:16 identifies a frame that is one hour, 23 minutes, nine seconds, and 16 frames into the tape. The frame after this one is 01:23:09:17.

Most non-digital consumer tape formats do not use a timecode. The numbers you see in the timer window on your VCR are obtained by the VCR counting frames. This method is not as accurate as timecode. The VCR's timer can become inaccurate when you shuttle the tape forward and backward. Most VCRs also reset the counter to zero when the tape is ejected.

When you start to log a tape, make sure it is rewound all the way to the beginning and the timer is reset to zero before you start. If you eject or reset the tape, rewind it to the beginning again and reset the timer, then wind it forward to where you left off.

Scene name, number, and description

Whenever a new scene appears, note the name or number of the scene. Add a description if necessary, such as "Sc15—Peggy's Bedroom." If you are coordinating the log directly with a script or detailed outline, you only need to enter enough information so the connection is clear.

Shot name, number, and description

The same information as for scenes, but for each new shot within the scene. For example, "Medium Shot—Peggy, sits at mirror and brushes hair."

Take number

If you are using take numbers, add an entry for each take. If the tape contains random footage of some location from which you will grab individual shots, you can make a note when you come across an interesting segment. For example, if you had an hour-long tape of playground footage, you might make notes whenever you see something that may be a useful shot: "01:03—Child jumps from swing, good smile."

Editor comments

This may be the only time you see all the footage at one time. Use the opportunity to make notes if you have any first impressions, such as "Take is no good, but performance is right on."

Director comments

If you are working with a director and viewing the footage together, write down any comments from the director, such as "Doesn't like performance; use the tighter angle."

One of the less glamorous jobs of an editor is keeping track of the raw footage. It is tempting to gloss over details when you are in the creative throes of editing, but keeping accurate notes and logs will always pay off by reducing hassles and helping you get a better product. Before you start editing, check the shots against your script or outline. Make sure you have all the material you need and know where to find everything. Every shot called out in the script or outline should be in your logs. Number every tape and store it on a shelf with the number showing on the edge of the cassette. Put tapes back when you are finished using them. Make sure any new tapes are logged and numbered.

Another reason for logging is to start building a database of shots in your head. The logging process may be boring, but it is a good way to help you remember where everything is. By viewing all the material and creating your own log, you can also start editing the movie in your head. You might see a shot on tape three that will work well with the interview on tape six. The shot on tape seven might help you fix a bad performance in scene four.

By the time you are finished logging, you will have a better idea of how you want to start, how the story will proceed, and maybe even the pacing of the edits. At the very least you will know that all of the necessary shots are there for you to edit—or that you need to go out and shoot some more.

Edit a rough cut

The first edit of your complete movie is called a *rough cut*. You generally start editing with the first scene and work forward in time from there. You may decide to start with a particular sequence, or you may decide to leave a placeholder shot in the beginning and start editing somewhere after that.

Assuming that you decided on an editing style and picked a place to start editing, choose your first shot and add it to the timeline in your Movie Maker project. Then proceed forward by adding one shot after the other. Generally, a scene starts with a wide establishing shot, moves to a medium shot, then moves to close shots. From that point you can go back to a wide angle to transition to the next scene or sequence. This is just a starting point. You may decide to edit a scene differently. Each time you add a shot, trim frames from the tail (end) of the outgoing shot and head (beginning) of the incoming shot so continuity is maintained across cuts.

As you edit, remember to switch between editing the movie and viewing the sequences you have edited. As you view the rough-cut sequences, consider how the audience will react to what you have created. Remember, you are supplying the audience with the information they need to understand your story. After the pieces of your movie are in roughly the right order, you move on to create your final cut.

Create effects

A movie often requires special post-production visual effects that are created with computers. Some effects, such as titles, can be created independently of production, so they can be started early in the production process. However, most effects rely on something that is shot during production and may even need to be created from a finished edit of a scene. An effect like these involves modifying frames that have been shot: adding titles, changing colors, and removing, replacing, or adding sections.

Today, most effects are created digitally; each frame is captured to a computer, modified, and then transferred back to film or tape, if necessary. Movie Maker does not enable you to add effects directly. You can use other programs, however, to create the effects and then edit the resulting footage back into your movie with Movie Maker. Chapters 12 and 13 explain how to create some simple visual and sound effects.

Edit a final cut

When you finish the rough cut, take a break and then go through the whole movie and do a *pace* or *fine-tune* cut. As you assemble a rough cut, you often get a myopic view of the movie because you are focusing on individual cuts and details. An individual cut may look good by itself, but fail when played in the context of an entire sequence.

It's also possible the cut you spent a long time on but could never get right looks fine when the whole scene is played through. This phenomenon could be due to timing; the timing of shots should match up in such a way that when a sequence is played through, the viewer feels a sense of rhythm. The rhythm of a scene is created by the pacing of the dialog, the movement of actors and the camera, the emotional energy that is being generated, and the timing of the cuts. You can affect the rhythm by adjusting the lengths of the shots. Most editors consider rhythm more important than visual continuity. As you fine-tune the movie, try to get a feel for the rhythm and how the scenes run together as a whole.

Add sound and music

As you come close to finishing, or *locking*, the picture, you can start smoothing the sound. A locked picture means that no more changes can be made to it. It is important that the timing of the picture be locked before doing final sound editing and design because the sound must maintain frame-accurate synchronization with the picture. For example, if you edit music to start exactly 35 seconds into a scene and the editor adds 10 seconds, the music will be *out of sync* with the picture; the frame on which you expected the music to start will be somewhere else. In high-budget features, months can be spent editing the dialog *tracks* (a track is a recorded sound element), adding sound effects, and recording original music.

In the early days of sound movies, all sound was recorded on the set during production, including the music. If an orchestra were used to score a scene, the entire orchestra was there on the set. The music, sound effects, and dialog were recorded as the scene was shot. This method was obviously limiting. Imagine shooting a submarine action movie in a real submarine with a live orchestra.

Moviemakers soon discovered ways to save the bulk of sound work until post-production. This took a huge burden off production and added a great deal of flexibility to the creation of a soundtrack. Music and effects can be created separately and edited to fit perfectly. The sound mixer on the set only has to be concerned with recording clean dialog tracks. However, even if there are problems during production, the dialog can be rerecorded and edited in post-production.

The subject of sound design is an advanced topic that is out of the scope of this section and not easy to do with a basic editing tool like Movie Maker. However, Chapter 13 offers some ideas for creating sound effects using other programs.

Editing with Windows Movie Maker

When working with film, an assistant editor is needed just to keep track of all the pieces of film, shots, and scenes, and to make sure the picture stays in sync with the sound. Movie Maker helps you handle many of the basic editing functions as you follow the post-production process:

Viewing, logging, and organizing shots

As you view a tape, you can capture it to your computer with Movie Maker. When the tape is finished, the automatic clip detection feature in Movie Maker divides the shots on the tape into clips, which appear in a Movie Maker collection as a series of thumbnail icons. You can click on a clip icon and play the shot. If you want, you can combine clips, split a clip into several more clips, and delete, rename, and move clips. You can then base your footage log on the clips. For example, you can have a log entry:

```
2:45   Scene 5, take 3 - Jack's head turn good
```
And a corresponding clip:

```
Sc5-Tk3
```
By maintaining a paper log that is synchronized to the clips in Movie Maker, you will know where every shot is on your computer and on which tape, and you will have the information you need to make editing choices.

Editing rough and final cuts

Movie Maker is a non-linear video editor that makes non-destructive edits. This means you can make as many changes and edit as many versions of a movie as you want without affecting the original footage or taking up more space on your hard disk drive. You can finish a rough cut and save the Movie Maker project file as RoughCut, for example. Then you can fine-tune the cut and save a new project file as FinalCut. These concepts are described in detail in the next section.

Doing sound design

A Movie Maker project comes with a blank sound track and a simple way to mix what you add to it with the sound that is already on the video clips, also known as the *production track*. You can add any sound you want to this extra track, including music, additional sounds effects, and dialog. You can also record sound on the track, such as a narration, while playing back the edited movie.

After using Movie Maker, you can take what you learn and apply it to how you shoot. For example, you can record background music and sound effects that you can place on the extra sound track. You can also trick the automatic scene detection feature into creating a clip. Movie Maker automatically creates a new clip whenever it detects a major change in the visual content of a scene. Therefore, you can trigger it to create a new clip by simply putting your hand over the lens. This can be useful when you want to mark the start of a section without stopping the camcorder.

We've shown you a little of the philosophy of editing, editorial styles, and the process of editing. In the next section, you will learn about the tools used to edit your movies.

Editing tools

Editing was very simple to understand in the early days of film. There was no sound, so the editor didn't have to worry about synchronizing the sound with the picture. There were also no post-production effects to worry about. In fact, there was barely any post-production at all; most movies were shot with a wide angle that showed the entire scene, like a play. The only shots in the movies were establishing shots—no close shots or cutaways. The editor worked with tools that cut and glued sections of film together. The main worry of an editor was the fire hazard posed by the highly flammable film stock.

Through experimentation, moviemakers learned that they could tell their stories more effectively by cutting to different angles and moving the camera. Then, sound and color were added to film. Recently, filmmakers started using computers to modify the images and sounds. Each advance in filmmaking technology has enhanced the audience's experience, but each advance has also added to the complexity of making movies.

In the early days, the director could make a movie by himself with a few actors. Later, the complexity of filmmaking led to an industry of specialists: music editors, sound designers, electricians, video technicians, and computer effects programmers. Today, at least for amateurs, the trend seems to be reversing. One person can operate a camcorder and then create a finished movie with Movie Maker.

Though most film editors now edit with computers, using the old methods is still the easiest way to understand basic editing concepts. The film editor's tools include a splicer, a trim bin, a synchronizer, rewinds, and a machine to view the edits in real time. A film copy is made from the camera original footage. This copy is called a *work print*.

From the work print, an editor removes the takes he wants to use in the rough cut. He uses a splicer to physically cut the film and join shots together with clear adhesive tape. As he adds shots, he puts them on a film reel that is held by a rewind at-

tached to an editing bench. Two rewinds enable the editor to move back and forth between sections of the film. When the editor removes frames from a shot, he saves the trimmed pieces by hanging them on small metal hooks on a trim bin. The bin is made to hold pieces that are too long or short to hang.

A synchronizer sits on the editing bench between the rewinds. Whenever the editor makes a cut in the film, he makes the same cut on a reel of magnetic film that contains the sound track. The sound and picture reels are both placed on the rewinds and kept in sync by running through the synchronizer.

Film editing is a very tactile process. A 10-second shot takes up 15 feet of film. You can pick up the film stock and look at the individual frames. You can pull a piece of film off a reel and see where the cuts were made. Removing a scene or moving a shot takes some physical work.

Video editing

When video editing came along, tasks like cutting and moving shots became virtual. When you edit a video tape, you don't actually cut or join anything physical. In video tape editing, you actually record shots from a source tape on one machine to another tape on a second machine. This made it a little more difficult to understand and explain editing concepts. Terms from film editing were still being used, and results were the same, but what physically happened with the picture and sound changed entirely.

Although video editing reduced the costs and complexity of dealing with film stock, the process had some frustrating limitations. When you edited a video tape, you worked linearly; you started at the beginning of the project and added shots to the record tape until you reached the end. In linear editing, each shot had to be added in the order in which it would appear on the edited tape. There was no easy way to add or remove material from the middle of the edited tape. You could change a shot to another shot of the same length, but you could not add or remove time without either editing from the master to a new master, or building the entire project over again from the point where you made the change.

In the 1980s, computer-based video editing tools became available. With computer editing, everything is stored on hard disk drives and record keeping is much easier and neater. Although you need large, fast hard disk drives and plenty of processing power, computer-based video editing allows you to do most of what you can with film, and some new things as well.

Computer-based video editing software like Movie Maker is considered *non-linear* and *non-destructive*. While a linear editor requires you to make edits in order from start to finish, non-linear means the editor allows you to insert, delete, and re-order shots at any point in the movie at any time. Non-linear systems are also non-destruc-

tive, because the original footage is not changed in any way during the editing process—unlike film editing, where you would physically cut the film to make an edit.

When you import or capture video using Movie Maker, the video data is saved in a source file on your computer and appears in a Movie Maker collection. The collections are virtual directories that help you organize the video and audio files you have saved with Movie Maker. For example, say you import the Windows Media-based video file Source1.wmv, which is in the folder c:\CampVideo. After you import it, you'll see the file as a folder in the Movie Maker collections, but the file itself has not been copied or moved. You'll learn more about importing files and dealing with collections in Chapters 8 and 9.

Movie Maker keeps track of your source video files with "pointers." The original source files remain in their original state throughout the editing process. The thumbnail icons and video clips are created by playing different parts of the source file according to pointers that are generated by Movie Maker when you make an edit. A pointer to the source file is generated when you import the video. When Movie Maker automatically creates clips from the source file, it creates a list of pointers. The pointers for a clip define *in* and *out* points—the points where the clip starts and ends. You can't actually see the pointers because you don't need them to edit.

When you drag clips from the collection, add them to the timeline, and then trim their in and out points, you are only creating and manipulating pointers. No files are changed or created. As you preview an edit from the timeline, the player uses pointers to play sections of the original source file. For example, if your timeline consisted of three Clip5, Clip3, and Clip17, it would point to three sections of the source video file with pointers like these:

	In	Out
Clip5	45.3	48.2
Clip3	23.1	28.9
Clip17	1:03.5	1:09.2

The jump from one section to another is instantaneous because Movie Maker stores data ahead of a cut so that it can make a seamless transition. When you save your project, Movie Maker creates a file containing the list of pointers from the timeline. The project file contains no media, just pointers, so it is very small. It's only when you finally save the timeline as a movie that Movie Maker creates a new file by reading the pointers and copying the referenced sections of your source video files.

A Movie Maker project consists of the project file and all the source files. When you open an existing project, Movie Maker locates all the source files and builds a

timeline based on the pointers in those files. The project can be saved in a different location from the source files, so if you move the project to another computer or move one or more of the source files, you must tell Movie Maker where the files are located. If Movie Maker can't find a source file when you open a project, it will prompt you to specify their new location.

Non-linear editing is a very efficient and flexible way to edit compared to the old methods. Non-linear editing is also the perfect tool for beginning moviemakers. All the mechanical aspects of editing like splicing and sorting little pieces of film have been removed from the process. Now you can concentrate on the fun stuff: making cuts.

Making cuts

As an editor, you select shots, put them in order, and specify the in and out points. Most of your transitions between shots are cuts, but with Movie Maker you can also use *cross-fades*. With a cross-fade, one shot fades out as the next shot fades in. This is a smoother transition than a cut, which is quite abrupt.

As you edit, remember that every new cut adds a new piece of information for the viewer. Make cuts for a reason; a cut should be motivated by the story. Start at the beginning and work forward, from left to right on the timeline. As you gain experience you will develop your own style of editing, but to start with, you can follow these editing procedures.

Editing procedures

Generally speaking, you'll follow a process like this for editing your movie in Movie Maker:

1. **Pick a shot.** Look at the thumbnails in your collections and select a shot. To preview a clip, select it. After it appears in the player, click play. If the shot isn't in a collection, import the media file containing it or capture it from tape. These tasks are explained in Chapter 8.

2. **Add the shot.** Drag the clip to the timeline and drop it where you want it. If it's the only shot on the timeline, drop it anywhere. If it goes at the end of a series of shots, drop it in the clear space after the last shot. If it goes between two shots, drag it to that position, align the cursor so that it is between the two shots, and then drop the clip.

3. **Play it.** With that shot selected in the timeline, click play.

4. **Mark the in point.** Locate the point where you want to start the shot, the in point, and set that. In Movie Maker, click **Set Start Trim Point** on the **Clip** menu.

5. **Play transition.** Click in the timeline about five seconds before the cut and click play. If this is the first clip on the timeline, skip to step 7.

6. **Trim it.** If the cut looks good, skip to step 7. In most cases, however, either the in point of the new clip or the out point of the previous clip will need to be trimmed.

 If you are editing a feature or television-style production, you may need to adjust the in or out points so continuity of action is maintained. For example, suppose you are cutting from a medium shot of a person to an insert of a pushbutton as he reaches out and pushes it. On the outgoing shot, you set an out point just as he starts to move his hand. On the incoming shot, you set an in point just as the hand moves into the frame heading toward the button. As you play the cut, you will get a feel for the timing of the action:

 - If it feels like the hand moves too quickly to the button, move the in point of the incoming shot a bit earlier: drag the left border of the clip slightly to the left.

 - If it feels like the hand moves too slowly to the button or you sense some of the movement is repeated or doubled, move the in point of the incoming shot a bit later: drag the left border of the clip slightly to the right.

 - If there is no hand movement at the end of the outgoing shot, the cut will not look right because the hand movement causes the audience to want to see the button. If this is the case, move the out point of the outgoing shot a bit later to include the beginning of the movement: drag the right border of the clip slightly to the right.

 Continue to adjust these two points until the cut seems fluid. Check the tips and tricks in the next part of this chapter for more tips. If you can't get the clip to work, delete it from the timeline and try another clip.

 Continuity of action is not usually an issue when editing a documentary-style movie. You will most likely trim shots for timing purposes and so the in and out points look clean, not so the action will match from shot to shot.

7. **Play the shot.** With the new shot selected in the timeline, click play.

8. **Mark an out point.** Locate the point where you want to leave the shot, the out point, and set that. In Movie Maker, click **Set End Trim Point** on the **Clip** menu. Don't spend too much time setting the out point now. Set it roughly, then trim it after you have placed the following shot.

 If you placed this clip between two existing clips, play the outgoing cut and make sure it works. If it doesn't work, trim the out point of the new clip and the in point of the following clip until it looks right. Adding a clip between two existing clips can be tricky because the cuts have to work on both ends. You

might get the incoming cut to work, but not the outgoing cut. For this reason, you will see it is far easier to work forward in time than to wedge new shots in between existing ones. If you find you are doing a lot of wedging, try to change your editing style, or take a moment to rethink what you are trying to achieve.

Also, you can save different versions of an edit by saving multiple projects. If you think you've made a mistake in your editing choices, you can go back to a previous version.

9. **Repeat the process for the next edit.** Go back to step 1 and continue with this process for every shot until you are finished.

Remember, as you edit you are only modifying a list of pointers. It is very hard to intentionally do anything that will damage the source files. As long as you make it a practice to regularly save your project file, you will not lose any data or work that you've accomplished. When working with film and tape, a mistake could cause permanent damage and hours of lost work. Movie Maker and non-linear editors allow you to make mistakes without causing irreversible damage.

One of the most useful features of non-linear editors is the ability to do versions. You can make one edit and save the project—for example, as CampOut1. Then use the same source files and create another version of the edit and save it as something like CampOut2. This doesn't change your source files, but gives you the flexibility to try out different edits or create multiple versions of the same movie.

Practice Editing

If you don't have any video to edit, you can use the source files of the campout movie included on the companion CD. The CD also contains a finished movie based on these source files. To use these source files, start Movie Maker, import them into a new project, log them, rename the clips, and build a movie on the timeline. You can import the source files from the CD, but keep in mind that the speed of your CD player will affect the quality of playback. In addition, you must have the CD in the player to create and edit movies using the source files. If you have the space, it might be easier to copy the source files to your hard disk drive and import from there.

As you edit, switch between being a cutter and being a viewer. If a cut doesn't feel right, try different approaches such as trimming the in and out points or using a different clip entirely. Remember, you can try as many variations of a cut and experiment as much as you want without permanently changing any of the source files.

For more information about using Movie Maker, see part 2 of this book or the online Help documentation included with the product.

Editing tips and tricks

The primary goal of editing is to cut the shots in a way that creates a continuous, seamless flow. The viewer should not notice the cuts themselves, but should focus beyond the cuts to the story. This is not to say you should avoid making cuts. You can make as many cuts as you want to tell your story. However, you should avoid cuts that call attention to themselves because that tends to pull the viewer away from the story.

In this section, we will discuss some specific editing tips and tricks that we haven't covered in depth yet. If a cut doesn't seem to work and you don't understand why, see if your problem is addressed here. You may find one or two tricks that can help you fix the problem.

Note that in some cases, there's no easy way to solve an editing problem because of the way the shots you want to use were composed and blocked during production. If nothing else, this illustrates the importance of thinking like an editor when you are shooting—if you can think ahead to the editing stage while shooting, you can be more confident about having the shots you need when it comes time to edit the movie.

If you still can't make your edits flow, get a second opinion. You may be too focused on the problem to see a solution—or it may not need to be fixed in the first place. Play your edited clips for a friend and ask for their reaction. Even the professionals do this, holding prerelease screenings to gauge how an audience will react. Based on audience feedback, they may go back and re-edit portions of the movie before releasing it to theaters.

Serving the story

One of the first things you should keep in mind when editing is the story you are trying to tell. Ask yourself questions like, does this cut help tell the story? Are you telling the audience enough, or too much? Can the audience follow movement, location, and time of day from these shots?

Here are a few more issues to think about. Don't expect to master all of this immediately, but trying to work these tricks into your repertoire will ultimately make you a better editor.

Motivation

The cut makes sense with what the viewer is seeing and feeling at that point in the story. It moves the story forward and tells the viewer something useful. In a feature style production, a cut is often motivated by some action and is a continuation of

that action from a different angle. In a documentary style production, a cut is motivated if it falls in line with what the viewer would expect to see.

For a cut to be motivated, the incoming shot must be significantly different from the outgoing shot. For example, you would add something significant if you cut from a person pointing at an off-camera object to a POV shot of the object, as in Figure 5.1. A new shot would not be motivated if it showed roughly the same visual content, for example, cutting from a 2-shot of two women talking about politics to a slightly tighter 2-shot.

Figure 5.1 – *Cutting to a POV shot often adds significant information to a story.*

Juxtaposition

When an editor thinks about the *juxtaposition* of two shots, she is concerning herself with what meaning a viewer may draw from placing the shots together. With every cut, a viewer makes a connection between the two juxtaposed shots automatically without you or the viewer necessarily being aware of it. Even if two juxtaposed shots are completely unrelated, the viewer will still attempt to relate the two.

If you are aware of juxtaposition, you can use it to tell your story by implying cause and effect relationships. For example, if you follow a shot of a crying baby with a shot of a teddy bear, the viewer may assume that the baby is crying because it lost the toy. In reality, the baby may be crying because it is hungry, and the teddy bear might be a toy that fell off the shelf in a department store. On the other hand, you should be careful of unintentional juxtapositions, such as following a shot of a car you want to sell with a shot of a lemon.

Simplicity

A shot should only contain information that is necessary to tell the story. It is often the editor's job to cut a shot down to its basic elements, removing unnecessary action and time and maintaining the focus of the shot on the story. This is not to say every shot should be short and spare. You can use a very long duration shot if everything that happens in it helps propel the story forward.

For example, suppose during a tense action scene, you use a shot of a character firing a gun, turning, and walking out a door, and the walk takes 30 seconds. If the only motivation for the shot is to show the gunman firing and leaving, you can cut the shot down to an essential 2 seconds by cutting after he fires and turns. The viewer will assume he is leaving because he turned. More than likely, the viewer will be more interested in seeing what happened to the person he fired at, so you can cut from the gunman to the person dodging the bullet. By paring shots down to their essentials, you help keep the viewer engaged and the story on track.

Maintaining continuity

Be careful to maintain consistency—or continuity—from shot to shot within a scene. If there is a large change in the appearance of the shots you use, your audience may assume that the scene has changed. The audience reaction may be enough to make viewers focus on the mechanics of your movie rather than the story. This doesn't mean you can't use a gritty, low-quality look to tell your story if that is what you want. But if you start with a gritty look, stay with that look, or change it in such a way that the viewer is not consciously aware of the change. Maintaining continuity simply helps the audience focus on your story and suspend their disbelief.

Visual continuity

The visual content of a new shot should match that of the previous shot. For example, an actor is holding an object in the same hand or the lighting and weather are the same. If it's raining in one shot in a scene, it should be raining in all shots in that scene.

A visually discontinuous shot is often called a jump cut. One easy way to get jump cuts is to remove part of the middle of a shot and put the two ends together. What the viewer sees at the cut point is a jump forward in time. For example, if your shot is a person walking away from the camera down a street and you pull 10 seconds from the middle of it, the person will appear to jump ahead at the cut.

A jump cut is very abrupt and can disturb the flow of the scene. If you want to remove time from a shot, cut to another shot and then back. For example, in the middle of the walking shot, cut to a person waving, then back to the walking person a bit later.

Continuity of movement

The movement from one shot to the next should seem continuous. If two connected shots show the movement of a single person, the second shot should start the movement at the point where that movement was cut in the previous shot.

Unless you are using the television production style, movement will never match exactly from shot to shot. Often, though, all you need is the suggestion of motion. For example, cutting from a person turning to a close shot of her hand moving up can fool the eye into thinking the motion is continuous. The cut will work if the movement is in the same direction and the angle change is big enough. Confusing the eye a bit and using some misdirection can often make up for a lack of visual continuity.

Figure 5.2 shows a cut from a single shot to an over-the-shoulder (OTS) shot as a person removes the lid from a pot of beans. Because the angle change is large, the movement seems continuous, and the viewer's attention focuses on the pot of beans, the eye is misdirected. The viewer wants to see what is in the pot and doesn't notice that the lid is being opened with the right hand in the first shot and the left hand in the second shot.

Figure 5.2 – *Maintaining continuity of movement despite a lack of visual continuity.*

Matching screen direction

Matching screen direction from shot to shot can help you maintain a sense of continuity even in situations where there is a serious lack of it. You do this by making sure primary objects generally move in the same direction and people are looking the right way when they look at objects off-screen. Figure 5.3 provides an example of matching screen direction.

If you were editing a movie about a marathon, you would match screen direction by showing one person running from screen left to screen right, cutting to another jogger moving from left to right, then cutting to a shot of the chase car facing screen right. All the shots would show or imply left-to-right movement. It makes the viewer feel comfortable knowing the race is being run from the left to the right. Likewise, if a person walks out of a door on the left of the frame, in the next shot he should enter the adjoining room from a door on the right side.

Figure 5.3 – *Matching the direction of movement from cut to cut.*

When you cut between two people, you would match screen direction by making sure each is looking off opposite sides of the frame at the other person off-screen, as shown in Figure 5.4. This is called matching *eye lines*. For example, suppose you are cutting between single shots of two people talking. (A single contains just one person.) If the person in the first shot is looking off screen left at the other person, then the other person should be looking off screen right. If the two are looking at opposite sides of the screen, the viewer has the feeling they are talking to each other. If they were both looking in the same direction, it would feel like they were talking to someone else off-screen.

Figure 5.4 – *Matching eye lines across a cut.*

The same holds true for cutting between OTS shots. In one shot, the first person's back should be on the left, with the second person facing him on screen right. In the matching shot, the placement should be reversed.

Screen direction is a primary example of the need for directors to understand editing. If you don't maintain screen direction during production, there is often no way to fix the problem in the editing room.

Moderate angle changes

The viewer may lose the sense of continuity if you cut from a very wide establishing shot to a very close shot of someone's eyes. There have to be enough recognizable elements and visual similarity between the shots for the viewer to perceive them as being in the same place. If you cut from a wide shot showing a person with palm

trees in the background to a medium shot of the person with palm trees behind him, the angle change will work. On the other hand, if the angle change is too small, the cut won't work because the viewer will perceive it as a jump cut, for example, cutting from a wide shot to a slightly less wide shot. The angle change has to be big enough to make a meaningful difference, but not so big that the viewer can't get his bearings.

Continuity of space

The viewer should have a clear idea of the angle a new shot is taken from in relation to the angle of the previous shot. Continuity of space is all about establishing a clear sense of geography, and an establishing shot usually helps. This is somewhat related to visual continuity, but has more to do with where the camera is positioned than whether objects match up in different shots.

You often run into problems with geography when a scene has many characters and complex movement, and it is shot from a number of angles. Sometimes a cut will confuse the geography if it is not handled carefully. It may be better to stay with one angle rather than adding confusion with multiple angles.

One thing that helps keep geography straight while shooting many angles is to imagine an invisible stage line running across the set. When blocking a scene during production, draw this line between two of the extreme angles (180 degrees apart). Then shoot all the rest of your angles on either side of that line, but avoid crossing the stage line. For example, suppose you are shooting four people sitting around a square table, as in Figure 5.5. Draw a line going through person 1 and person 3. You can shoot from behind person 1, and then turn around 180 degrees and shoot from behind person 3 opposite him. If you then shoot from behind person 2 or person 4, you will be crossing the stage line. If you are editing a scene where the director has shots that cross the line, you can simply try to avoid those shots. If you have to use them, avoid cutting to an extreme angle; keep changes in angle to less than 90 degrees.

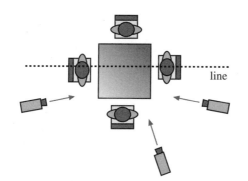

Figure 5.5 – *A stage line and potential camera positions.*

Tying it all together

After you finish the rough cut of your movie, go through the movie one scene or sequence at a time and fine-tune the edits. As you play entire scenes, get a feel for the pacing of the movie as a whole and try to follow the overriding emotional content. It's possible you will change a cut, even if it means deconstructing a cut that you spent hours perfecting.

Sometimes an editor will compromise visual continuity or break the rules in some other way to create the right emotional effect. It may seem odd, but viewers usually consider emotional content and the rhythm of a movie to be more important than any other editorial issue. This is why the discontinuous style used to make music videos works well. It shouldn't feel right to jump cut from a singer in a studio to the singer walking down a street, but editing to the rhythm of the music maintains a continuity of its own.

Conveying emotional content

The intended emotion should be derived from the basic goal of the movie, and should be so obvious it doesn't even have to be discussed. Nevertheless, the emotional content of a movie is often overlooked due to the technical details of creating the movie. As you play back a sequence, ask yourself if the emotions you intended are being conveyed.

For example, suppose you are making a documentary about aging. It's possible you became so close to the movie that you allowed the interviewees to lead you away from your original goal. Instead of feeling anxious and concerned about aging, maybe the viewer is feeling like it's maybe not such a bad thing after all and is wondering what point you are trying to make with your movie.

Keeping the story consistent

Watch for gaps and errors that cause the viewer to focus on the editing or an actor's performance rather than the story. Also, make sure the story doesn't become derailed by a scene or shot that is out of place.

For example, going back to the documentary about aging, suppose a scene shows a retired person happily jogging on the beach by his mansion. It's possible the scene played well by itself. However, when it's inserted in a movie in which you want to show the darker side of aging, the story takes an unwanted turn. When the viewer attempts to reconcile the events in the movie, he is left confused about its intent.

Maintaining rhythm and pacing

The cuts, action, and sound track should have a consistent and natural pace and tempo. The viewer can almost sense when the next cut will occur. The rhythm of editing correlates to the way we naturally feel about and perceive the world. When we are in a quiet, thoughtful mood, we tend to concentrate our visual attention on things longer—our rhythm is slow. When we are agitated or excited, our visual attention is shorter, we glance around more, and our blink rate increases—our rhythm is fast. If a scene is meant to create a feeling of excitement, such as a chase scene, the rhythm of the cutting should be fast to match the feeling. The rhythm and pacing of cuts is so important that viewers will overlook many visual inconsistencies if the rhythm suits the content of your movie.

Editing the camping movie

In Chapter 4, Dave shot some video footage of himself, his son, and his son's friends on a camping trip. When he got home from the trip, Dave imported the raw footage into Movie Maker and started editing the shots together.

In this section we will describe how Dave edited each scene. The source files and final edited movie are included on the companion CD. You can view the movie, CampoutFINAL.wmv, to see how Dave edited the scenes, and then import the source files, CampoutShoot1.wmv and CampoutShoot2.wmv, into a new project if you want to practice editing the raw footage. To view the movie, you need Windows Media Player, which is included with Windows Millennium Edition. You can also install Windows Media Player from the CD, if you want to view the files on a PC not running Windows Millennium Edition. For more information on how the sound was created, see Chapter 13.

Welcome scene

Dave did a simple cut from the welcome shot to the time-lapse shot. At one point near the end of the shot, a red car drove by the campsite. Dave decided this seemed out of place, so he edited out those few frames. Because the time-lapse shot is really only a series of jump cuts, one more isn't noticed.

Hiking sequence

Even though the hike took place on the second day of the campout, Dave decided it made a better story to move it here. If he'd edited the movie in real chronological order, the hike would've gone at the end of the movie, but he thought the Bean Witch scene would make a more compelling ending.

After viewing the source files, Dave arranged the shots roughly in his head to create a story. The kids would come into the forest, discover the lake, talk a bit, and then go back to camp. The sequence would start with a pass-by shot moving from right

to left, followed by a series of shots bringing them to the lake. Then he would use the walk-and-talk shot, and end with a pass-by moving left to right. He had shot plenty of coverage. The only problem he had was finding a good POV shot of a dragonfly at the lake.

Dinner scene

Dave wanted the dinner scene to happen spontaneously, so he shot a lot of coverage to make editing easier. However, as he viewed the source files, he knew this scene was not going to be easy to cut. First, cooking took too long. There were long periods when cans had been opened and the kids were trying to light the stove. He felt that the scene should be about a minute long, even though it actually took several minutes. He decided to use the two cutaway shots, the bean can opening shot and the asparagus shot, to cover time passing. Instead of showing the entire process of cooking the food, Dave used a few seconds of the cutaway shots.

Another problem, which Dave had not noticed during the shoot, was the sound of the propane stove. As you play the edited movie, you can hear the hissing of the stove pop in and out as Dave cuts from the master shot to the OTS shot. The only way to fix this sound problem would be to add hiss to the OTS shot and attempt to match sound levels between the shots so the hiss is continuous across cuts. This could be done with a separate program, but Dave decided it wasn't worth the bother. In the future, Dave would wear headphones while shooting to better monitor the recorded sound.

Card game scene

Dave edited this scene exactly as planned. The only issue was the very end of the scene when the kid goes into the forest. In the master, Dave noticed a problem while shooting, so he had the kids do a pick-up shot of the very end. Because the dialog was not scripted, he had some problems matching continuity when the kid on the left shows his hand. He had to cut back to the OTS shot of the cards before cutting back to the master to walk the kid out.

Night scene

Dave captured the shot for this scene through his video capture card so that he could raise the level of the audio track and adjust the video to get a mysterious, grainy look. Unfortunately, he raised the sound too much and it didn't match the rest of the movie. He also had a few continuity problems with this scene because the dialog wasn't scripted and the camera mike did not capture the voices well. Next time, Dave will consider using a fishpole to record better dialog.

Dave started the scene with a shot of the moon. As he was editing, he decided he needed a way to establish the time and emotion. The only suitable shots he had from the camping trip were during the day, so he got this shot in his backyard.

Monster scene

Dave used the best of the three takes. He decided not to use the entire shot because it got a little weird near the end (see Figure 5.6) and he didn't want the movie to upset Grandma.

Figure 5.6 – *The part of the monster scene that didn't make it in the final cut.*

In the next chapter, you take your finished movie and deliver it to your intended audience. You will learn about the two methods: downloading and streaming. You will also learn about Windows Media Technologies, and bit about the mechanics of distributing digital content over the Internet.

Distributing Your Movie

The last step in making a movie is creating the final audio and video content that will be distributed to your audience. If you were making a film, a specialist known as a negative cutter would edit or *conform* the camera-original footage, so that it matches the final edited version made with the work print. The sound would be mixed and combined with the edited original footage, and after several more steps, final release prints would be made and sent to theaters.

In Windows Movie Maker, the process is much easier, but similar in concept. When you save a movie, Movie Maker uses the information in your project file to locate the source files, and create—or *encode*—your movie as a file according to the edits you made in the timeline, the same way a negative cutter conforms the film.

Before you can save a movie, however, you need to determine how you are going to distribute it. The method you choose to deliver your movie to your audience will play a major part in determining the playback quality settings to use.

You enter quality settings in the dialog box that is displayed when you click the **Save Movie** command. Naturally, you want the highest quality for your movie. However, if you select the highest quality, the size of the final file may be too large to distribute the way you had planned. When making movies with computers, you need to find a compromise between quality and file size or *bit rate,* which we will discuss later in this chapter. The method you choose to get the movie to your intended audience establishes what quality setting you can use.

Windows Media Technologies

When you save your project as a movie, Movie Maker uses Microsoft Windows Media Technologies to turn your edited clips into the final movie file. This enables the distribution of high-quality audio and video in your movie over a computer network, such as a local area network (LAN) or the Internet. Windows Media gives you scalability and quality. Scalability means that you can choose many different ways to distribute your movie, because you can adjust the size of the movie to fit the distribution method. Quality in this sense means the audio and video will sound and look great regardless of how you encode and distribute your movie.

There are many ways to distribute a movie. You can scale a movie down to send in e-mail or fit on a floppy disk that you can mail to friends. You can also scale it up to

play it in a frame the size of your computer screen and send to friends on a Zip disk or CD-ROM. However, the real value of Windows Media Technologies is that it lets you create content suitable for streaming over a computer network such as the Internet.

Streaming is one way to distribute content. In this chapter, you will learn about the distribution methods of downloading and streaming, as well as Windows Media Technologies. The chapter also describes another tool that you can use to encode Windows Media files or live streams, and explores Windows Media Player 7. For specific information about distributing your movies with Movie Maker, see Chapter 10.

Downloading content

One method of distributing data over a computer network is downloading files. When you download, you copy a file from one computer to another over a network, like copying a file locally from a floppy disk to your hard disk drive.

When you want to play content that is available for downloading, you click a hyperlink on a Web page that points to the media file on a Web server. A Web server is a computer that is dedicated to downloading files and Web pages over the Internet or a Web-based corporate network. Your browser initiates the process of copying the file from the server. After the file is copied to your hard disk drive, you open it in Windows Media Player 7, which provides high-quality playback of many multimedia file types.

Downloading files takes time because you have to wait for all the data to be copied from the server to your hard disk before you can play it. Copying time is directly related to the available *bandwidth* of the network and of your modem (or NIC), as shown in Figure 6.1. Network bandwidth can be compared to a water pipe. If you connect to the Internet via a modem and telephone line, the size of your pipe is very narrow—only a limited quantity of data can get through in a given amount of time. A file is like a tank of water. A very large tank of water takes a long time to go through a small pipe. A file can take several minutes to download over the Internet. However, it only takes a few seconds to copy locally from your CD-ROM to your hard drive, for example, because the bandwidth is very high.

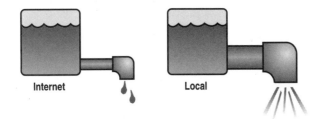

Figure 6.1 – *Bandwidth available over a phone line versus locally.*

Whenever you capture audio and video to your computer, they are no longer sound and pictures; they are data. Analog information from your camcorder is converted into a digital stream of zeros and ones, or *bits*. It helps to think of bits as a long series of instructions. The bits aren't the audio or video itself; they are instructions for how to recreate the content in analog form. When a user plays your movie, Windows Media Player 7 uses the instructions to recreate the original sounds and pictures. The more instructions you have, the better the rendition, the higher the quality: the more bits, the bigger the file, and the longer the download wait.

Streaming audio and video

With most audio and video available over the Internet, you download or copy a file, and then play the downloaded file from your hard drive. But what if you could skip the download process and simply play the audio or video as it was being sent to your computer? Instead of waiting for the bits to be copied, they would play as soon as they arrive. This is the concept of streaming: the bits are played as they are being received.

With streaming content, you have instant gratification. There is no download wait. Streaming an audio or video file is like playing a CD or tape. You have all the same playback controls, like play, pause, stop, and rewind. The only thing you don't have is the physical media: the tape or CD. You can choose what you want to listen to and when.

Streaming also enables you to do live broadcasting, just like a radio or television station, except over the Internet. You can eliminate the need for files altogether. A live encoder program sends the bits it creates directly over a network to a player, instead of to a file. Because Movie Maker was designed to edit video, it can only encode to files. If you want to create a live stream, you can use Windows Media Encoder, which is discussed later in this chapter.

The downside to streaming is that the bit rate of the media must be lower than the bandwidth of the network. Bit rate is the speed at which data is sent across the network. Returning to the plumbing metaphor, if bandwidth is the size of the pipe, bit rate is the amount of water—or data per second—that can travel through the pipe. Because you are playing the media as it is being received, if the network bandwidth is lower than the bit rate of the media, the media will not play properly.

If you are downloading a still image over a slow connection, the image quality will not be affected; it will just take longer for all the bits to get to your computer. The still image itself does not have a bit rate. On the other hand, a media stream does have a bit rate. As long as the media is playing, the bits are streaming at a steady and continuous rate. A player must receive a stream of bits continuously or the picture and sound will either stop or play back unevenly. Think of it this way: when you encode a file for downloading, file size is important and bit rate is irrelevant; when you encode a file for streaming, file size is irrelevant and bit rate is important. You can easily stream a very large file, even one that has an unlimited size (a live stream), as long as the bit rate is within the given bandwidth.

The bit rate of high-resolution, full-frame broadcast video is about 128 megabits per second (Mbps). To download one second of broadcast video over a 28.8 Kilobit per second (Kbps) modem would take one hour and 14 minutes. Streaming this type of video would be impossible over a network. To recreate every detail of a video frame would require so many instructions that most computers couldn't even play the video. It would also require a huge amount of storage space for the file. Windows Media Technologies handles this problem by using *compression*. Compression lowers the bit rate while maintaining the best possible quality.

Compression technologies

A compression algorithm analyzes the data and removes or changes bits so that the integrity of the original content is maintained as much as possible, while reducing the size and bit rate. An encoding program, such as Movie Maker, compresses the data, and Windows Media Player decompresses it.

There are two types of compression: *lossless* and *lossy*. As the names suggest, with a lossless compression, data can be compressed and decompressed, and the decompressed data matches the original data exactly. With a lossy compression, data is lost during the compression process and cannot be recovered during decompression. The amount of data lost depends on the quality of the compression algorithm and the amount of compression applied to the data. To achieve the low bit rates necessary to stream over the Internet, streaming media compression and decompression algorithms (called *codecs*, which stands for compression/decompression) are lossy.

Windows Media Technologies are engineered to get the highest quality possible at a number of bandwidths and to automatically adjust the stream to accommodate unevenness in available Internet bandwidth. When you select a quality option in the **Save Movie** dialog box, Movie Maker encodes a movie that does not exceed a given bandwidth. Therefore, you can create a movie with a bit rate of 20 Kbps, for example, that will play properly on a computer that is receiving the movie over a 28.8 Kbps connection. You can also create a movie at 384 Kbps that will stream over a high-speed connection, also known as a *broadband* connection, such as ISDN, ADSL, or a cable modem. A consequence of reducing the bit rate is a reduction in file size. A file that has been encoded for streaming may also be suitable for downloading or copying to a disk.

Movie Maker uses the Windows Media Audio and Windows Media Video codecs to compress your movies. Aside from being scalable and enabling high-quality playback of audio and video, they are designed to help the stream withstand highly variable bandwidth conditions. For example, when data is lost in transmission, the video codec attempts to fill in the missing parts of the frame. The audio codec enables you to get very good audio quality at relatively low bit rates. For example, you can get close to CD-quality audio at a small fraction of the bit rate and size of uncompressed CD audio. A standard CD can hold a little over an hour of music. If you compress the music with the Windows Media Audio codec, you could have near CD-quality playback and fit ten or more hours on one CD.

After your movie has been compressed, the amount of data and the bit rate is at the correct level for whatever distribution method you have chosen. Compressing the audio and video streams is the first thing Movie Maker does when it encodes your movie. The last step in the encoding process is converting the data into a format that makes it network-ready.

File formats

The two standard Windows multimedia file formats, AVI for video and WAV for audio, provide the highest quality playback for local files—files saved on your computer's hard disk or a CD. In addition, you could copy a file in AVI or WAV format over a network to share it with your friends. The main drawback to these files formats is that they are not suitable for streaming.

Windows Media Format is the file format used by Movie Maker, Windows Media Encoder, Windows Media Player, and other Windows Media Technologies.

Encoding a file in the Windows Media Format does a number of things that make it suitable for streaming. A Windows Media-based stream contains audio and video data divided up into packets. In addition, it contains redundant data that the player can use to reconstruct the stream if packets don't arrive intact. If multiple-bit-rate

encoding is used, the packets can also contain more than one stream of video so that a single stream or file can service users with different connection speeds. There is other information included in the packets to set up Windows Media Player and help it render clean, continuous audio and video. A packet can also contain script commands, markers, and text that add to the presentation of the media.

Windows Media-based files and live streams help ensure that the user's experience viewing the streaming content is the best it can be. To help further ensure a quality experience, the streaming content must be distributed from a Windows Media server.

Files that have been encoded with the Windows Media Format have a .wma, .wmv, or .asf extension. The first two extensions stand for Windows Media Audio and Windows Media Video, respectively, and are used on audio or video files created with one of the current encoding tools. The third extension, .asf, was used on audio and video Windows Media files created with versions of Windows Media Encoder prior to version 7.

Windows Media Servers

A Windows Media server, which is a computer running Windows Media Services, distributes streaming content to users over a network. This is similar to a Web server, but while a Web server downloads data using the fastest bit rate possible given the current bandwidth conditions, a Windows Media server can stream data at the bit rate for which a given file or live stream was encoded. As it streams a file or live stream, a Windows Media server communicates with Windows Media Player on the user's computer. If data is missing, the server can resend a packet. If a file or live stream was encoded with multiple-bit-rate streams, the server switches to the stream that is most appropriate for the available bandwidth.

If you had a Windows Media server connected to the Internet, all you would have to do to make a Windows Media-based audio or video file available to users is copy the file to a special directory on the server. A user connected to the Internet could then view the streaming file by opening it in Windows Media Player 7.

Windows Media Services uses a different protocol than Web servers. To open a page from a Web server, you would enter a Universal Resource Locator (URL) address like *http://www.microsoft.com/default.asp*, where http: specifies the HTTP protocol used by Web servers. To stream a file in Windows Media Player, you would enter an address using the Windows Media protocol, mms:. For example, if you wanted to view a Windows Media-based video stream, the address would look something like *mms://www.microsoft.com/MyFile.wmv*.

If you wanted to make the file available to users via a hyperlink on a Web page, you would link to a *metafile*. This metafile tells your browser to launch Windows Media

Player and directs the Player to the location of the file you want to stream. For more information about creating and serving content, see Chapter 14.

Creating streaming content

Streaming Windows Media-based content requires three basic components, although each of these may comprise more than one tool or service:

- **Encoding tools**. Used by content creators or producers to create Windows Media Format files and live streams. Movie Maker and Windows Media Encoder encode files using Windows Media Format.

- **Windows Media server.** A Windows-based server running Windows Media Services. This server hosts the Windows Media-based files and broadcasts live streams.

- **Windows Media Player.** Used to view Windows Media-based content, such as your movie.

Figure 6.2 illustrates these three components.

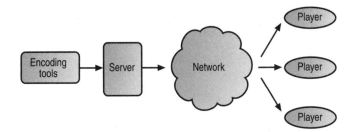

Figure 6.2 – *The three primary components of Windows Media Technologies.*

To set up a live stream, Windows Media Encoder is connected over a network to a Windows Media server, which makes encoded content available to users who are running Windows Media Player. The encoding computer encodes the stream, the serving computer serves it, and the playing computers play it. The three components are designed to work together—one tightly coordinated system for delivering media over a network.

If you want to stream your movies over the Internet, you can use an ISP that specializes in hosting streaming content. Windows Media Services is included with the Windows 2000 Server operating system, however, you will most likely not want to deal with the cost and hassle of maintaining a high-speed Internet connection. For more information about ways you can publish your movies, see Chapter 11.

Windows Media Encoder 7

Windows Media Encoder is the basic encoding tool. You use Movie Maker to edit
your movie, add still images, and then encode it to a Windows Media Format file.
The encoder doesn't edit or encode still images, but it does enable you to do other
encoding tasks, the most prominent being encoding a live stream, as shown in Figure
6.3.

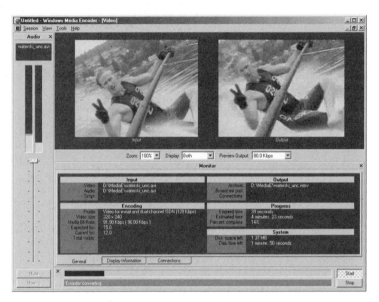

Figure 6.3 – *Windows Media Encoder.*

The following items describe the main features of Windows Media Encoder:

Multiple source support

You can create a "source group" that contains capture card devices for encoding
to a live stream or to files. You can enter encoder settings in a session, and then
assign multiple source groups to a session. Each source will be encoded with the
same settings.

On-the-fly source switching

If you have multiple source groups assigned to a session that is set up for live
encoding, you can switch between the sources on-the-fly. For example, if you
have cameras plugged into several video capture cards on your computer, you
can assign each to a different source group and then switch between them as you
stream live, as with live television. You could also encode the live session to a
file and edit it later in Movie Maker, similar to a live-to-tape television

production. If you were shooting a wedding, for example, you could switch between three cameras live instead of editing between them in post-production.

Visual feedback

As you encode a live signal or file, the encoder gives you feedback about the progress of the encoding. A dialog box also shows you the *IP addresses* of the computers receiving the stream. The computer communicates with other computers using this identifying address.

Screen capture

You can use a special codec that enables you to capture images from the computer screen and any movement on the screen. The Windows Media Screen codec is designed for users to encode things like computer software demos and tutorials.

De-interlacing

You can reduce the flicker that often results when a television signal is converted for display on a computer monitor. The standard television frame contains two fields; one field contains the odd numbered scan lines, and the other the even lines. The process of combining the two fields is called *interlacing*. The picture on a computer monitor is not interlaced and is typically of higher resolution than a television picture. Often when interlaced video is displayed on a non-interlaced screen, there is a flicker. De-interlacing combines the fields in such a way that flicker is eliminated.

Inverse telecine

To display movie film, which runs at 24 frames per second (fps), on television, which runs at 30 fps, redundant frames are added to the video. You don't notice these padding frames, but they do add to the bit rate and file size when encoded. Inverse telecine eliminates the extra frames. The final file runs at 24 fps and encoded files are smaller.

Multiple bit rate encoding

You can encode one file or live stream that actually contains multiple video streams, each set to play at a different bit rate. While streaming, the Windows Media server communicates with each player to determine the quality of the playback. When a multiple-bit-rate file or stream is distributed, the server automatically switches to a lower bit rate video stream if quality is suffering due to poor bandwidth conditions. When bandwidth improves, it switches to a higher quality stream.

Windows Media Encoder SDK

A software development kit (SDK) is available for the encoder that enables developers to write custom programs. If you know how to use Microsoft Visual

Basic or the C++ programming language, you can create your own interface and encode Windows Media-based files and streams. You could write your own editing program, for example.

Stream live direct to Windows Media Player

Typically, you encode a live stream to a server, which then distributes the stream over a network. If you want, however, you can distribute a live stream to up to 50 computers directly from the encoder. This could be used for streaming to a small group connected to a corporate LAN, for example. If you plan to stream to more than 50 computers, however, you must use Windows Media Services.

The files you encode with Movie Maker are completely compatible with those of Windows Media Encoder. You can edit a file made with the encoder, and use an edited file as a source in the encoder. For example, you could edit several files and add them as source groups in the encoder. Then you could encode a live stream and switch between the edited files on-the-fly. You can install Windows Media Encoder from the companion CD.

Windows Media Player 7

Microsoft Windows Media Player 7 is a complete, all-in-one player for Windows Media-based files and streams. It also plays MP3 and many other popular audio and video formats. Figure 6.4 shows a video stream playing in Windows Media Player.

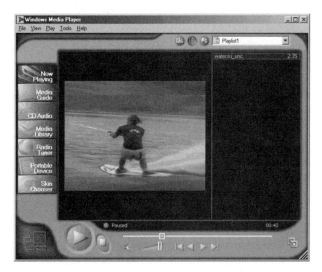

Figure 6.4 – *Windows Media Player 7.*

You click a command in the task bar on the left to display content and other information in the area on the right. Then, you select content files, and use the transport controls at the bottom to play them.

Here are brief descriptions of what each button does:

Now Playing

You can select content to play. If the content is audio-only, you can select a *visualization* to accompany it. Visualizations are splashes of color and interesting geometric shapes that change with the intensity and pitch of the audio. Video frames can be zoomed to twice or half the normal size, or you can view videos and visualizations full-screen.

Media Guide

The Player opens a special WindowsMedia.com Web page if you are connected to the Internet. From there, you can surf for Windows Media audio and video content and related sites on the Web. WindowsMedia.com has radio and television stations, special live events, streaming music, music videos, movie trailers, entertainment clips, and a special section that features broadband media.

CD Audio

If you have an audio CD in your CD-ROM drive, you can view the contents and play tracks. CD Audio displays information like track names, artist, and length. If you are connected to the Internet, you can get album details from a huge database of music information. You can also copy music from the CD to your hard drive. When it copies, the music is compressed using the Windows Media Audio codec. The saved files provide high-quality playback, but the size of the file is about on eighth that of the original, uncompressed music.

Media Library

You can search for content on your hard disk and any other drives and devices connected to your computer. The automatic search lists all content and organizes it like a directory tree. You can then delete, copy, and move content. You can save the location of radio stations that you like, and keep the radio station presets in the library.

Another very useful feature is playlists, which are lists of content that you can play from beginning to end or in any order. You could create playlists of short movies, for example. You could make a playlist for the grandparents that includes *Bob's birthday, Josh's graduation, Our 20th anniversary*, and *Cleaning the dog*. If you have a *CD burner*, you could then create a CD of the playlist elements and send it to grandma and grandpa.

You can copy a playlist of audio tracks to a portable device such as a Pocket PC. If you have copied CD audio, you can organize your favorite tracks into compilation playlists, such as a special playlist of several hours of music for a party. You can include radio presets and links to media files on the Internet in a playlist, too.

Radio Tuner

If you are connected to the Internet, you can search for radio stations that are streaming their broadcasts with Windows Media Technologies. Most of the radio stations you find broadcast over the air and stream their on-air signals over the Web. However, some broadcast stations offer different content for the Web. There are also a growing number of Internet-only radio stations. You can also search by format (rock, classical, news, and so on), call letters, name of a band, language, locations, radio frequency, and keyword.

Portable Device

You can copy content from your computer to a *portable device*. A portable device is a storage device or portable player that you can connect to your computer. Portable devices include the new portable music devices that can store and play hours of music and fit in the palm of your hand, as well as Pocket PCs and Palm-size PCs, Smart Media, Iomega Jaz and Zip drives, and CompactFlash cards. The content on your computer can be downloaded to one of these devices and taken anywhere. Because the music is encoded with the Windows Media Audio codec, sound quality is excellent.

Skin Chooser

You can select a different skin for Windows Media Player. A skin is a custom user interface that is built from graphic elements, XML, and scripts. The Player comes with a set of skins that you can try. When you choose a skin, the full Player goes away and the skin becomes the way you play videos, organize your media, make playlists, and so forth. You can switch back to the full Player at any time.

Dealing with audio and video on your computer can be confusing and frustrating, so many people don't even bother trying. Most people have figured out how to play their CDs and that's about it. But your computer is capable of much more. Windows Media Player 7 opens up the possibilities and turns your computer into a media center. The Player is designed to make dealing with digital content on your computer easy and more useful, by helping you organize it and handling confusing background tasks automatically. For example, if you start to play content that requires a codec that is not on your computer, Windows Media Player will try to find and install that codec automatically.

The designers of the Player also realized that computers are not always located in the places where you want to hear music or watch videos. Through the Player's integration with portable devices, the Internet, and CD burners, you can take music and media anywhere you want.

Skins

A skin is a customized interface for the Player. You can use the standard full mode Player that gives you all of the functionality, and ways to organize and search the Internet for digital audio and video content. You can also choose a different skin that has its own set of functions for the Player. Figure 6.5 shows an example of an alternate skin.

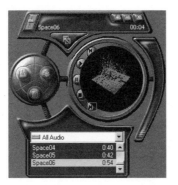

Figure 6.5 – *A Windows Media Player skin.*

You can think of the main part of the Player, the part that plays the audio or video content, as being invisible. To make the video frame and visualizations visible and provide a way to control the Player, you attach a skin to it—the full mode Player is actually just another skin. Different skins can expose different Player functions. For example, a skin may provide only play and stop buttons, and have a very elaborate graphical appearance. In the **Skin Chooser**, you can select from a number of skins. A collection of skins is included when you install Windows Media Player 7.

Skins can turn the standard Player interface into a work of art, something with visual appeal that you wouldn't mind having on your desktop. The interesting thing about skins, though, is that you can create your own. All you need is a graphics program and the Windows Media Player SDK, which you can install from the companion CD. Any graphics program will do, although you have more control and flexibility with one that supports layers, such as Adobe Photoshop. After creating your artwork, you create an XML-based skin definition file using a simple text editor, such as Microsoft Notepad. The Windows Media Player SDK provides complete instructions, a scripting reference, and samples. In many cases, all you have to do is cut and paste example code from the Windows Media Player SDK.

Wrap-up

In the part 1 of this book, you learned about making movies: how you can rethink your approach to shooting videos now that you can edit them with Movie Maker. You can plan a production, create scripts or outlines, shoot your video, and edit the disconnected shots into a movie that tells a story. Then, using Windows Media Encoder or Movie Maker, you can encode the file in Windows Media Format and distribute your encoded movie through e-mail, physical media like floppy disks, downloadable files, and streaming. You can also create a skin that includes your movie, and then send it or make it available for downloading from the Web.

In part 2, you learn how to use Movie Maker to record your video, organize your clips, edit your movie using video clips, audio clips, and still images, and share your movies with others.

Part 2
Using Windows Movie Maker

Introducing Windows Movie Maker

This chapter is intended to help you get started making great movies by giving you an overview of Windows Movie Maker. This includes an explanation of the menu choices and commands, as well as a quick orientation to the Movie Maker interface.

Movie Maker is a feature of the Windows Millennium Edition operating system. Movie Maker is designed to help you get home movies off of video tapes and onto your computer. After you record them to your computer, you can perform basic video editing techniques before sending them, if you choose, to family and friends by e-mail or by posting them to a Web site. Movies you create and save in Movie Maker use Windows Media Technologies to provide high-quality video and audio playback with reduced file sizes and bit rates. This means download times are shorter and you have more hard disk space for storing movies on your computer.

Movie Maker goes beyond just transferring recorded tapes to your computer; it lets you record live video to your computer using your analog camcorder, digital video (DV) camera, or Web camera. Or you can import existing multimedia files into Movie Maker to include in your own movies. If you have still images from a digital camera or ones that you have scanned to your computer, you can also use them in your movies. Of course, what movie is complete without sound? In Movie Maker you can add music or other audio to your movies, or you can record new audio tracks, such as personal narrations, while you are editing.

Part 2 of this book shows you how to do all these things in Movie Maker, and more. The goal of this chapter is to explain the basic elements of Movie Maker, so you are familiar with the interface and ready to start editing your own movies. Most of the information in this chapter can also be found in the online Help files in Windows Millennium Edition for Movie Maker, but has been provided here for your convenience.

The Windows Movie Maker interface

The basic interface, which is what you always see when you start Movie Maker, is designed so that you can immediately begin to make fun, enjoyable movies. The basic elements of Movie Maker include menus, toolbars, the monitor, a collections area, a recording dialog box, and a workspace (which is commonly referred to

throughout this book as the storyboard or timeline, depending on the selected viewing mode). Figure 7.1 shows the different elements of the Movie Maker interface.

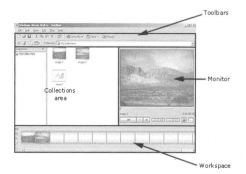

Figure 7.1 – *The Windows Movie Maker interface.*

Using the menus

You can perform most tasks by selecting commands from the menus in Movie Maker. The following sections provide brief descriptions of the commands on the Movie Maker menus. Shortcut keys for commands, if available, are listed in parentheses.

File menu

The **File** menu provides commands that help you work with new and existing projects and movies in Movie Maker. The following commands are available on the **File** menu.

New, Project (CTRL+N)

Use this command to start a new, empty project. If you have a project already started, Movie Maker prompts you to save any changes, if they have not been already saved, before starting a new project. When you create a new project, the storyboard or timeline is empty.

New, Collection

Use this to start a new collection. A collection is used to store and organize clips, which are the video, audio, or image files you import into Movie Maker. Organizing your collections and clips is discussed in Chapter 9.

Open Project (CTRL+O)

Use this command to open an existing project in Movie Maker. Project files have an .MSWMM file extension. After you open the project, you can make more changes to the project before saving it as a movie in Windows Media

Format by using the **Save Movie** command, which is described later in this chapter.

Save Project (CTRL+S)

After you have added clips to a project and arranged them on the storyboard or timeline, you need to save your project. If you save your project, you can later open and further edit that specific project rather than starting from scratch. Project files have an .MSWMM file extension.

Save Project As (F12)

Use this to save the existing project with a new name. This command is useful if you have an existing project that you want to use to create another similar project. By using this command, you can keep the original project intact while using it to create another project without having to add and then arrange the existing clips again.

Import (CTRL+I)

Use this to import existing multimedia files into Movie Maker. Importing files is discussed in detail in Chapter 8, including information about supported file types.

Record (CTRL+R)

This command opens the **Record** dialog box so you can record live video or transfer from recorded video tape into Movie Maker. The specific parts of the **Record** dialog box are detailed in Chapter 8, along with information pertinent to recording in Movie Maker.

Record Narration

Use this command to record a personal narration for your current project. Adding narrations to your movies is discussed in Chapter 10.

Save Movie (CTRL+M)

Use this command to save the current project as a movie. This saves the movie in Windows Media Format, so you can watch the resulting movie in Windows Media Player. Details about saving your movies are explained in Chapter 11.

Send Movie To, E-mail

Use this command to save your movie and then send it to someone using an e-mail program. Sending your movies by e-mail is discussed in Chapter 11.

Send Movie To, Web Server

Use this command to save your movie and then post it to a Web site. This lets you share your movies over the Web with family and friends. Detailed information about posting your movies to a Web site is found in Chapter 11.

My Videos

This command opens Windows Explorer and displays the contents of your My Videos folder. This is the default location of your saved movies.

Exit

This command will shut down Movie Maker.

Edit menu

The **Edit** menu lets you make changes to your current project, collections, or clips. The following commands are available on the **Edit** menu.

Cut (CTRL+X)

Use this command to remove clips from an existing project or collection. You will often cut and paste clips that appear in the storyboard or timeline when you are editing a project, which is discussed in Chapter 10. As an alternative to using the menu commands, you can move clips and collections by dragging them from one location to another.

Copy (CTRL+C)

Use this command to copy clips from one collection to another, or to create a duplicate copy of the selected clip or clips in a current project. When you copy and paste a clip, a duplicate copy is created. Again, copying is often done when organizing clips and editing a project, which are discussed in Chapters 9 and 10, respectively. You can also copy clips by dragging them with the mouse from one location to another while holding down CTRL.

Paste (CTRL+V)

Use this command to paste a clip that you have selected to copy or cut.

Delete (DEL)

Use this command to delete selected clips or collections. You can delete clips that appear in the collections area or in the storyboard or timeline.

Select All (CTRL+A)

Use this command to select all the clips in an entire collection or project. The items that are selected depend on where you last clicked with the mouse. If you last clicked in the collection areas, all the clips in the current collection are selected. If you last clicked in the storyboard or timeline, all the clips in that project are selected.

Select Storyboard/Timeline

Use this command to select the entire storyboard or timeline. This does not select the clips in the current project; it selects the entire storyboard or timeline so you can play all the clips added to the current project.

Rename (F2)

Use this command to rename a selected clip or collection in the collections area.

Audio Levels

Use this command to open the **Audio Levels** dialog box, which lets you balance sound levels between the audio track and the video sound track. Balancing audio levels is discussed in Chapter 10.

View menu

The **View** menu provides commands that enable you to control elements of the Movie Maker interface, such as displaying toolbars, toggling between storyboard and timeline views, and choosing the way clips are displayed in the collections area.

Toolbars

Use this command to determine which toolbars appear in Movie Maker. The four different toolbars you can control are the Standard, Projects, Collections, and Locations toolbars. Details about the specific toolbars and their use are discussed later in this chapter.

Status Bar

Use this command to turn the status bar on and off. The status bar is under the storyboard or timeline, and it provides tips about each menu command when you point to or select a command.

Collections

Use this command to hide or display the collections tree, which shows the structure of your collections. The collections tree appears next to the main collections area that shows all the clips in the currently selected collection.

Properties

This command lets you view the properties of a selected clip. The specific properties of a clip are discussed in Chapter 9.

Up One Level

Use this command to move up one folder level from a subfolder of a collection. If you have added one collection and you chose this option, you would move to the main My Collections folder.

Thumbnails

Use this command to display small bitmap images, called thumbnails, in the collections area to represent each clip. Collection views are discussed in Chapter 9.

List

Use this command to display only the names of the clips in the collections area. Collection views are discussed in Chapter 9.

Details

Use this command to see the properties of each clip in the collections area. Collection views are discussed in Chapter 9.

Storyboard

Use this command to see your current project in the storyboard view, which shows the sequencing of your clips. Both storyboard and timeline views are discussed in Chapter 10.

Timeline

Use this command to view your current project in the timeline view, which shows the timing of your clips and audio track. Both storyboard and timeline views are discussed in Chapter 10.

Zoom In

Use this command to decrease the time interval shown in the timeline view. This lets you see more precise timing information about the clips inserted in the current project.

Zoom Out

Use this command to increase the time interval shown in the timeline view. This lets you see the general timing information for clips inserted in the current project.

Options

Use this command to open the **Options** dialog box where you can adjust the settings for Movie Maker. Throughout this book, these options are explained in detail when they are pertinent to the task you are performing. The **Options** dialog box is described later in this chapter.

Clip menu

The **Clip** menu lets you work with clips. Most of these commands are used when you are editing a movie. Chapter 10 provides more detailed information about using these commands.

Add to Storyboard/Timeline

Use this command to add a selected clip to the storyboard or timeline. You can also drag clips from the collections area and drop them on the storyboard or timeline to add clips to the current project.

Set Start Trim Point (CTRL+SHIFT+Left Arrow)

Use this command to set the starting point of a clip.

Set End Trim Point (CTRL+SHIFT+Right Arrow)

Use this command to set the end point of a clip.

Clear Trim Points (CTRL+SHIFT+DEL)

> Use this command to clear any trim points of a selected clip in the current project.

Split (CTRL+SHIFT+S)

> Use this command to split one clip into two clips. This lets you break clips down into smaller segments that you can use in your movies.

Combine (CTRL+SHIFT+C)

> Use this command to combine clips. In Movie Maker, you can combine clips that are adjacent to one another that were previously split.

Play menu

The **Play** menu lets you control the playback of clips, whether the clips appear in the collections area or in a current project.

Play/Pause (SPACEBAR)

> This plays the current selection in the monitor. This includes playing one clip or many selected clips in the collections area, or clips that have been added to the current project, depending on what is currently selected.

Play Entire Storyboard/Timeline

> This plays all the clips that appear in a project in the storyboard or timeline. When you click this command, the entire storyboard or timeline is selected and then all the clips play in the monitor. Use this command to preview your work before saving it as a movie.

Stop (Period)

> This stops the clip or project that is currently playing in the monitor.

Previous Frame (ALT+Left Arrow)

> This moves the seek bar on the monitor to the frame before the one that is currently shown in the monitor.

Next Frame (ALT+Right Arrow)

> This moves the seek bar on the monitor to the frame after the one that is currently shown in the monitor.

Back (CTRL+Left Arrow)

> Use this command to move to the clip that is before the currently selected clip in a project.

Forward (CTRL+Right Arrow)

> Use this command to move to the clip that is after the currently selected clip in a project.

Full Screen (ALT+ENTER)

Use this command to play back a clip or project in a full-screen view on your computer monitor. Details about playing back clips in the full-screen view are discussed in Chapter 9.

Help menu

The Help menu gives you help and information about Movie Maker. This menu has the following commands:

Help Topics (F1)

This command opens the Help file that is provided with Movie Maker. The Help file covers all the features of Movie Maker.

Tour

This command starts the Windows Movie Maker Tour, which gives you a general overview of Movie Maker and its features.

Windows Movie Maker on the Web

Use this option to see more information about Movie Maker that appears on the Web.

About Windows Movie Maker

This will display the name, copyright, version number, and product ID of Movie Maker.

Options dialog box

The **Options** dialog box is where you can adjust the settings for Movie Maker. Throughout this book, these options are explained in detail when they are pertinent to the task you are performing. Here are brief descriptions of the settings in the **Options** dialog box:

Default author name

The name of the person who created the movie. This name appears when your movie is played in Windows Media Player.

Default imported photo duration (seconds)

The length of time, in seconds, that a still image is displayed when you add it to your project.

Automatically create clips

You can choose whether to use clip creation when recording source material or importing source files. Clip creation divides your video into smaller, more manageable clips each time an entirely new frame is detected. When recording

from a digital video (DV) camera, clips are created based on the time stamp placed by the camera.

Select this check box to create clips automatically when you import video; clear this check box to display the source material or source file as one clip in the collections area.

Reset Warning Dialogs

Use this button to reset the various warning dialog boxes that appear in Movie Maker, such as the warning that is displayed when you choose to delete a clip from a collection.

Select the **Do not warn me again** check box in the warning dialog box if you do not want warning dialog boxes to display in the future. Click **Reset Warning Dialogs** to see these warnings again.

Email options

Use this button to select the e-mail program you want to use when sending your movies in an e-mail message. If your e-mail program is not listed, choose the option **As an attachment in another e-mail program**.

Temporary storage

The location where your movies are temporarily stored when you save recorded source material as a movie, send a movie by e-mail, or send it to a Web server.

Import path

The default location from which source files are imported. When you import a file, this is the folder location that first appears.

Auto generate file

A movie file is automatically generated and saved to a specified location for recorded source material when the **Record time limit** check box is selected in the **Record** dialog box, and the specified time limit expires. The file is given a generic file name such as Tape 1.wmv. Additional movies are saved using the same naming convention with an incremented number (for example, Tape 2.wmv, Tape 3.wmv, and so forth).

If the movie contains audio only, it will be saved as a Windows Media-based file with a .wma file extension (for example, Tape 1.wma, Tape 2.wma, and so forth).

Using the toolbars

The toolbars provide an alternative to using the corresponding menu commands. Using the buttons to perform common tasks accomplishes the same results as the menu commands. However, using these buttons lets you perform common tasks a little more quickly than the menu commands. You can turn these toolbars on and off by right-clicking on the toolbar area and selecting toolbars from the shortcut menu.

Standard toolbar

The buttons on the Standard tool bar let you perform common tasks. Figure 7.2 shows the Standard toolbar.

Figure 7.2 – *The Standard toolbar.*

Table 7.1 lists the name of each button and the menu command equivalent of each button in the Standard toolbar.

Button name	Equivalent menu command
New Project	On the **File** menu, point to **New**, then click **Project**
Open Project	On the **File** menu, click **Open Project**
Save Project	On the **File** menu, click **Save Project**
Cut	On the **Edit** menu, click **Cut**
Copy	On the **Edit** menu, click **Copy**
Paste	On the **Edit** menu, click **Paste**
Delete	On the **Edit** menu, click **Delete**
Properties	On the **View** menu, click **Properties**

Table 7.1 – *Standard toolbar buttons.*

Project toolbar

The buttons on the Project toolbar let you perform tasks such as recording source material, as well as saving and sending movies. Figure 7.3 shows the Project toolbar.

Figure 7.3 – *The Project toolbar.*

Table 7.2 lists the name of each button and the menu command equivalent of each button in the Project toolbar.

Button name	Equivalent menu command
Save Movie	On the **File** menu, click **Save Movie**
Send (E-mail)	On the **File** menu, point to **Send Movie To**, click **E-mail**
Send (Web Server)	On the **File** menu, point to **Send Movie To**, click **Web Server**
Record	On the **File** menu, click **Record**

Table 7.2 – *Project toolbar buttons.*

Collections toolbar

The buttons on the Collections toolbar let you navigate through and control the appearance of your collections area. Figure 7.4 shows the Collections toolbar.

Figure 7.4 – *The Collections toolbar.*

Table 7.3 lists the name of each button and the menu command equivalent of each button in the Collections toolbar.

Button name	Equivalent menu commands
Up One Level	On the **View** menu, click **Up One Level**
New Collection	On the **File** menu, point to **New**, then click **Collection**
Collections	On the **View** menu, click **Collections**
Views (Thumbnails)	On the **View** menu, click **Thumbnails**
Views (List)	On the **View** menu, click **List**
Views (Details)	On the **View** menu, click **Details**

Table 7.3 – *Collections toolbar buttons.*

The Location toolbar

The Location toolbar lets you navigate through your collections. Figure 7.5 shows the Location toolbar. It provides a way for you to quickly find the specific clip and collection you are looking for. The Location toolbar is especially helpful if you choose not to display the collections tree next to the collections area.

Figure 7.5 — *The Location toolbar.*

Working in the collections area

The collections area displays the clips that have been imported into your collections. The collections are listed by name in the left pane, and the clips in the selected collection are displayed in the right pane. You can drag clips from the collections area to the current project in the storyboard or timeline, or you can view them by selecting the clip and clicking **Play** on the monitor or by double-clicking the clip.

You will often work in the collections area when you are first organizing your clips and collections, and when you are adding clips to your projects. These topics are discussed in Chapters 9 and 10.

Using the monitor and the monitor buttons

You can use the monitor to view individual clips or an entire project. By using the monitor, you can preview your project before saving it as a movie.

You can use the navigation buttons to navigate through an individual clip or an entire project. Additional buttons enable you to perform functions such as viewing your movie in a full-screen view or splitting a clip into two smaller clips. In addition, you can drag the slider on the seek bar to go to a specific part of a clip or an entire project. Previewing clips and projects and using the monitor area are discussed in Chapters 9 and 10.

Figure 7.6 shows the monitor and the monitor buttons.

Figure 7.6 – *The monitor, seek bar, and monitor buttons.*

The buttons on the monitor let you control the playback of a clip or an entire project. They provide an alternative way of controlling playback rather than using the commands on the **Play** menu. Table 7.4 lists the button names and the menu command equivalents.

Button name	Menu command equivalent
Play	On the **Play** menu, click **Play/Pause**
Pause	On the **Play** menu, click **Play/Pause**
Stop	On the **Play** menu, click **Stop**
Previous Frame	On the **Play** menu, click **Previous Frame**
Next Frame	On the **Play** menu, click **Next Frame**
Back	On the **Play** menu, click **Back**
Forward	On the **Play** menu, click **Forward**
Full Screen	On the **Play** menu, click **Full Screen**
Split	On the **Clip** menu, click **Split**

Table 7.4 – *Monitor buttons.*

Using the storyboard and timeline

The storyboard and timeline are sometimes referred to as the workspace. They are two different views that give you distinct information about your current project.

Storyboard view

The storyboard view, shown in Figure 7.7, is the default view for the workspace. In this view, you can look at the sequence or ordering of the clips in your project and easily rearrange them if necessary. You can also preview the selected clips in the monitor—or all of the clips in your current project when you click an empty area in the storyboard. Unlike the timeline view, audio clips that you have added to the current project are not shown in the storyboard view.

Figure 7.7 – *Movie Maker in storyboard view.*

Timeline view

The timeline view, shown in Figure 7.8, allows you to review or modify the timing of clips in your project. Use the timeline view buttons to perform tasks such as changing the view of your project, zooming in or out on details of your project, recording a narration, or adjusting the audio levels. To trim unwanted portions of your clip, use the trim handles which are displayed when you select a clip.

Figure 7.8 – *Movie Maker in timeline view.*

You can preview the selected clips in the monitor—or all of the clips in your current project when you click an empty area in the workspace.

You can create cross-fade transitions between two adjacent clips by overlapping the clips. Chapter 10 provides details on editing your movies in the timeline view.

Recording Video into Windows Movie Maker

The first step in creating movies with Windows Movie Maker, as you can probably guess, is to get your own videos and existing media files into Movie Maker. You can bring material in through a variety of methods such as importing existing files, like still images, audio, and video, or recording your own existing home videos to your computer. Recording videos to your computer means using your Web camera, analog camcorder, digital video (DV) camera, or VCR, along with an installed capture card, to record live or from tape directly into Movie Maker. You can have one or more of these capture devices attached to your computer. By using a wide range of different media in conjunction with some of the editing features available in Movie Maker, you can create movies that you can share by e-mail or over the Web with family and friends.

Connecting capture devices

The first step in recording with Movie Maker is to set up and configure your capture devices. These devices can include an analog or DV camera, a VCR, a Web camera, or just a microphone.

Before you can use most capture devices, you must have the correct software and drivers installed on your computer. Microsoft Windows Millennium Edition recognizes many of today's most popular capture devices and peripherals. Many times, these pieces of hardware come with software from the manufacturer that needs to be installed before you can use the specific device. When you are installing the device, consult the accompanying documentation to make sure that the device is installed properly.

Because of the wide variety of hardware available, it is nearly impossible to list every possible configuration. However, the list below describes some of the basic capture devices and explains how to connect them to your computer. Remember, depending on the capture device and associated hardware you have on your PC, you could use none, one, or several of the listed configurations.

DV camera connected to an IEEE 1394 (FireWire) card

To get the best quality from your DV or mini-DV camera, you should have an IEEE 1394 capture card installed on your computer. When the DV camera is connected to the IEEE 1394 card, you'll get the high-quality picture you expect from your DV camera. The IEEE 1394 card is simply a piece of hardware that passes the information to your PC. Because the data is already in a digital format, it can be read and transferred directly to your computer without altering the actual bits of the video and audio. This results in the highest-quality video that is possible when using consumer video cameras. Figure 8.1 shows an example of this connection.

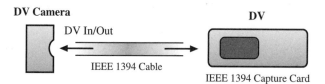

Figure 8.1 – *Connecting a DV camcorder to an IEEE 1394 capture card.*

DV camera connected to an analog video capture card

Even though you have a DV camera, you might not have an IEEE 1394 card. You can still use your DV camera as long as you have another video capture card installed on your computer. However, if you transfer video this way, from a digital device to an analog capture card, you will experience some loss in quality. This is because the data that is passed to the capture card is altered before the computer can use it. Figure 8.2a shows an example of this connection.

When you connect a DV device in this way, there are two main types of input: S-video or composite video. Both result in a loss of quality compared to using an IEEE 1394 capture card. However, if you have the appropriate connectors and your hardware can transfer either S-video or composite video, you'll probably want to use S-video because it results in higher-quality picture and sound. Figure 8.2b shows an example of this connection.

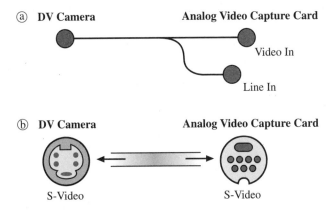

Figure 8.2 – *Connecting a DV camcorder to analog composite or S-video inputs.*

Analog camcorder connected to an analog video capture card

Analog camcorders include cameras that record in formats such as 8mm, Hi-8, VHS, and S-VHS. When recording from an analog camera to an analog capture card, you will not have the picture quality you would experience with a DV camera and an IEEE 1394 capture card. However, when using analog devices, you can use the software that came with your capture card to change some aspects of your video such as hue, saturation, brightness, contrast, and sound volume levels. Figure 8.3 shows a basic analog camcorder connection.

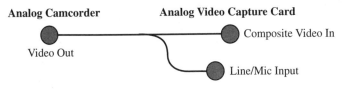

Figure 8.3 – *Connecting an analog camcorder to an analog capture card.*

Some analog camcorders have separate video and audio connections. In this configuration, the inputs could look similar to the one shown in Figure 8.4.

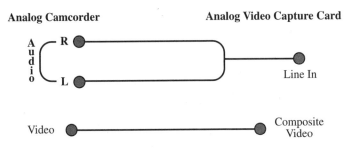

Figure 8.4 – *Using separate video and audio connections.*

Web camera connected to either USB or analog video capture card

The correct way to connect your Web camera to your computer depends on the type of camera you own. Some cameras attach to a USB port, while others may connect to your video capture card. These two pieces of hardware might be shipped together, or may have to be purchased separately. While some cameras can connect to any video capture card, some other Web cameras are proprietary, which means that you must have the appropriate capture card specified by the camera manufacturer for the Web camera to work. Consult the accompanying documentation to determine which applies to your specific Web camera.

Furthermore, some Web cameras have a built in microphone, while others do not. If your Web camera does not have a built-in microphone, you will need a separate microphone to capture sound. Plug it into the jack (often labeled Mic) on your computer or sound card. If you do not have a microphone and your Web camera does not have one built in, you will not be able to record sound without another capture device, such as a camcorder.

Figure 8.5 shows an example of possible Web camera connections. Note that your connection will depend on the type of Web camera you are using.

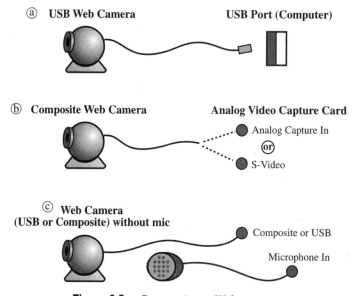

Figure 8.5 – *Connecting a Web camera.*

VCR connected to an analog video capture card

With the growing popularity of video capture cards and TV tuner cards, some people are beginning to use their computers as TVs. For example, if you have cable television, you could attach a coaxial cable from the cable outlet on your wall or the cable decoder box to your VCR. To complete the configuration, you could attach the video out and the appropriate audio connections to your computer. The video out would go to the video in jack on your video capture card (possibly labeled composite), and the audio jack would go to the line in jack of the sound card.

If you have home movies that are on standard VHS tapes, this is one way to get those movies into Movie Maker.

Note If both your VCR and video capture card provide S-video connections, you can connect them with a single S-video cable to transmit both video and sound. See the documentation provided with your VCR and capture card for more information about S-video connections. S-video provides higher-quality pictures and sound than composite video connections.

Figure 8.6 shows an example of connecting a VCR to a computer video capture card.

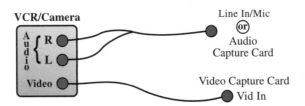

Figure 8.6 – *Connecting a VCR to a video capture card.*

Understanding the Record dialog box

After you have connected your capture devices to your computer, you are now ready to record your home movies or other footage into Movie Maker. This is the main feature of Movie Maker, and recording is made easy through one main starting point, the **Record** dialog box. So whether you are transferring home movies from a tape to your computer or using your Web camera to record a short message to send to a friend, it's all done in one main dialog box.

Figure 8.7 shows the **Record** dialog box when a DV camera is not attached or detected by your computer, or when the DV camera is in Camera (recording) mode.

Figure 8.7 – *The **Record** dialog box.*

Note You may not have the same devices listed as shown in Figure 8.7. As mentioned earlier, Movie Maker supports a wide variety of capture devices.

The **Record** dialog box provides an additional set of controls and another option if you have a DV camera attached to your computer and you switch it to the VCR or VTR mode, which is the playback mode you use to record from a tape into Movie Maker. The additional set of controls and the extra option are circled in Figure 8.8.

Figure 8.8 – *The **Record** dialog box when a DV device is attached to the computer in VCR (playback) mode.*

Before recording your tapes or other material into Movie Maker, it's important to have a solid understanding of the features provided by the **Record** dialog box. The following sections describe the different parts of this dialog box in detail.

Record

When recording, you can choose to record video only, audio only, or both video and audio. A majority of the time, you will probably want to record both the audio and video portions of your movies you are transferring to Movie Maker. After all, a major part of home movies includes the pictures of family and friends with dialog that shows their personality and truly captures the moment.

However, there may be times when you only want to capture the video portion of your movies because you want to personally narrate the scenes or add some other soundtrack. Let's face it, at times the dialog captured in movies does not add to the movie, or the quality of the sound in the movie is not exactly what was expected. In this case, you could record only the video of a home movie, add the resulting clips to your current project, and then record a narration describing the depicted scenes, people, or images. See Chapter 10 for more information about recording narrations.

Video and Audio device

Choosing the correct video and audio devices is essential to recording your source material into Movie Maker. To record successfully, you must choose the correct device and the correct line inputs. If either of these settings is incorrect, your video and audio will not be recorded successfully.

Table 8.1 shows common configurations when choosing the video and audio device settings. In the **Record** dialog box, click **Change Device** to see the devices available for use and to view or change your current recording settings.

> **Note** Remember, the connections on your machine may be different due to the variety of available hardware.

Task	Video device	Audio device	Line input
Record both audio and video from analog tape.	Video capture card	Default audio device	Line In
Record both audio and video from DV tape (DV IEEE 1394 capture card).	DV camera or VCR	DV camera or VCR(You will need to increase the volume of your camera or VCR to hear the audio of your movie. You will not hear the audio on your computer.)	(Already selected or non-applicable)
Record both audio and video from DV tape (analog video capture card).	Video capture card	Default audio device	Line In
Record live video and accompanying audio from a Web camera with a built-in microphone.	Web camera	Web camera microphone (This must be chosen as the audio device.)	(Already selected or non-applicable)
Record live video and accompanying audio from a Web camera without a built-in microphone.	Web camera	Default audio device	Microphone or Mic (if you have a microphone attached to your computer)

Table 8.1 – *Video and audio device settings.*

Note Even if you do not have any capture devices, you can still use Movie Maker. However, you will not be able to record directly into Movie Maker; you can only import existing media files to use in your movies.

For current video capture devices, two basic driver standards exist: Microsoft Video for Windows (VFW) drivers and Windows Driver Model (WDM) drivers. The only difference you're likely to see is the dialog box and the choices provided when you are configuring the device. You will know which standard your device follows by

the dialog box that appears after you click **Change Device** in the **Record** dialog box. A device that uses WDM drivers will have the dialog box with the extra video Line input option if the device has multiple line inputs, whereas a device that uses VFW drivers (or a WDM device that has only one line input) will not provide this option. Figure 8.9 shows the dialog box that is displayed if a capture device uses WDM drivers and has multiple line inputs.

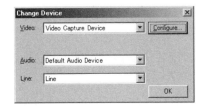

Figure 8.9 – *The **Change Device** dialog box for a device that uses WDM drivers and has multiple line inputs.*

The next two scenarios describe configuring a VFW capture device and a capture device that uses WDM drivers. The specific capture device connected can be a Web camera or analog camcorder.

To configure your analog video device (VFW drivers)

1. In the **Record** dialog box, click **Change Device**. The **Change Device** dialog box, shown in Figure 8.10, appears.

Figure 8.10 – *The **Change Device** dialog box for a capture device that uses VFW drivers.*

2. In the **Change Device** dialog box, select the device you want to use, and then click **Configure**.

3. In the resulting **Properties** dialog box, click **Video Source**. The resulting dialog box depends on the manufacturer of your capture device and the accompanying software.

Typically, you can control recording settings such as:

- Video connection to use.

- Image size.

- Standard to use, usually NTSC or PAL. NTSC is the broadcasting standard used in North America, while PAL is the European stan dard.

- Image format.

- Brightness, contrast, hue, and saturation of your video.

4. Click **OK** or **Close**.

5. After you have made these changes and others for the appropriate **Audio** device and **Line** input to use, click **OK** in the **Change Device** dialog box to return to the main **Record** dialog box and continue to specify your recording settings.

To configure your analog video device (WDM drivers)

1. In the **Record** dialog box, click **Change Device**. For devices with multiple line inputs that use WDM drivers, the **Change Device** dialog box appears, shown in Figure 8.11.

Figure 8.11 – *The Change Device dialog box for a capture device that has multiple line inputs and that uses WDM drivers.*

2. In the **Change Device** dialog box, select the **Video** device you want to use and then select the **Line** to use for the video. The setting you should select depends on how your camera is connected to your capture card

3. In the **Change Device** dialog box, click **Configure**.

4. In the resulting **Properties** dialog box, click **Video Source**. The resulting dialog box depends on the manufacturer of your capture device and the accompanying software. Therefore, you may see a name that is slightly different than **Video Source**.

Typically, you can control recording settings such as:

- Standard to use, usually NTSC or PAL. NTSC is the broadcasting standard used in North America, while PAL is the European standard.

- Your camera controls (for example, pan, tilt, and so forth).

- Settings such as brightness, contrast, hue, and saturation of your video.

5. Click **OK** or **Close**.

6. After you have made these changes and others for the **Audio** device and **Line** input to use, click **OK** in the **Change Device** dialog box to return to the main **Record** dialog box and continue to specify your recording settings.

Record time limit

The **Record time limit** option lets you set a maximum recording time. The value in this option is in the form of hh:mm:ss (hours:minutes:seconds). When a time limit is set, Movie Maker stops recording automatically when the time limit expires. This option is probably most helpful if you are recording long tapes, which may be one or two hours long. This lets you perform other tasks on your computer (or around the house) while your home movie is recording into Movie Maker. After the time expires, you will be prompted to name and save the resulting movie file.

If you have selected the **Auto generate file** check box in the **Options** dialog box, under the **View** menu, Movie Maker automatically names and saves the resulting file. The clip (or clips if **Create clips** is selected) is then imported into a new collection. (Chapter 9 explains how you use collections.) The actual imported video file is stored in the location specified in the **Record file** area in the **Options** dialog box. The files are saved as Tape1.wmv, Tape2.wmv, and so forth. If you chose to record **Audio only**, the resulting files are saved as Tape1.wma, Tape2.wma, and so forth.

The recording time limit depends on the amount of hard disk space you have available on your computer. If you set the limit for an amount of time that exceeds your available hard disk space, the time limit is automatically set according to the maximum amount of hard disk space that is available and the quality setting level that is selected. For example, if you set the **Record time limit** option for two hours and have specified the **Medium quality** setting level, but you only have one hour worth of disk space, the **Record time limit** box is automatically set at 1:00:00. If the content you want to record into Movie Maker requires more disk space, you have to either free up some hard disk space, choose a lower quality setting, or select another drive.

When you are recording, you need to have at least 300 MB of free disk space on your system drive, which is the drive on which the Windows Millennium Edition operating system is installed. For example, if Windows Millennium Edition is installed on drive C, this is your system drive. If the drive set in the **Temporary Storage** box of the **Options** dialog box is the same as the system drive, you will only be able to record content that can be stored on that drive above 300 MB. For example, if you have 301 MB of free hard disk space on your system drive, and **Temporary**

Storage is set to this same drive, you would only have 1 MB available for recording. Table 8.2 shows the drive requirements:

Drive	Free disk space on the Drive (MB)
System drive	300
Swap file	25 (always on your system drive).
Collection	50 (always on your system drive)
Non-system	0

Table 8.2 – *The free disk space necessary for various drives on your computer.*

Create clips

If you are recording a long tape that contains an hour or two of footage, navigating through the entire file to find the specific portion you want to use can be time-consuming. Selecting the **Create clips** option enables shot detection in Movie Maker, where a new clip is created each time an entirely different frame is detected. Clip creation and its use are described later in this chapter.

> **Note** You can permanently turn off the **Create clips** option by clearing the **Automatically create clips** check box in the **Options** dialog box. If you select this option, the **Create clips** check box in the **Record** dialog box will be cleared, and your recorded content appears as one clip in Movie Maker.

Disable preview while capturing (DV only)

Digital devices, such as a DV camera or a digital VCR, consume a lot of system resources on your computer. This in turn affects the performance of your computer and the quality of your recorded videos. One way to reduce the load placed on your computer system is to select the **Disable preview while capturing** check box. When you select this option, you will not see a preview of your movie in the monitor pane of the **Record** dialog box when you are copying a tape from your DV camera to your computer. Many DV cameras have an LCD panel where you could watch your movie as it records into Movie Maker.

This option only appears when a DV device has been detected and the device is set to playback mode. If you do not have any DV devices, this option does not appear when you are recording in Movie Maker.

Take photo button

Sometimes there is a part of a movie that just seems to say it all. In Movie Maker, you can capture that single frame by using the **Take photo** button. When you take a photo, the resulting image is saved to your computer as a JPEG image file, and the resulting clip is imported into the currently selected collection automatically. You can then add this image to your current project.

Just as when you save a video file, the resulting JPEG still image file is saved in your My Videos folder, though you can easily change the location where the photo is saved on your computer.

> **Note** The length of time a photo, and any other still image imported into Movie Maker, appears when inserted into a project depends on the time set in the **Default imported photo duration (seconds)** box in the **Options** dialog box. To set the default duration, type the duration for which you want your photos to appear in a project before using the **Take photo** button or importing other still images into Movie Maker.

Record

The final part of recording is to click the **Record** button to start recording your movie. After you click this button, the word Recording blinks to indicate that you are recording, and the time elapsed for that current recording appears next to it. After recording has begun, the button becomes a **Stop** button that you click when you want to stop recording.

Quality setting options

The quality of your final movie depends on the quality of the captuered source material. Because of this, choosing an appropriate value for the **Setting** options is important. A good rule to follow is to record your videos or movies by using the **Medium quality** or **High quality** settings. Remember, if you want to reduce the file size, you can always save the resulting movie at a lower quality setting after you have recorded it into Movie Maker.

The different **Setting** options you can choose from in Movie Maker affect the following aspects of the video and sound you record:

- The display size of your movie when your end user watches it in Windows Media Player.

- The number of video frames per second.

- The video bit rate, which is the speed at which the video in your movie streams.

- The quality of the audio in your movie.

- The audio bit rate, which is the speed at which the audio in your movie streams.

For example, if you record your movie using the **Medium quality** or **High quality** settings, the video displays as 320 pixels by 240 pixels in both profiles; however, the **High quality** setting captures 30 frames per second (fps), whereas the **Medium quality** setting only captures 15 fps. In general, the smoothness of motion in your video increases with the number of frames per second. Also, the audio quality will be greater with the **High quality** setting because the audio bits stream at a higher rate than they do with the **Medium quality** setting. Remember, the video and sound quality of the final movie you create in Movie Maker directly depends on the quality of the original recording.

You might ask, "If the **High quality** setting is better, why shouldn't I use it all the time?" Basically, the answer is disk space. A movie saved with the **High quality** setting consumes approximately twice as much disk space on your computer as the same content recorded at the **Medium quality** setting. When trying to determine which **Setting** option to use, consider the content or the possible content (if you are recording live from a camcorder or Web camera) of your recording.

For example, if you record a car race, you would probably want to use the **High quality** option rather than **Medium quality**. If you use the **Medium quality** or **Low quality** options, the movement of the cars might appear uneven and jerky because there is not enough information, or bits, in the video to accommodate the rapid movement of the cars. The sounds of the cars racing by will be clearer, too, if you select **High quality**.

Conversely, if you have a video that does not contain a lot of movement, such as a recording of people sitting and talking at a birthday party, you could probably safely use the **Medium quality** setting rather than **High quality**.

If you choose **Audio only** when recording your movies, only the audio portion of your movie is recorded. The profiles to save the resulting audio file change. The profiles you choose from only contain audio information; they do not contain video information because no video is saved. The settings **Low quality**, **Medium quality**, and **High quality** still exist; only the profile descriptions and the content saved are different. For example, if you select **Audio only** and choose the **Medium quality** setting, the profile description is "Audio for CD-quality (96 Kbps stereo)" and only audio is recorded. However, if you choose to record **Audio and video**, or **Video only**, the description for the **Medium quality** setting is "Video for e-mail and dual-channel ISDN (128 Kbps)" and either the audio and video, or only the video, is recorded.

For all profiles, whether you choose **Video and audio**, **Audio only**, or **Video only**, you'll notice that the information below the setting also changes, such as the profile

name, settings, and the amount of material you can record at that setting. The amount of time remaining is based on the amount of hard disk space you have available. Movie Maker determines this disk space according to the drive specified in the **Record file** area of the **Options** dialog box when the **Auto generate file** check box is selected. If the **Auto generate file** option is not selected, Movie Maker examines the amount of disk space on the drive specified in the **Temporary storage** box in the **Options** dialog box. This is important to know if you have more than one hard drive or if your hard disk is partitioned because you can choose which drive to save your recorded movies on.

As a general rule to follow, it is always better to choose a higher quality setting when recording. If you choose to record at a low quality setting, then save your movie at a higher quality setting, the quality of your saved movie will not increase. If you wanted to increase the quality of your saved movie, you would have to re-record the content at a higher quality setting, re-create your project, and then save your movie again at the higher quality setting.

The quality settings used during recording are the same ones used when you are saving and sending your movie. However, when saving a movie that you are going to send by e-mail or over the Web, other considerations, such as Internet connection speed and bandwidth, need to be made. For more information about choosing quality settings when saving and sharing movies with others, see Chapter 11.

Digital video controls (DV only)

The digital video camera controls let you control your DV camera through Movie Maker. They only appear when the camera is in playback mode (often labeled VCR or VTR on your camera) and connected to an IEEE 1394 capture card. Using the controls in Movie Maker lets you start and stop playback and recording from your computer. By controlling recording entirely in Movie Maker, you do not have to toggle back and forth between the controls on the DV camera and the ones in Movie Maker.

Recording a live source

Sometimes, you may want to record live into Movie Maker. For example, there are times when you might want to compose a simple video message using your Web camera and then send the brief greeting to a friend by e-mail. This is a popular use of a Web camera. Perhaps, there is another reason you want to record live. For example, you might be at a birthday party where everyone is in one area of the house and your camcorder or DV camera is connected to your computer and recording the festivities directly into Movie Maker.

If you want to record live into Movie Maker, you will need at least one of the following capture devices:

- A DV camera

- A Web camera

- An analog camcorder

- A TV tuner card (for recording TV broadcasts)

The following scenario describes how to tape a short video message for your movie. Because of the wide variety of devices that can be used to record live into Movie Maker, two of the most popular methods are described: from a camcorder (DV or analog) and from a Web camera. Both scenarios accomplish the same task, which is to create a short greeting.

To record live from a camcorder (DV or analog)

1. Make sure your camcorder is connected to your computer properly.

2. Switch the camera to the **Camera** position (or the position the camera needs to be in if you want to record). The camera should now be in Standby mode, but not recording to tape.

 Note Some cameras will shut off automatically if they are in Standby mode for a certain period of time. If this occurs, switch the camera from the **Camera** position, to the **Off** position, and then back to the **Camera** position. This turns the camera off and then back on, so you can continue recording live into Movie Maker. With most cameras, removing the tape from the camera prevents it from shutting off.

3. On the **File** menu, click **Record**. This opens the **Record** dialog box, which is described in the previous sections of this chapter.

4. Click **Change Device** in the **Record** dialog box. This lets you select your camcorder (DV or analog) as shown in Figure 8.12

Figure 8.12 – *The **Change Device** dialog box to select an analog or DV camera.*

The video device that is displayed by default is based on the last capture device you used when recording. Any new device detected by your system is selected before the previously used device. Since DV cameras are added each time you turn the DV camera on, the DV device is selected as the default video device if it is on at the time you launch the **Record** dialog box.

> **Note** If you are using an analog camera or a DV camera attached to an analog capture card, you will see an additional **Line** value for the **Video** setting if your capture device has multiple line inputs and uses WDM drivers. If so, choose the appropriate **Line**, depending on the physical connection of your camera to your capture card.

If you only have this one capture device attached to your computer and recognized by Movie Maker, the camera is selected by default and you can go to the next step.

5. The selected **Audio** device depends on your camera and capture card configuration.

 - **DV camera connected to an IEEE 1394 card**. When you select the DV camcorder, the **Audio** capture device automatically changes to the camera as well; the DV device captures the video and audio of your movie.

 - **DV or analog camera connected to an analog capture card**. The default **Audio** device on your system is selected. Choose the appropriate **Line**. For this configuration, the **Line** should be **Mic** or **Microphone** if you have a microphone attached to your computer or **Line in**. The specific configuration depends on the particular capture devices, connections, and camera you are using.

6. For this short clip, because it is only a short greeting, clear the **Create clips** check box. Because the **Create clips** option is cleared, the video is imported as one clip after it is recorded.

7. Clear the **Record time limit** check box because you want to control the recording process. This lets you start and stop recording manually.

8. For the **Setting** box, click **Medium** quality. The Medium quality setting is appropriate for this segment because you are only recording video that shows a person talking.

9. If you want, click the **Take photo** button to capture and save a still image of yourself. In the **Save Photo** dialog box, name the image **Myself.jpg** and click **OK**. The photo is then imported into the currently selected collection automatically, and the **Record** dialog box remains open.

> **Note** You might have to drag the **Record** dialog box to one side of your screen to see the imported photo clip.

10. To begin recording, focus on your subject (which could be yourself talking), click **Record**, and begin recording a short 10 to 20-second greeting. This greeting can be something simple like, "Here is my vacation movie."

> **Tip** After you click **Record**, the monitor in the **Record** dialog box appears empty. Wait for the video to reappear before beginning to record your video so that the beginning of your video is not cut off. If you have extra footage that you don't want, you can later trim the unwanted portion.

If you need to adjust the brightness, contrast, or color balance, and you are recording from an analog camcorder, use the software that came with your capture card to adjust these settings. For a DV camera that is connected to an IEEE 1394 capture card, use the controls on the camera as you normally would to get the picture and audio quality you want.

The short greeting you record is only recorded into Movie Maker; it is not recorded to the tape in the camera. If you want to record simultaneously to tape as well, press the **Record** button on your camera.

11. After you have completed your short message, click **Stop** to end recording. The **Save Windows Media File** dialog box then appears.

12. In the **File name** box, type **Chapter 8 Live Camera**, and then click **Save**. The **Record** dialog box closes, and the clip, named Clip 1, from the short message you recorded is imported into a new collection named Chapter 8 Live Camera. The file is given a .wmv file extension automatically.

> **Note** The file containing your recorded video is saved in the My Videos folder on your computer. It is recommended that you save your recorded movies in this folder; however, you can choose any folder on your computer.

13. To play the short video in Movie Maker, click **Clip 1**, and then click **Play** on the monitor. The short clip plays in the monitor.

To record live from a Web camera

1. Make sure your Web camera is connected properly to your computer and turned on.

2. On the **File** menu, click **Record**. This opens the **Record** dialog box, which is described in the previous sections of this chapter.

3. Click **Change Device** in the **Record** dialog box. This lets you select your Web camera as shown in Figure 8.13

Figure 8.13 – *The **Change Device** dialog box to select a Web camera.*

Note If you only have this one capture device attached to your computer and recognized by Movie Maker, the Web camera is selected by default and you can go to the next step. If your Web camera has multiple line inputs and uses WDM drivers as discussed earlier in this chapter, you will need to choose the appropriate **Line** for the camera.

4. In the **Change Device** dialog box, click **Configure**. This opens a dialog box that lets you control the settings for your Web camera. After you have made the appropriate changes, click **Close** or **OK** in the **Properties** dialog box, depending on the specific button name in the dialog box.

 Note The dialog box to control the settings for your Web camera depends on the type of Web camera you have. Many times, you can adjust the settings for your Web camera such as the brightness, contrast, video size, or exposure levels through the dialog box. Again, the options vary from manufacturer to manufacturer.

5. For the **Audio** device setting, do one of the following before you click **OK** in the **Change Device** dialog box:

 • If your Web camera has a built-in microphone, select it as the audio device. It usually appears as the camera name with Mic or Microphone in the option name.

 • If your Web camera does not have a built-in microphone, you can still record audio if you have a microphone connected to your computer through the microphone jack. In this case, choose the audio source from your computer for the **Audio setting**, and then choose **Microphone** (sometimes listed as **Mic**) for the **Line** value, if one is listed.

6. Before recording using your Web camera microphone or an attached microphone, check the microphone recording level. To do this:

 1. Click **Start**, point to **Settings**, and then click **Control Panel**.

 2. In the **Control Panel**, double-click **Sounds and Multimedia**, and then click the **Audio** tab.

3. In the **Sound Recording** area, choose the device you are using to record the audio. This is either the microphone on your Web camera or the microphone connected to your computer using the default audio device.

4. Click **Volume** to open the **Recording Control**. Drag the slider to the middle of the slider bar. This adjusts the volume of your recording.

5. Close the **Recording Control**, click **OK** in the **Sounds and Multimedia Properties** box, and then close the **Control Panel**.

7. In Movie Maker, clear the **Create clips** check box. Because the **Create clips** option is cleared, the video is imported as one clip after recording.

8. Clear the **Record time limit** check box because you want to start and stop the recording process manually.

9. For **Setting**, click **Medium quality**. The **Medium quality** setting is appropriate for this segment because you are only recording video that shows a person talking, which does not require a higher quality setting.

10. If you want, click the **Take photo** button to capture and save a still image of yourself. In the **Save Photo** dialog box, name the image **MyselfWeb.jpg** and click **OK**. The photo is then imported into the currently selected collection automatically, and the **Record** dialog box remains open.

 Note You might have to drag the **Record** dialog box to one side of your screen to see the imported photo clip.

11. To begin recording, focus on your subject (which could be yourself talking), click **Record**, and begin recording a short 10 to 20-second greeting.

 Note If you need to adjust the brightness, contrast, or color balance, click **Change Device**, then click **Configure**, and then use the software provided with your Web camera to change these settings.

12. After you have completed your short message, click **Stop** to end recording. The **Save Windows Media File** dialog box then appears.

13. In the **File name** box, type **Chapter 8 Web Camera**, and then click **Save**. The **Record** dialog box closes, and the clip, named **Clip 1** is imported into a new collection named Chapter 8 Web Camera.

14. To play back the clip in Movie Maker, click the clip and then click **Play**.

Recording from tape

Chances are if you own or have access to a camcorder, you have some home movies on tape already. One of the main functions of Movie Maker is to get these movies

off your tapes and onto your computer. You can record tapes from the following sources as long as they are correctly attached to your computer, properly installed, and recognized by Movie Maker:

- From an analog camera (for example, 8mm or S-VHS tape)

- From a VCR

- From a DV camera

The following scenarios describe how to transfer a complete tape of a home movie to your computer with Movie Maker. For this scenario, you will need to have some type of taped footage available to use. There are separate scenarios for transfer from analog (VCR or camcorder) and DV tape because some steps are different. Depending on your tape format, either analog or DV, complete one of the following scenarios.

> **Note** If your DV camera is connected to an analog capture card, follow the steps for transferring movies from analog tape to your computer. Because the DV camera is not connected to an IEEE 1394 card, Movie Maker recognizes it as an analog connection.

To transfer movies from analog tape (in VCR or camcorder)

1. Make sure the capture device you want to use is connected to your computer properly, and cue the tape to the point where you want to begin recording.

2. On the **View** menu, click **Options**, and then click **OK** when you have done one of the following:

 - If you want your movie to be automatically named and saved once the record time limit (if it is selected) in the **Record** dialog box expires, click the **Auto generate file** check box, and then select the location where you want your movie to be saved. The file is automatically saved when the record time limit expires.

 - If you want to name and save the movie yourself, clear the **Auto generate file** check box.

 > **Note** Choose the partition on your hard disk drive that has the most free disk space so you can record the full length of the tape. After the video file is recorded, you can always copy it to a different location as long as you have the disk space available.

3. On the **File** menu, click **Record**. This opens the **Record** dialog box, which is described in the previous sections of this chapter.

4. For the **Record** option, select **Video and audio** so that both parts of your video are recorded.

5. Click **Change Device** to select the device to use to record the movie. In most situations, if you are capturing from an analog device such as an analog camcorder, select the video capture card that the analog camera is attached to as the video device to use.

6. In the **Change Device** dialog box, choose the audio device that the camera is attached to use. You will want to select the default audio on your computer, though this again depends on your capture card.

 Note Some capture cards let you record both audio and video. In this situation, you would want to select the device to which the audio cable is connected.

7. For **Line**, you usually want to choose **Line In** as the connection. Again, because of the wide variety of capture devices and configurations, this may be different for your particular setup. The **Change Device** dialog box, once configured, should look similar to the one shown in Figure 8.14.

Figure 8.14 – *Recording from an analog device.*

 Note The names of the capture devices for your own computer will be different from those shown in Figure 8.14.

8. Click **OK** to return to the main **Record** dialog box.

9. Select the **Record time limit** check box, and enter the time limit. For example, if you have a tape with one hour of footage and you want to record the whole tape, set the limit for one hour.

 When setting the time limit, consider setting the limit for a few minutes longer than the actual tape so the end does not get cut off if the tape runs a minute or two longer. Remember, you can always trim, or hide, unwanted parts of your movie when you edit the resulting clip in Movie Maker. Trimming and editing projects is discussed in Chapter 10.

 Note Even if you select the Record time limit check box, you can still stop recording before the time limit expires and save the recorded portion.

10. Because the amount of footage is quite large, select **Create clips** so your movie is broken down into smaller clips. This will help you find a specific clip or part of your video when you are ready to create your movie in Movie Maker.

11. Depending on the contents of your movie, choose the appropriate **Setting** value. If you have the hard disk space available, consider using the **High quality** setting. Remember, after your video is recorded in Movie Maker, you can always save the movie you create at a lower quality setting to save disk space, but you cannot increase the quality once it is recorded into Movie Maker.

12. In the **Record** dialog box, click **Record**. The **Record** button becomes a **Stop** button, and the word Recording blinks indicating that you are now recording.

13. Depending on the device you are using, do one of the following:

 - If you are recording from an analog camera, switch the camera to the playback mode (usually labeled VCR or VTR).

 - If you are recording from a VCR, press the Play button on the VCR.

 Note When recording from a tape, click **Record** in Movie Maker and then begin playing back your tape. This prevents the beginning of your tape from being cut off.

14. After the time limit has expired:

 - The movie is saved as **Tape 1.WMV** if you selected the **Auto generate file** check box.

 - You must name and save the movie yourself if you did not select the **Auto generate file** check box. If you choose this option, in the **File name** box, type **Chapter 8 Analog Tape**.

 Note You can stop recording before the time limit expires by clicking **Stop** in the **Record** dialog box. After you stop recording, the **Save Windows Media File** dialog box appears, prompting you to name and save your recorded video.

15. On the camera, press the Stop button to end playback of the tape in the camera. This lets you continue recording from that point in the tape if you choose.

16. Independent of which option you chose, the resulting clips are imported into a new collection in Movie Maker. Depending on the option you chose, the resulting collection will either be named **Tape 1** or **Chapter 8 Analog Tape**.

To transfer movies from a DV device connected to an IEEE 1394 card

1. Make sure your DV capture device is connected to your computer properly.

 Note When you first turn on your DV camera, it must be detected by the operating system. For some cameras, this process can take up to two minutes. Therefore, you have to wait for the camera to be detected before you can record with it.

2. Switch your DV camera to the playback position, often labeled VCR or VTR on DV cameras.

Note Make sure the DV camera is turned on before you click **Record** so that Movie Maker can properly detect the camera.

3. On the **View** menu, click **Options**, and then click **OK** when you have done one of the following:

- If you want your movie to be automatically named and saved once the record time limit (if it is selected) in the **Record** dialog box expires, click the **Auto generate file** check box, and then select the location where you want your movie to be saved.

- If you want to name and save your movie yourself when the time limit expires, clear the **Auto generate file** check box.

Note Choose the partition on your hard disk drive that has the most free disk space so you can record the full length of the tape. After the video file is recorded, you can always copy it to a different location as long as you have the disk space available.

4. In Movie Maker, on the **File** menu, click **Record**. If your DV camera is connected to an IEEE 1394 card, one of the following dialog boxes appear:

- If your processor speed is less than 600 MHz, the dialog box shown in Figure 8.15 appears before the **Record** dialog box displays.

Figure 8.15 – *The warning dialog box that appears if the processor speed of your computer is less than 600 MHz.*

If the warning dialog box shown in Figure 8.15 appears, click **Yes** to continue recording.

- If your processor speed is 600 MHz or greater, the dialog box shown in Figure 8.16 appears before the **Record** dialog box is displayed.

Figure 8.16 – *This dialog box displays if your processor speed is 600 MHz or greater.*

In the dialog box shown in Figure 8.16, you have the option to:

- **Automatically start recording my video from the beginning of my tape**. This option automatically rewinds the tape to the beginning and then starts recording.

- **Begin recording my video from the current position on my tape**. This option automatically starts recording from the current part of your tape.

- **Use Default Recording Device**. This option lets you manually control the recording process.

 For this exercise, if the dialog box shown in Figure 8.16 appears, click **Use Default Recording Device**, and then click **OK**.

5. In the **Record** dialog box, click **Change Device**. In the **Change Device** dialog box, choose your DV camera for the video capture device. It should already be selected as the default device. For the audio source, the same DV device specified in the **Video** box is automatically selected.

6. Click **OK** to return to the main **Record** dialog box.

7. Select the **Record time limit** check box, and enter the time limit. For example, if you have a tape with one hour of footage and you want to record the whole tape, set the limit for one hour.

 When setting the time limit, consider setting the limit for a few minutes longer than the actual tape so the end does not get cut off if the tape runs a minute or two longer. Remember, you can always trim, or hide, unwanted parts of your movie when you edit the resulting clip in Movie Maker. Trimming and editing projects is discussed in Chapter 10.

8. If you are recording a long video segment, select the **Create clips** option so that your movie is broken down into smaller clips. This will help you find a specific clip when you are ready to create your movie.

9. Depending on the contents of your movie, choose the appropriate **Setting** value. If you have the hard disk space available, consider using the **High quality** setting. Remember, after your video is recorded in Movie Maker, you can always save the movie at a lower quality setting to save disk space, but you cannot increase the quality once it is recorded into Movie Maker.

10. To preserve system resources, select the **Disable preview while capturing** check box. When you are recording your video, you will not see a preview. However, if you are just playing your movie, it will still appear in the monitor of the **Record** dialog box.

11. Use the controls in the **Digital video camera controls** area to cue the tape to the point where you want to begin recording. You can also use the controls on your DV camera.

12. When you are ready to record, click the **Record** button in the **Record** dialog box. Your tape begins to play back and record into Movie Maker. The **Record** button becomes a **Stop** button, and the word Recording blinks indicating that you are now recording.

13. After the time limit has expired:

 - If you selected the **Auto generate file** option, the movie is saved as **Tape 1.WMV.**

 - If you did not select the **Auto generate file** check box, you must name and save the movie yourself. In the **Save Windows Media File** dialog box, type **Chapter 8 DV Tape** for the **File name**, and click **Save**.

 You can stop recording before the time limit has expired by clicking **Stop** in the **Record** dialog box. After you stop recording, the **Save Windows Media File** dialog box appears prompting you to name and save your recorded video. Unlike recording with an analog device, playback of the tape in the DV device stops automatically when you stop recording in Movie Maker.

14. The resulting clips are imported into a new collection in Movie Maker. Depending upon the option mentioned in the previous step, the clips appear in a new collection named **Tape 1** or **Chapter 8 DV Tape**.

Importing files

You may have material such as existing photos, audio clips, or other video files stored on your computer that you want to use in your movies. You can use these files after you import them into Movie Maker. When you import a file, a clip that refers to the file is created. Clips are the basic building blocks of your movie. The combi-

nation of clips, when added and arranged on the storyboard or timeline, forms you entire movie.

Movie Maker lets you import many different file types, including the following:

- Video files with an .asf, .avi, or .wmv file extension.

- Movie files with an .mpeg, .mpg, .m1v, .mp2, .mpa, or .mpe file extension.

- Audio files with a .wav, .snd, .au, .aif, .aifc, .aiff, .wma, or .mp3 file extension.

- Windows Media-based files with an .asf, .wm, .wma, or .wmv file extension.

- Still images with a .bmp, .jpg, .jpeg, .jpe, .jfif, .gif, or .dib file extension.

When you import a file that is not a video, the corresponding clip is stored in the currently selected collection. For example, in the scenario shown in Figure 8.17, all the clips that are not video clips would be imported into the selected collection named mountranier.

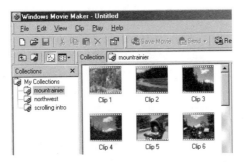

Figure 8.17 – *A selected collection named mountrainier.*

You may also have existing video files stored on your computer that you want to include in your movie. When you import a file that contains video, such as an .avi, .mpeg, or an existing Windows Media-based file, a new collection is created and the corresponding clip or clips are imported into a new collection. The new collection is named according to the video file name. For example, if you import a video named Forest.avi, a new collection named Forest would be created with the clips containing parts of that movie file. If you import several videos at one time, a new collection is added for each video file. See Chapter 9 for information about organizing your clips and collections.

When importing video files, think about how you are going to use the video in your movie. For example, if you have a video file that you are going to edit, you would want to enable the **Create clips for video files** option in the **Select the File to Import** dialog box (and the **Record** dialog box described earlier in this chapter).

Figure 8.18 shows the **Select the File to Import** dialog box with **Create clips for video files** selected.

Figure 8.18 – *The **Select the File to Import** dialog box with the **Create clips for video files** option selected.*

If clip creation is selected, Movie Maker breaks down the video file into clips. Clips are created when an entirely different scene or background is detected by a process called shot detection. When importing a video file, think about what it contains and how you plan to use it in your movie. If the video contains footage that you plan on using as a whole, such as a short introduction to your movie recorded using your Web camera, you might want to clear the **Create clips for video files** check box so the scene is imported as one entire clip. However, if you have a longer video file that you want to use only portions of, you probably want to enable clip creation. This makes it easier for you to find the specific clips you want to add to your movie.

Clips can be created by means other than shot detection. When a video file that has been recorded with a DV device is imported into Movie Maker, and **Create clips for video files** is selected, clips are created based on the date and time stamp placed in the file by the DV camera. When a Windows Media-based file is indexed and clip creation is enabled, clips are based on the file markers in the Windows Media-based file.

> **Note** As an alternative to using the **Import** command on the **File** menu, you can click and drag supported multimedia files from Windows Explorer directly into Movie Maker. The corresponding clips are then added to your collections.

To import files into Windows Movie Maker

1. Select the collection named **My Collections**. On the **File** menu, point to **New**, and then click **Collection**. Type **Chapter 8 Import** for the collection name and select this collection. This is the folder that the clips, which represent the imported source files (that are not video or movie files), are imported into.

2. On the **File** menu, click **Import**. The **Select the File To Import** dialog box appears. The default location specified in the **Import path** box on the **Options** dialog box appears. This is the path Movie Maker first displays when you want to import a file.

 Note If you keep all your content files under one folder, you can specify a new default import location by clicking the **View** menu, selecting **Options**, and then typing the folder name in the **Import path** box. This location is then automatically opened when you import files in the future.

 For exercises in this book, set your **Import path** to *DriveLetter*:\Tutorials if you copied the sample files from the CD to you computer system as mentioned in the beginning of this book. In this sample, *DriveLetter* should be substituted with the drive where you copied the files. For example, if you copied the Tutorials folder to your C drive, the **Import path** would read **C:\Tutorials**. All of the files used in the scenarios throughout the book are found in the Working folders for the specific chapter number under the main Tutorials folder.

3. Locate subfolder **Working** under **Chapter 8** on your computer. For example, if you copied the files in the Tutorials folder from the companion CD to your computer hard drive, and your hard disk letter is C, you would go to C:\Tutorials\Chapter 8\Working to find the specific files.

4. Hold down CTRL and then click the following files:

 - **MountRainier.wmv**

 - **Mountain1.jpg**

 - **Mountain2.jpg**

 - **Spacey.wav**.

5. Clear the **Create clips for video files** option so that the video file MountainRainier.wmv is imported as one clip.

6. Click **Open**. The following clips are created in the **Chapter 8 Import** folder: Mountain1, Mountain2, and Spacey.

 The clip for the MountRainier.wmv video appears as Clip 1 in a new collection named MountRainier because video and movie files are imported into new collections.

7. You can add these clips to the storyboard or timeline to create a new movie. Adding clips to your project and then editing it is discussed in Chapter 10.

The next chapter discusses strategies for keeping your clips and collections organized in Movie Maker.

Organizing Your Clips

After you have recorded or imported source material and files into Windows Movie Maker, it is time to organize your clips. Organizing your clips takes time, but the benefits are tremendous. The few minutes you take to organize your clips can help you save time further in the moviemaking process so you can spend your time doing the fun things like making the actual movie.

If clips are unorganized and just placed wherever, finding the right clip when you need it becomes difficult, time-consuming, and frustrating. If you can't find a clip you want, you may need to re-import the original source file, which takes time and further adds to the chaos in the collections area where clips and collections appear. The goal of this chapter is to help you avoid a cluttered collections area so you can quickly find the clips you need to make your movies.

After reading this chapter, you will be able to answer questions such as:

- How do I work with clips in the collections area?

- What are some strategies for organizing collections?

- How do I view and change clip properties?

- How do I move or copy clips between collections?

- How do I back up my collections file?

- How do I restore my collections file if it becomes corrupted?

Working in the collections area

A clip is the most basic part of a movie in Movie Maker. Clips come from an imported file or recorded material. Clips are pointers to the original source files, and you use the clips to create content in Movie Maker. A clip is created when you:

- Import a still image, video, or an audio file.

- Record content in Movie Maker.

- Record a narration.

- Take a photo.

In Movie Maker, clips are stored within collections, which are containers for one or many clips. The collection folders are displayed in the collections area.

Figure 9.1 shows the different parts of the collections area. The collections tree in the left pane shows the individual collections, while the clips contained within the selected collection are shown in the right pane.

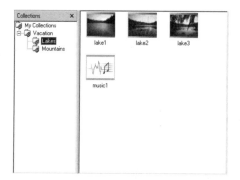

Figure 9.1 – *The collections area in Movie Maker.*

The collections area shows all the available clips you can work with to create your movie. Therefore, it is the starting point for creating movies to share with others. By working in the collections area, you can organize and work with your clips before adding them to the storyboard or timeline. Working with clips in this area lets you:

- Name clips
- Preview clips
- Change clip properties
- Change display views
- Put clips into collections

Naming clips

A clip is named automatically once it is created in Movie Maker. If the imported clip is a still image or audio file, the clip has the same name as the source file without the file name extension. For example, if you imported an image file named mountain.jpg, the clip is named mountain. However, if you import a video or movie file, the resulting clip (or clips if clip creation is selected) is given a generic name, such as Clip 1, Clip 2, Clip 3, and so forth. If you imported another video or movie file, those corresponding clips appear in a new collection, but they follow the same naming convention of Clip 1, Clip 2, and so forth. In this case, the clip name is both

generic and duplicated. Also, if you had selected to create clips, the thumbnail image of the individual clip might not be an accurate picture of what is shown in that clip.

If you own a digital camera and you transfer the images from your camera to your computer, the images are often assigned vague names such as Image001.jpg, Image002.jpg, and so forth. If you import these images into Movie Maker, this naming convention would be applied for the clip names as well. This is another instance where you should rename files, so you can quickly find your clips and start the fun part of creating movies.

You can give your clips descriptive names. A clip name can have up to 255 characters. Although you can use up to 255 characters, it is best to keep the names as short as possible while still giving each clip a name that is unique and appropriate to the content. You can employ any naming convention you like, but try to choose one that lets you quickly and easily identify the clips you want to add to your current project.

When a clip is added to your current project and the project is later saved as a movie, the clip name acts as a file marker in Windows Media Player. This file marker lets your end users go directly to that portion of your movie when they watch it in Windows Media Player. By naming your clips descriptively, your family and friends can go to the exact part of the movie they want to see. This is particularly helpful if you create a longer movie, and your viewers only have a few minutes to watch it. For example, your movie might contain vacation footage from your trip to the lake that shows you and your family fishing. Your end users may not want to watch the video of you and your family sitting in the boat; they might just want to see the fish you caught. You could name the clips that show the fish, and then viewers can go to the parts of the movie that shows the fish you caught when they watch it in Windows Media Player.

To name a clip

1. On the **File** menu, click **Import**.

2. Go to the **Working** folder under **Chapter 9**, select the **Create clips for video files** check box, click the video file **Waterfalls.wmv**, and then click **Open**. The clips are imported into a new collection and generically named because of the time stamp placed by a DV camera.

3. In the collection named **Waterfalls**, click **8/29/2000 1:12 PM (1)**.

4. On the **Edit** menu, click **Rename**. Type **Upper Sol Duc Falls** for the new clip name.

You can also rename a clip by using a keyboard shortcut. Click the clip named **8/29/2000 1:02 PM (1)** and then press **F2**. Type **Lower Sol Duc Falls**. Now, when you go to start your movie, you can easily identify and add these clips to your current project.

Previewing clips

You can see what's in a clip before adding it to your project by previewing it from the collections area. This lets you see the content of the clip in the monitor area, so you know it's the clip you want to add when making your movie. The monitor area has several buttons that let you play the clip or navigate to the specific portion of the clip you want to see when you preview the clip from the collections area. The buttons are like the buttons on a VCR; they can be thought of as the fast-forward, rewind, and play buttons for your computer. However, to fast forward or rewind a current clip, you must hold down the respective button, since these buttons only move from one frame to the next.

Drag the shuttle control on the seek bar to move quickly to the specific part of the clip you want to find. The seek bar is the line the shuttle control moves along to indicate which part of the clip is currently playing or selected. For example, you can use the shuttle control on the seek bar to go to the part of the clip where you want to split it.

To preview a clip

1. In the collection **Waterfalls**, click the clip named **Upper Sol Duc Falls**, and then click **Play** on the monitor. You can also double-click the clip to play it.

2. Click **Pause** on the monitor when the clip playback time is at about 4 seconds. The monitor displays the current frame where you stopped playback. The time in the form of hours:minutes:seconds.frames in the lower part of the monitor area indicates the playback time.

3. Click and drag the shuttle control to about 0:00:02.00.

4. Click the **Next Frame** or **Previous Frame** buttons to move backward and forward between frames, if necessary.

5. Press and hold down the CTRL key, click the **Lower Sol Duc Falls** clip in the same collection, and then click **Play**. Both clips now play in the monitor. Holding down the CTRL or SHIFT key lets you select multiple clips. Holding down the SHIFT key lets you select clips that are contiguous; holding down the CTRL key lets you select non-contiguous clips.

6. Click **Stop** on the monitor at about 0:00:20.00. The monitor is empty.

When viewing clips in the collections area, you can play them using the full screen of your computer monitor. When you preview a clip in the full-screen view, you must use keyboard commands to play and stop your movie.

Table 9.1 lists keyboard commands that are used when you preview the clip using the full-screen view. These same keyboard commands can be used when:

- You preview a clip or multiple clips from the collections area inaker monitor.

- You preview a clip or all the clips in your current project in monitor.

- You preview a clip or the entire project in the full-screen view.

Task	Keyboard shortcut
View movie using the full-screen view	ALT+ENTER
Play/Pause	SPACEBAR
Stop playback	PERIOD
Next frame	ALT+RIGHT ARROW
Previous frame	ALT+LEFT ARROW
Return from full-screen playback	ESC

Table 9.1 – *Keyboard commands for previewing clips in a full-screen view.*

To preview a clip in the full screen

1. Press and hold down the CTRL key, and then click the **Upper Sol Duc Falls** and **Lower Sol Duc Falls** clips in the **Waterfalls** collection. On the monitor, click **Next Frame**. The first frame appears in the monitor.

2. Click the **Full Screen** monitor button. The video is now cued in the entire computer monitor screen.

 Note When you preview a clip or play a movie in the full-screen view, the video may have small squares in the video. This is called pixelation, and it occurs because the video has been stretched. Normally, the pixels in the video are the same size as the pixels on your computer screen. When you stretch the video picture to fill the screen, the pixels in the video will seem much larger.

3. Press the SPACEBAR to play or pause the clip. The clip plays the first time you press the spacebar, and then stops the next time you press it.

4. Press ALT+RIGHT ARROW to move to the next frame in the clip, and then press ALT+LEFT ARROW to move to the previous frame.

5. When multiple clips are selected, press CTRL+RIGHT ARROW to move to the next clip, and then press CTRL+LEFT ARROW to move to the previous clip.

6. Press **ESC** to return to the regular view in Movie Maker. The clip continues in its state from the full-screen view. For example, if the video was playing when

you pressed ESC, the current clip continues to play when you return from the full screen.

Working with views in the collections area

In Movie Maker, you can choose how you want your clips to display in the collections area. You can choose to display your clips as thumbnails, with details, or in a simple list. The main purpose of working in the different views is to help you quickly identify and add the clip you want to your movie. Each view provides you with a different perspective of the clips in your collections.

The three different views in the collections area are:

Thumbnails view

The thumbnail view lets you see a bitmap image of each clip in the collections area. In this view, you can quickly recognize the clip and determine whether it is audio, a photo, or video by looking at the associated icon.

Figure 9.2 shows a sample of the collections area in the thumbnails view with three different clips labeled. The clip named Lake 3 is a photo, which is shown by a bitmap image of the actual clip. Clip 1 is a video; video clips have edges with small squares that represent film or video. Finally, clip Music 1 is an audio clip. Audio clips have an icon with musical notes. These three different icons are only shown in the thumbnail view of the collections area.

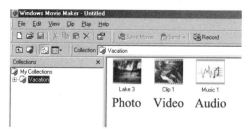

Figure 9.2 – *Three different types of clips in the thumbnails view.*

List view

The list view displays only the clip name with a small icon next to each clip. The different icons represent audio, photo, or video clips. This view is useful if you know what each clip contains, and you want to find and add clips to your current project quickly.

Figure 9.3 shows a sample of the collections area with the three different clips displayed in the list view.

Figure 9.3 – *Three different types of clips in the list view.*

Details view

The details view displays the clip name various properties of each clip. The displayed date is the date you imported the clip into your collections. The start time indicates the beginning of the clip, while the end time is the time the clip ends playback. The icons for the different clips in list and details view are similar.

Figure 9.4 shows a sample of the collections area with the three different clips in the details view.

Figure 9.4 – *Three different types of clips in the details view.*

Changing clip properties

Movie Maker clips contain properties that provide you with information about the clip. These properties are helpful when planning and producing your movie. By viewing the clip properties, you can see the clip's name, its playback duration, and the source file from which the clip was created. In the collections area, you can change the following clip properties:

Title

This is the name you give the clip. It appears as a file marker when your movie is played in Windows Media Player. This clip name is also shown when you move your mouse over a clip after you have added it to your current project in Movie Maker.

Author

This is the name of the person who created the clip. This property is completed automatically using the name specified in the **Default author** box of the **Options** dialog box.

Date

This is the date the file was imported into your collections. You can change this date by selecting a different date from the drop down list. The date property can be helpful if you have similar clips that contain minor changes or editions. You can look at the date property to determine which clip is the one you want to add to your current project.

Rating

This is the rating you can assign a clip. Your rating can be based on the type of content or the quality of the content.

Description

This is a short description you type for the clip. This is especially helpful if you have two similar clips that contain only slightly different content. By entering the description, you could type information that helps you tell the difference between the similar clips when you are making your movie.

Several other properties, which cannot be changed, also appear. These properties include:

Type

This property indicates what type of content the clip contains. The three possible types are audio, photo, and video.

Source

This property shows where the source file for the clip is stored on your computer. The source is an important clip property because it indicates what source file you have to edit to change the actual clip.

Length

This property shows the length of the clip in hours:minutes:seconds (h:mm:ss). The length property is ideal for determining if a video or audio clip will fit into your current project. For example, you may have several still images in your movie displayed while an audio clip plays. If the audio clip is not long enough, the music will stop playing before all the still images are shown. This creates an abrupt break in your movie. The Length property tells you how long the clip will play. The length of the clip is found by subtracting the start time from the end time.

Start time

This property lists the time the clip begins playing. The time is also displayed in hours:minutes:seconds (h:mm:ss). This property is helpful for determining when

a clip begins to play for a video or movie file that has been imported into Movie Maker and broken down into clips. The start time indicates what time the clip begins to play in relation to the entire video file.

End time

The end time indicates what time the clip stops playing in relation to the entire video file. This property is helpful for determining when a clip stops to play for a video or movie file that has been imported into Movie Maker and broken down into clips.

To change clip properties

1. If you are not already in the Thumbnails view, which is the default view of the collections area, on the **View** menu, click **Thumbnails**. The thumbnail view lets you see a bitmap image representing each clip created when you imported the video file waterfall.wmv. The thumbnail image is created from the first frame of each different clip that was created from the video file that you imported.

2. Click **Upper Sol Duc Falls**, and then, on the **View** menu, click **Properties**. This dialog box shows all the properties of the clip Upper Sol Duc Falls.

3. In the **Title** box, **Upper Sol Duc Falls** appears. If you want, you can change this clip name.

4. In the **Author** box, type your name; this identifies who created the clip.

5. In the **Description** box, type **This is the top of Sol Duc Falls in Washington state**. This field is an ideal place to put notes to help remind you of the clip contents. At times, the thumbnail image of a clip may be similar to another clip. This description property can help you quickly identify whether the clip is the one you want to use in your movie when you have similar clips.

6. Click the clip **Lower Sol Duc Falls**. The **Properties** dialog box for this clip now appears. In the **Description** box, type **This is the bottom of Sol Duc Falls in Washington state**. Click **OK** to close the **Properties** dialog box.

Note After a clip is added to the current project, you can still view and change the clip properties; however, you cannot change the properties after the clip has been added to the storyboard or timeline. If you want to change one of the clip properties, such as the name, you should delete the clip in the current project, rename the clip in the collections area, and then add it again to your project.

Moving and copying clips between collections

When a video file is recorded or imported into Movie Maker, a new collection containing the resulting clips is created. The new collection can help you to organize your clips and collections by keeping imported or recorded content in the same col-

lection. However, you may want to move or copy the clips to a new or existing collection.

> **Note** When you move or copy a clip to a new collection that contains a clip with the same name, the clip you copy in the collection will have the same name with a 1 in parentheses. For example, if you move or copy a clip named Clip 1 to another collection that also has a clip named Clip 1, the clip you copied will be renamed Clip 1 (1).

When you are moving or copying clips between collections, you can use menu commands, keyboard commands, or the mouse, depending on the method that is most comfortable to you.

To move and copy your clips

1. Select **My Collections**. On the **File** menu, click **Import**. Go to the **Working** folder under the **Chapter 9** folder on your computer. Press and hold down the CTRL key, and then click the following files:

 - **MarymereFalls.wmv**

 - **MutlnomahFalls1.jpg**

 - **MultnomahFalls2.jpg**

2. Clear the **Create clips for video files** check box, and then click **Open**. A new collection named MarymereFalls containing one clip named Clip 1 appears because it's a video file. The two clips for the image files MutlnomahFalls1.jpg and MutlnomahFalls2.jpg are imported into the selected collection, My Collections.

3. Click **My Collections**. Press and hold down the CTRL key, and then click the **MultnomahFalls1** and **MultnomahFalls2** clips. These are the clips you want to move.

4. Stop pressing the CTRL key, then rag the clips to the **Waterfalls** collection. The two clips of Multnomah Falls now appear in the Waterfalls collection.

 If you want to copy the clips, you can hold down the CTRL key while you are dragging the clips to the Waterfalls collection. When you hold down the CTRL key and drag the file, a box with a small plus sign appears indicating that you are copying the clip rather than moving the clip.

Strategies for organizing collections

The best way to organize your clips is to use a method that makes sense to you. That way you will be able to find the clips you are looking for quickly and can concentrate on creating the actual movie.

When organizing collections, you may want to create collections that mimic the location of the source files on your computer. For example, you may store your source files in a folder called My Movie Maker Collection Files, and this folder might contain subfolders that have source files organized by events, such as a birthdays, vacations, and weddings.

Figures 9.5 and 9.6 show how your collections can mimic the folders where source files are stored on your computer in the folder C:\My Movie Maker Collection Files.

Figure 9.5 – *Folders containing source files on a computer.*

Figure 9.6 – *Collections organized using the same folder structure.*

Note By keeping your source files in one location, backing up the source file location is made easier because you only need to back up one folder and its subfolders. See "Backing up your collections file" later in this chapter for more information on backing up your collections file in Movie Maker. Remember, backing up your collections file does not backup the source files as well. You need to backup your source files using a backup utility outside of Movie Maker.

Duplicating this structure where the folder **My Movie Maker Collection Files** corresponds to My Collections in Movie Maker lets you quickly find clips and locate the source file on your computer. You might want to locate the source file to edit it later, which also changes the imported clip. After you bring the file into Movie Maker, it is best to keep the source file in the original location with the same file name. If you move or rename the source file, you will have to find it before you can add the corresponding clip to a project in Movie Maker.

You can also create subcollections, up to six levels deep, to further organize collections within collections. Using subcollections lets you store your collections in an even more detailed way. In Movie Maker, you can drag one collection folder over another, and the folder you drag becomes a subcollection under the main collection. For example, if you have a main collection named Vacation, and collections from another place you saw on your vacation named Seattle and Mount Rainier, you could drag the Seattle collection over the Vacation collection, and then Seattle would be under the main Vacation collection. You could also drag the Mount Rainier collection under Vacation and it would appear on the same level as the Seattle collection.

By using subcollection folders, you can organize your clips in very detailed ways. If you do this, the movie-making process is a lot quicker because you do not spend a lot of time searching among all your clips to find a specific clip you want to use in your movie.

The following is a list of different strategies you can use to organize your clips. Remember, each strategy could be used in combination with another strategy if you use subcollections as discussed earlier.

Event

Organizing your collections by event helps you keep similar subject matter together. For example, you can store all of your birthday party audio, pictures, and videos in a folder named birthdays. To further organize the clips, you can create subfolders for each family member or friend. If you have clips from several birthdays for each person, you can create another subfolder for each separate date.

Movie

Storing all the clips in a movie in one collection is another way of organizing your collections. This method allows you to find the clip if you know what movie you used it in. Be aware that this might cause some duplication of clips in Movie Maker. This cannot harm your collections file; however, it can cause it to become quite large if you have many clips and collections.

Date

Organizing your collections by dates is a way of tracking the order in which you recorded or imported the various clips. This strategy is especially useful if you are creating movies that have a sequence of events. For example, if you took a vacation in the car and you wanted your friends to see highlights of your vacation on each day, this method allows you to create a documentary showing your days on the road in the order you saw the sites.

Author

Organizing your collections by author is ideal if you have several different people who use Movie Maker on your home computer. If you separate the

content by author, this would allow the different authors to keep their content separate from one another; however, each different author would still be able to use content from the other authors' collections.

Genre

Organizing your collections by genre lets you organize clips according to the content they contain. Different genres could include, but are not limited to: humor, sports, entertainment, and so forth. If you create a lot of movies that have a consistent theme, this could be a way to keep your clips organized. For example, you might want to create a movie that only contains clips of you and your family when you were camping and hiking in the mountains. You could have a collection called "nature" which features your family camping, hiking, and doing other nature-oriented activities.

Purpose

Organizing your collections by purpose lets you separate your clips according to the purpose they fulfill in your movie. For example, you might have a small video you use at the beginning of each movie you create in Movie Maker, and another short video you use at the end. You could have collections named Introduction and Conclusion that help you find and add the clips you want to play at the beginning and the end of your movie.

Tape

Organizing your collections by tape lets you organize clips according to the tapes they are stored on within your video library. If you have an organized video library, you could quickly find the clip on your computer as well by using the same strategy. If you have a number of whole video tapes recorded into Movie Maker, you could use the same naming convention as you do for your tapes. This strategy lets you synchronize your tapes with your movies in Movie Maker.

Media type

Organizing your collections by media type lets you keep clips organized according to the type of clip. For example, you could store all still images in one collection, audio clips in another collection, and video files in their own collection. This way, if you know what type of clip you want to add to your current project, you could go directly to the specific collection. If you use this method, you probably want to use one of the other strategies mentioned in this list to further organize the clips within a collection. For example, you could store clips in a collection according to media type, and then have subfolder collections under the main collection organized by event.

When you are organizing your clips, you may want to create a new collection named Recycle. You can then drag unwanted clips to this collection, so that only the clips you are likely to use remain. In the end, if you do need to use one of the clips that

you moved to the Recycle collection, you can just drag it back to the appropriate collection and use it in your project. You don't have re-import the original source file and worry about unnecessary duplicate clips.

Right now all the clips from the different waterfalls from the earlier exercises appear in several different collections without any real structure. You now want to better organize the different waterfalls clips.

To create and organize a new collection

1. Click **My Collections**. On the **File** menu, point to **New**, and then click **Collection**. This creates a new subfolder collection under My Collections. Name the new collection **Chapter 9 Organizing**. This is going to be the main folder for the different waterfall clips.

2. Click and drag the **MarymereFalls** collection over the collection Chapter 9 Organizing. The collection MarymereFalls now appears as a subfolder collection under the Chapter 9 Organizing collection. The clips in the MarymereFalls collection are also moved. Moving the entire collection is a quick way to move multiple clips at one time.

3. Click and drag the **Waterfalls** collection over the collection **Chapter 9 Organizing** as well. The Waterfalls collection now appears as a new subfolder collection as well.

4. Click the **Chapter 9 Organizing** collection. On the **File** menu, point to **New**, and then click **Collection**. Type **Multnomah Falls** for the new collection name. This collection appears as a subfolder of the Chapter 9 Organizing collection.

5. Click the **Waterfalls** collection, press and hold down the CTRL key, and then click the clips **MutnomahFalls1** and **MultnomahFalls2**. Drag them to the Multnomah Falls collection. These clips are moved again, this time to the Multnomah Falls collection.

6. Click the **Chapter 9 Organizing** collection. On the **File** menu, point to **New**, and then click **Collection**. Type **Sol Duc Falls** for the new collection name. This collection appears as a subfolder of the Chapter 9 Organizing collection.

7. Click the **Waterfalls** collection, press and hold down the CTRL key, and then click the clips **Upper Sol Duc Falls**, **Lower Sol Duc Falls**, and **MultnomahFalls2**. While still holding down the CTRL key, the clips to the Sol Duc Falls collection. These clips are copied to the Sol Duc Falls collection.

Now, when you start to create your project about waterfalls in Movie Maker, you can quickly find all the different clips containing footage of the different waterfalls in the Northwest.

Deleting a collection

Part of organizing your clips efficiently involves deleting unused collections. This prevents old collections from cluttering the collections area. For example, you might have imported a video file named Mountains.wmv, which results in a new collection named mountains. As part of your organization strategy, you might want to arrange your clips by date; therefore, you move the mountain clips to a collection you created that contains clips from other places you saw on that date. In this case, you would want to delete the old mountains collection.

> **Note** If you delete a collection that has subfolders under it, all the clips in the main collection and the subfolders below it will be deleted. Make sure that the collection you remove does not contain other collections with clips that you need for your current or future projects.

To delete a clip and a collection

1. Click the **Waterfalls** collection, and then click the clip **Upper Sol Duc Falls**. You want to delete this clip because it already appears in the Sol Duc Falls collection from the previous scenario.

2. On the **Edit** menu, click **Delete**. A dialog box appears confirming that you do want to permanently delete the clip.

3. Click **Yes**. The clip is deleted.

> **Note** If you have selected the **Do not warn me again** check box in this or any other dialog box in which this appears, this warning dialog box won't appear. The clip will be immediately deleted without this warning. If you want the warning dialogs to appear, on the **View** menu, click **Options**. Click **Reset Warning Dialogs** so that these warnings will appear.

4. Click the **Waterfalls** collection. On the **Edit** menu, click **Delete**. If the warning dialog appears, click **Yes** to confirm the deletion. The unused Waterfalls collection and any clips in the collection are deleted.

> **Note** When you delete a collection that contains clips, the clips are deleted. However, the source files are not removed from your hard disk or the location where they are stored.

Backing up your collections file

Your collections file contains information about the clips contained within your collections. The collections file has a .col file name extension, and is stored on your hard disk in the \Windows\Application Data\Microsoft\Movie Maker folder. The default name for the collections file is Windows Movie Maker.col.

Note It is strongly recommended that you do not attempt to open or edit the collections file. If you do, the file is likely to be corrupted and you will lose the current information about your collections, which is stored in this file. In this case, you would need to restore the collections file from a backup of the collections files. If you did not have a backup copy of this file to restore your collections, your collections and the clips contained in those collections would be lost and you would have to re-import the original source files.

Movie Maker prompts you to save a backup of the collections file after you make ten or more changes to your collections. Some of these changes occur when you record new content, import files, move, copy, or delete existing clips and collections. If you do not make a backup when first asked, the prompt displays each time you close Movie Maker and the **Do not ask me again** check box is cleared.

Note Backing up the collections file does not back up the source files because a clip is only a link to the source file; it is not a copy of the original file. Therefore, if your computer system fails and you do not have a backup of the source files, restoring the collections file will not bring back your collections because the actual source files are not available.

Backing up your collections file and source files is strongly recommended. A backup copy of this collection file lets you restore your clips and collections in the event the file becomes corrupted. Backing up the file to an external drive, device, or location lets you restore your Movie Maker collections if your entire computer should fail. If you have a backup collections file and source files, you do not need to re-import files into Movie Maker. You just need to move or copy the original source files to the same locations on your computer as they were before your system failed.

Note If your collections become quite large, re-importing the files into Movie Maker could be time-consuming.

You can directly save a backup of your collections file to the following locations:

- A 3.5-inch floppy disk.

- A hard disk.

- A removable-media disk.

- A recordable (CD-R) or re-writable (CD-RW) CD.

- A location on a network server.

Although Movie Maker does not let you save directly to the Internet, you can still store a backup copy of your collections file to an Internet location that you have rights to upload and download files. You could save a copy of the collections file to your hard disk and then upload it by using an external file transfer program. If your collections file later becomes corrupted, you can then download the file from the

Internet location to restore it. See the next section, "Restoring your collections file," for more information.

The size of the collections file is based on the size of your collections and the clips in those collections. Therefore, the size of the collections file can become quite large. This is an important consideration if you want to back up your collections file to a 3.5-inch disk that can only store 1.44 MB of data. When deciding on the location to store the backup copy, consider what location or device would be most accessible for you if the collections file becomes corrupted or if your entire computer fails and needs to be restored.

Restoring your collections file

If your Movie Maker collections file becomes corrupt, you can restore your collections to their state at the time the most recent backup collections file was created and saved.

Movie Maker prompts you with the dialog box shown in Figure 9.7 if your collections file becomes corrupted.

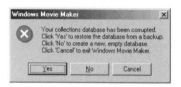

Figure 9.7 – *The dialog box that appears if your collections file becomes corrupted.*

When you click **Yes**, the **Collections Restore** dialog box appears. To restore the collection file, locate the backup copy of the collections file, which has the default name Windows Movie Maker Backup.BAK, and then click **Open**. Movie Maker will then open and your collections are then restored.

If you choose to restore your corrupted collections file from your backup copy, the backup copy becomes your new collections database file. Your collections and clips are then restored from the original state when the backup was created. In other words, if you make a backup copy of your collections file, then you import a new video into Movie Maker, and your collections file becomes corrupted, it would not include the collection and the clips from the video file you just imported. You would need to re-import that video. If you need to restore your collections files, you recover it from the media you backed up to. For example, if you saved it to your hard disk, you would restore it from that source.

Editing Your Movie

After recording your content and organizing your collections, you are ready to add clips and start your project. In Windows Movie Maker, a project consists of all the clips added to the current storyboard or timeline and the arrangement of those clips. With Movie Maker, you can take all of the raw footage shot with your camcorder and turn it into a finished movie—moving shots around, adding and deleting sections, and selecting only the shots you need to tell your story. Saving the project lets you open and edit it at a later time to make other changes. When you have edited the project to a point where you are ready to share it with others, you can then save it as a movie that can be watched in Windows Media Player.

Chapter 5 gave you a high-level introduction to editing concepts. This chapter will walk you through the processes you will use to edit a movie with Movie Maker. By the end of this chapter, you will be able to answer questions such as:

- How do I add clips to my movie?

- How do I rearrange clips within the storyboard/timeline?

- How do I copy clips added to a project?

- How do I trim unwanted portions of my clips?

- How do I split clips into smaller, more manageable clips?

- How do I combine clips?

- How do I record a narration?

- How do I add transitions in my movie?

- How do I adjust the audio levels in my movie?

Adding clips to your project

Editing a movie with Movie Maker begins when you start to add imported or recorded clips to the storyboard or timeline. Although you can add clips to your current project through the **Clip** menu, the quickest way to add clips to a project is to drag them from the collections area to the storyboard or timeline. In the timeline view, still images and video clips appear on the video track, while any imported or recorded audio clips appear on the audio track.

In the storyboard view, you can only add photos or video clips; you cannot add audio clips. If you try to add an audio clip to your current project in the storyboard view, Movie Maker automatically switches to the timeline view before adding the clip.

Figure 10.1 shows how audio, video, and photo clips are displayed in the timeline. Photo and video clips are both displayed as small thumbnail images. Video clips also display small speaker icons. When added to the timeline, audio clips appear in the audio track, and they display small speaker icons as well. These different indicators let you quickly identify the clip type and its contents.

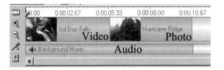

Figure 10.1 – *Video, photo, and audio clips in the Movie Maker timeline.*

When editing a project, you can add many clips to your project at one time. This lets you quickly add clips to your project, then rearrange them later. You select multiple clips by holding down the CTRL or SHIFT key and clicking the clips. Use the SHIFT key to select a range of clips, or the CTRL key to select multiple individual clips.

Regardless of which way you select and add multiple clips, the clips are added in the order they appear in the collections area.

The following example—along with the other examples in this chapter—walks you through the process using sample files that you copied to your hard disk from the companion CD. The files should all appear in the designated location. If you copied the Tutorials folder from the CD to your computer, all files will be under the main Tutorials folder on your hard disk. You can use the same process, substituting the names of your files for those shown here, when adding your own clips to a project.

> **Note** To save time when importing the clips for the scenarios in this chapter and throughout the entire book, make sure the **Import path** box in the **Options** dialog box is set to the Tutorials folder on your hard disk as discussed in the Importing files scenario in Chapter 8. Then, when you go to import the copied working files, you just need to select the Working folder under the appropriate chapter number.

To import and organize clips

1. Before beginning the project, you must import clips into Movie Maker. On the **File** menu, click **Import**. Open the **Working** folder under **Chapter 10** on your hard disk.

2. In the **Select the File to Import** dialog box, clear the **Create clips for video files** check box, click the **Files of type** box, and then choose **Windows Media files** since the video files are all in Windows Media Format.

When you select the **Files of type** box, this lets you see only the specific file types that you want to import.

3. Click **HurricaneRidge.wmv**, press and hold down the CTRL key, and then click **Rialto Beach**. Click **Open** to import these files into Movie Maker.

 Note You can also import other video and movie file types into Movie Maker. The Importing files section of Chapter 8 provides more information about supported file types.

 The following new collections and clips appear in the collections area:

 • HurricaneRidge

 • RialtoBeach

 Each collection contains a clip named Clip 1.

4. Click each collection and then click Clip 1. For each Clip 1, give it a more descriptive name. To do this, select the clip you want to rename, and then select **Rename** from the **Edit** menu.

 Table 10.1 shows the collection name and the corresponding new name for each clip named Clip 1.

Collection	New name for Clip 1
HurricaneRidge	Hurricane Ridge
RialtoBeach	Rialto Beach

 Table 10.1 – *Names for imported clips.*

5. On the **File** menu, click **Import**. Select the **Create clips for video files** check box, and then select the Working folder under **Chapter 10**. Click the file named **CrescentLake.wmv**, and then click **Open**. This imports the video into a new collection named CrescentLake.

 Because the **Create clips for video files** check box was selected, the file is broken down into clips. This video was originally recorded with a DV camera; therefore, the clips are created and named based on the time stamps placed in the video data by the camera.

6. Select the new collection named **CrescentLake**. Click each individual clip in the collection and give it a new, more meaningful name. To do this, select the clip

you want to rename, and then select **Rename** from the **Edit** menu as you did in step 4.

Table 10.2 shows the original clip name in the CrescentLake collection and the corresponding new clip name.

Original clip name	Crescent Lake 1
8/29/2000 11:53 AM (1)	Crescent Lake 1
8/29/2000 11:53 AM (2)	Crescent Lake 2
8/29/2000 11:55 AM	Crescent Lake 3

Table 10.2 – *Names for imported Crescent Lake clips.*

7. Click **My Collections**. On the **File** menu, point to **New**, and then click **Collection**. Name the new collection **Chapter 10 Editing**. Make sure this new collection is selected.

8. Before importing the remaining files, on the **View** menu, click **Options**. Set the **Default imported photo duration (seconds)** to **3** seconds, so any imported photo clips appear in the project for three seconds by default. Click **OK**.

9. On the **File** menu, click **Import** to import the remaining clips for this project. Press and hold down the CTRL key, and then click the following files:

 - **Activity05.wav**
 - **Black.bmp**
 - **Mood03.wav**
 - **MovieTime.gif**
 - **MovieTime_TheEnd.gif**

 Click **Open** to import the files into the selected collection, **Chapter 10 Editing**.

10. One way to organize your clips is to have all the clips for one movie in a single collection. To do this, move the video clips from the collections that were created when the video was imported. Do the following to organize the clips you have imported so far:

 - Click the **CrescentLake** collection and click the clip **Crescent Lake 1**. Press and hold down the CTRL key, and then click **Crescent Lake 2** and **Crescent Lake 3**. Drag these files to the Chapter 10 Editing collection.

 - Click the **Hurricane Ridge** collection, click the clip named **Hurricane Ridge**, and drag it to the Chapter 10 Editing collection.

- Click the **RialtoBeach** collection, click the clip named **Rialto Beach**, and drag it to the Chapter 10 Editing collection.

11. Click the **CrescentLake** collection. On the **Edit** menu, click **Delete**. In the dialog box confirming the deletion, click **Yes**. Do this for the remaining empty collections named **HurricaneRidge** and **RialtoBeach**.

12. Click the **Chapter 10 Editing** collection. Figure 10.2 shows what this collection should look like.

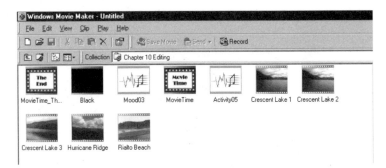

Figure 10.2 – *The clips contained in the Chapter 10 Editing collection.*

Note For your collections, the clips might not appear in the order shown here. The order is determined by the sequence in which the clips were imported or moved into the collection. Also, if the collections tree is displayed on the left side of the window, you will see any additional collections you created.

To add the clips

1. Click the clip **MovieTime**. On the **Clip** menu, click **Add to Storyboard/ Timeline**. Depending on the view you are in, it will either be added to the storyboard, which is the default workspace view, or to the timeline. The clip is added to the beginning of the storyboard or timeline. This is the first clip added to the current project.

2. On the **View** menu, click **Timeline** if you are not in the timeline view. Click the **Black** clip, and then drag it to the timeline. The Black clip is placed immediately next to the MovieTime clip.

 In the video track of the timeline, which contains any video or photo clips you add to the current project, there cannot be any space between clips.

3. Press and hold down the CTRL key, and click the audio clips named **Mood03** and **Activity05**. Drag the selected clips to the beginning of the audio track in the timeline. When you drag these clips, a line appears indicating where the files will be placed when you release the mouse button.

Dragging clips to the storyboard or timeline is an alternative to using the menu commands.

Note If you are in the storyboard view and add audio clips to the storyboard, Movie Maker automatically switches to the timeline view and then adds the clips to the timeline. Just click **OK** to confirm the switch to the timeline view.

4. To quickly add the remaining clips to the timeline, hold down the CTRL key and click the following clips in the Chapter 10 Editing collection:

- MovieTime_TheEnd
- Crescent Lake 1
- Crescent Lake 2
- Crescent Lake 3
- Hurricane Ridge
- Rialto Beach

Drag these clips to the timeline.

The clips are added to the timeline based on the order they appear in the collections area. Therefore, when you add multiple clips to the timeline, you may have to arrange them in the order you want them to appear in your project.

5. On the **File** menu, click **Save Project**. In the **File name** box, type **Chapter 10 Editing**, and then click **Save**.

By default, projects are saved with an .mswmm file extension in the **My Videos** folder under **My Documents**. After you save a project, you can later open and edit it further with Movie Maker. If you do not save the project, you will have to add and arrange all of the clips again if you want to recreate the movie.

Saving a project is not the same as saving a movie. A project contains information about the clips you are using, the order they will appear in your movie, and so on. A movie is a separate, encoded file that contains the final movie. A project can be edited further and then saved as another movie. A movie file cannot be edited further.

Arranging clips

The sequence of the clips in your movie tells the story. Therefore, you can change your movie and its message by altering the sequence and timing of the clips in either the storyboard or timeline view. Though you can use either view, it is often easier to arrange your clips by working in the storyboard view, which is the default view, because it displays only the ordering of the clips within your project. For example, if you have still images from a vacation, you could use the storyboard view to arrange

the clips so they appear in the order that you visited the corresponding sites or attractions on your vacation.

Figure 10.3 shows three clips that appear in a current project in the storyboard view.

Figure 10.3 – *A project shown in the storyboard view.*

The second view, the timeline view, shows the sequencing and timing of all the clips in your movie, including audio clips. This view also lets you create transitions between clips. For example, after you have established the sequence of the clips, you could work in the timeline view to insert transitions between clips and adjust the timing of the clips in your movie.

Figure 10.4 shows three clips that appear in a project in the timeline view. Notice that unlike the storyboard view shown earlier, the timeline view displays the inserted transitions and the added audio clip in the current project.

Figure 10.4 – *A project shown in the timeline view.*

The following example walks you through the process of arranging clips within a movie project. This is the basic technique you will use to edit movies in Movie Maker. Once clips have been imported or recorded into collections, simply place the clips you want to use in the storyboard or timeline, then arrange them as necessary to create the sequence of clips that tells your story.

To arrange your clips

1. If the project from the previous exercise is not already opened, open the project. On the **File** menu, click **Open Project**, click **Chapter 10 Editing.mswmm**, and then click **Open**.

2. On the **View** menu, click **Storyboard**. The storyboard view lets you see the clips in sequential order. When first arranging your clips, using the storyboard lets you quickly establish the order of the clips in your project.

In the storyboard view, audio clips are not shown, though they are still part of the project. Only the timeline view displays the audio clips in the project.

The first clip in the project should be the MovieTime clip, because that was the first one added to the project. The Black clip should be the second one in the video track. You need to re-arrange the clips so they are shown in the correct sequence.

3. Click the **MovieTime_TheEnd** clip. This is a title slide that should appear at the end of the project. On the **Edit** menu, click **Cut**. This cuts the clip from the project and lets you later paste it to a new part of your project.

 Note The MovieTime clips are title slides that introduce and conclude the movie. You can find many other title slide examples on the companion CD. Creating and animating title slides are discussed in Chapter 12.

4. Click the first empty space of the storyboard, and then, on the **Edit** menu, click **Paste**. The MovieTime_TheEnd clips now appears at the end of the project.

5. You can also move multiple clips at one time. If the Crescent Lake clips are grouped together in the storyboard, click the first clip named **Crescent Lake 1**, Press and hold down the SHIFT key, and click the last clip, **Crescent Lake 3**. If the Lake Crescent clips are not together in the storyboard, press and hold down the CTRL key, and then click each clip.

6. Drag the selected clips **Crescent Lake 1**, **Crescent Lake 2**, and **Crescent Lake 3** so they appear before the Rialto Beach clip.

7. Move the pointer over the clip named **Rialto Beach**. If you point to one clip on the storyboard with your mouse, a tooltip displays the clip's name. Click the **Rialto Beach** clip, and then click **Play**. The selected clip plays in the monitor. Click **Stop** to end playback.

8. To preview many clips in the storyboard, press and hold down the CTRL or SHIFT key, and then click **Play**. For example, to preview all three Crescent Lake clips, click **Crescent Lake 1**, hold down the SHIFT key, and then click the last Crescent Lake clip, **Crescent Lake 3**. Click **Play** to preview all three clips and the added audio. If the clips are not adjacent to one another, you can hold down the CTRL key to select multiple clips and preview them in the monitor.

The clips should be in the following order. If they are not, drag the clips as necessary to put them in this order:

- MovieTime
- Black
- Hurricane Ridge
- Crescent Lake 1

- Crescent Lake 2
- Crescent Lake 3
- Rialto Beach
- MovieTime_TheEnd

9. To preview the entire project, on the **Edit** menu, click **Select Storyboard/ Timeline**, and then click **Play** on the monitor. The entire project plays in the monitor. As an alternative to using menu commands, click an empty area in the storyboard, and then click **Play** on the monitor. The entire project, including the added audio clips, plays in the monitor.

10. On the **File** menu, click **Save Project** to save the changes you made to the current project.

When you previewed the entire project, you probably noticed that there is little connection between the video clips and the accompanying audio clips. Some of the video clips played for too long, while other elements, such as the image clips, were not displayed long enough. You can change these aspects of the movie as part of the editing process.

Copying clips

Within Movie Maker, clips can be copied within the same collection, from one collection to another, or within the current project. Copying clips enables you to reuse the same clip in your movie. By copying clips within your movie, you can "extend" the amount of time the clip plays without recording the same clip over and over again. Copying clips between collections is discussed in Chapter 9.

You can copy clips within Movie Maker by using menu commands, keyboard commands, the mouse, or a combination of these methods. Many times, using keyboard shortcuts and the mouse lets you work more efficiently.

The following steps illustrate how you can copy clips within a project. Once again, sample files that you copied from the companion CD are used, but the same process applies to your own files and projects.

To copy clips in a current project

In the current project, there is a plain Black clip. One common reason to use a clip like this is to create visual effects, such as a fade to black at the end of the movie. However, you might want this clip to appear elsewhere as well; therefore, you can copy the clip in the project.

1. If the project from the previous scenario is not already open, on the **File** menu, click **Open Project**. Locate and click the **Chapter 10 Editing.mswmm** project, and click **Open**.

2. Click the **Black** clip so you can copy it and use it several times in this project. On the **Edit** menu, click **Copy**. This copies the clip.

3. Click the **Lake Crescent 1** clip. On the **Edit** menu, click **Paste**. A copy of the Black clip is now pasted before the Lake Crescent 1 clip. Whether you are in the storyboard or timeline view, if you select a clip and then click **Paste**, the copied clip is inserted in front of the selected clip.

4. You can also use the mouse and keyboard to copy clips. Click any copy of the **Black** clip. Hold down the CTRL key, and then drag the clip to the point on the timeline where you want to add it. A square with a plus sign indicates that you are copying the clip. For this example, drag the **Black** clip to a point after the Rialto Beach clip.

5. To preview the entire project, click after the last clip in the storyboard and then click **Play**. The entire project plays in the monitor.

 Note You can use the same technique to copy audio clips.

6. On the **File** menu, click **Save Project** to save the changes to the project.

To begin to create some connection between the audio and video parts of your movie, you can trim out unwanted parts of a clip, whether it is a photo, video, or audio clip. This is the next step in editing the project.

Trimming clips

At times, a clip may contain footage that you do not want to appear in your movie. For example, when recording your movie, a clip may contain parts where you are setting up your actors and instructing them what you want them to do for the shot. In this case, you could trim out the unwanted segment of the clip so your audience only sees the results of your work, and not preparation time.

When you trim a clip, you only hide unwanted parts of the clip—the original content within the clip itself is not deleted.

In Movie Maker, clips can only be trimmed after they have been placed on the storyboard or timeline. When you are in the storyboard view, you must use either the menu commands or keyboard shortcuts to trim a clip; however, in the timeline view, you can use either of these two methods or you can drag the trim handles that appear when you select a clip in the current project. Dragging these trim handles is often the easiest way to trim a clip. As you drag the trim handles, which are the small triangles above the clip shown in Figure 10.5, the clip plays in the monitor. This lets you see exactly what you are trimming.

Figure 10.5 – *Trim handles appear when the clip is selected in timeline view.*

You can trim a clip at any point after you insert it into your project, whether it is playing in the monitor or playback is stopped. You can clear trim points at any time in the editing process if you want to restore the clip to its original length.

To trim clips and clear established trim points

1. Be sure the **Chapter 10 Editing.mswmm** project is open in Movie Maker.

2. Click the **Rialto Beach** video clip, and then click **Play** in the monitor so only this clip is played. The clip plays for about 40 seconds. Notice that there are unwanted jump cuts in the video. We need to trim off these unwanted parts of the clip.

 To find the time length of a video clip without playing the file, you can click **Properties** on the **View** menu. This displays properties for the selected clip, such as the title, author of the clip, clip type, the source file the clip refers to, the complete length, and the start and end times.

3. Click the **Crescent Lake 2** clip to see the total length of the clip. In this clip, the start time is four seconds because it is part of a video file that was split into clips. The start time in this clip refers to the location of this clip within the imported Windows Media file named CrescentLake.wmv.

4. Close the **Properties** box.

5. On the timeline, click the **Zoom In** or **Zoom Out** button, depending on your current settings, until the timeline displays in approximately three-second increments. The timing increments are displayed above the clips, beginning with 0:00:00.00. The current timeline is shown in Figure 10.6.

Figure 10.6 – *The timeline displayed in intervals just under three seconds.*

When you zoom in on the timeline, the time increments shown above the video track decrease so you see the timing in more detail. Conversely, when you zoom out the time increments increase, and the timeline is displayed in less detail.

6. Click the **Rialto Beach** clip and click **Play** on the monitor. When the clip time displays approximately 0:00:07.00 on the monitor, click **Pause**. Between six and seven seconds into the clip, the waves splash the people walking on the beach. We want to trim the clip so it stops playback before the camera jumps. Use the monitor buttons to get to approximately 0:00:06.77, which is where they get splashed

 To get to the precise part of the clip, click the **Previous Frame** or **Next Frame** button on the monitor to move from one frame to the next. For example, if the monitor displays before 0:00:07.00, click **Next Frame**; if it displays a number that is greater than 0:0007.00, click **Previous Frame**. To fast forward or rewind through frames, click and hold either **Next Frame** or **Previous Frame** on the monitor.

 As an alternative to using the menu commands, you can also trim clips by using the trim handles that appear when you select a clip in the timeline.

7. On the **Clip** menu, click **Set End Trim Point**. The video clip now stops playing at this point.

 When you trim a clip, the shaded regions show the trimmed parts of the clip. If you accidentally trim too much or too little of a clip, you can click **Clear Trim Points** on the **Clip** menu. This removes the established trim points so the entire clip plays back. But for this example, leave the trim point you just entered.

8. Click the last **Black** clip near the end of the project and trim it so that it plays for approximately two seconds.

 Note To find this point in the clip, point to the time display on the timeline and click on it when the pointer becomes an up arrow. A vertical line appears indicating that time, as shown in Figure 10.7.

Figure 10.7 – *The black vertical line on the timeline is a time indicator.*

9. Drag the end trim handle to the point marked by the line indicator. The clip now plays for two seconds. To find the exact time time, you can click the time display in the timeline and use the **Previous Frame** or **Next Frame** button on the monitor.

10. On the **Play** menu, click **Play Entire Storyboard/Timeline** to play the entire project.

11. On the **File** menu, click **Save Project** to save all the changes you made to the project.

You have now made many changes to the clips in your project. However, there are still a few more features in Movie Maker that you can use to enhance your movie, like splitting or combining clips, adding transitions, and adding a personal narration.

Splitting clips

Movie Maker uses shot detection to create individual clips from a longer video file when clip creation is enabled. When clip creation is selected and an entirely different frame is detected in the video, a new clip is created. However, there may be times when the content of the movie does not change dramatically (for example, the background stays the same). When this occurs, your recorded video appears as one large clip that can be difficult to use in your movie.

You can split clips into smaller, more manageable segments. For example, suppose you took a vacation in the mountains and recorded video of several different mountain peaks. However, because the sky appeared the same color and the mountains looked similar, your recorded footage appeared as one large clip. You might want to insert title slides (discussed in Chapter 12) to introduce the different peaks. In this case, you could split the clip to break it into smaller clips according to the different peaks.

Splitting clips enables you to use a clip in your movie in a variety of ways. You can take one clip and create many different clips from it to insert and then re-arrange in your movie. Adjacent clips can be combined again if necessary. This is discussed in the Combining clips section of this chapter.

To split a clip in your movie

1. Be sure the **Chapter 10 Editing.mswmm** project is open in Movie Maker.

2. Click the **Cresecent Lake 2** clip in the timeline, and then play the clip. After about three seconds there is an unwanted jump cut. This is the point where we want to split this clip.

3. Click in the time display to see the time indicator, and then use the **Next Frame** or **Previous Frame** to go to approximately 0:00:03.12.

4. Click the **Split** button on the monitor to split this clip. The first part of the clip is still named Crescent Lake 2, while the second part of the clip is named Crescent Lake 2 (1).

5. On the **File** menu, click **Save Project** to save the additional changes you have made to the project.

6. On the **Play** menu, click **Entire Storyboard/Timeline** to play the entire project.

Combining clips

After a video or audio clip has been split, the resulting clips can be combined again if they are adjacent on the storyboard or timeline. For example, if you had a clip that was split into Clip1, Clip2, and Clip3, and they were placed in that order on the timeline, the following combinations of clips could be combined:

- Clip 1 and Clip 2
- Clip 2 and Clip 3

However, Clip 1 and Clip 3 could not be combined.

To combine clips

1. Be sure the **Chapter 10 Editing.mswmm** project is open in Movie Maker.

 In the example project, there are now four clips showing Crescent Lake. You want to combine the four clips into two so you can create a transition between the clips later in the project. The four clips are selected in Figure 10.8.

Figure 10.8 – *The current project with the Crescent Lake clips selected.*

2. Deselect all four Crescent Lake clips if they are selected. Click the **Crescent Lake 1** clip, hold down the CTRL key, and click **Crescent Lake 2**. On the **Clip** menu, click **Combine**. Now the two clips are combined into one clip. The new clip created from the two clips is automatically given the name of the first clip, **Crescent Lake 1**.

3. Now, you want to combine the clip Crescent Lake 2 (1), which you split from Crescent Lake 2 in the previous exercise, with clip Crescent Lake 3. Click **Crescent Lake 2 (1)**, hold down the CTRL key, and then click **Crescent Lake 3**. On the **Clip** menu, click **Combine** to combine these two clips into one clip. For these combined clips, the clip is named Crescent Lake 2 (1).

4. Click an empty space in the timeline, and then click **Play** on the monitor to preview the entire project.

5. On the **File** menu, click **Save Project** to save the changes to the newly combined clips.

Adding transitions

With Windows Movie Maker, you can create a cut or a cross-fade (also called a dissolve) transition between clips. With a cut, when one clip stops the next one starts immediately, without any transition between the two clips. In Movie Maker, a cut is automatically created when you add clips to your project.

When two clips overlap in your movie, a cross-fade transition is inserted automatically. A cross-fade transition slowly replaces the content of the clip that is ending with video from the following clip. The length of the transition is determined by the amount of overlap between the two clips, so the length of the transition time increases as the amount of overlap between the two clips increases.

A cross-fade transition is inserted by simply dragging one clip over the previous clip. A cross-fade can be removed at any time by simply dragging the clips so that they no longer overlap.

When adding transitions, you must be in the timeline view. If you are in the storyboard view, you can still see the transition when you preview the movie; however, the length and the overlap of the transition are not shown in the storyboard view.

Transitions can be added to both audio and video clips. However, when a transition is created between two audio clips, both clips play simultaneously for the time they overlap; the first clip does not fade out while transitioning to the next audio clip. When two audio clips overlap, the volume of each audio clip is reduced to half of the normal volume.

To insert cross-fade transitions between clips

1. Be sure the **Chapter 10 Editing.mswmm** project is open in Movie Maker. This is the project we have been working on in all of the previous scenarios.

2. On the **View** menu, click **Timeline** if you are in the storyboard view. In Movie Maker, transitions can only be inserted when you are in the timeline view.

3. Click the **Zoom In** or **Zoom Out** button, depending on your current setting, so the timeline displays in increments of just over one second.

4. Click the first **Black** clip. Drag the end trim handle so there is approximately a two-second transition between this clip and the Hurricane Ridge clip, and then drag the start trim handle over the end of the MovieTime clip so there is approximately a one-second transition between the Black clip and the MovieTime clip.

5. If you only want to see the part of the video that has the transition inserted, click the time display on the timeline so the play indicator appears as shown in

Figure 10.9. Then click **Play** on the monitor. This lets you begin playback from the selected part of the project so you do not need to watch the whole project.

Figure 10.9 – *The play indicator in the timeline view.*

When you select the time display, be sure that no individual clip is selected; otherwise, only that clip will play, not the added transition.

6. Click the second **Black** clip and drag it over the end of the Hurricane Ridge clip so the transition is approximately three seconds long. The shaded area where the two clips overlap represents the transition time.

7. In the previous exercises for this sample project, the Crescent Lake clips were split into segments, and then later combined at different points. To create a short cross-fade transition rather than the simple jump cut transition that now appears, drag the **Lake Crescent 2 (1)** clip over the **Crescent Lake 1** clip so the transition is approximately one second long.

8. If necessary, drag the horizontal scroll bar to see the rest of the project. Click the **Rialto Beach** clip and drag it over the **Crescent Lake 2 (1)** clip so there is a short transition between the clips.

9. The final set of cross-fade transitions occurs with the photo clips at the end of the video track in the timeline. Drag the third **Black** clip over the Rialto Beach clip, and then drag the **MovieTime_TheEnd** clip over the Black clip to insert the final cross-fade transitions.

Editing audio tracks

Now you need to adjust the audio portion of the movie. In doing so, you need to plan ahead a little if you plan to add a narration, which is discussed later in this chapter. For example, if you plan to add a 10-second narration, allow for that addition to the audio track.

The first audio clip will be positioned so it begins to play 10 seconds into the movie.

1. Be sure the **Chapter 10 Editing.mswmm** project is open in Movie Maker.

2. To see the timeline in larger time intervals, click the **Zoom Out** button so the timeline displays in 10-second increments (0:00:10.00 on the timeline).

3. Drag the **Activity05** audio clip to about 10 seconds on the timeline. The audio clip should start to play at the same time as the cross-fade transition between the Black clip and the Hurricane Ridge clip in the video track.

4. Unlike video clips, audio clips can have blank spaces between them. One common transitional effect is to have a new audio clip begin to play slightly before the new video clip plays. For this project, drag the **Mood03** clip so it begins playing slightly before the Crescent Lake 1 clip in the video track, as shown in Figure 10.10.

Figure 10.10 – *Audio clips positioned along with video clips in the timeline view.*

5. To preview your entire project, click **Play Entire Storyboard/Timeline** on the **Play** menu. After you see and hear the results, you may want to make other adjustments to the clips so that the audio and video in the movie play to your liking.

6. On the **File** menu, click **Save Project**. This lets you save the added transitions and all other new changes you made to your project.

Recording narration

You can enhance your movie by adding a narration. A narration is a recording of your voice describing to your audience what is happening in your movie. However, you can go beyond a simple vocal track. For example, you might use the **Record Narration** command to record sound effects for your movie. You can learn more about adding sound effects to your movie in Chapter 13.

The most popular way to add a narration is to use a microphone that is attached to your computer. A microphone plugs into a mini-jack on your computer, sound card, or video card, depending on the particular hardware you have installed on your computer. Many times, the jack for the microphone is labeled MIC, or it may have an icon of a microphone. Also, some Web cameras have built-in microphones. Check the documentation provided with your specific computer, microphone, or Web camera to see how your hardware is configured. Once you have set up your microphone, you are ready to record the narration.

To record a narration in Movie Maker, you need to be in the timeline view. Adding your video or still image clips to your current project before recording your narration is a good idea because it lets you record your narration while the clips play. This helps you synchronize your narration with the clips in your movie.

When you click **Record Narration** on the **File** menu, the **Record Narration Track** dialog box, shown in Figure 10.11, lets you configure the recording settings.

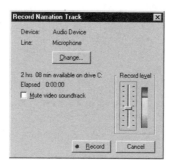

Figure 10.11 – *The **Record Narration Track** dialog box.*

The elements of the **Record Narration Track** dialog box include the following:

Device

This is the device that is being used to record your narration. After you click the **Change** button, you can specify the device and input to use. Most likely, the device used will be your sound or video card, or possibly your Web camera. If you have more than one microphone attached to your computer, you'll need to change devices depending on the particular microphone you want to use.

Line

This specifies the input source from which you will record sound from the recording device, such as a Web camera or microphone. Generally, this will be either Microphone or Line In. Check the documentation provided with your computer, sound card, or video card for information specific to your hardware configuration.

Time available

The length of the narration you can record, based on the amount of free hard disk space you have available to save a recorded narration. The value is based on the space available on the drive specified by the **Temporary storage** setting in the **Options** dialog box.

Elapsed

The length of time that has passed when recording your narration. The time elapsed is displayed as hours:minutes:seconds (h:mm:ss).

Mute video soundtrack

When you select this check box, sound from the video clips cannot be heard. Recording your narration is easier when you select this setting because the sound from the video clips may be distracting. If you select this check box, other sounds or music on your computer will also be muted. This includes other narrations or audio clips that may be already added to the current project, and which appear on the audio track.

Record level

This is the volume of your recorded narration. When determining the recording level, look at the position of the moving bar. The bar should be in the green area because this is the area where the narration sounds the best. If the moving bar appears in the yellow or red, the sound can be loud and distorted. On the opposite end, if the moving bar is below the green area, the volume of the recorded narration may be too low.

To record a narration

1. With the **Chapter 10 Editing.mswmm** project open, on the **View** menu, click **Timeline**. You must be in the timeline view to record a narration.

2. Make sure your microphone is connected to your computer. Then, on the **File** menu, click **Record Narration**. The **Record Narration Track** dialog box is displayed.

3. If you have more than one device available, click **Change** to choose the correct microphone. You may need to do this if you have a standard microphone and a Web camera or another camera with a microphone connected to your computer.

4. Drag the **Record level** slider, so it is in the middle of the bar. When you speak into the microphone, the moving line should be in the green area. If the line moves to the red area, the volume level is too high and your voice will be distorted when played in your movie. Conversely, if the recording level is too low, the narration might play too quietly in your movie.

5. Select the **Mute video soundtrack** check box. When you select this check box, the sound from the video clips will not play. This lets you create a narration where only your voice is recorded.

 Note If you do not mute the sound from the video clips, the sound might be recorded in the background when you are recording your narration. This can create background noise that can be distracting.

6. When you are ready to record your narration, click **Record**. The video plays while you are recording your narration so you can synchronize your narration with the video clips in your movie. This lets you describe or introduce the content of the video as it plays.

7. Click **Stop** to end recording your narration.

8. In the **File name** box, type **Narration.wav**, and then click **Save**. The narration is saved as a WAV file, and it is automatically imported into the currently selected collection in Movie Maker and added to the beginning of your current project.

9. If necessary, drag the **Narration** clip to the point in your project where you want the narration to play. For example, if you started narrating your project 10 seconds into the movie, you would move the resulting audio clip to that point in your video.

10. On the **File** menu, click **Save Project** to save the added narration and any other changes you made to the project.

Adjusting audio levels

If your current project contains narrations, other audio clips, and video clips that also contain audio, the sound in your movie can become confusing. This is not to say that you should not mix audio sources in your movie. After all, the combination of audio and video from different sources is what makes exciting, dynamic movies. Imagine a major motion picture without the accompanying music playing in the background; something would definitely be missing. The main idea is to balance the different audio sources so that all your audio plays correctly.

To make all the inserted audio clear to your audience, you can adjust the audio levels of two different sources: the sound in the audio track (for example, narrations or music clips) and the sound in the video track (the voices and dialog in your video clips). You can adjust the playback volume by using the **Audio Levels** slider, which you can access by clicking **Audio Levels** under the **Edit** menu, or by clicking the volume slider in the lower corner of the storyboard or timeline.

The **Audio Levels** control, shown in Figure 10.12, lets you adjust the volume so that one audio source plays louder than the other, or so they both play at the same level. Because the slider is in the middle of the slider bar in Figure 10.12, the audio in the video and audio tracks of the current project would play at the same volume level.

Figure 10.12 – *The Audio Levels dialog box.*

Note You can only adjust the audio levels in the timeline view of your project. When your project is displayed in the storyboard view, this feature is disabled.

Determining which audio track should play louder depends on the purpose of the existing audio in your movie. For example, if the video contains a baby's first words and you have music playing in the background at the same time, you would want to drag the slider towards the **Video track** so that the baby's first words play back louder than the accompanying music. However, if you have a basic slide show that contains still images and video clips in the video track, and a narration you added to your project in the audio track, you would want to drag the slider toward the **Audio track**. When you do this, you and your audience can hear the narration over the sound in the video clips.

Another reason for adjusting the audio levels is to cover up distorted audio in your video clips. This is useful if the sound from your source video is not as clear as you had intended. Though Movie Maker does not let you separate the distorted audio track from the video clip itself, you can cover the poor audio quality from the video by adding an audio clip to the project and then sliding the bar in the **Audio Levels** dialog box all the way to the **Audio track** side. When you do this, as long is there is no silence in your audio clip, the audio in your video will remain unheard.

Though the audio may be quite clear, at times the recording level might be too loud—the audio in the video dominates the movie, while any existing audio clip can be barely heard. When this occurs, you can adjust the slider bar so that the bar is near the **Audio track** side. This lowers the volume of the audio in the video clip so the audio clip can be heard.

To adjust audio levels

1. Be sure the **Chapter 10 Editing.mswmm** project is open in Movie Maker.

2. On the **Edit** menu, click **Audio Levels**. Make sure the slider bar is exactly in the middle of the slider.

3. Click an empty space on the timeline, and then click **Play** on the monitor. Notice how the sound from the video clip dominates the movie, so the audio clip can barely be heard.

4. To lower the sound from the video so the audio clip can be heard more clearly, drag the slider bar so that it is on the second line from the **Audio track** side, as shown in Figure 10.13.

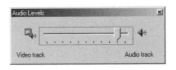

Figure 10.13 – *Adjusting sound to favor the audio track.*

When you adjust the **Audio Levels** setting, the sound level changes for the entire project.

5. Click an empty space in the timeline and then click **Play** on the monitor. Notice how the sound from the video now plays at a lower volume than before, so the audio clip plays more prominently.

6. Click **Close** to close the **Audio Levels** dialog box. The final project is shown in Figure 10.14.

Figure 10.14 – *The final project as it appears in the timeline.*

7. On the **File** menu, click **Save Project** to save these changes to your project.

Saving your movie

Once you complete all the changes to your project, you'll want to create a movie file that other people can watch. The following steps show you the basic process for saving your project as a movie. Chapter 11 provides more information about this process, along with tips for sharing your movie with other people.

1. To save your project as a movie that you and others can watch in Windows Media Player, click **Save Movie** on the **File** menu.

2. In the **Save Movie** dialog box, choose **High quality** for the **Setting**. Type the appropriate **Display area** information, and then click **OK**. In the **File name** box, the default name for the movie is the original project name, in this case **Chapter 10 Editing.wmv**. Click **Save** to save the project as a movie in Windows Media Format.

3. When your movie has been created, click **OK** in the resulting dialog box to open and watch your final movie in Windows Media Player.

The final movie of this sample movie appears on the companion CD. It is included in the files you copied from the Tutorials folder on the companion CD to your hard disk.

To play this movie in Windows Media Player

1. Click **Start**, point to **Programs**, and click **Windows Media Player**.

2. In **Windows Media Player**, on the **File** menu, click **Open**.

3. Locate the **Tutorials** folder on your hard disk or on the CD. Open the **Chapter 10** folder, and then open the **Final** folder.

4. Click **Chapter 10 Editing.wmv** and click **Open**. The movie plays in Windows Media Player.

Sharing Your Movie

After editing your movie to a point where you are satisfied, you are ready to save it and then share your movie with family and friends. Windows Movie Maker makes it easy for you to do this. You can send your movie in an e-mail message or post it to a Web site on the Internet.

This chapter discusses considerations you should make when saving and sharing your completed movies.

By the end of this chapter, you will be able to answer the following questions:

- How do I know what quality setting to use when saving my movie?

- How do I send a movie in an e-mail message?

- How do I share my movie with others on the Web?

- How do I post movies to a Web site that is not listed in Movie Maker?

Saving movies

In Movie Maker, you can save completed movies to your hard disk or another storage device that has enough free space. Whether you are planning to store your home videos on your own computer for your own enjoyment, or you are planning to share them with others, you need to save them in a Windows Media Format so that they can be played in Windows Media Player. You must save your movies before you send them in e-mail messages or post them to Web sites. When you send your movies directly from Movie Maker, saving the movie is part of this quick process.

Considering playback quality

When saving your movie, there are several important decisions you must make. The first consideration is choosing the quality setting at which to save your movie. Consider the following aspects of your movie when determining which quality setting to use:

The video content in your movie

To determine which quality setting to use when saving your movie, consider the video content of your movie. If you have a movie that contains only still image

clips inserted with accompanying music, such as in a slide show, use the **Medium quality** setting. Movies that do not contain any high-motion video clips can use one of the lower settings. However, if you have a lot of transitions, you might see a lot of pixelation at the lower quality settings.

If you have video that contains a lot of motion or action in the clip, such as people on a roller coaster, use the **High quality** setting or a custom setting. When a movie with a lot of motion in it is saved with a lower quality setting, the motion in the video can appear uneven and jerky because fewer bits are saved when the movie is saved at the lower quality settings.

The audio content in your movie

You must consider the audio in your movie as well. Typically, a movie that has simple narration does not need to be saved at a higher quality setting. However, more complex or dynamic sound tracks, such as music, require a higher quality setting. As with video, you need to save the movie at a higher bit rate to accurately encode complex audio information.

If you have a movie that contains both narration and music, save the movie at a higher quality setting. It's better to have a larger movie file than to have a movie with poor sound or video quality.

Your audience's Internet connection

When you send a movie in an e-mail message or post it to a Web site where the movie is not streamed, users must download the movie to their computer. They need to wait for the movie to be completely downloaded before they can watch it. The time it takes for your audience to download your movie increases with the file size of your movie.

Long download times can frustrate your end users. Be aware of how your audience connects to the Internet. If they connect through a dial-up modem, their download time is longer than if they connect through a faster Internet connection, such as with ISDN, DSL, or a cable modem. Consider their Internet connection speed when determining the quality setting to save your movie. When saving the movie, Movie Maker will show the file size and estimated download time at different Internet connection speeds when you select your quality setting. A lower quality setting will result in a smaller movie file, and therefore quicker download times.

When a movie is streamed to users' computers from a server running Windows Media Services, the movie plays while it is transferring to their computers; your users do not have to wait for the entire movie to be downloaded before they can begin to watch the movie.

Available hard disk space

If you have a movie that is quite long, the file size of the movie can be large even though it is compressed using Windows Media Technologies. If disk space is an issue, keep this in mind when saving your movie.

If you send the movie by e-mail, your users need to download the movie to their computers. If they do not have enough hard disk space, they will not be able to download and watch your movie. If you have less than 300 MB of free hard disk space on your system drive, which is the drive that the operating system is installed on, Movie Maker will not let you save the movie. To save the movie, you must first free up hard disk space. A movie saved at a higher quality setting requires more hard disk space than a movie saved at a lower quality setting.

Limitations on file sizes

Some Internet service providers (ISPs) or e-mail providers limit the size of a file you can attach to an e-mail message or post to the Web. Also, many service providers only provide a limited amount of space to store your files on their servers. Consult your ISP, e-mail provider, or Web hosting service to see what limitations they impose.

In conjunction with this, some Web host providers place a limit on the maximum bit rate a movie can be saved at and then successfully uploaded to their server. If a movie exceeds the limit, you will not be able to post your movie to that site successfully.

The goal is to keep the file size as small as possible without sacrificing the quality of your movie. One of the better ways to determine the best quality setting is to save multiple copies of your movie using the different quality settings. Then watch each movie in Windows Media Player. After you determine which version works best while still maintaining an acceptable file size, you can delete the other versions to save disk space, and then share the best version of the movie with others.

Creating and saving movies

The **Save Movie** dialog box, shown in Figure 11.1, lets you specify the quality setting, as well as metadata that appears when people watch your movie in Windows Media Player. This metadata can include the title, author, date, rating, and a short description of the movie.

When you save your movie, look at the file size and estimated download times shown in the **Save Movie** dialog box. These estimates give you an idea of the time it will take for your audience to download and watch your movie at the currently selected quality setting and using various Internet connection speeds. To get an idea of how the file size is affected by the quality setting, choose the different profiles and look at the resulting file size of your movie.

After you choose the setting you want, you can then save the movie to your computer. The movie is saved by default in the folder My Videos, which is in the My Documents folder. You can open the My Videos folder directly in Movie Maker from the **File** menu. You can also specify where you want to save each movie you create.

Figure 11.1 – *The **Save Movie** dialog box appears when you save or send a movie.*

After you have arranged your clips in the storyboard or timeline to the point where you have finished editing your project, you can then save it as a movie in Windows Media Format that you can watch in Windows Media Player.

To save a movie

1. Click **My Collections**. On the **File** menu, point to **New**, and then click **Collection**. Type **Chapter 11 Sharing** for the collection name. Select this new collection.

2. On the **View** menu, click **Options**. Set the **Default imported photo duration (seconds)** to **3** seconds, and click **OK** so that photos appear for three seconds by default when imported into Movie Maker and added to a project.

3. On the **File** menu, click **Import**. Locate the \Tutorials\Chapter 11\Working folder on your hard disk or the companion CD. Press and hold down the CTRL key and click the following files:

 - **Black.bmp**
 - **FishLadder.wmv**
 - **Introduction.jpg**
 - **Travel08.wav**

4. Clear the **Create clips for video files** check box and click **Open**. The FishLadder movie is imported as one clip into a new collection named FishLadder, and the other clips are imported into the current Chapter 11 Sharing collection.

5. To keep the clips organized, click the new collection named **FishLadder** and drag **Clip 1** to the Chapter 11 Sharing collection so it now contains the following clips:

 - Black

 - Clip 1

 - Introduction

 - Travel08

6. Click **Clip 1**, and then on the **Edit** menu, click **Rename**. Type **Fish Ladder** to give the clip a more descriptive name. Also, to keep your collections area organized, click the empty **FishLadder** collection, and then on the **Edit** menu, click **Delete**. Click **Yes** to confirm that you want to delete this empty collection.

7. With the **Chapter 11 Sharing** collection selected, click in the main collections area, which contains the clips, and then click **Select All** from the **Edit** menu. This lets you quickly select all the clips in the current collection.

8. Drag the selected clips to the storyboard or timeline, depending on your current view. If you are in the storyboard view, Movie Maker automatically switches to the timeline view because you are adding an audio clip.

 Note When you add multiple clips, the clips are added to the storyboard or timeline in the order they appear in the collections area and then top to bottom.

9. Click the **Black** clip and drag it to the beginning of the video track on the timeline. The clips in the video track should now appear in the following order:

 - Black

 - Introduction

 - Fish Ladder

10. Click the **Zoom In** button so the timeline displays in increments of about three seconds. Click the **Introduction** clip in the project and drag the start trim handle to approximately 0:00:02.67 on the timeline to create a short transition between the solid Black clip and the Introduction clip.

11. Click the **Fish Ladder** clip and drag the video clip over the end of the introduction clip to create a one-second transition.

12. Drag the **Travel08** clip in the audio track to the part of the video where the Fish Ladder clip begins to play, at the beginning of the transition. Drag the horizontal scroll bar below the timeline so you can see the end of the project. Click the

Fish Ladder clip and then drag the end trim handle so the clip stops playing with the music.

13. On the **Edit** menu, click **Audio Levels**. Drag the slider to the end of **Audio track** side so that the background music plays over the audio in the video. The audio level is adjusted for the entire project.

14. On the **Play** menu, click **Play Entire Storyboard/Timeline**. This lets you preview the entire project.

15. Click **Zoom Out** so the timeline displays in 0:00:10.00 intervals. On the **File** menu, click **Save**. In the **File name** box, type **Chapter 11 Sharing.mswmm** for the project name, then click **Save**. The current project is shown in Figure 11.2.

Figure 11.2 – *The current project with added transitions.*

16. On the **File** menu, click **Save Movie**. The **Save Movie** dialog box appears (without the completed information). The **Save Movie** dialog box appears each time you save a movie, whether you intend to watch it on your own computer or share it with family and friends.

Although the dialog box name is different when you send a movie in an e-mail message or to a Web site, the settings in the box are the same.

17. For this scenario, save the movie three different times by repeating step 16.

Note Each time you save the movie, the **Windows Movie Maker** dialog box appears to let you open and watch the movie in Windows Media Player. Click **No** each time you save the movie at the different settings. You will open and watch the movies in the next exercise.

Save the movie with the quality settings and file names shown in Table 11.1.

File name	Quality setting
FishLowSetting.wmv	Low quality
FishMediumSetting.wmv	Medium quality
FishHighSetting.wmv	High quality

Table 11.1 – *File names and quality settings for step 17.*

When you save the movie at the different quality settings, look at the estimated download times and the file sizes. Notice how the file size increases as the quality setting increases.

To view the saved movies

1. To start Windows Media Player, click **Start**, point to **Programs**, and then click **Windows Media Player**. This opens Windows Media Player so you can watch the three different movies saved at the different settings.

2. In Windows Media Player, on the **File** menu, click **Open**. Press and hold down the CTRL key, and then click the movies **FishLowSetting.wmv**, **FishMediumSetting.wmv**, and **FishHighSetting.wmv**.

When watching the movies in Windows Media Player, notice the difference between the movies when the same movie is saved with the different quality settings. For example, notice how the video size is smaller in the FishLowSetting.wmv movie (which is saved with the **Low quality** setting) compared to the movie saved at the **Medium quality** setting, FishMediumSetting.wmv, and the movie FishHighSetting.wmv saved at the **High quality** setting.

Besides the video display size, you'll probably notice other differences between the three movies. The fish in the movie saved at the **Low quality** setting appear to move more slowly than the fish in the movies saved with the **Medium quality** and **High quality** settings. Because the movies using the **Medium quality** and **High quality** settings contain more bits, or pieces of information, than the movie saved at the **Low quality** setting, the movement of the fish appears smoother with the higher quality settings. However, be aware of how the different settings affect disk space. The movies saved at the higher quality settings consume more hard disk space. When deciding which is more appropriate for you, consider who is going to watch the movie and how you plan to distribute it.

Sharing movies by e-mail

You can send your movie in an e-mail message, either from within Movie Maker or by using your regular e-mail program. All you need to do is add your own message to the existing instructions in the e-mail message, and then send the message.

Before the movie is sent, it is saved in the location specified in the **Temporary storage** box in the **Options** dialog box in Movie Maker. As a way of organizing your movies, you might want to create a separate folder on your hard disk to temporarily store movies that you send by e-mail or post to the Web. For example, you could create a folder on your hard disk named Sent Movies in the My Videos folder. If Windows Millennium Edition is installed on drive letter C, the complete path would be C:\My Documents\My Videos\Sent Movies.

After you successfully send the movie, a copy of the movie file is removed from the folder specified by the **Temporary Storage** setting. To save a permanent copy of the movie, use the **Save Movie** command on the **File** menu.

Before sending the movie, Movie Maker prompts you for several pieces of information. One is the name you want to use for your movie. The default movie name is the same as the project name displayed in the title bar of Movie Maker. If you have not saved the current project, the name for the movie, which you can change, is "untitled." Change the name so that it is meaningful to you and your audience.

In the following scenario, you will need to open the project named **Chapter 11 Sharing.mswmm**, which was created in the previous exercise. If you have another project created that you want to send, open that project instead.

To send a movie in an e-mail message

1. Make sure your computer is connected to the Internet.

2. On the **File** menu, click **Open Project**. Open the project **Chapter 11 Sharing.mswmm**.

3. On the **View** menu, click **Options**. Two features in the **Options** dialog box are used when sending a movie by e-mail: **Email Options** and **Temporary storage**.

4. In the **Options** dialog box, click **Email Options**, and then select **As an attachment in another e-mail program**. Click **OK** to return to the **Options** dialog box. When you send a movie by e-mail, **As an attachment in another e-mail program** is automatically selected.

 Note If you use one of the listed e-mail programs, such as MSN Hotmail or Microsoft Outlook Express, choose that e-mail application. This lets you send the movie directly from Movie Maker without manually starting the e-mail program and attaching the movie to your message.

5. Click **Browse** in the **Temporary storage** box. In the **Browse For Folder** dialog box, double-click **My Computer**, the Windows Millennium Edition system drive letter (for example, C), **My Documents**, **My Videos**, and then click **New Folder**. Name the new folder **Sent Movies**, and click **OK**.

 The **Temporary storage** box now reads:

 SystemDrive\My Documents\My Videos\Sent Movies

 where *SystemDrive* is the drive on which Windows Millennium Edition is installed. For example, if the operating system is installed on drive letter C, the path in the **Temporary storage** box would read:

 C:\My Documents\My Videos\Sent Movies

6. Click **OK** to close the **Options** dialog box.

7. On the **File** menu, point to **Send Movie To**, and then click **E-mail**.

8. In the **Send Movie Via E-mail** dialog box, complete the information as shown in Figure 11.3. This is the same dialog box that appears when you simply save a movie.

Figure 11.3 – *The **Send Movie Via E-mail** dialog box with completed information.*

Before you continue, click **Setting** to see the difference in the estimated download time and think about who you are going to send this movie to and their Internet connection speed. In other words, if your family and friends are going to watch this on their home computer and they have a 56 Kbps dial-up connection, it will take an estimated time of approximately 1 minute and 38 seconds; whereas, if you want to save it at the **High quality** setting, the estimated download time approximately doubles. For a shorter movie like this, the **High quality** setting might be best because the estimated download time is not an extraordinary amount of time and the movie has rapid movements that are nicely displayed when you save the movie at this quality setting.

> **Note** You can watch the movie of the Fish Ladder at the different quality settings by starting Windows Media Player and opening and playing the FishLowSetting.wmv, FishMediumSetting.wmv, and FishHighSetting.wmv, which are located in the **Samples** folder under the **Chapter 11** folder.

9. In the **Name the movie to send** dialog box, type **FishLadderEmail**, and then click **OK**.

When you save the movie, you do not need to type a .wmv file extension; Movie Maker automatically adds it to the file name. The movie—FishLadderEmail in this example—is saved on your computer to the location specified by the **Temporary storage** setting, which you set in step 5.

If you click **Cancel** at any point before sending your movie, it will not be sent by e-mail or saved on your computer. If you decide in the middle of the process that you don't want to send the movie, but you do want to save it to your computer, click **Cancel**, then click **Save Movie** on the **File** menu.

10. Because you selected **As an attachment in another e-mail program** in the **Email Options** field in step 4, it is automatically selected as the default method you want to use to send your movies by e-mail.

11. If you always want to send you movie as an attachment using another e-mail program, select the **Don't ask me again** check box. The next time you send a movie by e-mail, this dialog box does not appear.

 Tip If you later decide you want to see this dialog box and other warning dialog boxes, go to **Options** under the **View** menu and click **Reset Warning Dialogs**. This lets you see warning dialogs that you previously could not if you selected the **Don't ask me again** check box.

12. The **E-mail Movie As An Attachment** dialog box, shown in Figure 11.4, appears with instructions about how to send your movie as an e-mail attachment. Click **Close** after you send your movie.

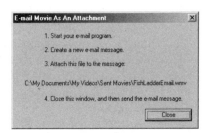

Figure 11.4 – *Sending a movie as an attachment in an e-mail message.*

Note If you use one of the listed choices in the **E-mail Movies** dialog box, such as **Default e-mail program**, **Hotmail**, or **Outlook Express**, that e-mail program automatically starts with the movie already attached. The e-mail appears with instructions about how to watch the movie. All you need to do is add a personalized message to the e-mail message, and then send it.

13. If you want to save a copy of this movie on your own computer in addition to sending it in an e-mail message, on **File** menu, click **Save Movie**. In the **File name** box, type a name for the movie, and click **Save**.

Sharing movies on the Web

You may decide that the best way to share your movie is to post it to a Web site for others to watch when they go to your site. If you decide you want to share your movies over the Web, you must have an account with a Web site hosting service that lets you post movies to your Web site. If you do not have an account with a Web site host provider, you can find information about how to sign up for one in Movie Maker. The **Sign me up** button takes you to the Internet and lists some possible Web site host providers.

If you already have an account with a Web site hosting service or ISP, you can create a profile that lets you send movies directly to your Web site from Movie Maker.

As when you send a movie by e-mail, a copy of the saved movie is temporarily stored in the location specified by the **Temporary storage** setting in the **Options** dialog box. After you close the **Sending to Web** dialog box and the movie has been uploaded to the Web site successfully, the copy of the movie is removed from the specified **Temporary storage** folder. To save a permanent copy of the movie to your own, use the **Save Movie** command on the **File** menu.

> **Note** All the Web sites listed in the following scenarios for this section are fictitious. You will not find the same Web site providers listed in Movie Maker.

To send a movie to a listed Web site provider

1. Make sure your computer is connected to the Internet.

2. On the **File** menu, click **Open Project**. Select the project you want to send or create a new one. If you have your own project that you want to save and send to a Web server, open that project.

3. On the **File** menu, point to **Send Movie To**, and then click **Web Server**. The **Send Movie to a Web Server** dialog box appears. This is where you specify the quality settings and enter the metadata that will be displayed in Windows Media Player.

 > **Note** The quality settings for saving a movie you want to send to a Web site are the same settings you use when you save a movie to your computer or send your movie in an e-mail message.

4. Complete the information in the dialog box. An example is shown in Figure 11.5. After you have entered the correct information, click **OK.**

Figure 11.5 – *Saving a movie before sending it to a Web site.*

5. In the **Enter a file name** box, the movie is given the project name by default. Click **OK** to save the movie. The movie is created and saved to the temporary storage folder, and then the **Send to Web** dialog box appears.

 Note The time it takes for the movie to be created and saved is based on the number of clips added to the current project; the more clips contained in the movie, the greater the time it takes to create and save the movie.

6. In the **Host name** box, select a listed host name from the drop down box as shown in Figure 11.6.

Figure 11.6 – *Selecting a Web hosting service profile.*

 Note This Web site address is shown only for demonstration purposes in this scenario. You cannot send a movie to this fictitious Web site provider.

 If you do not have a Web site host provider and you are already connected to the Internet, you can click **Sign me up** to find a list of Web site host providers that enable you to post your movies on-line.

7. In the **User/login name** box, type your user name, and then type your password in the **Password** box. Click **OK** to upload your movie.

 Note For demonstration purposes, the imaginary site in Figure 11.7, called **Southridge Video Shop** is selected with the user name **Kate** and the appropriate password.

Figure 11.7 – *Entering login information for sending a movie to a Web site listed in Movie Maker.*

 Choosing a listed Web site provider lets you choose the host, and then the other settings, including the Web site address, are already configured. All you have to do is type in your user name and password.

8. Click **Close** in the **Sending to Web** dialog box to close the box.

9. If you want to save a copy of this movie on your own computer in addition to sending it to the listed Web host provider, on the **File** menu, click **Save Movie**. In the **File name** box, type a name for the movie, and click **Save**.

To send a movie to an unlisted Web site provider

1. Make sure you are connected to the Internet.

2. On the **File** menu, click **Open Project**. Locate and click the project you want to send. Click **Open** to open the project in the storyboard or timeline.

3. On the **File** menu, point to **Send Movie To**, and then click **Web Server**. The **Send Movie to a Web Server** dialog box appears. This is where you specify the quality settings and enter the metadata that appears in Windows Media Player.

4. Complete the information in the dialog box. Example information is shown in Figure 11.8. After you have entered the information, click **OK**.

Figure 11.8 – *Selecting options for sending the movie to the Web.*

5. In the **Enter a file name** box, the name of your project appears as the default.
 For example, if your project was named Mountains.mswmm, Mountains appears
 as the default movie name. Click **OK**. The movie is created and saved, and then
 the **Send to Web** dialog box appears.

 Note When naming and saving the movie, you do not need to include the
 file extension .wmv; it is added automatically.

6. In the **Send to Web** dialog box, click **New**. This lets you set up a new Web site
 host provider profile. By creating a profile for your own account and provider,
 you can send movies directly to your own Internet site.

7. In the **Friendly name of Web site host** box, type a common name for your
 Web site host. This is the name that appears in the **Host name** drop down box
 after you enter the necessary information in the **Create Web Host Settings** dia-
 log box. For example, you could name the site My Movies.

 Tip If different people in your home use Movie Maker and use the same
 Web site host, but have separate accounts, you might want to type a friendly
 name to indicate which profile to select for each user in your family. This can
 help eliminate confusion over which profile belongs to which family member.

8. In the **FTP upload address for sending a movie to this site** box, type the FTP
 address. When you enter the address, just type the actual address without ftp://.
 Movie Maker automatically determines the protocol to use to upload your
 movie. For example, if the upload address is *ftp://ftp.hanson-brothers.tld*, you
 would type ftp.hanson-brothers.tld. For the specific upload address, contact
 your Web site host provider.

9. In the **Web address for viewing movies sent to this site** box, type the address
 where your end users go to view your Web site. In this box, type the entire Web
 site address including http://. For example, you would type the Web site address

http://www.hanson-brothers.tld if this was the actual Web address users would go to watch your movie.

10. In the **Name of home page file on this site** box, enter the home page file, including the .htm or .html file extension. If your home page name is a name other than index.html or default.htm, type that file name in the box.

> **Note** Only use the **Advanced settings** if they are required by your Web site host provider to upload your movie to their site. Generally, both the **Use passive FTP semantics** and **This Web site requires anonymous login** check boxes should be clear.

If you used the fictional Web site address examples in this scenario, the fields in the **Create Web Host Settings** dialog box would appear as shown in Figure 11.9.

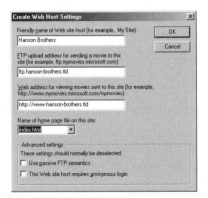

Figure 11.9 – *Sample information used to create a Web site host provider profile.*

11. After entering the information in the **Create Web Host Settings** dialog box, click **OK** to return to the **Send To Web** dialog box.

12. In the **Send To Web** dialog box, click **In my home page directory**. When this is selected, the movie is uploaded to the same directory as your home page. The new profile name is selected for the **Host name**. Next to the name, the text "user added provider" indicates that this is a Web host provider you added.

To organize your Web site, you might want to consider adding a directory named movies to upload your movies. In this case, you would select **In this folder in my site** and then type **movies**. This lets you keep your movies in one directory, separate from the other files, such as the HTML and graphics, in your Web site. If you choose to upload to a new directory, type a name for the new directory that does not yet exist. When the file is uploaded, the new directory will be created and the file will be uploaded into the new directory on your Web site.

13. In the **User/login name** box, type your user name, and then type your password in the **Password** box. Click **OK** to upload your movie.

 Note If you have multiple users who use Windows Movie Maker, consider clearing the **Save password** check box. This prevents other users from uploading their movies to your Web site.

14. After your movie has been uploaded successfully, click **Visit Site Now** to go to your Web site. Your Web browser opens and goes to the listed Web site address. This is the Web site address in the **Web address for viewing movies sent to this site** box that you typed when creating the custom Web host profile.

When your browser opens, your movie does not play automatically. If you want your users to play your movie directly from your Web site, edit your home page and create a hyperlink to the movie in your favorite HTML editor. Depending on your Web site host provider, you may be able to edit the page directly on the Web site, or you may need to download the page, edit it, and then upload the edited HTML home page.

To create a hyperlink to your movie from your home page

1. Open your home page in your HTML editor.

2. Assuming that the example Mountains.wmv movie file is in the same directory as your home page, you could insert the following hyperlink to the Mountains.wmv movie in your home page:

```
<A  HREF="Mountains.wmv">My  trip  to  the  mountains</A>
```

3. Save the changes to your home page, and upload the home page if necessary.

If you do not create a hyperlink in your home page, you can simply give your end users the exact Web site address, including the movie file name, that they can open in Windows Media Player.

To open a movie from a Web site in Windows Media Player

1. Click **Start**, point to **Programs**, and then click **Windows Media Player**. This starts Windows Media Player.

2. In Windows Media Player, on the **File** menu, click **Open URL**.

3. In the **Open** dialog box, type the complete Web site address, including the protocol (http://), domain, and the movie file name. For example, you would type *http://www.hanson-brothers.tld/Mountains.wmv* to play the movie called Mountains.wmv at the Web site *http://www.hanson-brothers.tld*.

Part 3
Advanced Uses for Windows Movie Maker

Working with Still Images

Throughout this book, we have primarily covered video. However, with the emergence of digital cameras and scanners, still images are very easy to capture on your computer. You can also capture still images by using the **Take Photo** feature that is available when you are recording source material from an analog or DV camcorder or from a Web camera into Windows Movie Maker. By using these tools, you can further enhance the movies you create in Movie Maker. For example, you can use images to create slide shows, to insert photographs in a documentary, to make sophisticated transitions, or to create credits.

It's best to start out with images that are 320 pixels wide by 240 pixels high because this is the video size used for the **Medium quality** and **High quality** settings, as well as for other custom quality settings. If you use images that are smaller than this, the resulting video in your movie may appear stretched. For example, if you have an image that is 160 pixels wide by 120 pixels high, the image needs to be stretched to fit into the 320 pixel by 240 pixel video size for the **Medium quality** and **High quality** settings. If you are planning to save your movie using the **Low quality** setting, your image does not appear stretched because the default video display size for this quality setting is 176 pixels by 144 pixels.

To see the difference between the two dimensions, use Windows Media Player to open the file named Comparison.wmv in the Tutorials\Chapter12\Samples folder on the companion CD. The first image that appears in this brief slide show is 320 pixels by 240 pixels, while the second image is 160 pixels by 120 pixels. This short video was saved using the **Medium quality** setting in Movie Maker. Notice how the first clip of the waterfall is clearer than the second clip.

In this chapter, some of the tips and tricks we'll discuss involve using third-party programs and features of the Windows operating system. You can use Microsoft Paint (which is a feature of the Windows Millennium Edition operating system), Microsoft PhotoDraw, and Microsoft Word. You can also use other image editing programs to accomplish the same tasks.

The final scenario of this chapter requires the use of third-party software to export frames as still images from existing video files such as AVIs. One tool you can use is Sonic Foundry Viscosity. You can download a trial version of Sonic Foundry Viscosity from the Web at *http://www.sonicfoundry.com*. After you export and save the still images, you can then use them in the movies you create in Movie Maker.

Creating custom transitions

A common trick is to create a clip that is just a solid white or black image. You can use these clips to create a fade in or fade out.

To create these fades in Movie Maker, all you need to do is add a solid white clip and a solid black clip to the project and create a cross-fade transition between one of your content clips and one of the solid clips. The length of the effect is up to you. You can fade to or from black, and you can fade to or from white.

Creating slide shows

Many people think of slide shows as a series of images shown one after the other while someone talks in the background. Sounds a little boring, doesn't it? Well, it doesn't have to be.

Movie Maker lets you jazz up the traditional slide show. In fact, the slide shows you create with Movie Maker are really movies, only the clips you use are images rather than full-motion video. You can do anything in your slide show that you could do in a movie. You can alter the amount of time each image is displayed in your slide show, and use cuts or cross-fade transitions between images. By changing the playback duration, along with adding your own narrations and music, you can easily create dynamic, fun slide shows—nothing like those boring old filmstrip presentations at school.

The still images you use for a slide show can be photos, scanned images, or graphics created in an image editing program.

A basic slide show

The following exercise is divided into several sections. The first section describes how to edit existing images using Microsoft PhotoDraw. The following sections describe how to use these images to create a slide show in Movie Maker.

Although these scenarios describe how to use Microsoft PhotoDraw, you can certainly use your favorite image editing program. The specific commands may be different, but the general concepts and procedures will be similar.

Finally, if you already have some image files available on your computer, try using them in place of the specific files listed in the exercise. This will let you create your own slide show immediately.

Editing images in Microsoft PhotoDraw

These procedures describe how to edit image files in Microsoft PhotoDraw. Once you have finished, the image files will be ready to import into Movie Maker. You can then use the clips containing these images to create a slide show.

If you don't have PhotoDraw installed on your computer, you can use a different image editing program to achieve similar results.

1. Start Microsoft PhotoDraw.

2. On the **File** menu, click **New**. Regardless of your default settings, select **Default Picture** for the template to use, and then click **OK**.

 Note If the **Microsoft PhotoDraw** dialog box appears, which lets you select what you want to do, click **Blank Picture**, and then click **OK**. Continue by clicking **Default Picture**, and then **OK**. This opens a blank page.

3. Because the background file is a custom size, on the **File** menu, click **Picture Setup**.

4. In the **Picture Setup** dialog box, make sure the **Units** box is set to **pixels**, type **320** in the **Width** box, and then type **240** in the **Height** box. Make sure **Landscape** is selected for the **Orientation**, and then click **OK**.

5. On the **Tools** menu, point to **AutoShapes**, point to **Basic Shapes**, and then click **Rectangle** to create a rectangle that acts as a border for your images.

6. Click **Edge** in the workpane list, and then click **Artistic Brushes** for the **Gallery type**. Select **Charcoal** from the Gallery.

7. Click the **Black** color square for the line color, and then type **15** for the **Width**. Drag the mouse on the blank page to create the rectangle.

 Note When you create the rectangle, start it a few points away from the edge of the blank white picture so there is an empty area between the rectangle edge and the edge of the image border. If necessary, click and drag the handles on the rectangle to resize it.

8. With the rectangle selected, on the **Format** menu, point to **Fill**, and then click **Picture**. This lets you fill the rectangle with a picture from the Gallery or with one of your own images.

9. Under the Gallery, click **Browse** to choose the image you want to use to fill the rectangle. Expand the Tutorials folder, the Chapter 12 folder, and then the Working folder. Click **Forest.jpg**, and then click **Open**. If you have images of your own, select the image you want to use to fill the rectangle. The image appears in the rectangle.

10. On the **File** menu, click **Save**. In the **File name** box, type **ForestBorder.jpg**. In the **Save as type** box, click **JPEG File Interchange Format (*.jpg)** because you can import JPEG images into Movie Maker.

11. In the **Save As** dialog box, click **Options**. The **Export Options** dialog box should have the settings shown in Figure 12.1. Click **OK** to close this dialog box, and then click **Save** to save the new image.

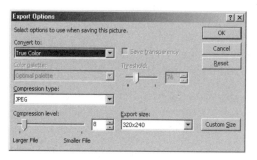

Figure 12.1 – *The **Export Options** settings for the current image.*

12. Click the rectangle to select it, and then click **Browse** under the Gallery to select another image to fill the rectangle. In the **Chapter 12** folder, locate the **Working** folder , click **MarymereFalls.jpg**, and then click **Open**. This fills the same rectangle with the different image. Again, if you have your own images, use one of them in place of the MarymereFalls.jpg image.

13. To save this new image with a new file name, on the **File** menu, click **Save As**. In the **File name** box, type **MarymereFallsBorder.jpg**. In the **Save as type** box, select **JPEG File Interchange Format (*.jpg)** again.

14. Click the **Options** button, and be sure the settings match Figure 12.1. Click **OK** to close the **Export Options** dialog box, and then click **Save** to save the new image.

15. Repeat steps 12 through 14. Table 12.1 lists file names of images in the Working folder that you can choose as the fill image and the corresponding new file name if you want to follow along with the steps described here. You can also use your own image files.

Fill image (graphics file name)	New saved file name
LakeCrescent.jpg	LakeCrescentBorder.jpg
PortTownsend.jpg	PortTownsendBorder.jpg
SolDuc1.jpg	SolDuc1Border.jpg
SilverLake1.jpg	SilverLake1Border.jpg
SilverLake2.jpg	SilverLake2Border.jpg

Table 12.1 – *Fill images and new file names for slide show images.*

16. On the **File** menu, click **Save As**. Locate the folder where you want to save this new image. In the **Save as type** box, make sure **PhotoDraw 2000 2.0 (*.mix)** or **PhotoDraw 2000 1.0 (*.mix)** is selected (depending on the version of PhotoDraw you are using, and then type **BorderImageTemplate.mix** in the **File name** box. Click **Save**. This becomes a template that you can later edit if you choose to make more slides.

17. After you have created the images that you want to include in your slide show, click **Exit** on the **File** menu in PhotoDraw.

Importing and arranging the slides

These steps describe how to import the image files you just created into Movie Maker, and then place the resulting clips on the storyboard or timeline to create the actual slide show.

1. Start Windows Movie Maker.

2. Click **My Collections**. On the **File** menu, point to **New**, and then click **Collection**. Type **Chapter 12 Slide Show** as the new collection name. The new collection appears one level below My Collections.

3. On the **View** menu, click **Options**. In the **Default duration for imported photos (seconds)** box, type **3**, and then click **OK**. Each imported image will appear for three seconds by default when you add it to your project.

4. On the **File** menu, click **Import**. Expand the **Chapter 12** folder to locate the **Working** folder, press and hold down the CTRL key, click the following files, and then click **Open** to import the images and audio files:

 • **Black.bmp**

 • **Forest.jpg**

- **LakeCrescent.jpg**
- **MarymereFalls.jpg**
- **Mood03.wav**
- **Mood06.wav**
- **PortTownsend.jpg**
- **SilverLake1.jpg**
- **SilverLake2.jpg**
- **SolDuc1.jpg**
- **TripofaLifetime.gif**
- **TripofaLifetime_TheEnd.gif**
- **White.bmp**

5. Again, on the **File** menu, click **Import**. Locate the folder where you saved the images with the borders around them. Hold down CTRL, click the following files, and then click **Open** to import these images:

- **ForestBorder.jpg**
- **LakeCrescentBorder.jpg**
- **MarymereFallsBorder.jpg**
- **PortTownsendBorder.jpg**
- **SilverLake1Border.jpg**
- **SilverLake2Border.jpg**
- **SolDuc1Border.jpg**

 Note You can also import these files from the \Chapter 12\Samples folder on your hard disk if you copied the Tutorials folder from the companion CD.

6. In the timeline view, click the current collections area, and then on the **Edit** menu, click **Select All**. Drag the selected clips to the timeline. All the photo clips, including the blank white and black slides, appear on the video track. The two audio clips appear on the audio track.

 Note You can create the blank white and black images in any graphics program. Both of these images are blank images. One has a white background fill and the other has a black background; both are 320 pixels wide by 240 high and saved as BMP images.

7. The first step to creating the actual slide show is to arrange the clips. On the **View** menu, click **Storyboard**. This lets you see the sequence of your video clips.

8. By dragging the clips to the storyboard, arrange the clips so they appear in the following order:

- **Black**
- **TripofaLifetime**
- **White**
- **ForestBorder**
- **Forest**
- **LakeCresecent**
- **LakeCrescentBorder**
- **MarymereFallsBorder**
- **MarymereFalls**
- **PortTownsend**
- **PortTownsendBorder**
- **SilverLake1Border**
- **SilverLake1**
- **SilverLake2**
- **SilverLake2Border**
- **SolDuc1Border**
- **SolDuc1**
- **TripofaLifetime_TheEnd**

Figure 12.2 shows the current project with the clips arranged correctly.

Figure 12.2 – *Image clips arranged in the storyboard view.*

9. Hold down the CTRL key and drag the **White** clip so one copy appears after the MarymereFalls clip and another copy appears after the clip TripofaLifetime_TheEnd. As you drag the clips, the storyboard scrolls horizontally.

10. Hold down CTRL and drag the **Black** clip so one copy of the clip appears after the second White clip, another appears after the SolDuc1 clip, and another appears after the third White clip. You will have a total of four Black clips.

11. On the **View** menu, click **Timeline**. If necessary, drag the **Mood03** audio clip so it is the first clip in the audio track and begins to play at the beginning of the

video, and then drag the audio clip **Mood06** so the two audio clips are next to one another without any gaps. On the **Play** menu, click **Play Entire Storyboard/Timeline** to preview the current project.

12. On the **File** menu, click **Save Project**. Name and save the project as **Chapter 12 Slide Show.mswmm**.

13. Right now, without any inserted transitions, all the clips in the entire slide show play for three seconds because this is the value you selected for the **Default duration for imported photos (seconds)** setting in the **Options** dialog box.

14. Click **Zoom In** or **Zoom Out** until the timeline displays intervals of approximately three seconds.

Adding transition effects to the slide show

Now you can add transitions to your slide show, rather than just cutting from one slide to the next. All the times listed for the individual clips in this exercise are approximate, based on the sample movie on the companion CD. Because this project involves many clips, the timing for the clips in your project might be different, which is fine. The goal is to create the slide show and make it your own.

1. Click **Zoom In** so the timeline displays in 1.33-second intervals. This lets you see the timeline in more detail.

2. Insert the first transition by selecting the **TripofaLifetime** clip and then dragging the start trim handle over the Black clip so the title slide begins to play at 0:00:00.80 in the project. Drag the end trim handle to 0:00:05.33 on the timeline.

To find the approximate time of the clip:

1. Point to the time display on the timeline.

2. When your mouse pointer turns to an up arrow, click the time display in the timeline. The play indicator appears, which is shown as an upside down triangle, and that time in the project appears on the monitor in hours:minutes:seconds format. The playback indicator is shown in Figure 12.3.

Figure 12.3 – *The playback indicator.*

When you click the time display and you see a single vertical line, you are seeing the time for the selected clip, not the entire project. Make sure the playback indicator appears.

3. On the monitor, click **Previous Frame** or **Next Frame** to go to the approximate frame.

4. Drag the trim handle of the photo clip to the approximate point marked by the playback indicator.

3. Click the **White** clip and drag the start trim handle to approximately 0:00:04.07 in the timeline. With this transition, the White clip causes the movie to become brighter before playing the following clip in the storyboard.

4. Click the **ForestBorder** clip and then drag the start trim handle so there is a transition between the two clips. The transition should begin at approximately 0:00:06.60 in the project.

5. Click the **LakeCrescent** clip and drag the start trim handle so the transition begins at approximately 0:00:12.60.

6. To see how this part of your project looks, click on the timeline display numbers so the play indicator appears. Drag it to the point where you want to begin playback, and then click **Play** on the monitor. Click **Stop** after you preview the portion of the project you wanted to see.

7. Click the **MarymereFalls** clip and drag the start trim handle to approximately 0:00:20.97.

8. At the middle of the current project, the Mood03 audio clip stops playback, and the Mood06 clip begins to play. At this time, insert a long transition between the **Black** and **White** clips so a transition occurs in the video when one audio clip ends and another begins. For the **White** clip, drag the end trim handle to 0:00:26.97 on the timeline.

9. Click the **Black** clip and drag the start trim handle to create a greater transition between these two clips. Drag the start trim handle so the transition starts at 0:00:24.93. Drag the end trim handle to approximately 0:00:28.80 so there is a transition between this clip and the PortTownsend clip.

10. Click the **PortTownsend** clip and drag the end trim handle to 0:00:31.87 on the timeline. This short transition, combined with the current images, makes the image appear to shrink. Click the timeline display before this transition and then click **Play** to see this transition effect.

11. Click the **SilverLake1Border** clip and the drag the start trim handle to 0:00:33.93 in the project. This slight transition gives the appearance that the rectangle is filled with the image because the shape stays stationary in each slide.

12. Click the clip **SilverLake1** and then drag the end trim handle to 0:00:40.00 on the timeline. A long transition now appears between this clip and the SilverLake2 clip.

13. Click the **SolDuc1** clip and drag the start trim handle to approximately 0:00:46.37 on the timeline. Drag the end trim handle to 00:00:49.97 on the timeline. This creates a short transition between the clips SolDuc1Border and SolDuc1—it appears as though the waterfalls grow outward, while at the end of the SolDuc1 clip it fades to black.

14. To insert the transition between the Black clip and the TripofaLifetime_TheEnd clip, click the **TimeofaLifetime_TheEnd** clip and drag the start trim handle to 0:00:51.67, and then drag the end trim handle to 00:00:56.63 so it becomes bright at the end before fading out.

15. For the final effect, click the **White** clip and drag the end trim handle to 0:00:57.77 so that the video fades in and then out as the audio clip stops playing.

16. On the **File** menu, click **Save Project** to save these changes in the project.

Saving the slide show as a movie

Finally, save the project as a movie that you can watch in Windows Media Player.

1. To save the movie, on the **File** menu, click **Save Movie**.

2. In the **Save Movie** dialog box, click **High quality** for the **Setting**, enter the **Display area** information, and then click **OK**.

3. In the **Save As** dialog box, accept the default movie name **Chapter 12 Slide Show.wmv**, and then click **Save**.

4. After the movie is created, click **Yes** in the **Windows Movie Maker** dialog box to open and watch it in Windows Media Player.

Adding a narration

If you want to add a narration, first add the clips you want to appear in your slide show and establish the order of the clips, then record narration by using the **Record Narration** feature discussed in Chapter 10. Just as when you are recording your movie, it's a good idea to have a basic script written for your narration. A few short notes on a piece of paper can help make recording your narration go smoothly.

Movie Maker lets you record your narration while the slides play. This helps you get the timing of the clips synchronized with your narration. Remember, you aren't lim-

ited to just one narration in your project; you can record several short narration segments and then arrange them to play at selected times.

In addition to narrations, you can also add background music to your slide show. You can import and use music that is in Windows Media Format (using .asf or .wma file name extensions), WAV, MP3, or other formats. Chapter 10 explains how to add music to your movies—the process is the same for a slide show.

Working with title slides

You can create title slides to introduce your movies. The contents of the title slides can contain whatever you like. For example, it can include a simple title and your name, or it can include a brief description of what your user is about to see in your movie.

Title slides often appear at the beginning and end of a movie; however, Movie Maker lets you add title slides wherever you like in your movie. For example, if you have still images from your vacation, you could add a slide showing the name of the place that will be seen in the next image.

As described earlier, you can use your favorite image editing program to create slides. The only thing you need to remember is to save your images in a graphic format that can be imported into Movie Maker. You can import files that have a .bmp, .gif, or .jpg file extensions, to name a few.

Creating animated title slides

In addition to using still images for title slides, you can also create titles that move. To do this, you make several different still images and then arrange them in Movie Maker so it looks like they are moving. By animating title slides, you can make words on the slides appear to bounce, scroll, or simply fade in and out.

When you animate your title slides, think about what your movie contains. For example, you often see commercial movies in which the opening titles fade in and out during the opening scenes of the movie. In Movie Maker, you can do the same thing.

The following scenario describes how to create a slide show that has animated title slides. By following the steps below, you can make the name of your movie, or other information, slowly appear on the screen.

The instructions are broken into two sets of procedures. The first section describes how to create the title slides in Microsoft PhotoDraw. The second section describes how to create the animation in Movie Maker. You can create the graphics in a differ-

ent image editing program as long as you can save the graphics in a file format that can be imported into Movie Maker.

Creating title slides in Microsoft PhotoDraw

First, you need to create the title slides. We'll use PhotoDraw to create the slide images, but you can use any image editing program that lets you save .bmp, .gif, or .jpg files.

1. Start Microsoft PhotoDraw.

2. On the **File** menu, click **New**. This opens the **New** window. Regardless of your default settings, choose **Default Picture** for the template to use.

3. Because the background file is a custom size, on the **File** menu, click **Picture Setup**. This opens a blank page.

4. In the **Picture Setup** dialog box, make sure the **Units** box is **pixels**. Type **320** in the **Width** box, and then type **240** in the **Height** box. Be sure **Landscape** is selected for the **Orientation** setting, and then click **OK**.

5. On the **Insert** menu, click **From File**. This lets you choose an image to use as the background. For this first title slide, select **MountBakerTitleSlide.jpg** in the Working folder for Chapter 12 on your hard disk, and then click **Open**.

6. If the inserted image appears outside of the blank image, drag the selected image so it appears in the blank page.

7. On the **Insert** menu, click **Text**. Click **Format Text** in the **Text** workpane list. In the **Text** window, replace the words "Type text here" with **Our Trip**. When complete, the animated title slide will read "Our Trip to Mount Baker."

8. Select the font you want to use.

9. In the **Size** box, select the font size. Specify **24** points, or an appropriate size for the font you chose. Be sure to choose a large font size so your text can be seen in the resulting movie.

10. In the **Text** workpane list, click **Fill**. Select a color for your text. In this example, the text is blue; however, feel free to choose your own color.

11. On the **Edit** menu, click **Duplicate**. Drag the copy of the duplicate text to the middle of the image. In the **Text** workpane list, select **Format Text**. Select the text **Our Trip** in the **Text** window, and then type **to**. This is going to be the new text for the third title slide you save.

 Note By duplicating the text, you keep the font type, size, and fill color consistent with the other text in the title slide. This helps to give your title slides

a more polished look, and saves you from having to specify the font, type size, and color again.

12. Drag the text to the center of the box if necessary.

13. Again, with the **to** text element selected in the image, on the **Edit** menu, click **Duplicate**. This duplicates the text.

14. In the **Text** workpane list, click **Format Text**. Select **to** in the **Text** window, and then type **Mount Baker**.

15. To make the "Mount Baker" text look different from the other text, click **Designer Text** in the **Text** workpane list, and then click **Designer Text 1** from the gallery. If necessary, drag the **Mount Baker** text element to the bottom of the image. Your final slide should look similar to the image shown in Figure 12.4.

Figure 12.4 – *The final title slide.*

Saving the title slides in Microsoft PhotoDraw

Before you can import still images into Movie Maker, they must be saved in a graphics file format that Movie Maker supports, such as graphic files with a .jpg, .bmp, or .gif file extension. Therefore, to use the slides you created in Microsoft PhotoDraw, you must save the image in one of these supported file formats.

1. Click the background image (which is the mountains), and then, on the **File** menu, click **Save Selection**. The mountain is going to be the first title slide. Choose a folder to save your title slide.

2. In the **File name** box, type **TitleSlide1.jpg** for the file name. In the **Save as type** box, choose **JPEG File Interchange Format (*.jpg)**.

3. In the **Save Selection** dialog box, click **Options**. In the **Export Options** dialog box, be sure the **Export size** box has the value **320x240**, and then click **OK**. Click **Save** to save the first title slide.

4. With the background still selected, press and hold down the SHIFT key, and then click the text element **Our Trip** in the image itself. The selected text and background will be the second title slide.

5. On the **File** menu, click **Save Selection**. Locate the folder where you saved the first title slide. Make sure that in the **Save as type** box, **JPEG File Interchange Format (*.jpg)** is selected. In the **File name** box, type **TitleSlide2.jpg**, and then click **Save**.

6. With the background and the "Our Trip" text element still selected, hold down the SHIFT key, and then click the **to** text. The selected text and background is going to be the third title slide.

7. Again, on the **File** menu, click **Save Selection**. Locate the folder where you saved the previous title slides. Make sure that in the **Save as type** box, **JPEG File Interchange Format (*.jpg)** is selected. Type **TitleSlide3.jpg** in the **File name** box and click **Save**.

8. With the background image and the text elements "Our Trip" and "to" selected, hold down the SHIFT key, and then click the final text element, **Mount Baker**. This selects the text for the fourth and final title slide, so now all the elements in the image are selected.

9. On the **File** menu, choose **Save Selection** once again. Make sure that in the **Save as type** box, **JPEG File Interchange Format (*.jpg)** is selected, type **TitleSlide4.jpg** in the **File name** box, and then click **Save**.

Before closing the image, save the image as a Microsoft PhotoDraw image. When you save the image as a Microsoft PhotoDraw image with a .mix file extension, you can later edit the individual text elements of the image. If you chose to save it as a JPEG graphics file, the image would be flattened, and you would not be able to edit the individual elements of the image. To save the graphics file as a Microsoft PhotoDraw image, perform the following steps:

1. On the **File** menu, click **Save As**.

2. Locate the folder where you saved the other title slides. In the **Save as type** box, make sure **PhotoDraw 2000 2.0 (*.mix)** or **PhotoDraw 2000 1.0 (*.mix)** is selected (depending on the version of PhotoDraw you are using), and then type **TitleSlideTemplate.mix** in the **File name** box. Click **Save**. This becomes a template image that you can later edit if you want to create additional title slides.

To animate the slides in Windows Movie Maker

After you have the slides you want to use, you can import them into Movie Maker and begin animating your slide show. To animate the slide show, you need to ar-

range the slides in the order you want them to move, and then set the playback time for your slides.

1. Start Movie Maker.

2. Select **My Collections** in the collections area. On the **File** menu, point to **New**, and then click **Collection**. Name the new collection **Chapter 12 Animated Titles**. This helps to keep the clips organized in one single collection.

3. On the **View** menu, click **Options**. This opens the **Options** dialog box. In the **Default imported photo duration (seconds)** box, type **5**. All the photos you import will be displayed in your movie for five seconds by default.

4. On the **File** menu, click **Import**. Locate the folder that contains the four title slides you created in the previous section. Press and hold down the CTRL key, and then click **TitleSlide1.jpg**, **TitleSlide2.jpg**, **TitleSlide3.jpg**, and **TitleSlide4.jpg**.

5. In the collections area, hold down the CTRL key, and then click the following clips: **TitleSlide1**, **TitleSlide2**, **TitleSlide3**, and **TitleSlide4**. Drag the selected clips to the storyboard. If necessary, drag the clips to arrange them in sequential order.

6. On the **View** menu, click **Timeline**. This lets you see the timing of the clips. Depending on the current setting for the timeline, click the **Zoom In** or **Zoom Out** button on the workspace toolbar so that the timeline appears in 2.67-second intervals. The timeline should now appear as shown in Figure 12.5.

Figure 12.5 – *Title slides placed in the timeline.*

7. On the **Play** menu, click **Play Entire Storyboard/Timeline**. Notice how the text appears abruptly as the slide show plays. To have the text appear slowly and fade in, you need to create transitions.

8. Drag **TitleSlide2** over **TitleSlide1** in the timeline so it begins to play at approximately 0:00:02.67. Click an empty space in the timeline, and then, on the monitor, click **Play**. The text now fades in with the inserted transition.

 Note The time the text takes to fade in is directly related to the transition time. If you want the text to fade in more slowly, increase the transition time.

9. Click the clip **TitleSlide3** and drag it over **TitleSlide2** in the timeline so it begins to play at approximately 0:00:7.00, so a transition appears between the

clips TitleSlide2 and TitleSlide3. This transition time is shorter than the other so that the word "to" appears rather quickly. The important words are "Our Trip" and "Mount Baker," so you want these words to appear slowly and more dramatically.

10. Finally, click **TitleSlide4** and drag it over **TitleSlide3** so that TitleSlide4 begins to play at approximately 0:00:10.67. The project should appear as shown in Figure 12.6.

Figure 12.6 – *Title slides in the timeline with the added transitions.*

11. On the **File** menu, click **Save Project**. In the **File name** box, type **Chapter 12 Animated Titles.mswmm**. This lets you save the project, so you can edit it or add additional clips to the current project.

12. On the **File** menu, click **Save Movie**. Select **High quality** for the **Setting** box, and then type your own information in the **Display information** area. Click **OK**.

13. The movie is saved as **Chapter 12 Animated Titles.wmv** by default because the project is named Chapter 12 Animated Titles.mswmm. Click **Save** to save the movie. The **Creating Movie** dialog box appears with a progress bar showing the saving status of the movie.

14. In the **Windows Movie Maker** dialog box, click **Yes** to open and watch the movie in Windows Media Player.

When you create animated title slides, you may want to make the animation repeat several times. When you do this, all you need to do is add and arrange your title slides, and then copy them throughout the project. Be aware that when you copy and paste clips that are part of a project, the timing of the clips is retained; however, transitions are not copied. Therefore, you must re-create any transitions between clips that you copy and paste in your project.

You may want to use the animated title slides in several movies you create. You can save the animated sequence as a single movie that you can later import back into Movie Maker and use in other projects.

If you create slide shows that contain a repeated animation, such as a title slide that has text grow and shrink several times, make sure you copy the clips many times before you save it as a movie. You can always trim the resulting video clip; however, the playback duration cannot be extended. Therefore, it's better to have more material than less.

Note When you import animated slide movies, make sure the **Create clips for video files** check box is cleared so that entire movie is imported as a single clip.

More methods for creating title slides

The following scenario is broken down into two sets of procedures. The first section describes how to create the title slide images using Microsoft Word and Microsoft Paint. (Paint is a feature of the Windows Millennium Edition operating system.) The second section describes how to create and use the animation in Movie Maker.

Using Microsoft Word and Microsoft Paint

Using Microsoft Paint and Microsoft Word is another way you can quickly create title slides for your movies. You can copy and paste the WordArt from Microsoft Word into Microsoft Paint, and then save the resulting images as BMP images.

1. Start Microsoft Word.

2. On the **Insert** menu, point to **Picture**, and then click **WordArt**. This lets you insert WordArt into the current Word document.

3. In the **WordArt Gallery** dialog box, choose a WordArt style. Figure 12.7 shows the one we selected, but you can use whichever one you want. Click **OK**.

Figure 12.7 – *Selecting an element in the WordArt Gallery.*

4. In the **Edit WordArt Text** dialog box, accept the default choice of **Arial Black** font and **32** point size. Feel free to use another font or size. Type **Sol Duc Falls** in the **Text** box, and then click **OK**.

5. To enhance the resulting WordArt, click **Format WordArt** on the WordArt toolbar. On the **Color and Lines** tab, click **Color**, and then choose **Fill Effects**. You can fill the WordArt with an image.

6. Click **Picture** in the **Fill Effects** box, and then click **Select Picture**. Locate the **Working** folder in the **Chapter 12** folder on the companion CD, and then select the image file **Falls1.jpg**. Click **Insert**.

7. Click **OK** in the **Fill Effects** box, and then click **OK** on the **Format WordArt** box.

8. Click the WordArt text in the Word document. On the **Edit** menu, click **Copy**. This lets you copy the WordArt text to the clipboard. This is the text that is going to be pasted into Microsoft Paint.

Now start Microsoft Paint and complete the title slide.

1. Click **Start**, point to **Programs**, point to **Accessories**, and then click **Paint**. This starts Microsoft Paint.

2. On the **Image** menu in Paint, click **Attributes**. Enter the information as it appears in Figure 12.8, and click **OK**.

Figure 12.8 – *The **Attributes** settings for the title slides in Microsoft Paint.*

3. On the **Edit** menu, click **Paste** to paste the WordArt text into Paint. With the text still selected in Paint, drag it to the middle of the image so your title slide looks similar to the slide in Figure 12.9.

> **Note** Before you save the title slide, make sure you click in a blank, white area of the image so the entire image is selected. If you do not deselect the text, only the text will be saved. When you import the resulting image into Movie Maker, there will be an undesirable blank space above and below the image.

Figure 12.9 – *The WordArt text placed in Microsoft Paint.*

4. On the **File** menu, click **Save**. Locate the folder where you want to save the image, and then type **SolDuc1.bmp**.

5. In Microsoft Word, click the WordArt element. On the **WordArt** toolbar, click **Edit Text**. This lets you make changes to the WordArt.

6. In the **Size** box, type **20**, and then click **OK**. This makes the text smaller.

7. On the **Edit** menu, click **Copy**. This copies the new, smaller text to the clipboard.

8. In Microsoft Paint, on the **File** menu, click **New**. The image size should still be 320x240. On the **Image** menu, click **Attributes** to double-check and make sure the attributes are correct, as shown in Figure 12.8.

9. On the **Edit** menu, click **Paste**. This pastes the smaller WordArt text into the blank page. Drag the selected text towards the middle once again, and then click in a blank, white area to select the entire image.

10. On the **File** menu, click **Save**. In the **File name** box, type **SolDuc2.bmp**. Save the file in the same location as the previous image, and then click **OK**.

Animating title slides in Windows Movie Maker

After you create your title slides, you can them animate them in Movie Maker. For this scenario, you are going to animate the title slides so the text shrinks and grows in your movie.

1. Start Movie Maker. On the **File** menu, point to **New**, and then click **Project** to start a new project.

2. Select **My Collections**. On the **File** menu, point to **New**, and then click **Collection**. Name the new collection **Chapter 12 Shrinking Text**. This helps to keep the clips organized in a single collection.

3. On the **View** menu, click **Options**. This opens the **Options** dialog box. In the **Default imported photo duration (seconds)** box, type **1**. All the photos you import will be displayed for one second in the movie. After you add the clips to a project, you'll need to further reduce this time. However, 1 second is the minimum time amount you can select when importing files.

4. On the **File** menu, click **Import**. Locate the folder that contains the two title slides you created. Hold down the CTRL key, and then click **SolDuc1.bmp**, and **SolDuc2.bmp**. These are the title slides for the project.

 Note If you did not create the title slides, locate the **Samples** folder in the **Chapter 12** folder on the companion CD, and then select the slides.

5. In the collections area, hold down the CTRL key, and then click the **SolDuc1** and **SolDuc2** clips. Drag the clips to the storyboard. If necessary, arrange them so SolDuc1 appears first.

6. On the **View** menu, click **Timeline**. Click the **Zoom In** button on the workspace toolbar until it appears grayed out. The timeline is now listed in increments of 33 frames (displayed as 0:00:00.33 on the timeline).

7. Click **SolDuc1** in the current project. Drag the end trim handle so it is up against the start trim handle. Repeat this step for the clip SolDuc2.

8. Click an empty area of the timeline, and then click the **Play** button on the monitor to see the animation. The text appears to shrink. You now need to make it repeatedly shrink and grow.

9. Hold down the CTRL key, and then click **Solduc1** and **Solduc2** in the project. While still holding down the CTRL key, drag the selected clips to the end of the project. Repeat this step 10 times, so the animation plays for roughly three seconds. When you copy the clips, a small plus sign appears indicating that you are copying the clips.

Figure 12.10 shows the current project as it appears in the timeline.

Figure 12.10 – *The current project.*

10. On the **File** menu, click **Project**. In the **File name** box, type **Chapter 12 Shrinking Text.mswmm**. This saves the project so you can edit it later.

11. On the **Play** menu, click **Play Entire Storyboard/Timeline** to preview the entire project.

12. On the **File** menu, click **Save Movie**. Choose **High quality** for the **Setting**, type the appropriate information in the **Display information** area, and then click **OK**. Accept the default name **Chapter 12 Shrinking Text.wmv**, and then click **Save**. After the movie has been created, click **Yes** to watch it in Windows Media Player.

Adding an existing title clip to a new movie

The following procedure describes how to import the movie created from your title slides and add it to another project to make an entirely new movie.

1. On the **File** menu, point to **New**, and click **Project** to start a new project.

2. On the **File** menu, click **Import**. Locate and click the **Chapter 12 Shrinking Text.wmv** video you just created, make sure the **Create clips for video files** check box is cleared, and then click **Open**. The video is imported into a new collection named **Chapter 12 Shrinking Text (1)**. The "(1)" appears because you created another collection with the same name in a previous section.

 Note If you did not create the video with shrinking text title slides, locate the **Final** folder in the **Chapter 12** folder on the companion CD, and then select the movie **Chapter 12 Shrinking Text.wmv**.

3. Click the new collection named **Chapter 12 Shrinking Text (1)**, and then on the **Edit** menu, click **Rename**. Type **Chapter 12 Previous Movie** for the new collection name.

4. Select the **Chapter 12 Previous Movie** collection and click **Import**. In the **Chapter 12** folder under the **Working** folder, choose the movie named **SolDucSample.wmv** and the audio file named **Mood02.wav**, clear the **Create clips for video files** check box, and then click **Open**. The movie is imported into a new collection named SolDucSample as a single clip, while the audio file appears as Mood02 in the Chapter 12 Previous Movie collection.

5. Hold down the CTRL key, click the clips **Clip 1** and **Mood02** in the **Chapter 12 Previous Movie** collection, and drag them to the beginning of the timeline. Drag **Clip 1** in the **SolDucSample** collection to the timeline as well so it appears after the other Clip 1.

6. Click **Zoom In** or **Zoom Out** so the timeline appears in 10-second intervals. On the **Play** menu, click **Play Entire Storyboard/Timeline** to play the entire project. The movie plays now, but the sound of the waterfalls is probably very loud, so the background music can barely be heard.

7. As discussed in Chapter 10, you can change the audio levels. On the **Edit** menu, click **Audio Levels**. Drag the slider bar towards **Audio track** so it appears at the second line from the Audio track side, as shown in Figure 12.11.

Figure 12.11 – *The Audio Levels setting for the current project.*

8. To add a last touch to the new project, click **Zoom Out** until the timeline displays in 2.67-second intervals (0:00:02.67). Drag the clip of the waterfall over the title slide clip so the waterfall clip begins to play at 0:00:02.67 on the timeline. Your current project should look similar to the one shown in Figure 12.12.

Figure 12.12 – *The current project with the added transition.*

9. On the **File** menu, click **Save Project**. Name the project **Chapter 12 Previous Movies.mswmm**, and click **Save**.

10. On the **File** menu, click **Save Movie**. Select **High quality** for the **Setting**, and type your own information in the **Display information** area. Click **OK**. You selected the High quality setting because this video contains video with rapid movement, such as the waterfall and title slides, as well as the added background music.

11. The movie is saved as **Chapter 12 Previous Movies.wmv** by default. Click **Save** to save the movie. The **Creating Movie** dialog box appears with a progress bar showing the status of the movie creation process.

12. In the **Windows Movie Maker** dialog box, click **Yes** to open and watch the movie in Windows Media Player.

Creating a stop-motion animation

Stop-motion animation makes stationary images and objects come alive with motion. This is the same technique used to create animations in feature films before digital animation became feasible, although it is still used by some professional animators. Using a Web camera and Windows Movie Maker, you can make objects around your home or office come alive. These objects can be toys, clay figures you create, or just about anything you can imagine. You can even feature yourself in stop-motion animations.

Because you can record narration in Movie Maker, you can easily add voices and other sounds to your animated objects.

When you create stop-motion animation, you are simply capturing frame-by-frame images of an object or person and then compiling them as a movie. In Movie Maker, this is accomplished by using the **Take Photo** button, saving the individual images, and then arranging the images in order on the timeline. Stop-motion video is just like recording full-motion video, so all of the principles discussed in part 1 of this book can be applied to animations. The only difference is that you are recording frame-by-frame rather than continuous video.

Some DV cameras have the ability to record using a feature called time-lapse, where only selected frames are recorded. For example, if your camera has this feature, you could specify the camera to capture every fifth frame. Some Web cameras are pack-

aged with software that lets you do the same thing. By using these features, you can quickly create your own stop-motion videos.

Animation basics

The overall goal of stop-motion animation is to create the appearance of motion by playing a series of still frames very quickly. If each frame is slightly different, the subject will appear to move when all of the frames are played back. This requires capturing a rather large number of frames. Because of the number of frames shown each second, it creates the appearance of fluid motion. This is not to say that you need to capture 30 different still images for one second of stop-motion animation; that would be quite time-consuming. However, the more frames or still images you capture, combined with only slight movement of the object in each frame, the more lifelike your animation will appear.

One method of creating stop-motion animations uses a stationary background. You move the objects you want to animate against this background, making a small movement, shooting a frame, and repeating the process until the animated movement is complete. One of the greatest challenges is keeping the background exactly the same so it looks like the images or people are realistically moving. If the background changes and jumps around, your animation may not be as realistic as you like—although that may be the look you are trying to achieve. When capturing the image, the best rule is to keep the camera in a stationary position and only move the objects you are trying to animate. This way, only the position of the object changes, which is the purpose of stop-motion video.

If you move the object off the established line, your figures may appear to walk in a curved or erratic path rather than a straight line. Establishing a physical line can help easily solve this problem. For example, you could use a piece of string, or better yet, something more transparent like dental floss or fishing line to mark the path of movement. Just align the camera so the line is not included in the images you capture.

This same principle can be used if you are trying to make an object appear to spin. Use a small piece of string or a small scrap of paper to mark the position of the object. This way, the image will always appear in the same portion of the frame with only the view of the object itself changing.

When you create stop-motion animation in Movie Maker, you'll need to use the **Zoom In** feature extensively. By decreasing the increments of time shown in the timeline, you can better control the timing between each frame or clip. This is important for making your animation appear realistic. In most cases you will be working with clips that last less than a second. Using clips that last for longer periods of time makes the animation seem unrealistic because the objects or persons will move in a slow, robotic way rather than in a uniform, smooth motion. Again, this may be the effect you are trying to achieve.

Creating images for an animation

The first step in creating stop-motion animation is to create the images you will use.

1. Start Windows Movie Maker.

2. On the **View** menu, click **Options**. In the **Default imported photo duration (seconds)**, type **1**, and then click **OK**. All the imported photos now appear for one second when placed in your movie.

3. Click **My Collections**. On the **File** menu, point to **New**, and then click **Collection**. Name the new collection **Chapter 12 Stop Motion Me**. Select this collection so that the photo you take is imported into this collection automatically.

4. On the **File** menu, click **Record**. This opens the **Record** dialog box. For **Record**, select **Video Only**. You will add a separate audio clip later in the project.

5. Keep your camera—whether it is a Web camera, analog camcorder, or DV camera—in a still position. Move your head to one side of the frame, and then click **Take Photo**.

6. In the **File name** box, type **Me1.jpg**, and then click **Save**. The photo is then imported as the clip Me1 in the Chapter 12 Stop Motion Me collection.

7. Move your head to the opposite side of the frame, and click **Take Photo** again. In the **File name** box, type **Me2.jpg**, and then click **Save**. This image is automatically imported into the Chapter 12 Stop Motion Me collection as Me2.

8. Repeat step 7 two more times, this time moving your head to the top of the frame and then to the bottom of the frame. Name the images **Me3.jpg** and **Me4.jpg**. Both images also appear as clips in the Chapter 12 Stop Motion Me collection.

9. Click **Cancel** to close the **Record** dialog box.

10. On the **View** menu, click **Timeline**.

Creating an animation in Windows Movie Maker

Now you can use Movie Maker to arrange the individual clips and create an animation. If you do not have images available, you can use still images from the **Samples** folder in the **Chapter 12** folder on the companion CD.

1. Hold down the CTRL key and click **Me1**, **Me2**, **Me3**, and **Me4**. Drag the clips to the timeline. The clips now appear in the same sequential order in the timeline.

2. On the timeline, click **Zoom In** until you are zoomed all the way in. The timeline now appears in 1/3-second intervals. Click the clip **Me1**, and then drag the end trim handle toward the start trim handle so both trim handles are together. Do this for the clips **Me2**, **Me3**, and **Me4**. The current project is shown in Figure 12.13.

Figure 12.13 – *The current stop-motion video.*

3. Click an empty space in the timeline, and then click **Play** in the monitor. The short video plays in the monitor.

4. In the current project, click the clip **Me1**, hold down the SHIFT key, and then click **Me4**. This lets you select all four clips in the project. Hold down the CTRL key and drag the selected clips to an empty space next to the current clips. A plus sign appears indicating that you are copying the clips. Repeat this step five more times.

5. Click the **Chapter 12 Stop Motion Me** collection. On the **File** menu, click **Import**. Locate the **Working** folder in the Chapter 12 folder on the companion CD, and then click the audio file **Wmpaud2.wav**.

6. Drag the **Wmpaud2** audio clip to the beginning of the project. The audio clip now appears at the beginning of the clip.

7. Click the **Wmpaud2** audio clip and drag the end trim handle so the audio clip stops playing with the photo clips.

8. On the **Play** menu, click **Play Entire Storyboard/Timeline** to preview the entire project.

9. On the **File** menu, click **Save Project**. In the **File name** box, type **Chapter 12 Stop Motion Me.mswmm** and click **Save**. This lets you save the project so you can edit it later.

10. On the **File** menu, click **Save Movie**. Choose **High quality** for the **Setting**, type the appropriate information in the **Save Movie** dialog box, and click **OK**. The default name for the movie is **Chapter 12 Stop Motion Me.wmv**. Click **Save**.

The movie is now saved for you or others to watch in Windows Media Player. This short introduction video can be imported into Movie Maker so you can use it as an introduction to future movies.

Creating a slow-motion movie

When creating stop-motion animations, you can create different effects by changing the settings of your camera. For example, you can change the brightness and contrast of the camera so the background is dark and only the person's face is visible. This was done for the photos in the stop-motion video named **Chapter 12 Stop Motion Me.wmv**, which you can open from the **Final** folder under the **Chapter 12** folder on the companion CD in the **Tutorials** folder. In this movie, only the person's head appears because the brightness of the camera was set to the darkest possible value.

In the video you just created, the person's head moves rather quickly throughout the video so that it looks like the video was shot as fast-motion video. However, you can easily create the opposite effect, where it looks like a video was recorded slow motion as well. To do this, you can basically follow the same procedures discussed in creating animated title slide shows. However, rather than using words, you'll use actual images.

The following scenario involves the use of still photos from the previous exercise. To save you time, use these same images. If you do not have images available, still images that you can use can be found in the **Samples** folder in the **Chapter 12** folder on the companion CD.

1. On the **File** menu, point to **New**, and then click **Project**. This starts a new project.

2. On the **View** menu, click **Timeline** so you are in the timeline view where you can see the timing of the clips.

3. Click **Zoom In** or **Zoom Out** so that the timeline is displayed in 1 1/3-second intervals (0:00:01.33). This lets you see the timeline in smaller increments, so you can adjust the timing of these clips more precisely.

4. On the **View** menu, click **Options**. The **Default imported photo duration (seconds)** should be **1** second from the previous exercise. If it is not, type 1, and then click **OK**.

5. With the collection **Chapter 12 Stop Motion Me** selected, on the **File** menu, click **Import**. Locate the **Working** folder under the folder **Chapter 12**, and select the image **Black.bmp**. Click **Open** to import it into the current collection.

6. Select the collection **Chapter 12 Stop Motion Me**, hold down the CTRL key, and then click and drag the following clips to the timeline and arrange them in the following order:

 - **Black**
 - **Me2**
 - **Me3**

- **Me1**

- **Me4**

The solid black image at the beginning helps the video to gently fade into the main part of the movie.

7. In this step, all you are doing is creating long transitions so it looks like the head slowly appears in the video. One at a time, click the clips listed in Table 12.2 and drag the start trim handle so the clip begins to play at the listed time.

Clip name	Approximate start time
Me2	0:00:00.09
Me3	0:00:01.33
Me1	0:00:02.67
Me4	0:00:04.00

Table 12.2 — *Clip names and start times for the current project.*

8. To add an audio clip, click and drag the clip **Wmpaud2** from the **Chapter 12 Stop Motion Me** collection to the beginning of the audio track. Hold down the CTRL key, and then drag a copy of the audio next to it. Click the new copy of the Wmpaud2 clip and trim the clip by dragging the end trim handle so the audio stops playing with the video clip.

Figure 12.14 shows the current project. Your project will look different if you used your own photos; however, the timing of the clips should look similar.

Figure 12.14 – *Animated clips in the timeline.*

9. On the **File** menu, click **Save Project**. Name the project **Chapter 12 Slow Motion.mswmm** and click **Save**.

10. On the **Play** menu, click **Play Entire Storyboard/Timeline** to see your project.

> **Note** At this time, you can make any adjustments to the transitions to speed up or slow down your project. Remember, to decrease the speed of the video, increase the transition time between two clips. To increase the speed, reduce the transition duration.

11. On the **File** menu, click **Save**. In the **Save Movie** dialog box, choose **High quality** for the **Setting**, type the appropriate **Display information**, and then click **OK**. Accept the default name, **Chapter 12 Slow Motion Video.wmv**, and then click **Save**.

12. After you movie has been saved to your computer, click **Yes** in the **Windows Movie Maker** dialog box to open and watch the video in Windows Media Player.

Creating still images from your videos

In this chapter, a predominant theme has been to create motion from still images. But what if you have a recorded video file and you want to save particular frames as individual photos? Unfortunately, Movie Maker does not currently let you save individual frames from a movie as still images. However, there are third-party applications that allow you to do this.

To export individual frames as still photos, the video often has to be in an uncompressed format, such as an AVI file. When you open the AVI in a video editing application, you can view the individual video frames. You can then export these frames as individual still images, which you can then import into Movie Maker.

Sonic Foundry Viscosity is one program that enables you to save individual video frames as image files. You can download a trial version from their Web site at *http://www.sonicfoundry.com*.

To extract images from an AVI file in Sonic Foundry Viscosity

1. Start Sonic Foundry Viscosity. On the **File** menu, click **Open**. Locate the **Working** folder in the **Chapter 12** folder on the companion CD. Select the file **Waterfalls.avi** and click **Open**.

2. Click the **Play** button under the individual frames to view the movie.

3. Hold down the CTRL key, and then click each video frame you want to export as a still image.

4. On the **File** menu, click **Export Frames**. This lets you save the selected frame as an individual image file. Select a location on your computer.

5. In the **Frames to export** area, click **Selected frames**. Also, click **Specify base name**, and then type **Waterfalls**. This will help keep all the individual images together with a uniform naming convention.

6. Click **Save**. The frame is now saved as a JPEG image on you computer. You can now import this image into Movie Maker to use in your movies.

Adding Sound Effects

When you edit with Windows Movie Maker, you can add sound effects and music to make your movie more complete and help tell your story. During production, a director is concerned with the look of the movie, the performances of people, and getting clean sound. It isn't until post-production that the majority of sound work is typically done, because then producers, directors, and editors have more control of their time and resources. On the set, a director is often fighting the clock and dealing with problems like surly actors and bad weather. Production is also more expensive because there are more people, rental equipment, and location costs involved. If you are shooting a one-time event, like a wedding or birthday party, there is often no time to be concerned with the sound.

In the original talkies, the music and sound effects were added as the scenes were being shot. Many elements had to work together flawlessly, so it took many hot, frustrating, expensive hours to get a good take. By waiting until post-production to do sound work, you take a huge load off production, and because you don't have the expense of production, you have the time to concentrate on getting the sound right.

The main reason for doing sound in post-production, though, is so the sound can cross the cuts. Suppose a 20-second scene has four shots in it. If you want music or a background sound to run continuously through the scene, it has to play across the cuts or over more than one shot. The only way to do that is to wait until the scene has been edited, and then add the music or sound.

This concept is represented visually by the timeline in Movie Maker. The video clips run across the top part of the timeline, and running parallel to it just below the clips is the sound track. If you drop a sound effect just below the *in* point of a clip, the sound will play on that cut. If the sound is long enough, it can play across as many cuts as you want. If you record a narration track, you create one sound that crosses every cut in the movie.

With just a *production track*—the sound connected with the video clips—you can't do much to add to the sound in post-production because the picture is locked to the sound. Whenever you make a picture edit, the sound is edited, too. However, if you have just one sound track to work with in addition to the sound from the clips, a whole world of possibilities opens up. With this sound track, you can do *sound design*.

Exploring sound design

Just as interior design can transform a drab living room, sound design can transform an incomplete, broken, or lackluster sound track. As you play your final movie, you may notice that your sound track is less than perfect. It doesn't seem finished, and you can hear the sound pop and change abruptly with the cuts. There may be nothing wrong with the way you edited the movie; this is just how unfinished audio tracks sound.

If you don't want to do any extra sound work, you can often adjust your picture cuts to clean up sounds that are cut off. But to give the sound a continuous feel, you may need to do at least some sound design. A director and editor typically spend a great deal more time worrying about the visual aspect of a movie than the sound, so they count on the talent of a good sound designer to clean up and complete the sound track.

You design sound to do the following things:

Fix the track

If you played the campout movie included on the companion CD, you probably noticed how the sound of the stove cuts in and out, the level of the sound is uneven throughout the movie, and there are occasional pops and other unmotivated off-screen sounds. The primary job of sound design is to clean the track: remove or replace sounds and even out the sound so the viewer cannot hear the cuts.

Enhance the sound

The job of the sound recordist and mixer on a production is to deliver clean dialog tracks. If the tracks are clean, the editor can cut between takes and shots and the sound will remain consistent. This is as it should be. However, because good production sound is devoid of background sound, the sound designers must add it back in during post-production or the track will seem sterile. For example, a residential background sound can be added to an interview that is shot in a very quiet room to add life to it.

Engage the viewer

Sound can be added to help tell the story and add the emotion back into a scene. Bird sounds can make a scene lighter and happier. Machines clanking rhythmically can make a scene feel heavy and depressing. Music is also a sound. Often a scene will sound and look better and more complete with the right music.

We live in a visual world. Sound is invisible to most people. Unless you live and breathe sound and music, you probably don't think about it much. To do sound design, you have to listen to and study sound in movies, television, and the world

around you. You have to actually experiment with sound. Try changing aspects of the sound and listen to the effect.

Smart movie producers know the value of sound. They know that their million-dollar visual effect will come to life only after the sound designer has added the right sound, which usually costs a great deal less. It is surprising to everyone, except sound designers, how often sound saves the day. An expensive scene that just doesn't seem to come together with editing can sometimes be fixed instantly with the right music or background sound. A good sound design always makes the pictures look better.

The sound designer is concerned with the three types of sound in a movie:

Dialog

People speaking as the primary sound in a scene. Dialog can be on-screen sound, in which we see the person talking, or off-screen sound, in which the person talking is in the scene but is not visible, such as a voice on the telephone, or outside the scene, such as a narrator. Background voices, such as people in a crowd, are usually considered sound effects. If a dialog or sound editor cannot fix poorly recorded dialog sound, he can replace the sound in a studio. This process used to be called *looping*; now it's called *Automated Dialog Replacement* (ADR). The actor comes to an ADR stage and recreates the voice track by watching playback of the picture.

Sound effects

Any sound that is not dialog or music. Sounds effects can be created and added to a scene, or taken from the production track or *wild* track. A good location sound person will record wild sound if the ambient sound is very loud or unusual. Wild means the sound is not synchronized to the picture. For example, if you are shooting by the ocean, you can record some wild ocean sound with no dialog and the sound designer can use it to smooth out the cuts.

There are two types of sound effects: *sync effects* and *backgrounds*. A sync effect is a sound that must synchronize with something in the picture, such as a door closing or punch during a fistfight. Sync effects are usually short. A background does not synchronize with the picture, but adds to the ambient sound. Often, backgrounds can be created in a loop to play continuously, such as a residential fill loop or forest bird loop.

Music

There are two types of music: *source* and *underscore*. Source is music that originates in the scene, such as from a radio, elevator music, or a live band. During production, avoid shooting with music in the background; you might not notice that someone has a radio on while you're shooting dialog, but you will

when you edit and the music jumps on every cut. If you want source music in a scene, record it wild and add it after you edit so the sound crosses the cuts.

Underscore is music that originates outside the scene, and that underscores the emotion of the movie. Underscore is the orchestra we hear underwater that tells us we should be frightened because the shark is approaching, or the music we hear on the battlefield that tells us we should feel proud, but saddened, as our heroes charge toward the front line. Almost all commercial movies have original scores that are recorded in a studio in synchronization with playback of the movie.

Designing sound with Windows Movie Maker

You can approach sound design with Movie Maker the same way you approach it with any editing tool. However, because Movie Maker is a simplified editing program, it doesn't provide some of the advanced sound design features you'll find in professional sound design tools. Some things you can do very easily. However, if you want to do tasks that are more complicated, you can use a third-party program that specializes in sound production.

Before we start, let's take stock of what we have to work with in Movie Maker:

Import sounds

You can add sound clips to your collection and then add them to your timeline. Movie Maker enables you to import many different types of audio files including WAV, AIFF, and Windows Media Format (using .wma or .asf file name extensions). The sounds can be compressed or uncompressed, and can have a mix of sample rates and bit rates.

With this variety of choices, sound work is much easier. Many professional sound editing programs don't allow this variety. For example, some only import uncompressed, CD-quality files.

Synchronize sounds with the movie

You can place sound clips in sync with the edited movie and production track by dragging the clip left or right on the timeline. For example, suppose you have a clip of a hunter shooting a rifle, but the gunshot sound is unconvincing. You can import a beefier gunshot sound and synchronize it with the rifle on the production track. When both sounds are played together, they will sound like one big gunshot.

Mix the sounds

You can adjust the mix of the production and sound tracks. It is very unlikely that two sounds created separately will have the same sound level. The mixer has a slider that enables you to control the overall balance of the two tracks.

Record sound

Many tools can record sound, but what makes the Movie Maker **Record Narration** feature so useful is that you can record in synchronization with the movie playback. Recording to playback enables you to do narration directly to the picture.

You can also do *Foley*. Foley is a process used in making commercial movies in which actors record sound effects in a studio while watching a playback of a movie. Sounds like footsteps and clothes rustling are difficult or tedious to do by editing alone. Suppose a scene of two lovers taking a romantic walk on an old wood pier was shot while a pile driver was operating off-screen. The picture works because the camera doesn't show the pile driver, but the production track is unusable. To fix this scene, the sound editor brings in actors who recreate the sound of the footsteps by walking on a creaky wood floor in the Foley studio. To complete the scene, the sound editor adds ocean water lapping and sea bird loops.

Another useful aspect of the **Record Narration** feature in Movie Maker is that it creates uncompressed WAV files. Because the sounds are standard WAV files, you can easily import them in many third-party sound design programs. You can, for example, create a Foley track, and then add an audio effect like reverb in another program. When you save the WAV with the name of the original file and put it in the location of the original file created by Movie Maker, your project opens the new file in place of the old one.

The sound design process

When you start thinking about designing the sound for your movie, approach it the same way you did your script or outline, pre-production, production, and editing. Look at the whole movie and think about what you want the sound design to do. Instead of adding a crash here and a piece of music there, think about the story as a whole and how sound can add to it and help tell your story. Planning is especially important for music, because music tells the audience how you want them to feel. Just because music seems to work well in one scene doesn't mean it will work for the overall effect you want to convey.

You can start designing sound before editing is finished by collecting wild sound. However, you will not be able to do final sound work until you have a finished edit, or *locked picture,* to work with because most of your detailed sound work must synchronize with the picture. If you start before the picture is locked, make sure the work you do can be easily adjusted if the edit changes. For example, if you edit music to fit a 30-second scene and the editor adds 20 seconds, make sure you can come up with the additional music.

After the picture has been locked or is very close to being locked, you can start designing the sound in earnest. A major motion picture has thousands of sound elements that must be created, edited, and mixed. To keep everything straight, a sound designer follows a process. You can follow the same basic process to design the sound in your movie:

1. **Spot your movie.** Play it back and note where sound work needs to be done to help tell your story.

2. **Locate sounds.** Make a collection of all the individual sound elements.

3. **Design the sound.** Mix and adjust the sound quality of the elements, and then create final sound files.

4. **Sync with the picture.** Import the final sounds into Movie Maker, and then synchronize them in the timeline.

5. **Mix the sound.** Adjust the sound elements, and then save your movie.

Spot your movie

When commercial movies are handed over to the sound and music editors who will do the sound design, all the decision makers meet first in a *spotting* session. A spotting session is held in a screening room. The movie is played back, reel by reel, and the director, producer, editor, and others decide where sound effects and music need to go, and what dialog work needs to be done.

When you spot your movie, you can make one or two lists. Indicate roughly when you want a sound to take place, about how long it needs to be, and a description, for example, Table 13.1 shows what the spotting notes might look like for the campout movie.

Start time	Length	Description
0:06	:30	Music01, covers time-lapse of tent
0:46	2:00	Music02, covers hike
5:45	1:30	SFX01, Night BG

Table 13.1 — *Campout movie spotting notes.*

Remember the three reasons for doing sound design: to fix a track, enhance the sound, and engage the viewer. Sound problems can be introduced during production, such as airplanes flying overhead or poor recording of dialog. Sound problems can also be introduced during editing, such as background sound that changes abruptly

or bumps with the cuts, or sounds that are cut off at the head or tail of a clip. Enhancing the sound with a good background can smooth out abrupt cuts or cover up sounds that are cut off. If the tail or *ring out* of a rifle shot is cut off, for example, you could add a gunshot on the sound track that has a complete ring out.

Music can often make a scene seem more complete. It doesn't fix problems with airplane noise or cut-off rifle shots, but it can sometimes pull a scene together. Underscore music is an interesting phenomenon. It doesn't seem logical that it would work. In real life, you don't hear hidden orchestras in submarines underscoring the drama that is taking place onboard. Underscore music is completely unrealistic, yet we hear it all the time, and we don't stop going to movies because of it. In fact, we are more likely to enjoy a movie that has a good score. People don't go to movies to see realism; they get enough of that already. People enjoy movies because movies allow them to be involved in a different reality. This doesn't explain why underscore works—no one knows the answer to that. Suffice it to say, it does work and people enjoy it.

People watching a movie don't listen to underscore directly; the music seems to enter the mind through some unconscious emotional channel. It tells us how we should feel. If the emotion in a scene is vague or confused, or if you simply want to reinforce a feeling, the right music can help an audience understand a scene. When a hand reaches in and grabs a character's shoulder from behind, a sudden dissonant chord tells us that everything is not all right. A small boat sailing off into the sunset can convey a sense of either foreboding or well being depending on the underscore.

As you spot your movie for music, look for areas where you want to convey a feeling and ask yourself if the movie does it on its own, or could use some help. If your scene contains dramatic shots of old English churches, for example, does it play well with the production track of tourists talking, or would the scene be helped by adding some pipe organ music? With your movie, you are creating a reality for the viewer. People watch movies to learn and feel something. People are more likely to overlook a less than perfect sound track if it contains the right music conveying the right emotion. Music often completes the experience for viewers. Music tells us how to feel; emotion makes a movie seem real.

Locate the sounds

Use your spotting notes to create a list of sound elements that you need, and then track them down one by one. Some sound elements, like a door slam or simple background, can be added directly to the timeline. Others may need to be adjusted when you design the sound. For example, a simple background may be better with multiple tracks, or a voice may be better with an effect such as reverb.

A sound designer has many sources for sound, including:

Production sound

All the sound work you do is based on the edited production track. Production sound is all the sound that was recorded, including bad takes and parts that were edited out; in other words, the raw footage. Production sound is often the best source of additional sound for reinforcing and fixing problems, especially if the location sound person recorded any wild sound. For example, if you wanted to build a background loop, you could use wild sound or a long pause from an outtake. When you are searching for sound effects, this is the first place you should look because the quality of the sound is more likely to match that of the edited track.

Library

There are a few good libraries of sound effects on CD available for amateur, non-commercial use. These libraries consist of all the basic sounds: rain, birds, cars starting and drive-bys, footsteps, doors closing, and dogs barking. Some libraries seem large, but actually consist of many useless sounds, like old tube radios being tuned and steam trains. Before you purchase a library CD, look through the titles first. The CD may have ten car sounds, but they may all be of a 1948 Hudson, which would limit their use in a modern movie.

Record to picture

Plug a microphone into your computer and use the **Record Narration** feature in Movie Maker to record directly to your edited movie. The feature was built for adding narration to a movie, but you can use it to record anything, such as Foley or music.

Record wild

If you can't find a specific sound in the raw footage or your library CD, you can record it yourself. Fortunately, there are many inexpensive, high-quality choices for recording wild sound. All that you need is a portable recording device and a microphone. You can also use your camcorder. For example, if you need a good car start, set up your camcorder on a tripod next to your car, or use another recorder, and then start your car. There is a variety of good quality cassette recorders on the market, and the new mini-disc recorders make excellent sounding recordings.

Sound design programs and keyboards

Third-party sound design programs enable you to modify existing sounds. You can use them to simply adjust the volume level, or completely modify the sounds so they don't sound anything like the original. For example, you could turn a cat meow into a space alien voice by lowering the pitch and slowing it down. Some synthesizer keyboards also come with sound effects or allow you to modify the musical sounds.

You can find music on CDs, the Internet, on television, the radio, and many other places. The problem is you may not have the rights to use it. Any music, commercial, private, or non-commercial, was created, performed, recorded, and distributed by someone or some company. It is therefore owned by someone. If you use some music, make sure you know about your rights and those of the music owners. If your movie contains some commercial music and you have not obtained the rights to use it, you could be in violation of a copyright law, especially if your movie is widely distributed, or is connected with a business or commercial venture.

Aside from commercial music, there is music you can buy that is made for use in amateur, non-profit movies. It's called production library music or *needle-drop*. Many large music stores carry CDs of library music and sound effects. A selection of short production music clips is included on the companion CD.

If you want to create your own music, there are programs you can buy with which you can enter parameters or adjust music samples on a timeline and create pseudo-custom tracks with your PC. Check with a musical instrument store that has a good selection of MIDI software and keyboards. Of course, you can always record the music yourself. If you can play guitar or piano, find a quiet room, and record yourself with your camcorder or mini-disk recorder and a microphone. You can also record directly to Movie Maker by using the **Record Narration** command.

Design the sound

The goal of this phase of sound design is to create finished sounds that can be added to the timeline in Movie Maker. This is the basic process for each sound element created:

1. **Capturing sound.** Record the sound from an external playback device to one file on your computer.

2. **Designing sound.** Modify the sound using a sound design program.

3. **Cleaning sound files.** Make sure the head and tail are clean.

4. **Saving sound files.** Save the final sound element.

You can do all these things with one sound design program. There are many good ones on the market, from free or shareware programs to expensive, professional, *multi-track* programs.

In the inexpensive category, the tool that is the most readily available and easiest to use is Sound Recorder, which is installed with your Microsoft Windows operating system. To open it, click **Start**, point to **Programs**, point to **Accessories**, point to **Entertainment**, and then click **Sound Recorder**. This simple tool can be used for

capturing sound through your audio capture card, doing simple editing and cleaning, adding echo, changing the playback speed, adjusting the volume, and then saving with the desired settings.

Sound Recorder may be all you need to get started. However, if you want to do anything else with your sound, you need a third-party sound design program.

There are two basic types of tools for doing sound design: sound editors and multi-track recorders. Sound editing programs are far more elaborate than Sound Recorder. Sonic Foundry Sound Forge, shown in Figure 13.1, is an example of a medium-priced sound-editing tool. You can use it to capture sound, or import a sound or video file. When you capture, Sound Forge displays a large, accurate sound meter with which you can correctly adjust the recording sound level. The sound file appears as a waveform. You can select parts of the waveform, and then cut, paste, and copy selected sections. Sound Forge has many editing and processing features for adjusting the quality of a sound. For example, you can change the *dynamics* of a sound to bring up the low levels, while keeping the high levels from getting too high and distorting.

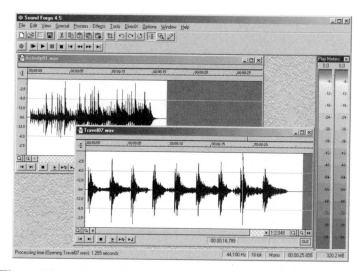

Figure 13.1 – *Sound files opened in Sonic Foundry Sound Forge.*

With a multi-track sound editing program, you create a layered sound by placing sound elements in synchronization on multiple tracks. The timeline in Movie Maker is a simple multi-track with two tracks: the production track and the sound track. Professional multi-track programs that are used to make commercial movies and music typically have 24 tracks, but can have over 96. When a movie is mixed, the multi-track editor, with its 24 tracks of sound, is synchronized to the playback of the film projector or video tape recorder. The sound mixers watch the picture and adjust

the levels of the dialog, sound effects elements, and music that are recorded on the individual tracks. The mixed sound is then recorded either to another track of the multi-track or to magnetic film.

A sound clip is represented in the multi-track timeline as a block containing a wave-form. When you first open a file in a track, the full length of the sound is visible. You can drag the left or right edges of the block to shorten the sound at the beginning or end, and move the whole block to sync it with sounds on other tracks. Like Movie Maker, multi-track programs do non-linear and non-destructive editing. This means you can change elements in the timeline all you want without affecting the original source files. In most cases, the only sound file you will create is the final file of the overall mix.

There are a few moderately priced multi-track sound editing programs available for personal computers, such as Vegas Audio from Sonic Foundry, which is shown in Figure 13.2. For more information, see the Sonic Foundry Web site at *http:// www.sonicfoundry.com*.

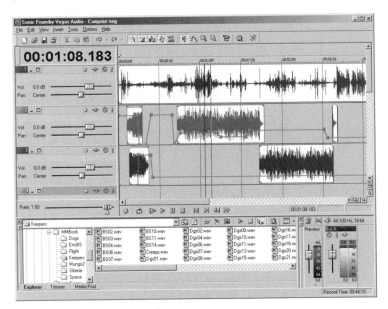

Figure 13.2 – *A multi-track project in Sonic Foundry Vegas Audio.*

Capturing sound

Use your sound editing program (such as Sound Recorder or Sound Forge) to record sound elements from an external device (such as a portable recorder, camcorder, microphone, or CD player) to a file on your computer. If you capture with Sound Forge, you can adjust input sound levels using the audio meter in the capture dialog

box. If your capture program does not have a meter, use the meter in the mixer pro-gram included with your sound card. If no meter is available, you will have to record by trial and error; record a little bit and then play it back to see how it sounds.

It is very important to capture at the proper level and to avoid *clipping* the sound. Clipping occurs when the sound level exceeds the upper volume limit of digital sound. A clipped sound is very unpleasant and cannot be repaired. Watch the sound meter as you record and make sure the level is as high as possible without going into the yellow zone, and never into the red zone. Red means the sound is clipped.

You also need to enter capture settings before you start recording. The important capture settings are:

Compression

The type of codec used to compress the sound data as it is being recorded. A setting of PCM means the sound is uncompressed. If you can, use PCM for capturing your sound elements.

Sample rate

The number of times per second the analog waveform is sampled as it is being converted to digital data. The higher the sample rate, the better the quality. Lowering the sample rate results in a loss of the higher frequencies, like turning the treble control down on your radio. For CD quality, the sample rate is 44,100 Hertz (Hz). This sample rate produces very good quality, but a CD-quality file is twice as large as a file sampled at 22,050 Hz. The rate of 22,050 Hz is a good compromise.

Bit depth

The number of bits contained in each sample of sound data. The more bits, the better the sound. You have a choice of 8 bits or 16 bits. 8-bit sound has a brittle noisy quality. You should always use 16-bit sound.

Mono/Stereo

A stereo file actually contains two tracks, or channels—one for the left speaker and one for the right speaker. A stereo sound file is twice the size of a mono file, which contains one track. If your movie will not be stereo, you can capture your sound elements in mono to save space on your hard disk drive.

If you just start capturing with Sound Recorder, the sound will be recorded using the default settings, and they may not be what you want. In Sound Recorder, open the **Properties** dialog box on the **File** menu. The line after **Audio Format** lists the cap-ture settings, such as:

```
PCM 22,050 Hz, 16 Bit, Mono
```

To change them, click **Convert Now**, and then select new settings in the list.

Designing sound

After you capture a sound element or import a file with a sound editing program, the file appears in a window in waveform view. As you play the file, the cursor points to the part of the waveform that you are listening to. The waveform height corresponds to the volume, and the width corresponds to time. High-pitched waves are close together; low-pitched waves are spread out horizontally. If the sound is a door closing, for example, you can see the different parts in the waveform: the quiet period before the close, the point where the sound starts—the *attack*—and the period after the main part of the sound where it trails out as it reverberates in the room— the ring out or *decay*. If you have a program like Sound Forge, try selecting different parts of the waveform, cutting and pasting the sound, and listening to the results.

You can use a sound-editing program to do the following basic operations:

Editing sound to size or creating a loop

If an element is a sync sound, you can trim off any excess sound on the head and tail, being careful to leave the ring out intact. With a properly trimmed head, you can easily sync the clip in Movie Maker by aligning the left edge of the clip in the timeline with the video.

You can loop a sound if you want it to play continuously. Loops are often used for backgrounds. For example, in the campout movie, Dave could have created a background loop of a section of the propane noise from the raw footage, and then added the loop to the cooking scene to help cover the cuts.

A loop is created by connecting the end of a section to its beginning. You can create one easily with Sound Forge; simply drag the cursor in the waveform to make a selection, and then play the selected section as a loop. The goal is to create a seamless loop that sounds as though it is has no beginning or end. A good loop is created by trial and error. With Sound Forge, you can adjust the loop points (the left and right edges of the selection) as you play the loop. After you a find a section that loops well, trim it by deleting everything before and after the loop points. Then, copy the loop repeatedly until the sound element is long enough to cover the section in your movie.

Figure 13.3 – *A waveform section selected for looping in Sound Forge.*

Changing the volume and dynamics

In a sound editing program, you can adjust the overall volume level of a sound element. You can adjust the volume down to play in the background behind the production track, such as a piece of music that plays behind dialog. You can also adjust the volume up to play in the foreground when you want the sound on the production track to play as background.

Programs like Sound Forge enable you to change the dynamics of a sound. Dynamics is the difference between the highest and lowest volume levels of a sound. If you find that the difference is too great—the low points are too low compared to the high points—you can adjust the dynamics using *audio compression*. This type of compression is completely different from data compression.

Most sound editing programs also enable you to add permanent fades to the beginning and end of a sound. If you want to fade out a music track, for example, rather than cut it off, you can select a section of the tail and use the command that creates a fade out.

Equalizing the sound

While a volume control raises or lowers the overall volume of a sound, an *equalizer* raises or lowers the volume of a range of frequencies. The simplest equalizers are like the treble and bass controls on a car radio, with which you can adjust a broad range of frequencies. The equalizers in a sound editing program enable you to adjust very narrow ranges. You can equalize a sound element to match the quality of the sound on your production track. If the track is very thin sounding, with little bass, for example, a well-recorded door close may stand out. To make the door close match, you can reduce the bass or lower frequencies of the sound.

Adding other effects and processing

Every sound editor comes with a variety of features. Most provide reverb and time compression features. You can add reverb to a sound to match the production track. For example, if you want to add a bird loop to a scene in a large church, you can add reverb to the birds. Time compression enables you to change the length of a sound without affecting the pitch. This can be helpful if you want to cover a 35-second scene with a 30-second music clip. Simply slow it down a bit.

To combine sounds, you can use a multi-track program, such as Vegas Audio. With a multi-track, you combine the sounds vertically on however many tracks you need, and then adjust the synchronization of sounds by dragging elements horizontally in time. You can adjust the volume of each track with a mixer, and then save the over-all mixed sound as a file.

Most multi-track programs enable you to change the mix of tracks over time. With Vegas Audio, you can draw a volume graph over a track, as shown in Figure 13.4. This graph is a visual representation of the volume changes you want.

Figure 13.4 – *Multi-track blocks with volume graphs in Vegas Audio.*

If you use a sound editor or multi-track editing program, we recommend you read the manual or on-line help, so you can get the most out of your investment. Then, experiment with the processing and editing features. The only way to learn sound design is by doing and listening.

Cleaning sound files

The last step in designing the sound elements is cleaning the head and tail. Even if a captured sound needs no design work, it should be cleaned. A cleaned sound file is much easier to work with in Movie Maker.

To clean a sound, simply delete everything from the head and tail except the part you want to keep. You should leave a small amount, no more than one-quarter of a second, of silent sound at the head and tail to avoid possible click sounds at those

points when Movie Maker plays the clip. Figure 13.5 shows a small sound file that has been cleaned.

Figure 13.5 – *A sound element that has been cleaned.*

Saving sound files

After you have finished the sound element, save the file. If you imported the file, you can save your designed sound with another name to avoid destroying the original. When you use **Save as** to create a new file, be sure the format of the file is configured correctly. If the original was compressed, for example, save the new file as PCM. Also, make sure to save files in a format that can be imported into Movie Maker. In most cases, the files should be saved as WAV files.

If you are creating a mixed file using a multi-track editing program, make sure the file is in the format you want. If the multi-track editor does not provide a way to change the format of the mix-down file, you can save the mixed file, and then change the settings and clean the sound in another sound editing program.

Sync with the picture

Place all your finished sound elements in a subdirectory of the directory containing the raw footage used in your movie. In the last phase of sound design, you synchronize the elements to your picture and production track, and then save a movie. Remember, Movie Maker is like a multi-track editor with two tracks: the production track and the sound track.

Follow this process to import and sync sound with your movie:

1. **Import the sound.** Add the files to a collection and rename the clips if necessary. Chapters 8 and 9 explain how to import clips and organize them in collections.

2. **Place the clips.** Drag the sound elements one at a time to the sound track on the timeline, and place them in sync with the production track and picture. Figure 13.6 shows an example of sound elements and video elements placed on the timeline. Move the clip, and play the movie repeatedly until you find the point where the elements sync the way you want them. Then, save the project. Chapter 10 explains how to place and work with clips using the timeline view.

Figure 13.6 – *Syncing sound and video in the Movie Maker timeline.*

3. **Check the mix.** Play the movie and check the mix between the production and sound tracks. Adjust the mixer balance so foreground sounds on the production track are even with foreground sounds on the sound track. For example, make sure a foreground music piece is at the same level as foreground dialog.

4. **Fine-tune the elements.** If the background sounds are too loud or soft for the foreground production track, open the sound file in your sound editor and adjust the audio levels. Save the file again, then re-play that section of the movie. You may need to go back and forth a few times to get the balance right.

 To make editing easier after you import a sound file in Movie Maker, leave the file in the directory you imported it from when you work on it in the sound editor. If you edit the file without moving it, the clip will be in the same place when you go back to your Movie Maker project. If the sound editor does not allow you to save a file, it is because the sound file is still in use by Movie Maker. If this happens, click another sound file in the collection. Movie Maker will release the file you are editing and you can save it.

5. **Save the movie.** After all sounds have been placed and the mix between the production and sync tracks is good, save the movie.

The process of designing sound with Movie Maker is easy because it is somewhat limited. You can do simple sound design tasks quickly, but you will be limited if you want to accomplish more complex tasks. For example, you can't have a background and music clip play at the same time. Another limitation is not being able to continually mix the tracks as the movie plays; you can't turn the music up in one place and down in another.

For many users, the simple sound design features provided by Movie Maker will be sufficient. However, once you become acquainted with editing in Movie Maker, you may want to try more ambitious sound design techniques. In the last section of this

chapter, we describe a technique to give you more control over the mix and placement of sound elements in your movie.

We cannot guarantee the results you'll get with these techniques. Everything we suggest does work, but you may need to read the manual of a program or understand more about your computer's sound capture card to make some things work on your system—in other words, you will need to figure some things out on your own because we don't know what hardware or software you are going to use. Take risks; try things; and remember to save your work.

Mixing against a production track

As you have seen, the sound mix you can create with Movie Maker is somewhat limited. If you want to change the mix, you have to lower the audio level of a file, and there is no way to play more than one sound at a time on top of the production track. If you want to do more accurate and detailed sound work, you need more than one audio track and you need to mix against the production track.

To do all this, you need the following devices and tools:

Multi-track recorder

In this section, we use Vegas Audio, but many multi-track programs offer the same features. Make sure you know what types of files can be imported into the program you use. Some will only accept files with sample rates of 44,100 or 48,000 Hz, for example, and all files must be of the same rate and uncompressed.

Mixer

A simple audio mixer into which you can plug the line input and output of your sound card, and speakers or headphones. A sound level meter is also recommended. To avoid confusion between this mixer and the sound card mixer program on your computer, we will call it the outboard mixer, meaning it is outside the computer.

Duplex sound card

If your computer and sound card were purchased in the last few years, you probably have a duplex sound card. Duplex means the electronics in the sound card used for recording are separate from those used for playing back sound through the speakers. Before proceeding, you should check the sound card documentation just to be sure. What you need to be able to do in this procedure is capture the sound of the production track as it plays back. If your card has separate record and playback electronics, this will work. Older sound cards

combine these functions into one set of electronics, and would not be suitable for the sound editing techniques we will cover here.

The diagram in Figure 13.7 shows how to connect the sound equipment. However, read the following section before making any connections.

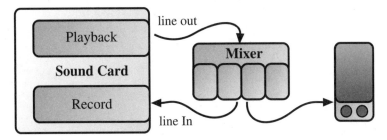

Figure 13.7 – *How to connect the hardware to record a production track.*

Connecting the hardware

The following steps walk you through the process of recording a production track for editing in a third-party sound editing program. These instructions are general in nature, because details will be somewhat different depending on the hardware and software you are using. We recommend that you read through the instructions at least once before trying this, just to make sure you understand all the issues ahead of time. Consult the documentation provided with your hardware or sound editing program for setup and operation details.

1. **Turn off line input.** Most sound cards provide a way to listen to a source sound connected to the line input. The cards do this by connecting the record side of the card to the playback side. In many cases, this is a good thing to have.

 However, if you make this connection when you connect the output of the playback side to the input of the record side, a *feedback* loop is created. Feedback is caused when the input of a card or audio amplifier is connected directly to its output. The card is listening to the sound of itself. If the sound card mixer is set to a point where the card is amplifying the sound, and you have set up a feedback loop with the wiring, the card will increase the volume in a continuous loop. What you hear is a very loud, high-pitched tone.

 If this happens, disconnect a cable in the loop immediately. Feedback can cause damage to speakers, as well as your hearing.

 To avoid feedback, turn off the **line in** on the playback side.

1. Double-click the speaker icon in the task bar to open the sound card mixer program. The dialog box that opens is most likely the mixer for the playback side of your card. Check the documentation that comes with your sound card if this is not clear.

2. To make sure the mixer is the playback mixer, click **Options**, and then **Properties**.

3. In the **Adjust volume for** panel, check to make sure the **Playback** option is selected, and then close **Properties**. If you want to see the mixer on the record side, select **Record**.

4. On the playback mixer dialog box, select the **Mute** check box for the **Line** volume slider or turn the slider down all the way. If there are other sliders that can cause feedback, mute them, too.

5. Close the sound card mixer.

 Before connecting the cables, turn down the volume just in case you missed a slider that should be muted.

2. **Connect the cables.** The line output from the sound card connects to a channel on the outboard mixer. The line output from the outboard mixer connects to the line input of the sound card. After you finish, slowly turn the volume of the outboard mixer and master volume of the sound card mixer up to normal.

 If you get feedback, turn the volume controls down and check the playback mixer again. Either you need to mute another slider or your card's mixer does not follow the model we are using here. Check the documentation provided with your sound card for more information.

 After you are satisfied with the sound level going into your mixer and feeding the sound card input, open your Movie Maker project.

Capturing the production track

3. **Set up to record a narration track.** Click the **Record Narration** button and click **Record** to start a test recording. You should see the meter in the dialog box move with the sound of the movie as it plays. If it doesn't, turn up the volume slider. Adjust the volume control on the outboard mixer and the slider on the dialog box for the optimum sound level. If there is still no sound, check the cable between the output of the outboard mixer and the sound card. It should be plugged into the Line in connection on the card. Also, check the sound card mixer on the record side to make sure it is not muted. If you still have no sound or if there is some other problem, check the documentation provided with your sound card.

4. **Record the production track.** Click **Stop**, and then **Cancel** in the **Save Narration Track Sound File** dialog box. You do not need to save the test recording. With everything set up, click **Record** again and continue recording without stopping until the movie finishes. At that point, recording stops automatically.

5. **Save the track**. Enter a name and path for the new sound file—for example, c:\MyProject\Audio\Mix.wav. The new recording is added to the audio track in the timeline.

6. **Play the movie.** Play the movie from the timeline: the edited movie, not just one clip. You should hear the original production track played against the recording you just made. Check the sync. If the two tracks are in sync throughout, you are in good shape. If the sync is off consistently throughout the movie, drag the new track to the right slightly to find synchronization. If the sync changes over time, you can adjust the final track after you add and mix the new sound elements in the multi-track editor.

If your movie is long and the sync drifts more than a few seconds, you should consider abandoning this technique. Your computer may be too slow or may not have enough memory.

7. **Locate the WAV file.** Note the location and name of the file, and then rename the file. For example, if the path is c:\MyProject\Audio\Mix.wav, you can rename it ProdTrak.wav. If you get an error when attempting to rename the file, save the current Movie Maker project, and then open a different project. Doing this causes Movie Maker to release the file, so you can rename it.

Working with the multi-track editor

8. **Open a new project or session in your multi-track sound editing program.** In this example, we use Sonic Foundry Vegas Audio. Add the production track, ProdTrak.wav, to the first track of the project and make sure it starts at zero on the timeline by sliding it all the way to the left.

9. **Add sound elements to the other tracks.** Place them against the production track. Use the functions in the multi-track program to blend the sounds. Most multi-track programs have a method for drawing volume graphs over a track, so you can change the volume continuously to blend the way you want with the production track. If you cannot add volume changes to a track, assign set volumes to different tracks, for example, make the volume low on tracks 2 and 3 and use these tracks for background sounds, and make the volume higher on tracks 4 and 5, and use these for foreground sounds.

10. **Mute the production track.** After you have finished your mix, mute the production track. You will create a mix file that contains everything except the production track. When you play the project, you should only hear the sounds you have added at the levels you have set to work with the production track. The foreground sounds should be out front, and background sounds should be low as they would be if the production track were present. If a 30-second section has no added sounds, you should hear nothing.

11. **Mix to a WAV file.** Use the multi-track editing program to create a mixed WAV file. Make sure the mixed file has the same settings as the file created by Movie Maker. Most multi-track programs provide a way to view source file properties and set the properties for mixed files. For example, the Movie Maker file is uncompressed (PCM) and mono, with a sampling rate of 22,050 Hz and bit depth of 16 bits. Make sure the mixed file is the same.

Keeping sync

12. **Replace the original production track file.** Copy the mixed file you just made to the location of the original production track, and give it the same name as the original file, for example mix.wav. You should now have ProdTrak.wav, the original file that was renamed, and mix.wav, the new file renamed with the original name.

13. **Open the Movie Maker project.** Movie Maker puts the new mixed file on the timeline in place of the original file. Play the movie. You should hear the new mixed track along with the production track. Adjust the mix between the two sound tracks.

14. **Play the movie all the way through.** If it plays correctly, save the project and save a movie.

 If the tracks go out of sync, adjust the timing of the mixed track. To do that, drag the track to the left or right slightly and check the sync again. If the track gets progressively more out of sync the further you play into the movie, split the track at several points and adjust the sections separately. At the first point where you notice a loss of sync, move back in the track to a blank space and split the track. Then, drag the new track slightly to the right and check the sync again. Keep playing the movie until the sound track loses sync again, and then repeat the process.

 The type of sync loss that gets progressively worse as the project plays is most likely due to uneven playback when you recorded the original production track file. Your computer's CPU cannot keep up with the demand and data is lost. This unevenness can be seen when you play the movie from the timeline, but is not reflected in the final encoded movie.

Movie Maker is designed to be a simple video editing tool. While using this technique, keep in mind that you are doing things with Movie Maker that are not directly supported. However, we encourage you to try new things and experiment.

Playing Movies with Windows Media Player

Now that you have learned to use Windows Movie Maker to create movies, this chapter will show you how to watch your movies using Microsoft Windows Media Player. Version 7 of Windows Media Player is a revolutionary software tool that allows you to put music and movie files on your computer and then use those files in a variety of unique ways. You can access digital content from all over the world through the Internet, organize your selections, create custom user interfaces, and put it all on a Web page. In addition, the Player provides exceptional sound and video playback quality because it uses the new Windows Media-based file formats to provide higher-quality playback from smaller file sizes than ever before. The Player also takes advantage of superior Windows Media-based streaming media technology to allow you to listen to and watch live media events. Windows Media Player 7 makes playing movies on your computer fast, easy, and fun.

In this chapter, you'll get an overview of the Player and an explanation of its major features. You'll learn how to get the latest version of the Player, how to take advantage of all its movie-related features, and how to use advanced techniques to distribute your movies on the Internet. For more details on using the Player, see the *Windows Media Player 7 Handbook*, by Seth McEvoy (Microsoft Press, 2000). You can also get more information from the Windows Media Web site at *http:// www.microsoft.com/windowsmedia*.

Getting the latest version of the Player

Before you can play movies using Windows Media Player, you will need to install the latest version of the Player, which should be version 7 or later. You need the latest version in order to take advantage of all the new video file features used by Windows Movie Maker.

Check which version of the Player you have by choosing **About Windows Media Player** from the **Help** menu. Figure 14.1 shows the dialog box that displays the version of the Player.

Figure 14.1 – *Windows Media Player version number.*

You can always get the latest version of Windows Media Player from *http:// www.microsoft.com/windowsmedia*.

If you are using Windows Millennium Edition, a version of Windows Media Player is already installed; however, a newer version of Windows Media Player 7 has been shipped since the release of Windows Millennium Edition. This version of the Player is included on the companion CD, and can also be downloaded from the Web site mentioned in the previous paragraph.

The Player has a new feature in version 7 that will help you make sure that you always have the latest version installed on your computer. Once version 7 or higher is installed, the Player will automatically check the Windows Media Web site at regular intervals and tell you if there is a newer version of the Player than the one you have installed.

> **Note** Installing the Player involves working through a series of dialog boxes. If you accept the default selection for each dialog box, the installation process will be simpler than if you customize at each step. One of the features of the Player is that you can configure it in a wide variety of ways. If you want to make your installation as quick and easy as possible, choose the defaults because you can always go back and change the options later.

Windows Media Player features for movies

Windows Media Player has a lot of interesting features, but there are only a few that you need to know about in order to play movies. First, this section will show you how to get your movie up and running on the Player. Then it will cover the basic controls, the features of each view, the different modes, the video settings, and how to use playlists and file markers.

> **Note** The Player user interface uses the term *video* or *clip* for all forms of moving pictures, such as videos and movies. Because this terminology is part of the software of the Player, it will be necessary in this chapter sometimes to use the terms clips or videos when referring to the movies you create with Movie Maker.

Playing a movie

If you want to get started right away and see your movie on the Player, all you have to do is double-click on the file that Movie Maker saved. Double-clicking on the movie file will launch the Player and start your movie playing. Figure 14.2 shows what a movie will look like in the **Now Playing** view of the Player.

Figure 14.2 – *Playing a movie.*

The **Now Playing** view is initially divided into two panes. The left pane shows the movie and the right pane shows the playlist, which includes the movie that is currently playing. The rest of the playlist includes all of the other selections that you have chosen to group together in a specific category; for example, videos of vacations, birthday parties, weddings, and so on.

Player controls

At the bottom of the screen shown in Figure 14.2, are the controls of the Player. From left to right, the controls perform the following functions:

Play/Pause
Plays the video with one click. Pauses it with another click.

Stop
Stops the video and rewinds it to the beginning.

Seek
Moves playback of the video to any position, from the beginning to the end or anywhere in between.

Mute
Temporarily stops the sound from playing.

Volume

Adjusts the sound from soft to loud.

Previous

Begins playing the previous video clip in the playlist.

Fast rewind

Moves the playback position of the video back a few seconds.

Fast forward

Moves the playback position of the video forward a few seconds.

Next

Begins playing the next video in the playlist.

Player views

The Player has several main features that are accessed through separate views. Each view is accessed by clicking on the task buttons on the left side of the Player window. The main views and the features included within them are:

Now Playing

This feature displays the currently playing video, the current playlist, and lets you change various settings. If you are playing an audio-only file, a visual representation of the music called a *visualization* will appear instead of a video.

Media Guide

You can use this feature to surf the Internet, get the latest entertainment news, and download new audio and video from the Web.

CD Audio

If you have a CD player, you can use this feature to listen to audio CDs or copy tracks from your CD to your computer.

Media Library

You can organize all your audio and video with this feature, keeping everything in playlists that sort content by author, title, and so on.

Radio Tuner

Use this feature to tune in to Internet radio stations. You can search for specific categories, locations, and frequencies of stations.

Portable Device

If you have a portable music device or a Pocket PC, you can copy music from your computer to your device with this feature.

Skin Chooser

Skins are custom user interfaces that make it possible to change the way the Player looks and functions. Use this feature to download skins and apply them to the Player.

Player modes

Windows Media Player has two main display modes. The one that you saw in Figure 14.2 is called *full mode*, because it contains all the features of the Player. The other mode is called *compact mode* and is used primarily for playing audio and video. You can change modes by selecting full mode or compact mode from the **View** menu of the Player.

Whenever Windows Media Player is in compact mode, it displays a custom user interface called a *skin*. The Player has a default skin that you will see the first time you choose compact mode. Figure 14.3 shows the default skin that is displayed in compact mode.

Figure 14.3 – *Compact mode of the Player using the default skin.*

The default mode looks similar to the full mode Player except that it does not have the task buttons on the left or the menus at the top. It also does not display the playlist on the right. However, if you click on the handle at the right edge of the default Player, a drawer will slide out showing the current playlist. Figure 14.4 shows the drawer extended. Many skins contain drawers that allow you to access features not available on the surface of the skin. Having drawers makes it possible to reduce the clutter by putting features out of the way into drawers—you only pull them out when you need them. This also makes it possible to have more visually interesting and intricate artwork.

Figure 14.4 – *The default skin with the playlist drawer opened.*

Skins come in many sizes, shapes, colors, and designs. They can range from ones that resemble a standard Windows-based program, like the Classic skin shown in Figure 14.5, to the unique Headspace skin shown in Figure 14.6. If you want even more skins, take a look at the Windows Media Skins Gallery at *http://www.windowsmedia.com*. And if you're really adventurous, you can design your own skins. Information about creating skins is available in the Windows Media Player 7 Software Development Kit (SDK) and the *Windows Media Player 7 Handbook*.

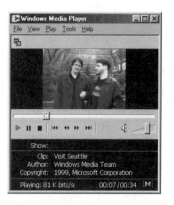

Figure 14.5 – *Classic skin.*

Figure 14.6 – *Headspace skin.*

Video settings

There are two types of video settings. You can change the display size of your video and adjust the brightness, contrast, hue, and saturation.

Adjusting video size

The movies you created in Movie Maker are saved in one of two different sizes. Once you save your movie, the video display size is either 176 pixels wide by 144 pixels high or 320 pixels wide by 240 pixels high. The video display size is determined by the quality setting specified when you created the movie.

When you play movies on the Player, you may want to change the display size of the movie. You can adjust the displayed video size from the **View** menu of the Player by choosing the **Zoom** option. A movie will normally have a default display height and width measured in pixels. You can choose from several Zoom options:

- Fit to Window

- 50%

- 100%

- 200%

You can also fill your entire monitor screen with your movie by using the full-screen display mode.

Fit to Window

The Player will zoom the video to fill the video pane of the **Now Playing** view. Figure 14.7 shows a video being played using the **Fit to Window** option.

Figure 14.7 – *Fit to Window zoom size.*

50%

The video will be shown at 50 % of the default size of the video. For example, if your video were 128 pixels by 128 pixels in size, 50 percent of that size would be 64 pixels by 64 pixels. Figure 14.8 shows a video being played at 50 percent of the default size.

Figure 14.8 – *A movie displayed at 50 percent of normal video size.*

100%

This is will show the video image size at 100 percent of the default size. Figure 14.9 shows a video at 100 percent zoom size.

Figure 14.9 – *A movie displayed at 100 percent of normal video size.*

200%

You can view a video at 200 percent of the normal video size. Figure 14.10 shows the 200 percent zoom size.

Figure 14.10 – *A movie displayed at 200 percent of normal video size.*

Viewing full-screen videos

If your video monitor supports it, you can view a video in full-screen mode. You must select the **Fullscreen Mode Switch** option in the **Performance** tab of the **Options** dialog box, which you can reach by clicking **Options** on the **Tools** menu.

Full-screen mode will display your video so that it fills the entire screen of your monitor. You can go back and forth between full-screen mode and the regular view of the Player by pressing the ALT and ENTER keys simultaneously. Figure 14.11 shows a full-screen video.

Figure 14.11 – *Full-screen video mode.*

Adjusting other video settings

You can adjust the video settings for brightness, contrast, hue, and saturation. There are three buttons near the top of the full mode Player; the one on the left is called **Show Equalizer & Settings** in the **Now Playing** view. When you click this button, a new pane appears in the **Now Playing** view that contains various settings for the Player. If you click the arrows near the bottom of this new pane, one of the options is **Video Settings**.

Drag the sliders that correspond to the brightness, contrast, hue, and saturation to make adjustments to the video displayed by the Player. Figure 14.12 shows the **Video Settings**.

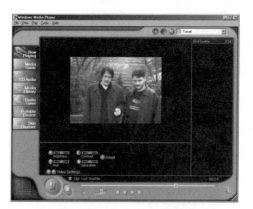

Figure 14.12 – *Video settings for brightness, contrast, hue, and saturation.*

Video playlists

Windows Media Player separates video files from audio files and puts them into the **Media Library**. You can copy your videos to new playlists and use the playlists to keep track of your movies.

Figure 14.13 shows the **Media Library** view of the Player. Videos are referred to as *clips* by the **Media Library**. The left pane shows the **All Clips** folder being selected and the right pane shows the contents of the folder sorted by Name, Author, Length, Creation Date, and Bit rate.

Figure 14.13 – *Media Library view with All Clips selected.*

You can copy clips to a new playlist and sort your video collection by playlist. For example, you could keep all your vacation videos in one playlist and your birthday party videos in another. Figure 14.14 shows a playlist named Travel that includes a video about visiting Seattle.

Figure 14.14 – *Travel playlist with a video about visiting Seattle.*

File markers

Windows Media Player lets you insert markers into a video so that you can move to a position anywhere in the file. This allows the user to move back and forth to named scenes in your video. You can move the video position to a file marker by clicking **File Marker** on the **View** menu. Figure 14.15 shows the file markers for a simple video that only has three marked positions: Beginning, Middle, and End.

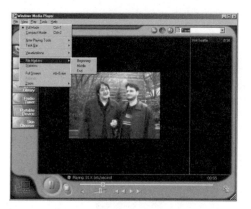

Figure 14.15 – *A video with three file markers.*

You can insert file markers automatically or with a tool called Windows Media Advanced Script Indexer. If you use more than one clip to create a movie in Movie Maker, the name of each clip will automatically be used as a file marker and the position of the beginning of each clip will be used as the file marker position for that section of the movie.

If you want to edit the file markers that were inserted into your movie, or if you want to add new ones, you can use the Windows Media Advanced Script Indexer tool. A copy of the tool and complete documentation for it is included on the companion CD included with this book.

Advanced Techniques

If you want to put your movie on a Web site, you can use Windows Media Player to display it in a Web page. You can also create custom skins to enhance your movies. Using the Player in a Web page and creating skins requires some artistic and computer programming skills. The technical information necessary to put your movies on a Web page and create skins is beyond the scope of this book. If you want to learn more about doing this, see the Windows Media Player 7 SDK and the *Windows Media Player 7 Handbook*.

The following examples will give you a basic idea of what's involved in putting your movie on a Web page and creating custom skin designs. These are very simple examples intended to show what can be done rather than how to do it.

Adding video to a Web page

You can add video to a Web page by including a few extra lines of HTML code. The functionality of the Player is accessed through an ActiveX control that is included with Windows Media Player 7. Using video in a Web page requires Web programming skills and an understanding of HTML, Microsoft JScript, and ActiveX. If you are a Web programmer and have a movie you want to display in a Web page, you will find the coding easy if you use the guidelines given in the Windows Media Player 7 SDK, which is included on the companion CD.

Figure 14.16 shows a Web page that is playing a video using Windows Media Player.

Figure 14.16 – *Video playing in a Web page.*

If you have a series of Web pages that you would like to synchronize with your movie, you can use the technique of *URL-flipping*. A URL is a link to a Web page. You can insert URLs into a video file at specific positions with the Windows Media Advanced Script Indexer tool, which is on the companion CD of this book and is part of the Windows Media Resource Kit. Once the URLs are inserted into the video file, when the file is played, the Web pages referenced by each URL will be displayed in the browser. This lets you display a synchronized sequence of Web pages like slides in a slide show.

Figure 14.17 shows a video on the left side of the browser frame and a linked Web page on the right. As the video continues to play, synchronized Web pages will be displayed in the right frame. Code examples of URL flipping are given in the Windows Media Player 7 SDK.

Figure 14.17 – *An example of URL flipping, with video on left and a linked Web page on the right.*

Creating skins for a video

With a little art and programming skill, you can create custom skins that fit the theme of your movie. There's a wide range of possibilities for the types of art you can create for skins.

The following example demonstrates the basic elements involved. With a little more art and programming, you can create full-featured designs. This example shows how to create a video-playing skin in only 21 lines of code and only a few pieces of simple artwork. Figure 14.18 shows this very simple skin playing a video. The skin has only the minimum elements of a **Play** and a **Stop** button.

Figure 14.18 – *Simple skin with two buttons showing a video.*

Code for a simple skin

Skins require some programming skills, but the amount of code needed to generate the skin shown in Figure 14.18 is very small. Here it is:

```
<THEME>
    <VIEW
        backgroundImage  =   "background.bmp"
        titleBar  =  "False">
        <VIDEO
            top  =  "10"
            left  =  "80"
            width  =  "180"
            height  =  "180"/>

        <BUTTONGROUP
            mappingImage  =   "map.bmp">
                <BUTTONELEMENT
                    mappingColor  =  "#00FF00"
                    onClick  =  "JScript:  player.URL='file:seattle.wmv';"/>
                <STOPELEMENT
                    mappingColor  =  "#FF0000"/>

        </BUTTONGROUP>
    </VIEW>
</THEME>
```

The code shows the basic XML structure of a simple skin. Every skin begins and ends with the **THEME** element. Because this is a simple skin, there is only one **VIEW** element. The single view contains two main elements: one is the **VIDEO** element that displays the video on the screen, and the other is the **BUTTONGROUP** element for the group of two buttons. The **Play** button is a custom **BUTTONELEMENT**, and the **Stop** button is a predefined **STOPELEMENT** button that stops the video. The **Play** button has a line of JScript code that is called by the click event when the button is clicked; the code will use the Player's **URL** property to start the video playing.

The skin requires two pieces of art. The first is the background image that the user sees. This is similar to Figure 14.18, but without the actual video picture in the middle. The second image, map.bmp, is a mapping file used by the Player to determine what happens when the user clicks the skin. The color green (#00FF00) is used for the **Play** button, and the color red (#FF0000) is used for **Stop**. The mapping file image is shown in Figure 14.19.

Figure 14.19 – *Mapping file for a simple skin.*

Enhancing the image

You could enhance the image surrounding the video by adding some simple clip art. For example, you could add a picture of the Seattle Space Needle. Figure 14.20 shows the same skin as Figure 14.18, but with clip art obtained from the Microsoft Clip Gallery.

Figure 14.20 – *Skin with Seattle Space Needle clip art.*

Now that you have learned to combine Windows Movie Maker with Windows Media Player, you can make your own movies and use your computer to show them to your friends and family. You can even put your movies on a Web site and show them to the whole world. The possibilities are endless because now you have complete control of the whole moviemaking process—from beginning to end. Steven Spielberg, watch out!

Glossary

This glossary defines terms used in *Windows Movie Maker Handbook*. In addition to Windows Movie Maker terms, Microsoft Windows Media Technologies and other common industry terms are defined.

B

bandwidth

The data transfer capacity of a digital communications system, such as the Internet or a local area network. Bandwidth is usually expressed in the number of bits that a system is capable of transferring in a second: bits per second (bps). High bandwidth or broadband refers to a network capable of a fast data transfer rate.

bit rate

The speed at which digital audio and video content streams from a source, such as a file, to be rendered properly by a player, or the speed at which binary content in general is streamed on a network. Bit rate is usually measured in kilobits per second (Kbps), for example, 28.8 Kbps. The bit rate of a Windows Media file or live stream is determined during the encoding process, when the streaming content is created. Bandwidth is the total bit rate capacity of a network. For audio and video content to render properly when streaming over a network, the bandwidth of the network must be high enough to accommodate the bit rates of all the different content that is concurrently being streamed.

blocking

Planning the movements of the actors and camera in a scene or shot.

b-roll

A term used in television journalism to describe extra footage that is shot to augment the primary footage.

C

call time

The time when you need a particular person or group of people on the set (the place where you are going to shoot).

camera original

The unedited film or videotape that comes from the camera containing the original images and sound, also called raw footage or the shoot reel.

capture

To convert analog video or audio to digital data, which can be stored as a file on a computer.

capture device

A hardware component that converts analog content (either audio or video) to digital content for use on a computer. For example, a video capture device enables you to record output from a live video camera, a Web camera, or a VCR onto your computer.

clip

The audio, video, or still images within Windows Movie Maker. Clips are stored in collections.

clip creation

The process of detecting and splitting video content into separate clips. Clips are created by Windows Movie Maker when there is a significant change from one frame to another.

codec

Abbreviation for compressor/decompressor. Hardware or software that can compress and decompress audio or video content. For Windows Movie Maker, codecs are used to decrease the file size of content so that it can be sent over a network.

collection

A container for organizing clips.

combine

The process of assembling two or more contiguous video clips.

compression

The coding of data to reduce the size of a file or the bit rate of a stream. Content that has been compressed must be decompressed for playback.

confrontation

The main part of a story, which takes place after the setup and before the resolution. It is at least half the length of your movie. During the confrontation, the story and plot progress: the viewer learns and changes along with the characters.

contrast ratio

The difference in brightness between the darkest and lightest parts of a scene.

content

A general term that refers to audio, video, images, text, and any other information that is seen or heard as part of a presentation.

coverage

The raw footage from which the editor creates the edited master. The more coverage you have, the more choices you have when you edit.

cross-fade

A method of smoothly moving from one video clip or photo to another. With a cross-fade transition, the frames in the playing clip fade out as the frames in the new clip fade in. Also called a dissolve.

cut

The basic type of transition used when making an edit from one shot or clip to another. A cut is an instantaneous, abrupt transition.

cutaway

A shot that briefly interrupts the main action to show something that is happening somewhere else.

D

dailies

A compilation of the good shots from the previous day's shoot.

depth of field

The measurement of the area in front of and behind the subject that is in focus.

digital video (DV)

Video images and sound stored in a digital format.

direct memory access (DMA)

Memory access that does not involve the microprocessor, and is frequently used for data transfer directly between memory and a peripheral device, such as a disk drive.

dissolve

A basic type of transition used when making an edit from one shot or clip to another. A dissolve is a slow transition in which the outgoing shot fades out as the incoming shot fades in. Also called a cross-fade.

dolly

A heavy, wheeled platform used to move the camera smoothly while shooting.

dolly grip

A person who moves the dolly with a handle.

download

A method of delivering content to a person over a network; in this method, audio or video files are copied to a client computer and then played locally. The other method of delivering content is streaming. The methods are differentiated by the location of the source content. With the streaming method, the source content is located on a remote server and played by streaming it over a network.

F

frame

One of many static images that, when displayed sequentially in rapid succession, become a motion picture or video.

frame rate

> The speed at which individual frames change. The higher the frame rate, the smoother the motion appears.

G

gels

> Colored or frosted sheets of plastic used to change the color, intensity, or characteristic of light. Gels are normally placed in front of high-wattage studio lights and are specially made to withstand the heat generated by them.

H

head

> The beginning of a scene, shot, clip, film, or tape. The end is called the tail.

header

> Part of the structure of a Windows Media stream that contains information necessary for a client computer to interpret how the packets of data containing the content should be decompressed and rendered. A header can include information such as codec types and settings, error correction used, and instructions for how to interpret the data structure of the packets.

I

IEEE 1394

> The Institute of Electrical and Electronics Engineers 1394 (IEEE) standard for a high-speed serial bus that provides enhanced PC connectivity for a wide range of devices, including consumer electronics audio/video (A/V) appliances, storage peripherals, other PCs, and portable devices.

illustrated audio

> A Windows Media stream consisting of static images that change in synchronization with an audio track; often referred to as a slide show.

import

> To bring existing digital audio, video, and still image files into Windows Movie Maker.

iso

> Abbreviation for isolated camera. In a television-style production, an iso camera records on videotape separately from the switched master. Its video is used as extra coverage in case the switched tape needs to be edited.

L

lavalier

> A very small microphone that is clipped to a person's clothing. Originally, it was worn around the neck on a cord, like a necklace.

live to tape

A production that is run as if it is being broadcast live, but is actually being recorded on videotape.

M

master

A final edited tape.

microphone noise

An artificial sound that is introduced when an object touches the microphone.

mixer

An electronic unit that has a series of volume controls with which you adjust and mix the sound coming from one or more sources.

monitor

The area on the Windows Movie Maker screen where you can preview clips.

movie file

The file created by combining the audio, video, and still images contained in your project. You can save movies to your hard disk, or send them in an e-mail message or to a Web server. Movie files are saved as a Windows Media file with a .wmv extension.

N

noise

In video, graininess or "snow" that appears in the picture. In audio, noise is any undesirable sound.

O

outtake

A take (shot) you do not use.

P

pan

To pivot the camera in a horizontal plane, so objects in the frame move from side to side.

pick-up

A shot or part of a shot that you get later to repair or improve a previous bad take.

player

A program that displays multimedia content, typically animated images, video, and audio. For example, Windows Movie Maker content is displayed by using Microsoft Windows Media Player.

project file

The file created when you save the results of adding various clips to the workspace. This file is saved with an .mswmm extension.

prop

Anything that is used by a character, such as a cigarette, boat oar, or lawn mower.

R

raw footage

The unedited film or videotape that comes directly from the camera, containing the original images and sound. Also called the camera original or the shoot reel.

resolution

The last part of a story, which takes place after the confrontation. It is roughly one-fourth of the movie. During the resolution, the confrontation is resolved, and the story comes full circle.

Resolution is also the amount of detail that can be captured in a picture by a video system, not related to focus.

rough cut

The first complete edit of a movie. It is like a rough draft of the movie.

S

scene

The core ingredient of a movie. As you follow a movie or read a script, a new scene starts whenever there is a change in time or location.

script

A written document that defines a movie by describing in words what the audience sees and hears.

sequence

A group of related scenes.

set

The scene you are shooting minus the characters and props. For example, it can be a room constructed specifically for the production or a real room.

shot

The video recorded from when the camera starts recording to when it stops.

source file

The original file that is imported into Window Movie Maker. This file can be an audio file (.mp3, .asf, .wma, etc.), video file (.wmv, .asf, .avi, .mpg, and so on), or a still image file (.jpg, .gif, and so on).

source material

The original audio and video content that is recorded into Windows Movie Maker. The content can come from a variety of sources, such as a videotape, an audiotape, a Web camera, or a television broadcast. After source material is recorded in Windows Movie Maker, the content becomes a Windows Media source file stored on your computer with a .wmv extension.

split

To break an audio or video clip into two parts.

still image

A graphic file, such as a .bmp, .gif, or .jpg file.

stinger

An electrical extension cord.

storyboard

In Windows Movie Maker, a view of the workspace that focuses on the sequencing of your clips. In general, a visual representation of a script, or parts of the script, that resembles a comic strip.

subject

In photography, the primary object or objects in a shot.

switcher

An electronic video router containing rows of buttons that a technical director presses to switch from one camera's picture to another camera's picture during a live television production. The finished videotape does not necessarily need any further editing because the edits or cuts were made by the switcher as the event was recorded.

T

tail

The end of a scene, shot, clip, film, or tape. The beginning is called the head.

take

In production, a version of a shot. Having multiple takes of a shot gives you choices in the editing room.

tease

The beginning of a story, where you introduce the main characters and engage the viewer in the story.

tilt

To pivot the camera in a vertical plane, so objects in the frame move up or down.

timeline

A view of the workspace that focuses on the timing of your clips.

transition

The method of moving from one video clip or photo to another, such as a cut, dissolve, or fade.

transport controls

Buttons that appear in the user interface of Windows Movie Maker when a DV device is detected. With these controls, you can play, stop, pause, rewind and fast forward the recorder.

treatment

A short document that describes the story and characters in a movie.

trim points

The points at which playback of a clip begins and ends. There are two trim points: start trim point and end trim point.

trimming

The process of removing parts of a clip that you do not want in your project without deleting them from the original source material. You can trim by adjusting the start or end trim points of a clip.

W

Windows Media file

A file created by using Microsoft Windows Media Technologies that contains audio, video, or still images stored in Windows Media Format. It is highly optimized for streaming. This file can be streamed by Windows Media server and played by Windows Media Player.

Windows Media Technologies

Tools and services for creating, storing, and streaming live and on-demand content.

Windows Movie Maker

A feature of Windows Millennium Edition that helps you capture audio and video source material and edit them into movies.

work print

A film copy that is made from the camera original footage. A film editor uses the work print to edit a film.

workspace

The area of Windows Movie Maker in which you create your movies. It consists of two views: storyboard and timeline, which act as a container for work in progress.

Index

About the Authors

Bill Birney

Bill Birney has a diverse career in the media. He started out as a disc jockey in Tucson. After college, he worked on a small team creating original programming for cable television: directing, running audio, building sets, wiring remote trucks, and coordinating the on-air schedule. In Hollywood, he worked in film and television as a recording engineer, sound designer, and music editor. He has been a broadcast promotion manager and performing musician. He has written, produced, directed, and edited hundreds of television spots, as well as films and videos for corporate communication and entertainment.

While with Microsoft, he has composed and recorded music, and designed sound for MSN and numerous CD-ROMs, including Microsoft Dangerous Creatures and Microsoft Flight Simulator. Bill currently writes Microsoft Developer Network articles, books, and other user education material for the Microsoft Digital Media Division.

Matt Lichtenberg

Matt Lichtenberg started as a technical trainer before turning his interests towards the written, rather than spoken, aspects of computer technical instruction. Both during and after his undergraduate work, he worked as a computer-training instructor at two universities in the Washington, D.C., area, as well as a non-profit agency, before teaching and pursuing his Master of Technical and Scientific Communication degree at Miami University (Ohio). At Microsoft, he is the lead writer for the Windows Movie Maker help documentation.

Seth McEvoy.

Seth McEvoy has twenty-five years of experience in the computer industry as a programmer, technical writer, and editor. He has specialized in learning computer languages, ranging from assembly language to COM, XML, and thirty others. In his nine years at Microsoft, he has written the programming code and text for many of their software development kits including: Windows, Microsoft Office, OLE, and Interactive Television. As a technical editor at Microsoft Press, he edited *Inside OLE*, by Kraig Brockschmidt, and other books.

He has also written 34 computer and children's books for publishers such as Simon & Schuster, Dell, Compute, Bantam, and Random House. His most recent book, *Windows Media Player 7 Handbook*, was published by Microsoft Press. One of his children's book series, *Not Quite Human*, was adapted for three TV movies by Disney.

MICROSOFT LICENSE AGREEMENT

Book Companion CD

SOFTWARE PRODUCT LICENSE

The SOFTWARE PRODUCT is protected by United States copyright laws and international copyright treaties, as well as other intellectual property laws and treaties. The SOFTWARE PRODUCT is licensed, not sold.

1. **GRANT OF LICENSE.** This EULA grants you the following rights:

 a. **Software Product.** You may install and use one copy of the SOFTWARE PRODUCT on a single computer. The primary user of the computer on which the SOFTWARE PRODUCT is installed may make a second copy for his or her exclusive use on a portable computer.

 b. **Storage/Network Use.** You may also store or install a copy of the SOFTWARE PRODUCT on a storage device, such as a network server, used only to install or run the SOFTWARE PRODUCT on your other computers over an internal network; however, you must acquire and dedicate a license for each separate computer on which the SOFTWARE PRODUCT is installed or run from the storage device. A license for the SOFTWARE PRODUCT may not be shared or used concurrently on different computers.

 c. **License Pak.** If you have acquired this EULA in a Microsoft License Pak, you may make the number of additional copies of the computer software portion of the SOFTWARE PRODUCT authorized on the printed copy of this EULA, and you may use each copy in the manner specified above. You are also entitled to make a corresponding number of secondary copies for portable computer use as specified above.

 d. **Sample Code.** Solely with respect to portions, if any, of the SOFTWARE PRODUCT that are identified within the SOFTWARE PRODUCT as sample code (the "SAMPLE CODE"):

 i. **Use and Modification.** Microsoft grants you the right to use and modify the source code version of the SAMPLE CODE, *provided* you comply with subsection (d)(iii) below. You may not distribute the SAMPLE CODE, or any modified version of the SAMPLE CODE, in source code form.

 ii. **Redistributable Files.** Provided you comply with subsection (d)(iii) below, Microsoft grants you a nonexclusive, royalty-free right to reproduce and distribute the object code version of the SAMPLE CODE and of any modified SAMPLE CODE, other than SAMPLE CODE, or any modified version thereof, designated as not redistributable in the Readme file that forms a part of the SOFTWARE PRODUCT (the "Non-Redistributable Sample Code"). All SAMPLE CODE other than the Non-Redistributable Sample Code is collectively referred to as the "REDISTRIBUTABLES."

 iii. **Redistribution Requirements.** If you redistribute the REDISTRIBUTABLES, you agree to: (i) distribute the REDISTRIBUTABLES in object code form only in conjunction with and as a part of your software application product; (ii) not use Microsoft's name, logo, or trademarks to market your software application product; (iii) include a valid copyright notice on your software application product; (iv) indemnify, hold harmless, and defend Microsoft from and against any claims or lawsuits, including attorney's fees, that arise or result from the use or distribution of your software application product; and (v) not permit further distribution of the REDISTRIBUTABLES by your end user. Contact Microsoft for the applicable royalties due and other licensing terms for all other uses and/or distribution of the REDISTRIBUTABLES.

2. **DESCRIPTION OF OTHER RIGHTS AND LIMITATIONS.**

 - **Limitations on Reverse Engineering, Decompilation, and Disassembly.** You may not reverse engineer, decompile, or disassemble the SOFTWARE PRODUCT, except and only to the extent that such activity is expressly permitted by applicable law notwithstanding this limitation.

 - **Separation of Components.** The SOFTWARE PRODUCT is licensed as a single product. Its component parts may not be separated for use on more than one computer.

 - **Rental.** You may not rent, lease, or lend the SOFTWARE PRODUCT.

- **Support Services.** Microsoft may, but is not obligated to, provide you with support services related to the SOFTWARE PRODUCT ("Support Services"). Use of Support Services is governed by the Microsoft policies and programs described in the user manual, in "online" documentation, and/or in other Microsoft-provided materials. Any supplemental software code provided to you as part of the Support Services shall be considered part of the SOFTWARE PRODUCT and subject to the terms and conditions of this EULA. With respect to technical information you provide to Microsoft as part of the Support Services, Microsoft may use such information for its business purposes, including for product support and development. Microsoft will not utilize such technical information in a form that personally identifies you.

- **Software Transfer.** You may permanently transfer all of your rights under this EULA, provided you retain no copies, you transfer all of the SOFTWARE PRODUCT (including all component parts, the media and printed materials, any upgrades, this EULA, and, if applicable, the Certificate of Authenticity), **and** the recipient agrees to the terms of this EULA.

- **Termination.** Without prejudice to any other rights, Microsoft may terminate this EULA if you fail to comply with the terms and conditions of this EULA. In such event, you must destroy all copies of the SOFTWARE PRODUCT and all of its component parts.

3. **COPYRIGHT.** All title and copyrights in and to the SOFTWARE PRODUCT (including but not limited to any images, photographs, animations, video, audio, music, text, SAMPLE CODE, REDISTRIBUTABLES, and "applets" incorporated into the SOFTWARE PRODUCT) and any copies of the SOFTWARE PRODUCT are owned by Microsoft or its suppliers. The SOFT-WARE PRODUCT is protected by copyright laws and international treaty provisions. Therefore, you must treat the SOFTWARE PRODUCT like any other copyrighted material **except** that you may install the SOFTWARE PRODUCT on a single computer provided you keep the original solely for backup or archival purposes. You may not copy the printed materials accompanying the SOFTWARE PRODUCT.

4. **U.S. GOVERNMENT RESTRICTED RIGHTS.** The SOFTWARE PRODUCT and documentation are provided with RESTRICTED RIGHTS. Use, duplication, or disclosure by the Government is subject to restrictions as set forth in subparagraph (c)(1)(ii) of the Rights in Technical Data and Computer Software clause at DFARS 252.227-7013 or subparagraphs (c)(1) and (2) of the Commercial Computer Software—Restricted Rights at 48 CFR 52.227-19, as applicable. Manufacturer is Microsoft Corporation/One Microsoft Way/Redmond, WA 98052-6399.

5. **EXPORT RESTRICTIONS.** You agree that you will not export or re-export the SOFTWARE PRODUCT, any part thereof, or any process or service that is the direct product of the SOFTWARE PRODUCT (the foregoing collectively referred to as the "Restricted Components"), to any country, person, entity, or end user subject to U.S. export restrictions. You specifically agree not to export or re-export any of the Restricted Components (i) to any country to which the U.S. has embargoed or restricted the export of goods or services, which currently include, but are not necessarily limited to, Cuba, Iran, Iraq, Libya, North Korea, Sudan, and Syria, or to any national of any such country, wherever located, who intends to transmit or transport the Restricted Components back to such country; (ii) to any end user who you know or have reason to know will utilize the Restricted Components in the design, development, or production of nuclear, chemical, or biological weapons; or (iii) to any end user who has been prohibited from participating in U.S. export transactions by any federal agency of the U.S. government. You warrant and represent that neither the BXA nor any other U.S. federal agency has suspended, revoked, or denied your export privileges.

DISCLAIMER OF WARRANTY

NO WARRANTIES OR CONDITIONS. MICROSOFT EXPRESSLY DISCLAIMS ANY WARRANTY OR CONDITION FOR THE SOFTWARE PRODUCT. THE SOFTWARE PRODUCT AND ANY RELATED DOCUMENTATION ARE PROVIDED "AS IS" WITHOUT WARRANTY OR CONDITION OF ANY KIND, EITHER EXPRESS OR IMPLIED, INCLUDING, WITHOUT LIMITA-TION, THE IMPLIED WARRANTIES OF MERCHANTABILITY, FITNESS FOR A PARTICULAR PURPOSE, OR NONINFRINGEMENT. THE ENTIRE RISK ARISING OUT OF USE OR PERFORMANCE OF THE SOFTWARE PRODUCT REMAINS WITH YOU.

LIMITATION OF LIABILITY. TO THE MAXIMUM EXTENT PERMITTED BY APPLICABLE LAW, IN NO EVENT SHALL MICROSOFT OR ITS SUPPLIERS BE LIABLE FOR ANY SPECIAL, INCIDENTAL, INDIRECT, OR CONSEQUENTIAL DAM-AGES WHATSOEVER (INCLUDING, WITHOUT LIMITATION, DAMAGES FOR LOSS OF BUSINESS PROFITS, BUSINESS INTERRUPTION, LOSS OF BUSINESS INFORMATION, OR ANY OTHER PECUNIARY LOSS) ARISING OUT OF THE USE OF OR INABILITY TO USE THE SOFTWARE PRODUCT OR THE PROVISION OF OR FAILURE TO PROVIDE SUPPORT SERVICES, EVEN IF MICROSOFT HAS BEEN ADVISED OF THE POSSIBILITY OF SUCH DAMAGES. IN ANY CASE, MICROSOFT'S ENTIRE LIABILITY UNDER ANY PROVISION OF THIS EULA SHALL BE LIMITED TO THE GREATER OF THE AMOUNT ACTUALLY PAID BY YOU FOR THE SOFTWARE PRODUCT OR US$5.00; PROVIDED, HOWEVER, IF YOU HAVE ENTERED INTO A MICROSOFT SUPPORT SERVICES AGREEMENT, MICROSOFT'S ENTIRE LIABILITY REGARDING SUPPORT SERVICES SHALL BE GOVERNED BY THE TERMS OF THAT AGREEMENT. BECAUSE SOME STATES AND JURISDICTIONS DO NOT ALLOW THE EXCLUSION OR LIMITATION OF LIABILITY, THE ABOVE LIMITATION MAY NOT APPLY TO YOU.

MISCELLANEOUS

This EULA is governed by the laws of the State of Washington USA, except and only to the extent that applicable law mandates governing law of a different jurisdiction.

Should you have any questions concerning this EULA, or if you desire to contact Microsoft for any reason, please contact the Microsoft subsidiary serving your country, or write: Microsoft Sales Information Center/One Microsoft Way/Redmond, WA 98052-6399.

**For information about Microsoft Press®
products, visit our Web site at
mspress.microsoft.com**

Microsoft®